Garage Rock
Monster Rock
Progressive Rock
Psychedelic Rock
Folk Rock

Vol. 1
Edited by
Martin Jones

Critical Vision ... An imprint of Headpress

A Critical Vision Book
Published in 2005
by Headpress

Headpress/Critical Vision
PO Box 26
Manchester
M26 1PQ
United Kingdom

[**tel**] +44 (0)161 796 1935
[**fax**] +44 (0)161 796 9703
[**email**] info@headpress.com
[**web**] www.headpress.com

British Library Cataloguing in Publication Data
A catalogue record for this book is available from the British Library

ISBN 1-900486-41-5
EAN 9781900486415

**LOVERS BUGGERS & THIEVES
Garage Rock, Monster Rock,
Psychedelic Rock, Progressive
Rock, Folk Rock**

www.headpress.com

Contents

Acknowledgements
By Martin Jones

WITHIN THIS FIRST volume of *Lovers Buggers & Thieves* (yes, more are planned) you will find a wild selection of writings on music and musicians: some familiar, some not. Most fall within the subgenres suggested, some hang off the fence. Some look out from the shadows. But be assured that garage, monster, psychedelic, progressive and folk rock are but a short step away from each paragraph. Come in, enjoy, but tell someone where you're going…

Thanks to all the contributors for their hard work, and by turn thanks to the various people who helped them. Also thanks to David Kerekes (for taking up the project), Gerard Alexander (for unwittingly providing the 'Disturbo Music' tag), Mark & Rachel Brook (we nearly got him, didn't we?) and Mike Stax.

Readers are reminded that the internet is a pigeon-toed, candy coloured, cosmic tumble dryer, and as a result websites that were available during the writing process may well not be there by the time this volume hits the shops. Sorry.

This book is dedicated to The Cramps.

Foreword

By Eddie Shaw (Monks)

Eddie

DURING THE EARLY 1960s, rock music in America was considered entertainment. Elvis was the image of innocence while shaking his hips and breaking loose from the constrictions of the uptight generation before him. He was the pet of his loving mother. He was the sensitive boy who could make girls cry.

Enough of that! My heroes were jazz players like Duke Ellington and Miles Davis. They had taken the blues to a new level, long before groups of European guitar players worked very hard to put a white face on it. And all of a sudden, the blues was everywhere. To escape the overindulgence, I became a refugee from the blues. If you know what the blues is, then you know this for sure: Misery ain't got no lasting satisfaction. A reaction was already setting in.

It was about this time that I, with four other young men, all exiles from one place or the other, were discharged from the army, having served our time as required, defending the creed of greed, or to put it another way, the wonderful values of Capitalism. We were just waking up.

Germany was a hotbed of musical activity. Unlike how it was in the United States, rock and roll was a cultural activity, and the Germans took the words seriously. There were rock groups playing everywhere; seven nights a week; four hours, six hours, and eight hours on stage. Working in such an environment, how could any group not get tight? And there we were, right in the middle of it.

The Monks were a group of five individuals who came from different backgrounds and different musical interests. Gary Burger, a country boy from the woods of Minnesota, was just getting into the sounds of the Ventures. In Renton, Washington (Hendrix's hometown), Elvis caused Dave Day Havlicek to be reborn. In fact, belief in Elvis saved him. Ever heard that message before? Larry, the "Chicago Kid," learned to play music the old fashioned way, evolving into an organist who, quite frankly, could be called crazy. Roger Johnston was a refugee from Texas who wanted to do more than just ride a horse and say, "Yippee!" His favorite drummer was Louie Belson and because of that, he became a drummer for the Monks. I was a brash, foolish kid from Nevada, who dreamed I would be an important jazz musician someday. Instead I became a minimalist, playing my own base part.

Actually there were seven monks. Two of them, Karl Remy and Walther Niemann, guided us across the border to the void. It was all preordained. None of us wished for this. It was a matter of musical evolution. Words are the beginning of lies. In the beginning was Hamburg, and the words were I Want To Hold Your Hand. At the end of the Hamburg era, were the anti's with silly shaved heads, shouting, "Be a liar everywhere, Shut Up! Don't cry!" It was a cause of concern for those with the silly long hair.

There had to be a reaction and we were it. It wasn't necessarily fun or easy. It had become time to tear things down. Smash the grandmother style of schmaltz. Time to deconstruct. Time to destroy the words that lied. It was time to pray for liberation and tear down the barrier between the stage and the audience.

I think we did it. Now we're all Monks. We're all lovers, buggers, and thieves.

Introduction

By Michael Lucas (The Phantom Surfers et al)

AMONG THE LESS-NOTED marvels of the present age is the ease with which one can make competent and technically polished rock. Armed with a home computer and inexpensive software, a ten year old can peck out a few riffs on a virtual keyboard, lay down some digital drumbeat, choose from a legion of digitally simulated instruments (Heavy, fusion or funk rock bass? Click. Edgy or emo guitar? Click. Some percussion to accentuate the merengue beat of the bridge? Click. How about a two bar string quartet interlude before the final chorus? Hell, why not? Click), then connect the intro, verse, chorus, bridge and 'guitar' over 'noise landscape' break segments with a few mouse movements and Bill's your uncle! A creation that sounds every bit as good as the glossy pap that currently passes for Rock.

The total elapsed time from first invocation of the Muse to finished CD or MP3 will probably be less than an hour, which will pass as pleasantly as though the music maker were playing *Doom* or *Vice City*. No need to get through those first few weeks of fumbling with a conventional instrument that deter most rock aspirants, much less the countless hours of aggravation spent assembling and maintaining an aggregation of other artistes.

Best of all for today's computer-literate armchair rock star is the ability to minimize the troublesome but all-too-human intangibles indicated by terms such as inspiration, passion and soul: this is precisely why these programs allow one to effortlessly match the quality of the music produced by the entertainment industry (that there are probably some smart-assed youngsters making worthwhile music on their computers is outside the purview of the present essay).

This book, on the other hand, is concerned with an engaging cast of characters who poured into their music an excess of human qualities, with an emphasis on exhilaration, savagery, dementia, desperation, eccentricity, befuddlement and just plain chowderheadedness.

Between these enchanted covers you will find chronicles of such longstanding heroes of the aesthete elite as the Sonics, Stooges, Bonzo Dog Band, Monks and Screaming Lord Sutch, as well as lesser-known but nonetheless estimable objects of fascination ranging from the otherworldy Skip Spence to the preposterous Wild. And, as though that wasn't already enough to warrant your purchase, a look at the strange world of fake (and even non-existent) Beatle outtakes, plus a battle of the bands burlesque between aluminum dinosaurs Iron Butterfly and Led Zeppelin are served for your delectation.

As is all too rare in books dealing with the rock beast, you will find that the wordsmithery is not only compelling (although some of it should carry a warning that self-urination is liable to result from reading) but loaded with information and insight.

Yes, this is the sort of book that second and third rate academics plunder for their bloodless, jargon-heavy defenses of specious theories on (un)popular culture (such as Professor Valdemar Bivalve's paper on *The Persistence of Post-Socialist and Pre-Semaphoric Expression of Subversive Rock Modes as They Correspond to the Persistence of Sacred Sites in the Iberian Peninsula and Certain Odontophoric Aspects of the Leftover Egg Salad Sandwich I Had for Breakfast*, to be published in the next Mollusk University Quarterly Journal of Cultural Digestion, be sure to pick up a copy at your local newsstand).

You are to be congratulated for your discernment in selecting this edifying tome instead of wasting your time on the windy smarm of puffed-up point-dexters and vampirish ponces that take up far too much shelf space in the book emporiums of the world. Why do you think they're called eggheads? Because their heads crack so easily when you get them out in the street!

The Sonics

Supersonic psychogarage punk's not dead

By Phil Tonge

I wanna hold your hand... *The Beatles*

I'M GOING OUT OF MY HEAD AND I WISH I WAS DEAD! *The Sonics*

WHERE CAN YOU BEGIN? It's hard enough with any piece on music, let alone on a band who helped show the way the rock world would go and sow the seeds of a coming sonic war. Some bands seem to pop up in the landscape of rock'n'roll chronology just where you'd expect them, the Stones or Slade for example. Others, like adulterine castles on the horizon, emerge totally out of place with utter contempt for time, taste or pop decency. Think Devo, The Very Things or The Sonics.

We were a wild, dirty, kickass band.
Bob Bennett[2]

The Sonics started life as a "bedroom band" made up of high school kids in Tacoma, Washington State in 1960. Founder member Larry Parypa, playing a guitar he'd wired up to a reel-to-reel tape recorder, fannied about with a drummer called Mitch Grabner. Although Mitch didn't actually have a drum kit, just a high-hat; then a snare drum was acquired and finally Mitch's dad was persuaded to cough up the cash to rent a bass drum and pedal from a local music shop. Along the way more members fell into the ranks of the band, which now had a name: The Sonics. This was something else that Mitch's dad supplied, as Andy Parypa was later to say: "The original drummer in the group, his father thought of the name."[3] Other sources always speculate about the name, citing the nearby Boeing aircraft plant and numerous passing jets for the whole "sonic-boom thing". In the end, the name just fit, that's why it stuck.

As well as a new saxophone player and (upright) bass player, The Sonics now had a lead guitarist in the shape of Stuart Turner. Deprived of any proper amplifier he too rigged his guitar to a tape recorder. Then in early 1961 the (unknown) bass player was kicked out and replaced by Larry's brother, Andy Parypa, while a bloke called Tony Mabin filled the now vacant sax spot. The early Sonics concentrated on instrumentals, like their heroes Link Wray and local cult bands The Wailers and The Roamers.

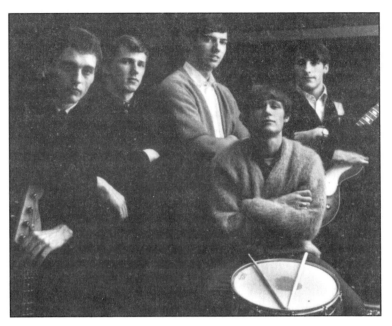

The Sonics
The classic line-up

Gerry Roslie[1]
organ/piano/lead vocals

Andy Parypa
bass

Larry Parypa
guitar

Rob Lind
saxophone

Bob Bennett
drums

The local bands probably influenced me as much as anything. The Wailers were a band that preceded the Sonics by a few years and every opportunity possible, I would go watch them perform... There were other local bands like the Frantics and Dynamics... Influences were people like James Brown, Freddie Kind... Bill Doggett was a big influence on all the Seattle groups, we had all his albums. *Andy Parypa*[4]

Left The Sonics as they appear on
the album *Here Are The Sonics!!!*

But, as with most bands thrashing around the rehearsing period of their formation, personnel problems were constant and tiresome. Bill Dean replaced Mitch as drummer, Marilyn Lodge joined to become The Sonics first vocalist and lastly Rich Koch replaced Stu Turner on lead guitar. Koch was a bit of a catch for the band has he had once played for The Wailers, and this was seen as quite a coup for the young, spotty, untried band. However, things once again refused to gel and Koch and Lodge left in 1963. Local gun-for-hire singer Ray Michelson (ex-Vikings, Falcons, Imperials) joined the line up but just as he settled in, drummer Bill Dean threw his sticks away to be more involved with hot-rods (just like the original drummer of The Buzzcocks nearly twenty years later).

Schlepping around the music scenes of Tacoma, Seattle and other centres of culture in the US Pacific Northwest, Andy and Larry came across the occupant of the drum stool of local band The Searchers. This was none other than Bob "Boom-Boom" Bennett. When he agreed to play for them, Andy and Larry went back to The Sonics camp, only to find that pop sweetheart Ray was settling down, getting married, buying a pipe and slippers and leaving the band. Telling new drummer

Bob about this, Bennett said that his mates in The Searchers would like to join up too. These mates were keyboard stamper Gerry Roslie and Sax huffer Rob Lind. Current Sonics hornblower Tony Mabin was booted out and so, by late 1963 the classic line up was complete.

Come 1964 and Gerry decides he'd (a) like to write some songs and (b) quite like to try his larynx out at this singing lark, thus was born his legend as "the white Little Richard" (© Every Yank music writer since). Not to be outdone, Larry Parypa was trying to forge his own sound by generally abusing his guitars and combos (the tape recorder lash-up a thing of the distant past). "I'd kinda trash and hammer the guitar and was actually playing it like a percussion instrument as I couldn't play notes... There's a couple of songs where I used a Fender Jazzmaster, which was popular in those days. A few years later you couldn't give 'em away. Then I bought an Epiphone Rivera..."[5] Larry also showed that he wanted The Sonics to be a band that was always going to go that one bit further than anyone else when he heard how Link Wray achieved his classic fuzz sound. Link carefully punctured the paper speaker cones in his guitar amp/combo with a pencil, arranging the holes in circular patterns for the best sound possible. Larry just picked up the biggest ice pick he could find and went for it.[6]

With surf being dead in the water (oh dear) by 1964, and Merseybeat not yet supreme in the States, there was a hungry young audience for the overloaded guitar and rumbling wall of drums, sax, bass and the talented organs of Gerry Roslie.

Soon The Sonics were selling out shows at low-life rock gigs and "sock-hops" with residencies at such diverse venues as The Red Carpet, Olympia's Skateland, Evergreen Ballroom, Pearl's, Spanish Castle Ballroom (whey-hey!) and *slightly* less camply, St Mary's Parish Hall. As the boys local reputation increased Buck Ormsby, the bass player of The Wailers, decided to approach them with a view to signing to his own record label Etiquette Records. Sitting in on a band practice in Bob Bennett's basement, Ormsby was impressed enough by their "dirty" sound to snatch them up on the spot and get them into the studio to record a debut single. This would be the Roslie-penned The Witch[7], backed with a cover of Keep A Knockin, thus summing up The

Sonics' live appeal: That being dark and nasty self-written songs followed by cover versions mutated into things from the black lagoon.

The Witch became a hit record in the Northwest, thanks to The Sonics' effect on local kids when they played it at gigs and the word of mouth that followed. This first recording also highlighted another facet of The Sonics' musical personality, the total disregard for the "done thing" in the studio. Much to the dismay of studio engineers the band would turn everything up way past eleven so every needle would be stuck in the red, just to capture the loud, dirty sound of their live sets. In some cases this involved vandalising the building itself, studio staff looking on in disbelief as the band would tear the soundproofing off the walls. "That's how we ended up sounding like a train wreck," said Andy Parypa.[8]

However, the results are well worth the material damage. The Witch, with its central driving force of Andy Parypa's chopping riff, Lind's panzerfaust sax and Roslie's howling of his evil lyric sounds more like the product of 1976 than 1964. After a particular rowdy gig at Tacoma's Curtis High School, local DJ Pat O' Jay turned up to do a disco at the same venue. All night he was pestered by these crazy eyed teens asking for The Witch. So he played it on his show, and sales went up and up. Although there were limitations, most rock stations refused to play the record until after three p.m. (when the kids were *out* of school) and even though it was the fastest and biggest selling single in the local charts *ever*, the powers that be insisted that it was "just too far out to be number one".[9]

If they thought The Witch was far out, what the hell did they make of Psycho?

Psycho, another Roslie-penned song, was selected for the next single release in early 1965. This time accompanied by Buck Ormsby (usually on hand to placate the owners of small two-four track studios over damaged/overloaded/melted equipment), the boys headed to the Audio Recording Studio owned by a certain Kearney Barton. Psycho is the *definitive* Sonics' track. This time the band are locked together, presenting a solid phalanx of ugly, fantastic garage punk, topped only by the frantic drumming of Bennett (who's hitting those skins like they're going to jump up and kill him) and Roslie's insane wail-scream-keening. The lyrical content is just so *wrong*

for the time. Nearly everyone else is singing about huggy-love and cars (yes, I know Boss Hoss is about a car, but no theory is ever 100 per cent watertight, is it?) and there's these surly looking nutters singing about mental illness, suicide and mad lust in no uncertain terms. An instant classic, Psycho unsurprisingly became another big seller, helped by the re-issue of The Witch having it replace Keep A Knockin on the B-side. (When asked in an interview why this switch, Larry Parypa replied: "Have you ever heard Keep A Knockin'?[10])

Flushed with their local success, The Sonics and Ormsby (the nominal producer of all their Etiquette releases) decided the time was right to record their debut album. Heading back to Barton's ARS studio, where they obviously hadn't caused enough damage to be banned from the building, the band set about recording their first LP, *Here Are The Sonics*. Unfortunately, the crude nature of early sixties recording technology was about to reveal its cruder side. All that was available at ARS was a two-track tape recorder and there was only one mike for the whole drum kit. This led to some "fine-tuning" in the studio equipment that meant the next album would have to be recorded elsewhere. The next album, *Boom*, sure enough was recorded at the Wiley/Griffith studios, which were an outfit that specialised in country and western music. What the owners and engineers thought when The Sonics came marching through the doors with that psychotic gleam in their collective eye is anyone's guess. And of course, *this* is the studio where the incident with the soundproofing occurred: Caught up to their ankles in cardboard egg-boxes ripped from the studio walls and ceiling they said, "Just trying to get a liver sound", and carried on. The result in February 1966 was the excellent *Boom*. This included the Roslie-penned Don't Be Afraid Of The Dark, Shot Down, Cinderella and the frankly satanic He's Waiting. The remainder of the tracks were the usual covers, including a version of Louie, Louie which has to be the most bleak and menacing ever put on vinyl. When the band just die away to leave the guitar hacking out the riff, it's one of rock'n'roll's darkest moments.

By now The Sonics were concentrating on becoming the region's stalwart support act for visiting big-time bands. These included Jan And Dean, The Beach Boys, The Kinks, The Righteous Brothers, The Byrds, The Mamas And The Papas, The Lovin' Spoonful, The Shangri-Las[11] and Herman's Hermits[12] amongst others. By the middle of 1966 there was a major falling out with Buck Ormsby and Etiquette Records. Some members of the band thought that Etiquette was essentially The Wailers' record label and that they could never really promote The Sonics nationally, while other members had some beef about financial matters. The upshot of this meant that The Sonics left Etiquette and signed to Jerden records. Jerden was owned by Jerry Dennon, whose record label was most famous for making Louie, Louie by The Kingsmen a huge national/international hit in 1963. Taken off to the Gold Star Studio in Hollywood and produced by Larry Levine, the next Sonics album was going to be their breakthrough record.

The Sonics
Selected Discography

Yes, I'm aware there's a huge pile of bootlegs, live stuff and compilations but I'm just concentrating on the key stuff.

Singles

The Witch/Keep a Knockin
(Etiquette 11) 1964
The Witch/Psycho
(Etiquette 11. Re-issue) 1965
Psycho/Keep a Knockin
(Etiquette 13) 1965
Boss Hoss/The Hustler
(Etiquette 16) 1965
Don't Be Afraid Of The Dark/
Shot Down
(Etiquette 18) 1965
Cinderella/Louie Louie
(Etiquette 23) 1965

Albums

HERE ARE THE SONICS
(Etiquette ETALB 024/ET-LPS 024) '65
BOOM
(Etiquette ETALB 025) 1965 or 1966, depending who you believe.
Introducing The Sonics
(Jerden JRL 7007/JRLS 7007) 1967. Even The Sonics didn't like this one.
LIVE FANZ ONLY
(Etiquette ETLP 1185) 1986. The '72 Seattle Paramount reunion gig.
PSYCHO-SONIC
(Big Beat CDWIKD 115) 1993. British compilation LP. Your best introduction to The Sonics. Worth it alone for the live version of The Witch.
THE SAVAGE YOUNG SONICS
(Norton Records CNW 909) 2001. A collection of rough and ready home demos and live recordings from 1961–64. Compiled with the help of Larry Parypa, whose sleeve notes reveal that his mum taught him guitar and played with The Sonics at their first gigs.

1967's *Introducing The Sonics* is a big letdown indeed. The still-present problem of record companies diluting a band's sound to attain the broadest appeal and therefore kill off that which made them appealing in the first place had kicked in, big style. Levine and GLS were not going to let the boys take charge and fuck around with the expensive equipment. "We're the experts, you monkey-boys just play your songs," seemed to be the order of the day. Not many people liked *Introducing The Sonics*, especially themselves, referring to it as "the worst garbage". By now cracks had started to appear in the line up of the band, the old chestnuts of musical and personal differences leading to walkouts, sackings and resignations.

"I think Bob Bennett quit first, around early '67. I think because he wanted to play different, more blues-oriented music. Rob Lind left to go into the Air Force and Roslie, who had a strange temperament, was eventually fired by my brother. (I left in) February of '68," said Larry Parypa.[13] Whilst Andy Parypa recalled, "It was a situation of conflicting personalities over who was actually the leader of the band. Larry and I were the founding members... But it was Roslie who was the focal point because he was the lead singer. Once Roslie was gone, it was no longer The Sonics. We all knew that."[14] Perhaps also with the whole hippy thing just peeping over the hill the band knew nasty, dirty, evil, short-hair hate music would go out of fashion for a wee while...

The Sonics limped on for a while as the classic line-up dwindled away, and the band, now with Jim Brady on vocals, became tamer and tamer than their Spitfire former selves. Adding strings and horn sections did not enamour them to their dwindling fan-base and in 1968, Andy Parypa smelt the coffee: "Me being the mercenary I am, sold The Sonics' name and everything... I just sold out, took the cash and ran. Jim Brady took the name only because it had value."[15]

And that was basically that for one of the most out of time, out of place rock bands the world's ever been deafened by. The ersatz-Sonics faded away within a few months, never to be heard of again. The classic line-up came back for one final gig in 1972 at the Seattle Paramount, an event captured on the LP *Live Fanz Only* on, naturally enough, Etiquette Records. And all was quiet until the late 1980s when Psycho was used on the soundtrack to *Henry, Portrait Of A Serial Killer*, (I have a feeling the band would have loved that) whereupon some new interest was sparked off in the band. After all, that's where I first heard them.

Then in the mid nineties, with the release of the *Psycho-Sonic* compilation CD in Britain, people could hear what all the (muffled) fuss had been about. I remember hearing their version of Have Love Will Travel at the sixties night at Nottingham weirdo-parlour The Cookie Club[16] and being mightily impressed. Then Ian the DJ started spinning Psycho and The Witch and I was hooked. Rushing out to buy *Psycho-Sonic*, I would then proceed to play it at startled music fans at any given opportunity. The best example being frightening 'Henry the Barman' at a local pub (you could gain access to the stereo if you were a regular) as he point-blank *refused* to believe these recordings were from 1964–5.

Also, I noticed that the grottier the speakers you played The Sonics through, the better they would sound. The shagged-out old sound systems of rough clubs and dodgy pubs produced a much more satisfying rumble than your top-of-the-range set-ups in people's homes.

As for the band's legacy, well you could point out what appear to be influences on The Stooges or The Flaming Groovies. Or point out similarities with acts like The Hives or Black Rebel Motorcycle Club, but it's all a bit tenuous, as nobody seems to have heard of The Sonics. Except The Cramps of course, who covered them, but then again which obscure band *haven't* they heard of? Then there's the fact that Cyanide by The Lurkers seems to be a direct carry-on (and topping of) of Strychnine, but that's grabbing at straws.

I'm sad that The Sonics never achieved the level of recognition that they deserved and that even today they're still a *tiny* cult band, but sometimes I feel that it's cool to have your own little dirty gang of rock-nasties all to yourself. At least they never went the "Early stuff excellent, big chart success, sucky middle period albums, boring, fat, junkie concept albums, tax exile stadium rock tour, sudden interest in saving the rainforests, royal funeral gig" route. As Gerry Roslie put it in Psycho: "WW-WWAAAARRRRGGGUUUHH!!!!!"

Disturbo Music

By Simon Collins

It's all right getting out of it, as long as you can get back in again.
Mick Jagger on the death of Brian Jones

ARCESIA BEGAN HIS musical career in the 1940s and fifties as Johnny Arcessi, a swing band singer in Rhode Island, the East Coast home state of H P Lovecraft. After (it's safe to assume) some sort of mid life crisis, Arcessi moved out to California in the 1960s, where, in keeping with the *Zeitgeist*, he turned on with acid. A *lot* of acid. This transmuted him into Arcesia, a way-gone acid folk singer, and in 1970, at the ripe old age of fifty two, he recorded his one and only album, the phenomenally rare *Reachin'*, from which Butterfly Mind is taken. Sadly, Arcesia was just a bit too weird even for a generation raised on Frank Zappa and Captain Beefheart, and he died in obscurity in 1978. In a world where nutters like Axl Rose and Slipknot make a good living from their own psychopathology, it's a shame that the lysergically saturated Arcesia wasn't more appreciated.

Butterfly Mind opens with a delicate vision of beauty and innocence:

Butterfly mind
Idling away the hours
Going from flower to flower
For your nectar's desire

Yet there is a serpent in this pollinated paradise:

Don't let a wasp grab you
Don't let a hand nab you
Don't let a net get you
And make you a beautiful dead thing
For all his friends to see

The song continues in this bathetic tone, until the fragile dream of the sixties is finally dispatched in a tableau of psychedelic squalor:

… Living on liquor and pills
Entombed in a room that's so far out
But not as far out as you.

So far, so far out. What makes Butterfly Mind so memorable, however, is that not so far beneath the addle-pated acid-bath of verbiage, and despite the solo acoustic guitar arrangement, Johnny Arcessi's crooning roots are clearly audible. Arcesia's strangulated tenor sounds like Barry Manilow having an onstage breakdown after drinking spiked pina coladas. Or, to come at it from another direction, it's the voice of Jim Morrison, if The Doors had pushed the cocktail lounge tendencies of *The Soft Parade* and *LA Woman* just a little further; if ol' Jimbo had broken on through to the other side just a little more. And of course, Morrison had his own dalliance with butterfly imagery in When The Music's Over:

Before I sink into the big sleep
I want to hear the scream of the butterfly

Is one of the true gods of rock really so far removed from a marginal musical outsider? It's a sobering thought. Gene Youngblood, reviewing The

Doors' second album, *Strange Days*, opined:

> The Beatles and the Stones are for blowing your mind. The Doors are for afterward, when your mind is already gone.

Now we know this isn't quite true: *Arcesia* is for when your mind is already gone.

All in all, though, the singer that Arcesia most closely resembles is Lorenzo S Dubois, the beautiful freak played by Dick Shawn in Mel Brooks' *The Producers*, the one who sings the song about "Hey river, you stink!" at his audition and ends up playing Hitler. Arcesia is the Ed Wood Jr of acid rock. We can only sit and listen, slack-jawed and dumbfounded. Johnny Arcessi, we salute you, for verily no one was as far out as you.

Further Information

There isn't a whole hell of a lot, unfortunately. The interested reader is referred to the astonishing outsider music compilation *Songs in the Key of Z* (Cherry Red Records, September 2000, catalogue number CDMRED175), compiled by New York-based journalist, music historian and DJ Irwin Chusid, and the companion book, also called *Songs in the Key of Z* (Cherry Red Books, new edition January 2001, ISBN 1901447111). Both of these are available online from Amazon and other outlets. The album contains Butterfly Mind, and you're pretty unlikely to hear any Arcesia anywhere else, although there was a vinyl only reissue of the *Reachin'* album in Germany in 1997. Lotsa luck tracking down a copy (and send me a tape if you do!).
In America, the CD was released by Gammon Records [**w**] www.gammonrecords.com. Parallel World is the website of Paul Major, who tracked down Arcesia's relatives and saved his story from oblivion [**w**] www.parallel-world.com. There's also a *Key of Z* website: [**w**] www.keyofz.com. Cherry Red has a website too: [**w**] www.cherryred.co.uk
Songs in the Key of Z volume two is imminent. I can hardly wait, although sadly it doesn't feature any more Arcesia.

Jeff St John And The Id.

TWO ELEMENTS COMBINED to blow the minds of Australian youth in the late sixties.

The first was musical. The rampant overdose that was The Jimi Hendrix Experience; the doom-laden psychodrama of The Doors; the ominous sagas of Jefferson Airplane and the spaced-out, paisley-fried hymns of Pink Floyd saturated their brains with otherworldly imagery.

The second was chemical. When Australia became the prime destination for US soldiers on "rest and recreation" leave during the Vietnam War, they didn't just bring a lot of bad memories; they brought drugs. Particularly LSD, which had not been introduced to the country in any commercial quantities up to that time. Suddenly, everybody wanted to "turn on". From the grooviest pop combos to the punkiest Garage bands, the "freak-out" became the only way to be "in".

For the popsters, it gave them the opportunity to have that 'novelty' hit they'd been seeking. Whereas many Garage groups used acid to obliterate the realisation that they would never have a hit. Many apparently found the path to truth via acid, while many more were so burnt out that truth didn't matter anymore. I've chosen to focus on my favourite psychedelic moments in Australian music, but many more exist for those wishing to explore the lava lamp nightmares of many years ago...

■ Jeff St John And The Id, Yama and Copperwine

Jeff St John sang in The Syndicate — with guitarist Peter Anson, Don McCormack on drums, David Bentley on organ, and John Helman on bass

— before they became The Wild Oats and then Jeff St John And The Id. Their first single, covers of Lindy Lou c/w Somebody To Love established the soul experience of their style of rhythm and blues. Jeff's mellow yet soaring vocals casting a spiritual glow over even the most insipid lyrics. Eastern Dream dwelt on another plane from the stuff that was littering the singles charts in Australia at that time. With the release of Big Time Operator, The Id became one of the top national attractions, playing residencies in both Sydney and Melbourne nightclubs.

By 1967, Jeff St John left The Id to follow his own musical path. He combined with a vast number of musicians to form Yama, which cut only one single, the mysterious Nothing Comes Easy c/w Everybody's Gone, both originals aspiring to a transcendence to a better world. Jeff had suffered from spina bifida since birth, and would use callipers to strut around the stage; but, after an operation on his legs in late 1967, he was confined to a wheelchair. By 1969, undaunted, Jeff had recovered enough to form a new group, Copperwine. Featuring Peter Figures (drums), Barry Kelly (organ), Ross East (guitar) and Alan Ingham (bass), Copperwine delved into the old and the new, bringing full mind-expanding conclusions to such soul standards such as Reach Out, Cloud Nine and Sing A Simple Song. Originals such as Fanciful Flights Of Mind and Any Orange Night pushed at the barriers of consciousness in ways never before undertaken by Australian bands. Copperwine's album, *Joint Effort*, also included an early ecological epic called Environment In 3 Parts, along with the space-head-trip-out of Teach Me How To Fly.

By 1972 however, everyone had landed, though Jeff St John continued in a somewhat poppier vein.

LB&T How seriously was music considered as an art form in the mid sixties?

JEFF ST JOHN There always was an artistry involved. There was always the striving to be that little bit different. That little bit in front of the game. But it wasn't something that you would crucify yourself in front of the Town Hall for, at that stage. It certainly became much more important to me later, but for a whole bunch of other reasons.

Fanciful Flights of Mind

Australian Psychedelic Music 1967-72

By Gerard Alexander

LB&T Was there much rivalry between bands?

JEFF ST JOHN There was much fraternity between bands. There was a healthy sense of competition, which was almost counter to the principal philosophies of the day. Some of the dreamers believed that you could exist without competition but I think it is a natural trait which often improves the end product.

LB&T Were there any hazards in playing live from the audience?

JEFF ST JOHN I never really experienced that. At one of Sydney's peripheral suburbs, there was what might be called a dance-hall brawl, but it had nothing to do with us. We did the sensible thing and packed up our tents and vanished into the night (laughs).

LB&T Did you have difficulties getting the sound you wanted when playing live?

JEFF ST JOHN I can count on the fingers of one hand the number of venues where I actually enjoyed the acoustics. The greatest problem that existed back then was that imagination far outstripped the technology.

LB&T What was the usual audience reaction to your shows?

JEFF ST JOHN It depended on where we were. There were elements out in the audience arena that didn't care what we did. Others so adored what we did that we could do no wrong.

LB&T Was there ever a deliberate effort to change the style of music to please an audience?

JEFF ST JOHN My priority has always been quality, quality and quality. What you are trying to do is to convince people that what you are offering them is quality. It might be different from what they're used to hearing, but it's still quality. Sometimes you succeed at that and sometimes you don't. That's the way I take on any project. If it's not the best I can do, I won't do it.

LB&T Do you prefer creating music on you own, or the interplay of a group?

JEFF ST JOHN It's usually a gestalt. Having said that though, I'm usually the catalyst, the person that instigates the process. The ultimate value of the process is the gestalt, because let's face it, when you make music, you rarely make music just on your own. More often than not you're making it with people so the telepathy has to be there, the empathy has to be there and that has to start at the very grass roots of the concept.

LB&T What was the most beautiful moment you've experienced onstage?

JEFF ST JOHN Copperwine and I managed to steal the show at Ourimbah, Australia's first honest-to-god full-blown pop festival. We were booked to play bright and early on Sunday morning. We'd done at least two jobs the night before. We arrived at Ourimbah in the wee small hours of the morning and curled up in our cars and went to sleep. We got ourselves together to in the morning to get up on stage and perform. During our first song, I uncharacteristically had my eyes closed. The song was this huge ballad Can't Find My Way Home. In having my eyes closed throughout the whole performance I was really gathering my strength to me, I guess, for the rest of the performance. What I didn't realize was that I was emoting to such a degree that when we finished the song, during the silence immediately after the song, I heard this tumultuous roar and I opened my eyes and lifted my head very slowly to see in front of me a sea of ten thousand people spontaneously rising to their feet and giving us a standing ovation for the first song in our set. That can be pretty moving, hell of way to start the day (laughs).

LB&T How much did the introduction of drugs change the mood of Australians in that decade?

JEFF ST JOHN Drugs, by their very nature simply tend to confuse things. Unless you yourself can understand that the primary reason you're confused is the drug and nothing else, then of course you can be misled. During that whole period it was such

an extraordinary time of experimentation that the drugs were just accepted as a normal part of the development of people. The attitude was: They're there, we'll use them, we'll find out what happens later.

LB&T How strongly was the visual emphasis of a band relied upon?

JEFF ST JOHN I'm a very visual performer, I'm extremely energetic onstage. The physical process of performing, for me, just comes with the job. I can't sit still. I've always had a highly developed sense of theatricality. It was never to be allowed to trivialize the musical quality, so the theatricality was there to augment and support the musical foundation.

The Coloured Balls album cover.

■ The Wild Cherries
The Coloured Balls

Les Gilbert (organ) was the only player left from the original line-up of The Wild Cherries, a Melbourne band that played blues and jazz standards from 1964-7. Lobby Loyde (guitar) had just arrived from The Purple Hearts, wanting to try out his new Marshall 100 watt amps, so he, along with Keith Barber (drums) Peter Eddy (bass) and Danny Robinson joined Les in a new version of The Wild Cherries. Four singles came from their twenty-month tenure together. All were experimental in the extreme, often sounding like hyperbolic rock operas condensed into three minutes. My faves though are Krome Plated Yabby, with a shimmering bronze feel to the guitar, and That's Life, which is filled with candyfloss nightmares, and yet can be played in front of a mixed audience without any deleterious effects.

By late 1968, the band went its separate ways, only to be reborn yet again in 1971, this time with Lobby on guitar, Teddy Toi on bass and Johnny Dick on drums. This line-up's best work ironically appears on Lobby's solo album *Lobby Loyde Plays George Guitar*, recorded in 1970. It's chock-full of the most swirling, stuttering distorted guitar playing this side of an earthquake. Dream is psych-out writ large, with overlapping vocals competing for your flabbergasted attention.

By 1972, Lobby had finally lain The Wild Cherries to rest in favour of a new project, the counter-revolutionary Coloured Balls! Aiming to piss off both the musical establishment that was swept up in peacenik delirium and the general public that was then coveting a return to nature, Lobby hit both targets dead centre. With Andy Fordham (guitar), Janis Miglans (bass) and Trevor Young (drums), Lobby created a band that cut their hair to short mullets, wore flannel shirts and denim jeans, and played what to our modern ears sounds very much like punk rock, with a gob of heavy psych crammed back deep in Lobby's gullet. Releasing their *Ball Power* album in 1973, The Coloured Balls appealed to a very working class crowd, as well as drawing a following from the 'sharpies' (Australian skinheads). The news media started playing this aspect up in their coverage of the band, and so gigs became harder to find. The standout tracks in their work, for me, are Human Being, which delivers a guttural throbbing engine of destruction to your front door, and G.O.D., a long apocalyptic drone that grows in intensity till it dissolves.

LB&T With The Purple Hearts, was there an initial drive to create your own sound?

LOBBY LOYDE When I joined them they were

called The Impacts. I came from a different school altogether to those guys because I had a classical background. My first rock and roll kinda bands had been a Shadows copy sorta thing and a jazz combo with seven other guys, where I played bass. My old man's a chromatic harmonica player, and he used to play me the blues till my ears fell off (laughs). So The Purple Hearts were into the rhythm and blues thing and I was looking at the blues from another point of view. It was two different styles melding because they were playing their vision of the blues, seeing as they were poms [English] and one was Scottish, and I was raised with the traditional blues from America. They were playing it a lot more upbeat than the laid back style I was used to. I had grown up listening to work and prison songs from the Mississippi delta and the English thing was much more 'white-boys' taking on the blues and bringing it to the pop field. I really enjoyed it though. It was so interesting.

LB&T How difficult was it to get the right sound when you were playing live in those days?

LOBBY LOYDE We were using fairly good equipment. I had a VOX AC30 amp, as did the other guitarist, and the bass player had a VOX D60, so we were renowned for sounding good. A lot of the Brisbane bands were right into sound because another Englishman by the name of Tony Troughton used to build these Marshall-like amplifiers. It was quite different to the hire-a-crappy-PA Melbourne scene. Brisbane always had a thriving scene because an English DJ called Tony McCarthur would get all these 'underground' records from Britain, all R&B stuff, and play them on the radio very late at night. He would have 'dance hops' in boathouses where teenagers could come, and slowly the music started spreading to all the clubs. The drummer in The Purple Hearts, Adrian Redmond, had a club called The Red Orb. That was like the birthplace of R&B in Brisbane. Promoters were able to fill some pretty big rooms just with people getting into this music.

LB&T When you relocated to Melbourne, you brought The Wild Cherries back to life…

LOBBY LOYDE The keyboard player, Les Gilbert,

used to play a cut-down cello with piano strings as a bass guitar. Malcolm McKee used to play guitar; Kevin Murphy played jazzy drums; the singer John Bastow was a crazed blues fan/architect and Rob Lovett, the other guitarist, was from the 'left wing' R&B school (laughs). I used to go and listen to 'em. When Rob left to go and sing with Python Lee Jackson in Sydney, I joined, and Les bought a Hammond organ with Leslie speakers and became a keyboard player again. With John Phillips on bass, we went on a semi-psychedelic tangent live. This crew, like me, had started to listen to all those LA and San Francisco groups like The Grateful Dead, Big Brother And The Holding Company, The Thirteenth Floor Elevators and we were loving it. Because of our classical backgrounds, we loved to experiment with melodies and tones. You just gravitate towards that. You turn up to a gig and everybody's tripping and your first song ends up twenty-five minutes long even though it's only supposed to be three and it's all downhill from there (laughs).

LB&T What was your stage show like?

LOBBY LOYDE It was very frenetic, but only because you were belting from one side of the stage to the other to let someone know what the next key change was going to be. We would play at the Catcher from three to five o'clock in the morning and that would be only four or five songs.

LB&T Were there any dangers in playing live?

LOBBY LOYDE We used to scare away any troublemakers with our music. We'd come on to play after people who were doing basically 'top forty' stuff, and blast these mammoth twenty-minute numbers, so audiences probably thought we were more aggressive than they were. We led a charmed life. Which is why when I formed Coloured Balls, which was the intention with the sheer volume we played at, we stood over crowds of thousands (laughs).

LB&T Was it a deliberate attempt to be more extreme than any Australian band had been to at that stage [Circa 1972]?

LOBBY LOYDE Oh God, yeah! You're trying to go

somewhere, to be original, you don't want to do what's been done before. There was no money in Australia so you went on for the sheer pleasure of it. All the money that came through the doors in those days went into the promoter's pockets. You were happy to be paid so that you could buy some more strings!

LB&T Is that the reason that there are so few recordings of The Wild Cherries and The Coloured Balls?

LOBBY LOYDE Well on the Cherries B-sides we had to play some soul/blues stuff, because that reflected what the record companies wanted for their commercial reasons. On the A-side, you would get a chopped down four-minute version of our psychedelic numbers. They never let us make an LP because they said, "That kinda music is like a waste of vinyl." That's why we tossed in the towel. Until I played with Billy Thorpe And The Aztecs, I had never recorded a whole album. And that was only allowed because it was in-your-face 'pub rock' I guess.

LB&T What was the most surprising thing about playing then?

LOBBY LOYDE The amount of tolerance audiences had for really exploring the other side. The incredible rapport you'd get with them because you took them on a journey. You play better when they're trancing out or going ballistic to it. You can play loud rock and roll and people can dance to it, but if it's not taking them on that journey it's nothing. When one of you hints at a theme as you play, and that leads to a progression none of you have ever thought of before, and it takes you to unexplored tangents, that's the greatest feeling. In 1975, I went to England and met every psychedelic person I could, playing with Southern Electric, and they all talked about musical journeys as well. The Wild Cherries used to do a song called G.O.D. — Guitar OverDose — an E Minor Modal thing that builds to this big crescendo, and there's a version of it on *Summer Jam*, that takes up one side of the record. Yet they take out the last ten minutes of the song, which is totally coloured feedbacks, creating feedback harmonies. The harmonies start very pure but become

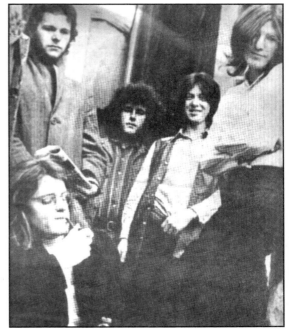

Company Caine, first line up.

like diminished thirds, so ugly, then other melodies start to cut through it. I love all that. We had been scheduled to play the morning set at the Sunbury Festival, and when we opened with G.O.D. it woke the whole crowd right up. That's the recording on *Summer Jam*.

■ From Little Gulliver And The Children to Company Caine

Gulliver Smith was always the centre of attention in Melbourne, so it was inevitable he would one day be in a band. In 1965, his intentions got serious and he formed soul/R&B band Little Gulliver And The Children, immediately issuing the singles Short Fat Fanny, Hey Little Girl and No Money Down, all featuring his trademarked habit of interrupting the song he was doing to tell some little vignette that was quite unrelated. The band appeared on local TV shows such as *The Go!! Show*, and after releasing an EP in late 1966, Gulliver left for the warmer climes of Sydney. Gulliver sang in Dr Kandy's Third Eye, a performance troupe, but they left no recordings for our evaluation. Gulliver did write

some songs with them which he would carry into Company Caine, his next major band. The last version of Melbourne band Cam-Pact featured Russell Smith (guitar), Cliff Edwards (bass) and Ray Arnott (drums). They wanted to try more free-form, avant-jazz types of music, so they joined Gulliver Smith and Jeremy Noone and created Company Caine. This was something quite distinct from anything done in Australia up to that time, with songs often giving way to noise or gatecrashing theatrics which then resolved themselves in time for the melody to resume. The 1971 album *Product Of A Broken Reality* remains fresh to this day, with songs such as the satirical The Day Superman Got Busted and the macabre Symptoms still capable of conjuring all manner of spirits. The commercial failure of these ventures however led to the inevitable breakup, but the possibilities offered by bands such as Company Caine can never be dismissed.

LB&T Was there a visual concept to the band Little Gulliver And The Children?

GULLIVER SMITH Not really, we were just beatniks trying to play rock and roll (laughs). The 'beat generation' had just gone by and we were influenced by that a lot. Most people at that stage (1964) were doing Beatles music but we preferred the R&B and soul sounds coming out of America. That's when I started ad libbing and talking in the middle of songs, dropping to my knees and tearing off my shirt (laughs). I remember listening to gospel records where people would start preaching in the middle of the song. A lot of soul music would have guys interrupt the singing to talk about their broken heart, so that gave me the idea. I used to imitate Johnny Ray when I was nine or ten. He used to cry on stage.

LB&T How did Dr Kandy's Third Eye come about?

GULLIVER SMITH I moved up to Sydney because we weren't getting much work in Melbourne anymore. I used to do the TV show *It's All Happening* quite a bit in Sydney and one time I just decided to stay here. I had gone past the soul and blues area by that time and I wanted to be more creative and write more. It was hard to get work with Dr Kandy because the clubs would say "Play more commercial music."

LB&T How theatrical was your show then?

GULLIVER SMITH We did a lot of ad libbing again, but the music was much more free-form, left from all our jazz influences, specially Sun Ra. We never had foldback so I could never hear myself on stage but it didn't bother me. I don't know what it sounded like out the front, but it was good playing it (Laughs).

LB&T What was the audience's reaction to your show?

GULLIVER SMITH Eventually Paddington Town Hall and other venues started to have that sort of music on, and the people would come to get into it. We played Woody's Wine Bar on Mondays, where we could be ourselves, but when we went to the suburbs, like Fairfield, we had to revert to playing more soul stuff to survive.

LB&T Was the songwriting a collaborative effort?

GULLIVER SMITH I used to write most of the material with guitarist Dave Kain. A lot of songs were made up on the spot, starting with one or two chords and seeing what happened at the end of it, if it had an end (laughs). It didn't come together properly until we formed Company Caine.

LB&T What were Company Caine's best moments?

GULLIVER SMITH We were on the first Sunbury Pop Festival. The album we recorded, *Product Of A Broken Reality* was great, because we had a week in the studio where we just played our repertoire and could do whatever we wanted to. The GTK shows on ABC TV were always great to do because they were live and the producers there were very open. They said to us that as long as we didn't say "fuck" we could play what we wanted to. It was a ten minute show, so when we played Symptoms, there wasn't time for anything else. We did a couple of songs on GTK that we never recorded in a studio, which makes it a shame that ABC erased so many of the videotapes so that they could re-use them.

LB&T What drew you to the New Orleans style R&B that you play in your solo album?

GULLIVER SMITH A guy called Stan Rofe in Melbourne used to play all this stuff when I was about fourteen or so. I loved the sound of Little Richard's band in the fifties. Years later I heard Dr John's *Gumbo* album and Huey Piano, and I was struck by the feel of their music.

LB&T How did bands go about getting gigs?

GULLIVER SMITH We never had managers, we had agents at most stages. When I was Little Gulliver, my manager changed my name from the original spelling of Gullifer, which is Welsh, to Gulliver. Until I started Dr Kandy's Third Eye, all my ad libbing came in the middle of songs. I would make up little stories, sometimes lasting up to five minutes, and the music would play softly behind me (laughs).

■ Tamam Shud

The Intermedia Circus in Sydney heralded the debut performance in 1967 of Tamam Shud, formerly known as The Sunsets (see the chapter: You're Driving Me Insane). They had transformed from an R&B garage band to a light-show resplendent 'head' group, dancers replaced by audiences that sat and listened to their holographic odes to existence. Tamam Shud means "The End" in Persian, but it was a bright new beginning for this group. Lindsay Bjerre was the main driving force behind the change and after their debut album *Evolution* came out in 1968, guitarist Zac Zytnik left, to be replaced by sixteen year old Tim Gaze. The single released from the album, Lady Sunshine, was peaceful enough to make it into the charts, while its B-side, Evolution, was a descent into the maelstrom. By 1970, the new line-up had gelled enough to record their 'concept' album, *Goolutionites And The Real People*. Very much a product of its time, the songs cover a range of ecological concerns, guitars traipsing heavily over much sacred ground, but still wanting to care. Asked to write the music for a new surf movie *Morning of the Earth*, Tamam Shud came up with three new songs, introducing a conga player and a flute to enrich their exotic sounds. by 1972, Lindsay decided he had said all he had to using this musical form, and he broke up the band and began playing country.

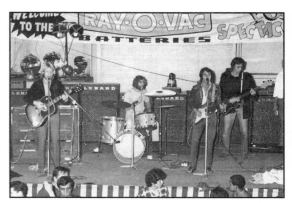
Tamam Shud. Image courtesy Terry Stacey.

LB&T At what point did you start considering what you were doing as 'art'?

TIM GAZE When I first realised that it was important for me to be playing and expressing original music, not just working in a band as a jukebox, and that music and surfing/film are a great blend.

LB&T Was there a camaraderie between bands playing the same venues?

TIM GAZE Like anything I suppose. Some people you were drawn to or just ended up getting to know, others seemed to remain not contacted with, depended on styles and geography, touring, etc. You might see some people a lot, but not necessarily talk with them.

LB&T What was the most dangerous moment you had playing live?

TIM GAZE When a particularly nasty smoke bomb went off at Largs Pier Hotel, Adelaide, during an Ariel show. Yellow smoke went out of control. I couldn't see or breathe. Had to get off stage. Last time we used that. Otherwise, some of the fights that used to break out were pretty full on.

LB&T What difficulties were posed by the available technology then?

TIM GAZE To me it was all evolving, so I wasn't really all that aware of difficulties so much. It all ran on power and the gear was pretty reliable, guitar

amps, etc. Even light shows were still evolving. It was all pretty new. Maybe sound systems? Too much into playing the music. There wasn't as many options, so you just kept creative I guess.

LB&T What was the attitude of audiences to your playing?

TIM GAZE Usually pretty good. It was still evolving and people were excited by it. These days, people can be pretty blasé, they've heard it all, and usually don't have to pay or make an effort to hear a show. I think our music culture seems to have become somewhat devalued.

LB&T Did you try to develop a particular 'sound' or was it spontaneous?

TIM GAZE I just plugged in and played pretty well, there were things like bass and treble, etc. Pretty simple to get a sound if you were tuned in to the idea of what your instruments' tonal aspects could be. You gotta be able to hear it. Good amps are the go, and realising that just because an instrument is electrically amplified, that the tonal end result is still that of how you play your instrument, not just the amp or effects. It's all in the wrist!

LB&T Did you write music better as part of a group or individually?

TIM GAZE Often the ideas were already in my head, or the other person's head, but pulling them together into arranged pieces of music with the band was what we did. So the enjoyment of that process depended on the skill of the other players: Technically, socially, whether they were good listeners, etc. We used to rehearse most days of the week in a house, all set up like we played 'live'. That's how we spent our days.

LB&T What was the most beautiful/transcendental moment on stage?

TIM GAZE I can remember seeing 'Tully' have a few beautiful and transcendental moments on stage. As for me, the excitement of playing something new for the first time and knowing it worked with eve-

rything else that was going on was a great buzz, pushing the envelope I suppose you would call it these days. Some of which may have turned to self-indulgence, but hey, nobody's perfect.

LB&T How much did the introduction of drugs affect the music in Australia?

TIM GAZE Pretty hard question. I think drugs have always been there, we just didn't know that then. Depends how much you take and what it is. Pot seemed to be the substance of choice when I was coming up through the scene. Pretty cruisy. It was everywhere and nobody seemed to worry about it that much. LSD and narcotics on the other hand were a little more intense, maybe less emphasis on the music with the tougher drugs. More emphasis on the self. So yes, the music was definitely affected not only from the musicians point of view, but the punters as well.

LB&T Was the visual impact of a band that important in those days?

TIM GAZE Yes, I think so. With the Shud, we all just dressed casual but in the style of surf-cum-hippie I suppose. No real effort taken. To dress up, so to speak, was not really the focus of what we were about, it was the music that spoke for us, but the image was just kind of automatic really. I have never been comfortable with the idea of 'stage outfits'. I'm too rebellious. Love music, hate show biz.

■ Cam-Pact

The Camp Act, as they were originally called, was certainly an apt name for this puffy shirt wearing, paisley bedecked quintet from Melbourne that formed in 1967 from the ashes of popular folk combo The Eighteenth Century Quartet. Keith Glass (vocals/bass), along with Greg Cook (guitar/keyboards) and Trevor Courtney (drums/vocals) wrote all their original material, with Chris Stockley (guitar) and Mark Barnes (bass) providing backup. Cam-Pact issued a film promo with their first single Something Easy wherein Chris and Mark are coming out of a lingering mouth-to-mouth kiss and from

there on they appeared on every music program in the nation. The song itself was an up-tempo soul number with the most polished production of any band at the time. For the second single they cut a cover of I'm Your Puppet, and began straying into the delusional trappings of the best psychedelia. The B-side is their masterpiece. Drawing Room begins warmly with Keith's vocals crooning to your enchanted delight as he creeps closer and closer to your heart, then you're trapped in the kaleidoscopic phasing that affects even the small string section that had been until then behaving so properly. Following that effort the group began to have urges to play more experimental stuff. Keith left to sing in the Australian stage production of *Hair* but some of the others chose different company (see: Company Caine, above).

Cam-Pact.

LB&T How did Cam-Pact make it to Australian TV?

KEITH GLASS They would say to you, "If you want to go and do *Happening* or (in our case) *Uptight*, we need new material all the time." Most bands didn't have albums, so you didn't have the opportunity to do something different all the time. The record labels weren't that interested in putting out albums because they were making more from the singles market. So we'd just go and record extra tracks just for the TV market. A lot of these are a little freer, recorded very quickly by comparison, but I prefer some of them to the stuff we recorded as singles.

LB&T Was much care taken in record production?

KEITH GLASS There were always problems with recording in the sixties because the engineers were such klutzes. Apart from Roger Savage no one had any feel for the thing at all. We were always fighting engineers and so was every other band.

LB&T What about playing live?

KEITH GLASS You couldn't hear what you were singing. We had huge amps, but the PAs were the smallest components in the whole system. The only saving grace was that the rooms we played were often very small, like the Thumping Tum and places like that in Melbourne, and you could hear the sound bouncing back from the rear wall.

LB&T How did you arrive at the name Cam-Pact?

KEITH GLASS We were sitting around in Her Majesty's Hotel, in South Yarra (Melbourne), a big gay hangout, a trendy pub really, trying to think of a name for our new band. One of the guys went to the toilet and read a sign on the door that said, "Be Modern Be Camp". So we said, "We'll call it 'The Camp Act' as a joke." That lasted until we came to release our single when it became 'Cam-Pact', to reflect a power set instead. None of us were homosexual, but because it was a sign of the times, I suppose, we were fairly fey. You know, purple pink trousers, frilly shirts, stuff like that. The only thing we did that was promoting that image was a photo session where we all jumped in bed together completely naked. A giant blow up of that photo was hanging in the Thumping Tum until some guy came in one day and said, "This is outrageous!!" It didn't take much to upset people back then. We did a couple of stupid articles in *Go-Set* magazine to say that we had been defiled by priests but the weird thing was that it hardly raised an eyebrow (Laughs). The band's name was bit of a handicap in some instances though. We still did four nights a week, very hard working.

LB&T What was your set list like at first?

KEITH GLASS R&B classics, and obscure classics at that. A lot of accent on Stax, some Motown, and we

attempted to write our own songs, but we weren't as successful at that as we would have liked. The psychedelic thing came in because it was a sign of the times. We ended up doing basic soul music with psychedelic edges. We had aspirations to being pop stars but I was never really inclined that way, but our set certainly included some pop numbers.

LB&T Did audience reactions change once LSD entered the Australian scene?

KEITH GLASS Probably, but by that stage I had left the band and was in *Hair*. I detested most of the so-called 'acid rock' bands because of their wanky twenty-minute solos. We were never like that, we were doing tight four minute songs. We tended to drop songs if other people had started to do them, but as we knew the music a lot better than others, we could always introduce something fresh. Drawing Room is an example of what many consider our psychedelic classic. I think it's a bit of a mess. It has its interesting things but it doesn't rank with Krome Plated Yabby by The Wild Cherries which is *way* above what any band here was attempting then.

LB&T What was better, live playing or recording?

KEITH GLASS Every band sounded better live than on record. Pat Aulton was one of the few producers that would allow bands to record with their amps set at their own level. David Fraser recorded a lot of bands in Melbourne, and recorded them very badly, mainly for TV shows. We had to pay for these sessions, but they were important for promotion. Most of the TV shows were coming out of Melbourne so the exposure meant you could get regular gigs.

LB&T What was the most exciting time you had on stage?

KEITH GLASS The first time teenage girls ever grabbed me and pulled me off the stage I couldn't believe what was happening. We weren't really into a lot of drugs, but we were trying to get some (laughs). All we ended up with was speed most of the time. When I was doing *Hair* I certainly did the show completely under the influence of acid several times. You had to shake yourself back to reality

whenever another song was coming up (laughs). Half the audience was out of it, including guys straight out of the army who wanted to be hippies. These guys had been fighting in Vietnam, using all these drugs, now they wanted to fit in with what the young people were doing so they were wearing all the hippie threads too. The Mandala Theatre in Sydney would have a W C Fields movie showing, followed by three hours of Tamam Shud playing, everybody was into the psychedelic thing. You'd go to see bands in the ballrooms and find the audience was all lying on the floor, out of it (laughs).

■ Daevid Allen

Born in Melbourne, Daevid trained to be a graphic artist while learning guitar on the side. From a well-to-do family, in 1960 he decided to move to London, where he met Robert Wyatt, an impressionable teen who slipped quickly into a life of debauchery at Daevid's suggestion. In Paris, Daevid performed with William Burroughs and Terry Riley in a series of tape experiments/poetry exhibitions. Daevid also wrote and performed in a theatrical version of Burroughs' novel *The Ticket That Exploded*. Then he began playing free jazz with a group he called The Daevid Allen Trio. In 1966, Daevid had a vision that told him how he should lead the rest of his life. He became deeply involved in Soft Machine, an English psych group featuring his friend Robert Wyatt on drums, Kevin Ayers on bass and Mike Ratledge on organ, recording the sole single Love Makes Sweet Music with them. He was refused re-entry into England after a subsequent French tour, so he remained there and formed Gong. Utilizing his unique glissando style of guitar playing, in combination with various effects pedals being developed, he was able to create the total space music he had heard in his head all along. Daevid and Gilli, an ethereal whisperer, recorded Banana Moon and the long journey that is Gong was at last commenced. Unlike most of the artists covered in this chapter, Daevid Allen continues to record his eccentric forays into the outer realms of the human condition to this day. He lives in New South Wales, but he tours with each new incarnation of Gong as the tides take him.

LB&T What has been the best place to play?

DAEVID ALLEN I'd say probably France. And the reason for that is because the government supports the venues. They've got the most beautiful venues in France, all paid for with government money. They employ engineers to take care of the PA and all the equipment and to constantly upgrade it. They treat you like human beings when you go on a gig. They put you up in a hotel and feed you beautiful French food both after the gig and before it. You feel like an artist. You are treated like somebody equivalent to everybody else. There isn't this feeling of the artist being an outsider, the rejected, bludging off everybody. The way that in Australia there is this feeling that the taxpayer is supporting these people so that they can get stoned all the time on the beach.

LB&T What is the wildest incident at a gig?

DAEVID ALLEN That again happened to me in France. Within the last ten minutes of a gig a person appeared beside me in an absolute panic saying there had been a bomb planted under the stage and it's about to go off at any moment. My reply was, "What a great way to go, no way are we going to stop." And we didn't, we played extremely well for the last five minutes and of course the bomb didn't go off because there was no bomb. The audience and the promoters were in a riot mode but we had a fabulous concert!

LB&T What's the joy of playing in a band?

DAEVID ALLEN Well sometimes I do and sometimes I don't, but they're both good times. When you play by yourself, you don't have to worry about other people. On the other hand, you also don't have anyone to feedback off.

LB&T Was the set list changed for each gig?

DAEVID ALLEN It depends. With everything you do in performance, there are some pieces that are hot at the moment. They're working. They have the energy coming through them. Songs, poems are like people, they have souls. When you come to a song, you are asking the soul of that song to come through when you sing it. It's only going to be magic when the soul comes through. So you are in your angelic or demonic voice asking, "Come through, oh soul, come through." So you tend to stick to playing the songs where this seems most likely to happen.

LB&T Do you have any favourite item of clothing for performing?

DAEVID ALLEN My favourite clothes are the ones that have a big hole down in the front where my cock can hang out (Laughs). I'm on a mission to prove that my penis is not ageing, because my penis always was very, very old. You never see erect penises in movies, and I think they are vital to today's society, especially aged erect penises (laughs). I used to prefer to play completely naked, but as that wasn't suited to the colder climes of Europe, I would usually wear skin-tight bodysuits. Preferably skin coloured.

LB&T What has been the most violent incident that you can recall?

DAEVID ALLEN When I was held up at knifepoint in Venice, California, for five hours on the night before a really important gig. I was looking for a tarot reader at three o'clock in the morning and I backed into a car with some Puerto Rican gangsters. I had my guitar with me but they wanted to take my tape recorder to pay for the small dent I had made to their car. As they eyed my guitar I began to lick it sensuously and because they were so fucking macho, they sprang back in alarm. I had them. One of them said, "Suck my dick," and I said, "No way mate, I'm Australian." They freaked out about the whole thing and just took off in their car (laughs).

LB&T What's been the most transcendental moment at a gig?

DAEVID ALLEN When your toenails twinkle, and your fingernails twinkle and you twinkle all over. A gig where there's this warm swell, the applause is only at half volume, but it brings tears to your heart as you know everybody out there is tingling and it brings a sense of twinkly white light. You feel as if something else has happened, so much energy has

come in and the clapping just goes on and on and there is this sea of warmth. It's happened a lot.

LB&T What was the worst aspect of playing in that era?

DAEVID ALLEN I'm too much of a relentless optimist to think of any... Let me see. The worst things were caused by chemical abuse. Damage to liver, outrageous prima donna behaviour, wild and uncomplicated egotism. All because you are the subject of adulation, you become the screen on which people project their most private loves or fears. You don't know what they're thinking, so you deal with them with your egotism, which can become excessive.

■ Clapham Junction

In 1969, there was a temporary ban on playing English records on Australian radio stations. Basically, the local record companies wanted royalties from the stations every time they played one of their songs. The stations refused, and that led to the playing of some very obscure local acts on national radio. Such as this group, who recorded their one original song for posterity, Emily On A Sunday, during a drunken binge at World of Sound studios. Full of crunching power chords and thunderous drumming, the song details the problems of getting Emily away from her parents, at least on Sundays. Melancholy without any brains at all, and better for it.

■ The Dave Miller Set

One of the heaviest Sydney combos, often banned from playing the smaller halls due to their excessive volume, they had two exceptional songs. Naturally, neither made the hit parade. Guy Fawkes, vocals awash in Leslie Speaker swirl, string section surging forward in times of calm, drums phasing across the stereo channels, this cover of an Eire Apparent song was one of the best produced tracks in Australia. Why, Why, Why, an original up-tempo ballad, tackles the insecurities of a teenage lover with questioning guitar stings and more phased drums. After an ill-timed tour of Indonesia, the band broke

up and Dave Miller released a solo album. The rest of the group soon found work in the many hard rock units starting up.

■ King Fox

All in their mid-to-late teens, these millionaires' sons formed a group to impress their girlfriends at formal functions and strut their paisley eminences to everyone's distraction. They also wrote a lovely baroque paean to their eternal past, demonstrating that they could play the instruments their parents had bought for them most capably. Unforgotten Dreams made it to number three on the national charts, with a hastily recorded album set to be released until all the members failed their end-of-year exams and were promptly forced to disband by their parents. The album must be residing in some stygian vault, waiting for its resurrection...

■ Velvet Underground

Naming themselves after the same book that inspired a certain New York band, this group, originally from the industrial city of Newcastle, played mostly Jefferson Airplane/Grateful Dead covers to an appreciative Sydney crowd. Existing mainly for club/dance dates, they released one explosive single, Somebody To Love c/w She Comes In Colours, both driving , hypnotic, organ fuelled covers. They lasted five years, before joining up with pop singer Ted Mulry in 1972 and forming the chart topping glam/boogie band The Ted Mulry Gang.

■ The Glass Web

Little is known about this Adelaide group that in 1971 unleashed two scorching singles of prime juvenile psychedelia. Two Faced Woman is the tale of a guy left behind by an unfaithful lover, his wah-wah guitar his only source of companionship. Or maybe that's just my interpretation. In A Year Or So, someone else will start over, according to this great little anti-war, fuzz-smacked ditty. Truly a sign of the times and yet sounding like something from 1966.

Disturbo Music

By Sleazegrinder

PICKWICK INTERNATIONAL (or, Mr Pickwick as it was sometimes known) was a catch-all 'budget' label from Woodbury, New York, which pretty much released anything that could turn over a fast buck. Details of the label's history are scarce, but they appear to have emerged in the mid 1960s. Early releases were brazen scam jobs, where session musicians would record the hits of the day — surf, soul, whatever — and Pickwick would present them as the real thing. They released countless compilations of this ilk, all the way into the disco era, and were still spitting out God-awful albums like *Country Road: Teddy Bear & The Great C.B. Talk and Trucker Songs LP* when they finally gave up the ghost in the early 1980s. But along with all the legally dubious Dolly Parton repressings, *Popeye The Sailor Man*, 'listen and read' book/seven-inch combos, and sing-along Christmas records they foisted onto the public, they also dipped their dirty hands into the Halloween novelty record game with the black-wax atrocity I present you with today, *Sounds To Make You Shiver*. Oh, and shiver you will, motherfucker, believe me.

Of course, you just can't scare kids anymore. These days, they start fucking at twelve; they have guns, and they listen to German industrial music. But thirty years ago, Halloween sound effect records were enormously popular, and highly effective. While the local ghosts and goblins trick or treated through the neighbourhood, impish older folks would stick their stereo speakers in their living room windows, drop the needle onto a record like *Sounds To Make You Shiver*, and howl in sadistic laughter as the terrorized tots ran screaming into the bosoms of their parents. Sure, it was mostly creaking doors, overdriven synths and down-on-their-luck voice-over actors channelling their inner Karloff, but goddamn it, it worked.

Nobody in our neighbourhood was more glee-fully prepared to shock and awe on Halloween than my crazy-ass uncle Peter. This guy would stuff old clothes with pillows, toss a Nixon mask over a balloon, douse the whole mess in red paint, and hang his lynching victim from a tree branch in his front yard. He'd get realistic looking papier mache body parts from his Carney buddies, and half-bury them everywhere, so that his property looked like a particularly bad day on the Ho Chi Minh trail. He would cover the house in spider webs, complete with five-foot tall rubber tarantulas, whose eyes would glow red in the darkness. The scratching and moaning and chain rattling blaring out of the speakers was the rancid icing on his worm-ridden Halloween cake. It was an annual house of horrors, and very few kids even showed up, too creeped out by the situation to beg for candy.

From the age of four to about eight or nine, I was elected to 'help' uncle Peter with his spook-a-thons. Being a timid child anyway, I viewed these yearly sessions as pure torture, some kind of punishment for whatever it was I had been doing wrong all year long. I actually don't remember *helping* him at all; I spent most Halloweens at Peter's hiding under the stairs, waiting for my mom to come and get me the fuck out of there.

Late in 1974, when I was five years old, Peter came over with a bundle of Christmas presents for the family. Peter was sort of a fat, dumb, trucker version of Tony Clifton a lot of the time, so you could pretty much expect all his presents to be entirely inappropriate. My dad, a recovering alcoholic, would get a bottle of booze. My mom, Peter's sister, would get sleazy lingerie. That kind of thing. This year, his present to me was obviously a record album of some kind, and I hoped against hope that it was something cool, like the latest KISS, maybe.

It was not something cool at all.

I ripped open the green foil wrapping and stared,

in fitting horror, at my present. Still sealed in cellophane, and with a 'New: $2.99' price tag on it, it was a Halloween record called *Sounds To Make You Shiver*. I had endured this nightmare just a couple months ago, and it had scared me so badly that I threw up. Peter, the evil motherfucker, was so amused by this that he had decided a reprise of the incident over egg nog and yule-tide cheer would be a goddamn howl. "Put it on", he told me, winking at my dad. I was already crying before I even got it out of the dust jacket.

There are no production credits on this record. For all I know, Pickwick might've just lifted this stuff right off of an old episode of *Chiller Theater*, or something. This is unfortunate, because now I may never know who drew *Sounds To Make You Shiver*'s cover. It is signed, simply, by one 'Daniel'. I'd like to know who this Daniel is, so I can hunt him down and punch him in the balls for all the undue psychic damage he inflicted on my already stressed five-year-old mind back then. You see, the astonishing artwork that this malicious bastard so shakily rendered for the *Sounds To Make You Shiver* cover seared itself into my brain the moment I saw it, and I have yet to shake it loose. When I decided to hunt this album down for the sake of this article, I had no problem describing to people exactly what it looked like, even after almost thirty years.

Even today, I think the cover is one of the most horrifying things I've ever seen. A veritable clusterfuck of Halloweeny nastiness, its centrepiece is a hastily rendered castle of freaks that juts out of the ground at a forty-five-degree angle, as though even the bricks wish to uproot themselves and get in on the mayhem. A very Ronald Reagan-esque Dracula gazes down upon the gristly tableau from the castle's clock tower, a bug-eyed, muscle-bound hunchback crouching behind him. The clock is, of course, stuck on perpetual midnight. The level directly below the vampire features three arched jail cells, which barely contain their gruesome captives. The first one holds a giant, green, one-eyed octopus, already bursting through the flimsy bars. Just the idea of a giant, one eyed octopus is bad enough, but one that can crawl around on land is infinitely worse, and if its behaviour is so unseemly that Dracula *himself* needs to keep the thing locked up... Well, the horror of it all is just to much to even ponder. In the middle,

there's a screaming, white-haired hag, who bears more than a passing resemblance to Iron Maiden's long suffering mascot, teen-zombie wonder Eddie. Could famed Maiden artist Derek Hess — who's just about the right age — have also stumbled upon this abomination as a child, and unconsciously catalogued these atrocities until one of them spilled out from his paintbrush, launching a whole new wave of terror (or, at least, terrifyingly ponderous British heavy metal) into the world? Maybe. *Probably.* Next to the hag is a toothy, slobbering blob of orange goo. I don't know what it's supposed to be, and I don't wanna know. Above the castle, bats whiz around in the inky night sky, the full moon managing to poke itself through streaming black clouds, and a ghost, like hazy smoke, drifts up and away with a curious smile on its face. It's probably just happy to be escaping.

The lower half of the castle houses a mad scientist's lab; or at least it did before the insanely mis-proportioned Frankenstein monster smashed it all to bits. 'Ol Frank, chains wrapped around his ankles and his eyes squeezed shut, appears to be bursting out of the earth in the foreground of the cover painting. He is joined in the lower right hand corner by a Paul Naschy-type werewolf with a lazy eye and a stylish wide leather belt. To the monster's left, a distracted looking witch stirs up some trouble in her bubbling cauldron, a thick white smoke rising up and drifting all around our rampaging beasties. Behind her, there's a truly berserk looking Yeti (his oversized mouth wide open, like a boa constrictor's detached jaw), running out of the frame, presumably to eat something that doesn't want to be eaten. In front of her, an old wooden coffin, its skeletal tenant clawing his way out.

And let us not forget the graveyard in the background, with its twisted trees, hanging noose, reanimated zombies, stomping axe murderer, and the charming tombstone which reads, simply, "RIP YOU". Nice. As if all this insane, Sub-*Creepy* hackwork wasn't explicit enough, blood dripping letters in clashing shades of red, green, grey, and purple scream out *Sounds To Make You Shiver*'s intentions: "Bloodcurdling! Terror! Horror! Stereo!"

Now I ask you, dear reader: Just what kind of sick fuck is gonna hand this monstrosity to a five-year-old, and call it a Christmas present?

I had absolutely no intentions of ever playing this record, of course, but Peter insisted. My shy, reserved nature as a child was always a source of amusement to my five Type A, military trained uncles, so they figured this would be good for a laugh. I plopped it onto the oversized spindle on our gigantic turntable and braced myself. Thirty seconds into side A's A Night In A Haunted House, and I was bawling my eyes out. My mother took pity on me, and turned the record off. The next morning, I shoved the fuckin' thing as far as I could into a green trash bag full of Christmas debris, and just tried my best to forget the whole thing. I didn't sleep well for weeks afterwards.

A lot has changed in thirty years. Somewhere in the late eighties, my uncle Peter walked into the Veteran's hospital in whatever sweltering Florida city he was living in, and demanded to see a military psychiatrist right away. When they told him he would have to make an appointment and come back in a month, he pulled out a .357 Magnum and shot himself in the head with it. Before he left for the hospital that morning, he had mailed out rambling suicide notes to his brothers and sisters, complaining of the weird psychotropic experiments he was forced to take part in during the Korean War. Or something like that. At any rate, he's dead. Me? Well, I became a sleazy rock journalist, who also happens to write about splatter movies and other nightmarish subjects. I'm not shy anymore, either. Perhaps Peter's Halloween debacles had something to do with the way I turned out, I dunno. Personally, I think the time I walked in on him eating a bucket of Kentucky Fried Chicken in the nude was more of a life-changing event than his stupid spook show record, but I can't deny that *Sounds To Make You Shiver* is certainly one of the more enduring long-players rattling around in my brain.

I never thought I'd be holding it in my hands again, however. Six months ago, when Martin Jones told me about this book project, a 1,000 different albums popped into my mind; crazy, hopelessly obscure nuggets of sonic wonder that I could extol on in breathless rock-speak, soaking up the sweet juices of super hipsterism with every paragraph. But then, I figured every *other* contributor to this book had the same jerky ideas, so I dug as far back as I could, and came up with this mindbender. I always

have been a sucker for punishment. *Sounds To Make You Shiver* was remarkably easy to find, and I think I got it for about three dollars from some dealer in England, who was probably thrilled to get the cursed thing off his hands. I have been staring at the cover for months, but have yet to actually play it. Until now, anyway. The wife's asleep, so at least she won't have to see it if I start crying again.

■ Side A
A Night in a Haunted House

Wind. Rattling chains. A Bubbling synthesizer that sounds like tiny demons hatching sinister plans. Pained moaning, the orgasm of the damned. Heavy feet shuffling up stone stairs. Some guy with a half-assed Romanian accent says, "Watch out… There may be somebody behind you!" A woman screams in torment as she gets stretched on a rack. Cats howl. Somebody who sounds a *lot* like Dani Filth starts whispering some crazy shit. An out of tune piano starts plinking away in a wind tunnel. Church bells chime. Several demonic voices chatter and slur in swirling stereo. More bloodcurdling screams from the tortured broad. This thing goes on for another ten minutes or so, but I'm already a nervous wreck.

■ Side B
Scary Fun

Ok, so the Howling Owl and Banging Shutter cuts probably aren't too bad, but there is *no fucking way* I'm gonna listen to Frankenstein's Monster Breaks Loose or Count Dracula And His Victims at 3:37 a.m. Fuck it, man. It's stupid to suffer for art.

Well, there you go. I faced my childhood fear, and it bit me right in the face. At least I was right about how over the top this insane record is. *Sounds To Make you Shiver* makes Whitehouse, or NIN, or any of those other would-be sonic terrorists look like twee pop stars, baby. You wanna *get the fear*? You got it. Now if you excuse me, I'm going to go bury this damned thing in the backyard, and try my best to forget all about it for another thirty years.

The Keys Of The Day After Tomorrow

It's Monk Time!

By Martin Jones

Another band around at that time was called the Monks. While they were playing they looked like so many others with their perfectly trimmed Beatle cuts, but when they finished a song they would bow and reveal shaven bald patches in the middle of their crowns. Just like real monks. But very silly.[1]
The Kinks' guitarist Dave Davies, reminiscing about their 1965 European tour

SIX YEARS BEFORE Dave's brother Ray wrote the line "Boys will be girls and girls will be boys" for Lola, a bunch of soldiers based in Germany were singing "Boys are boys and girls are choice"… Or was it "Boys are boys and girls are joys"? It was always hard to get a handle on what the Monks actually were (even the hedonistic Dave Davies was baffled, it seems). An early incarnation of one of their songs was entitled Paradox. Just right for five American soldiers who were also musicians: five American musicians who were stranded in Europe, who dressed like their religious namesakes, who looked like a novelty band and recorded one (and one only) of the most influential 'lost' albums of the twentieth century; whose slightly sinister image promised a grab bag of ethereal voiced psychedelia — say in the vein of The Byrds or Electric Prunes — but was actually dark, dark pop music scabbing over the tendons of cynicism, thrashed out on instruments previously not up to the challenge. No wonder their record company dropped them. No wonder they burned out before the sun of the Summer of Love could warm the hems of their garments…

In early 1964, those five upstart Americans — stationed in Frankfurt, West Germany since 1962 — formed a gig-happy beat group, The Torquays. The band's members remained the same right through to their transformation into Monks later the next year; although, for a minute amount of time, an English girl — her name lost in history — sang with them. Gary Burger (guitar), Larry Spangler (organ), Roger Johnson (drums), Thomas 'Eddie' Shaw (bass) and Dave Havlicek (rhythm guitar) shared vocals and cramped stage space knocking out the kind of covers expected of a gigging band in those post-Hamburg days. They even adhered to the dress code expected: White shirt, black tie, leather waistcoat, winkle pickers. Nothing

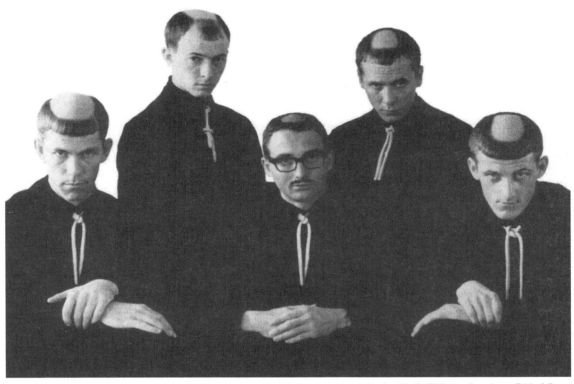

The Monks spent a year living like this. (L–R) Roger, Gary, Larry, Eddie & Dave.

to freak out the club circuit regulars. But beneath the standard pop image lay some dormant, itchy-fingered musicians. Both Roger Johnson and Eddie Shaw, the rhythmic backbone of The Torquays, were primarily influenced by jazz music; and Dave Havlicek was a nutzoid Elvis fan, so original songs began filling the cracks between Chuck Berry, Little Richard and Johnny Kidd numbers. Some of these songs had vocals, some didn't. Some would disappear altogether. Two would become The Torquays' only vinyl release. A few of them would grow in strength over the next year. Later in 1964, the band entered a small studio in Heidelberg and produced their own independently released single, There She Walks c/w Boys Are Boys (both songs written by Burger and Havlicek). In retrospect, there are nods to a past and hints at a future in the single: The past in the B-side's musical tip of the hat to Chuck Berry — particularly Memphis Tennessee — before it breaks out in almost-restrained shouts, handclaps, and an organ solo; the future in the spooky similarity between the opening bars of There She Walks, and

The Velvet Underground's There She Goes Again, almost three years and a continent away (maybe this wasn't so much of a coincidence, as Lou Reed served his time before the Velvets as a session musician for here-today-gone-tomorrow pop singles). With 500 copies of the single pressed, Larry Spangler would sell them to curious fans from the top of his organ; but there was no real beginning for The Torquays, just a standstill whilst the band experimented with a newer sound, something less to do with melody and more to do with rhythm. Hard rhythm. The Torquays had new songs, but they never played them at gigs, instead using the daylight hours before to rehearse, to hone this emergent sound in. It took a year, with the band still retaining their original moniker, and the metamorphosis was slow, but eventual: Ideas were picked up and dropped in rapid succession, and every subsequent jam kept a little of what was good. Gary Burger accidentally discovered guitar feedback in June 1965 in the Rio Bar, Stuttgart, when he left his instrument leaned up against an amp during rehearsals. Learning to

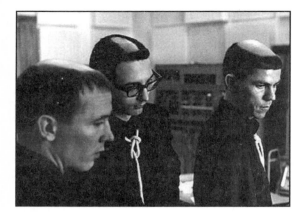

Eddie, Larry and Roger in the studio.
All photos courtesy the Monks, unless noted otherwise.

control the *fuzz*, Burger filtered this new noise through a Gretsch Black Widow guitar, via a specially made 100-watt amp (aided by the ever-trusty Gibson fuzz box). Elsewhere, the beginning of The Torquays' transformation into something else onstage was happening with Larry Spangler and Dave Havlicek adopting the stage surnames Clark and Day respectively. The all-new Larry Clark discovered there was much more to his keyboard than a simple pretty accompaniment, whilst Dave Day dropped his rhythm guitar in favour of… A six-string banjo. Formerly a pop novelty, the banjo in rehearsals quickly became the cheese grater of the music: Harsh, abrasive and plain not-meant-to-be-there; a border of sound like the prodding finger of an annoyed listener. Day played it like a guitar, and fitted two microphones inside, just for added antisocial effect. The backbeat of the rehearsals was made up of Eddie Shaw's maximum-power amp-shaking bass and Roger Johnson's skin-thumping drums, now released from their ineffectual pop beats, written out in oversized sticks. Gary Burger summed their development up when he commented, "If it isn't there, it's probably gone."[2]

A name was found for this developing music, so far away from The Torquays: Uberbeat. A German-English bastardisation meaning "Overbeat": Simple, direct, repetitive, hammering the message home, over, and over, and over. "The music became very minimalistic and blunt — a pre-Gregorian Punk Chant,"[3] as Eddie Shaw saw it. All five band members participated in the writing of songs, and

by mid 1965, they had been discharged from the army. A new order was waiting for them, a new enemy to fire Monks songs at, under the guise of The Torquays. Over the summer they played six hours a night on weekdays and eight or more at weekends, in Stuttgart, Heidelberg and Heilbronn. "We would look at each other and wonder who in hell would want to hear this music!" Gary Burger recalled

> My guitar would be howling like a pack of wolves prepping to slaughter the sheep. Roger played his tom-toms like out of Africa and Dave's banjo racket made one think of a factory where they tested ammunition for the 5th World War. Add Ed's pounding bass and Larry's irritating organ and you indeed had the band of hellish sublime! We knew we'd piss 'em off with this music and we loved the idea… Come to us if you love abuse because we ain't playing covers no more.[4]

Some of the standard crowd pleasers still cropped up in their sets, but originals — including Boys Are Boys, Love Come Tumbling Down and Paradox — were rapidly becoming the mainstay. Like the five Liverpool boys before them, the five stranded Americans quickly found out how to cope with the West German work ethic: Drink, drugs and girls. All of them dipped their toes in one or the other. Chess-playing Larry Clark stayed teetotal, but chased the girls; Eddie Shaw was newly married, but drank the booze. Only Roger Johnston hit the amphetamines head-on, needing the top up to carry him over into the next nights' show, thrashing out those unstoppable drums (he scored off an elderly woman named Oma, who had introduced The Beatles to speed). Around the same time as they confronted audiences, the band — now the Monks — entered a studio in the village of Ludwigsburg to record demos for their managers (Karl Remy and Walther Niemann) to lug around record companies. The studio was large, designed for orchestras, not intense proto-punk; a fact that horrified the unprepared engineers, who tried to keep each musician as far away from each other as possible whilst recording (as if contact would make their sound harsher). But, amazingly, over two eleven-hour days — worked back-to-back with

gigs — the Monks laid down nine new songs and re-recorded Boys Are Boys (the demos were released, along with The Torquays' single, as *Five Upstart Americans* by New York label Omplatten in 1999).

Mostly clocking in under two minutes, these demos all share similar traits. Each song has a church-style organ solo intro, like it's going to launch into a hymn, and a few lines of speech from one of the Monks, usually reciting the title. But these are some pissed-off choirboys. After Burger's lines at the beginning of Monktime (done to greater effect on the subsequent album version), the song establishes the template of the Monks sound; that is, to put down layer after consistent layer of it — one-note organ, bone-breaking drums, razor banjo — until a point is reached where there is nothing else to do except say, "If it ain't broke, don't fix it." This is music as a whirlpool. Take Higgle Dy Piggle Dy (a close musical cousin to another demo track, Love Came Tumbling Down): It's four-minutes-ten-seconds long, and yet there are no vocals for three-and-a-half minutes. In that time, the Monks establish a speedy cascade of banjo, organ and drums/cymbals, giving the music a chance to warm up before changing tack, although there's little room for any other instruments here, or on any of the demos. Space Age has a simple countdown from "ten", whilst the music is filtered through one of those big old ticker tape-spewing 1950s computers. Vocals are kept to intros and repetitive (in a positive way) recitals of titles: An amp-rumbling bass begins We Do Wie Du, and the near-novelty style of Hushie Pushie provides plenty of space for Burger to tune his guitar to the same wavelength as The Ventures or The Shadows. But always lurking in the background — as best shown on the relentless Oh How To Do Now — is that concrete wall of sound, dividing East from West, reminding the listener that there's something sinister attached to five men dressed in black making noises like these. A Boris Karloff-creeping-round-the-old-dark-house organ introduces Pretty Suzanne (formerly Paradox), and a voice whispers, "It's pretty here, my pretty... It's pretty Suzanne", before the song launches into that unrecognised relative of the horror story, the fairground waltz. But the best is saved for I Hate You, a song as antagonistic as its title suggests. Burger's intro goes like this: "Ha-ha! Call me, baby. Call me. But don't forget baby, *I hate*

Photoshoot in Hamburg.

you!" before the terrifying drums — war cry of some outsider tribe — kick in, and a low-slung beat from the rest keeps up with it, prowling midnight streets for bruised hookers, unleashing Burger's Black Widow feedback, screaming a call-and-response of "I HATE YOU BABY! But call me!" Here, the Monks are picking up the remains of dead relationships.

Outside the studio, the Monks' image took on a radical change from the former anonymous club circuit wear. They began to sport black suits at all times, with little white nooses hanging round their necks in place of ties, a statement on the very inescapable nature of work, conformity, and nine-to-five lives: all a rope around your neck. "Ours were plain and visible," Eddie Shaw said. "The people with the painted silk ropes are the ones you have to watch, but even then, when they get smart, many of them trade theirs in for either an invisible one or a plain one. No matter what the ropes look like, they are all used for the same thing."[5] A few band members took matters one step further, and had tonsures shaved into their no-longer-GI-standard hair. Reluctantly, the others followed. The tonsures were like a cigarette burn on the skin of the sixties, Beatles mop-tops with the middle cut out...

The record companies that their managers took the demo to — including Phillips and Ariola — refused them point blank, but when Jimmy Bowien of Polydor Hamburg heard the tapes he offered to re-record some of the songs and present them to his company: Not softer versions, but different. In November 1965, in a studio in Cologne, they were

recorded on four-track: Hushie Pushie and Pretty Suzanne were dropped, and the songs Shut Up, Complication, Drunken Maria and That's My Girl were added, whilst Space Age became Blast Off! The twelve songs earned them a contract, but straight after the Monks returned to touring, playing support to British chart regulars such as The Creation, The Easybeats, The Troggs and The Kinks, acknowledging their presence with the occasional cover of For Your Love (where Burger would play twelve-string guitar) and All Day And All Of The Night (which Clark would sing), making a name for themselves, their music, and their image.

The Polydor sessions were released in March 1966 as *Black Monk Time*: twelve original tracks written by all five members of the band, something of a rarity at the time, but not as rare as the actual LP, which was only released in Germany. The sound is clearer, more vocalised, perhaps harder. No, *definitely* harder: Fuzzier, speeded up. The seven songs re-recorded from the original demos are fuller, with more lyrics filling in the instrumental gaps… They launch straight in at a high speed one-two beat with Monk Time, and Burger's introduction to the band, the album, makes up their manifesto:

Alright, my name's Gary
Let's go, it's beat time, it's hop time, it's Monk time now!
You know we don't like the army
What army?
Who cares what army?
Why do you kill all those kids over there in Vietnam?
Mad Viet Cong.
My brother died in Vietnam!
James Bond, who was he?
Stop it, stop it, I don't like it!
It's too loud for my ears
Pussy galore's comin' down and we like it.
We don't like the atomic bomb
Stop it, stop it, I don't like it . . . stop it!
What's your meaning Larry?
Ahh, you think like I think!
You're a Monk, I'm a Monk, we're all Monks!
Dave, Larry, Eddie, Roger, everybody, let's go!
It's beat time, it's hop time, it's Monk time now!

After this madness, it's straight into a song that comes a close second to I Hate You for antagonism: Shut Up. Drums, bass and banjo open up and fall together into a "One-two-cha-cha-cha" rhythm, with guitar and organ rebelling, darkly. The band sings as a whole:

Got a reason to laugh
Got a reason to cry
Believing you're wise
And being so dumb

This is a wake-up call for a distant America, for anyone listening, for anyone unnerved by Burger sneering "My brother died in Vietnam" on Monk Time. But there's no let-up from the Monks: "Be a liar everywhere", they hiss, "SHUT UP! DON'T CRY!" Before Shaw's bass comes out of nowhere and the whole volatile mixture begins a fall down a very black well. As well as the re-recorded I Hate You, Shut Up is matched in intensity by Complication: The three tracks make up *Black Monk Time*'s unholy trinity. After a dirty, fragmented (put your ear to the speaker and you can almost hear the cuts being made in the chords) guitar that makes Complication the Monks' most 'conventional' rock song, and the sawing banjo riffs, the lyrics are prime examples of the band's approach: Repetition, call-and-response, minimal; perhaps a natural reaction to playing only in a country where English was not the first language. To get the message over, speak loudly, and use as few words as possible. And those you do use, make them important. Burger screams, "COMPLICATION! COMPLICATION! COMPLICATION! CONSTIPATION!" And you realise that because the world and its stupid ways are getting on their nerves, that the Monks are intent on making sure that everything they do gets the fuck on *your* nerves.

The final four songs on *Black Monk Time* are as upbeat as you'd want them to be after listening to stuff like Complication. Drunken Maria ("Sleepy Maria, Don't drink!/Drunken Maria, Don't sleep!"), Love Came Tumblin' Down, Blast Off! and That's My Girl are the reprieve, from Burger's guitar, from Johnson, Shaw and Day's three-strong gang of noise, from Clark's impression of the abominable Dr Phibes caught in an end-of-the-pier show. By the

time the last song, That's My Girl (where Burger chides an ugly guy with a good looking girl, before realising that she's *his* girlfriend) throws in a sharp line of amped-up fuzz down the middle, you realise that this what was all those daytime experiments as The Torquays were for: A record called *Black Monk Time*.

A single was taken from the album, Complication c/w Oh, How To Do Now. One photo of Burger screaming into a microphone on the cover probably did little to tempt the record-buying public (the b&w shots on LP and single seem to suggest that the Monks were operating autonomously, in control from some snow-blockaded Eastern fortress), and both the LP and single did minimal business, despite gaining some critical praise in Europe. The Monks' unending touring and single-plugging appearances on German TV shows such as *Beat Beat Beat* and *Beat Club* (where their set included the never-put-to-vinyl jam Monk Chant) were gathering no material gains for them: The first royalty cheque was divided up into approximately ten dollars per person, and, in the long run *Black Monk Time* failed to pay back its cost.

The Monks were a split-second blip in rock history, the uncredited pathfinders between the past and present. Just as The Torquays' only single provided a link between Chuck Berry and The Velvet Underground, so the Monks circa *Black Monk Time* were waving goodbye to the past and ushering in the future. But, unfortunately for them, that's all they were: Ushers. Servants between rock 'n' roll and the fuzz of feedback. One night they supported Bill Haley And The Comets, an event that excited rocker Dave Day, especially when the pair had a picture taken together, Haley's spit curl already looking like a relic from a distant century compared to Day's wild attire. This was a nod to their past. A glimpse of the future came when an undiscovered Jimi Hendrix turned up at a Monks show (he was touring Germany with The Experience) and was suitably impressed, especially by Gary Burger: How he utilised feedback, and how he used the wah-wah pedal, an uncommon addition for guitarists at the time. It's tempting to say that Hendrix saw the light with the Monks, and took what he had learned to rework it into his own songs. Hendrix burst out on the public with just the right amount of sass,

sex and unquestionable skill. The Monks were left behind. Their time and place in rock history came and went with *Black Monk Time*. There could be nothing after except burn out.

The Monks just wanted to play live, record songs, and hope that their managers were taking care of the boring business side, but that was not the way things were going. They were trapped: Wanting to take more interest in the whole picture, but unable to because of seven-nights-a-week gigs. Nothing was changing: the LP had caused no ripples, and

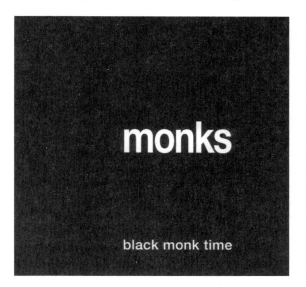

they were still playing the same sticky, stinking venues they had as The Torquays. They wanted to play further afield, in places like America, but a catch-22 became apparent: They could only play the States when they had a hit record there, but Polydor weren't releasing any Monks records in the States. Something had to give, internal friction was taking over the creative impulse like a tumour: Eddie Shaw was having to balance being a gigging musician and a husband, Roger Johnson's moods were swung, pendulum-style, by his speed intake; and Larry Clark and Dave Day constantly rubbed each other up the wrong way, a shared antagonism that went back to the Torquays days, when both had had relations with the female singer. Fearing they had a dead act on their hands, Polydor pressured the band to produce songs in a more traditional vein. They wanted pop music, but were unaware that an

LP had already been released full of it: Pop music fed through a meat mincer.

Again using Jimmy Bowien as producer, the Monks brought out I Can't Get Over You c/w Cuckoo in late 1966. Featuring Larry Clark in his sole recorded lead vocal, the A-side is their attempt at a love song. It may be a step away from *Black Monk Time*, but it was still untypical pop music: The opening riff is cool but hardly in the same class as Complication's pay-attention chords, and then the song strays away as some kind of bierkeller bop, with lyrics ("Said you loved me but you're puttin' me down/Now you're out runnin' all over town/Said that you loved/Know that you lied...") that belonged back in their beat-group-for-hire days. On the B-side, however, if Cuckoo is a stab at commercial pop, then it may well be the most bizarre smash-and-grab ever. The familiar Monks traits are there: Hammering instruments, all together for the Cause, words that mean nothing, or perhaps everything ("Now someone stole my cuckoo/And I wanna know who who/Did you take my...") and a soaring falsetto against Burger's harsh lead vocal; all this and an instrumental break led by Clark's organ cast in molten iron, make Cuckoo the best Monks song post-*Black Monk Time*.

But the single did as little business as their previous releases, and the band once again went back on the road, touring Sweden in early 1967, making a radio and television appearance (performing Blast Off! on a futuristic set on the show *Drop In*) and causing a little furore over hotel arrangements. After one gig, they returned to their hotel to indulge in drink, drugs and groupies. Checking out the next morning, the desk clerk voiced his shock at the band's behaviour: Unbeknownst to them (their Swedish road manager had done the booking) they had spent the night at a monastery, not a hotel. The man behind the desk was an abbot, not a clerk.

Such PR stunts were just more weight on the Monks increasingly tired shoulders. Fame was not appearing on the road that carried them from gig to gig. Tours to Vietnam and, finally, America, were talked about but nothing was acted on. The group ethic that had brought them this far was beginning to crack, aided by grass and the emerging hippie scene: There was a diluting of the sound, welcomed by some of the band, hated by others. The cover of

their final single, Love Can Tame The Wild c/w He Went Down To The Sea (again produced by Jimmy Bowien, and released early in 1967) speaks volumes. The five Monks are lost in a sea of green foliage, their heads bowed. They look worn down. The biting monochrome photos adorning *Black Monk Time* and Complication had now been replaced by bloated Technicolor, robbing the band of their edge. The evidence is presented in the songs: Love Can Tame The Wild is the sound of a band eviscerated, given some balloon-light lyrics to sing ("Thru the years/Smiles and tears/Live as one will come a son/Love's a thing that loves to sing/Love can tame the wild") over a mock-country backing, shorn of those familiar banjo and organ sounds. He Went Down To The Sea, is, in its own way, quite bizarre. But not bizarre like Cuckoo. Shifts in priorities meant that for this song, Larry Clark played bells and piano, Gary Burger utilised his twelve-string guitar, Dave Day returned to rhythm guitar and Eddie Shaw juggled bass and trumpet. There is some prophecy abounding in the lyrics, but what for, it's hard to make out:

> He threw a rock and the seagulls soared
> He touched another and the oceans roared
> He traced a name there in the sand
> And thought of the girl that used to be
> And thought of the girl that used to be

It's as if, blinking and unsteady, the Monks had been dragged out into the sunlight of 1967, handed some unfamiliar lyrics and instruments, and told to make a good job of it before someone realised they looked out of place. This was not lost on some of the band members, who were now fed up with their image. 'Normal' clothes were being worn; hair was being grown. Only Larry Clark stuck to the Monk manifesto, but his enthusiasm was unable to change things back. Even Dave Day had got fed up with the banjo — that square-marching sergeant that the others had to keep up with — and returned to a guitar. A recording session was undertaken back at Hamburg's Top Ten Club (with unassuming song titles such as Yellow Grass, P.O. Box 3291 and I Love You Schatzi), but by now Polydor had withdrawn their backing, and the band were left without a label. The record company were unsure of how people would take to the LP in Britain and the USA, and

the proposed tour of the Far East looked like doing little to help the band's fortunes. Both Gary Burger and Roger Johnson had gotten married, and all three betrothed Monks were finding it hard to come up with reasons to be away from their wives for so long. They were beat, beat, beat. Finally, Johnson flew back to Texas, sending a postcard of resignation to Burger. It was the one thing that they had all wanted to do, it was just a case of who would call it quits first. Burger got the plane to New York. Eddie Shaw and his wife, with Larry Clark in tow, went back to the USA by tramp steamer. Only Dave Day was to stay on: In an eerie case of foreshadowing set about by the cover of their last single, he spent the subsequent nine years living like a hermit in the forests of Germany...

There was no before or after for the Monks, they were of their time. No past or future, only existing in the present moment: Seed planters in the night, anonymous bridge builders between an exciting past and a fuzzy, pedalled-up future, oblivious to the trends around them. *Black Monk Time*, with its pitch, no nonsense cover, has, within its grooves, the future already mapped out, all the way up to 1976 and punk rock. Although there was no way they could ever be allowed to visit there, the Monks were — as the linier notes to that LP suggest — already playing the keys of the day after tomorrow.

Interview with Monks
by David Kerekes

THE FOLLOWING INTERVIEW with Eddie Shaw, Dave Day, Gary Burger of the Monks was conducted in Benidorm, Spain, on November 21, 2004, a few hours before their headlining gig at Wild Weekend V.

Three Monks in Benidorm (L–R) Eddie Shaw, Dave Day, Gary Burger. Photo: Miss Nailer

LB&T Can you tell us a bit about your early days playing in the Monks and The Torquays before that?

EDDIE We all met in the army and ended up staying in Germany afterwards, playing the GI bars as The Torquays — a show band, typical stuff. We spent a year and a half playing the night club circuit where we developed Monk music and got a record contract.

Germany was the breeding ground for groups because that was where they would go to get work. You couldn't get that kind of work in Britain, or the United States, and develop those chops. That's what we did. One month in Heidelberg, one month in Stuttgart, one month in Köln, one month in Munich. In a year and a half we had three days off. When you are playing six hours or so a night on stage you get bored and start to experiment. Everyone was doing the blues in some fashion, throughout Europe. We weren't particularly interested in the blues — or at least I wasn't; I felt I had already done it. And experimenting was a reaction to that, playing around with feedback. Technology actually changed the music a lot. Amplifiers were getting better. Power was getting stronger — a 100w amp could do a lot of things that a 10w amp couldn't do. All of a sudden you discovered you could put a guitar in front of it and create this noise. You could use great big drumsticks as opposed to these Jazz drumsticks and you could put this overbeat over it and get the words down to minimalist meaning that could be

understood by anyone in their own situation. If you say, 'I hate you but call me,' that could mean I hate you or be a song about being in love. It could be the modern love story.

LB&T The banjo is an odd instrument to have in a rock'n'roll band. How did that come about?

DAVE Originally I was playing rhythm guitar — a Fender — but we got so loud with the organ and everything that you couldn't hear me; I got drowned out. One of the managers said you ain't coming through, how about you play the banjo. I said I can't play the banjo, but maybe a six string like a guitar. I went shopping around the German stores and found one. I didn't know what to do, so I ended up taking the back off and putting two microphones in and that was the beginning of the banjo sound. It just fit right in with the rest of them. It stood out. A clickerty clack sound.

LB&T How did the image come about? It was quite a severe thing to do.

EDDIE Like any managers do, they talked to us about how we should look in terms of stage presence. They helped us with that. They were our Brian Epsteins in that sense. They decided that with the music being minimalist maybe a minimalist look was good. Maybe a strong image, like a Monk.

GARY It was instantly identifiable by anyone who saw us on the street. We walked into this barbershop in Frankfurt as The Torquays and we walked out as the Monks. People were looking at us differently.

LB&T When you weren't performing did you walk around as the Monks?

ALL Yes. All the time.

EDDIE We walked around the streets like that. We lived the role. You know that thing about Method acting? We became it.

LB&T How did the audience perceive the Monks?

DAVE Scared of us at first.

EDDIE Hamburg they loved us. Munich they hated us. [laughs]

LB&T A typical show?

GARY If we were doing a bar it'd be a six or seven hour night — working seven days a week, six hours on stage a night, eight hours on Sunday. Sunday there would be a two-hour matinee, maybe three, Sundays were awful. Once we became the Monks we started to play different kinds of venues, a hall perhaps and we'd do four hours there.

EDDIE There were days when we did three shows in a day in three different towns — those would be one hour shows. It was a lot of work. We lost a lot of weight because of the stress and the long distances between jobs. It was a rough business.

LB&T How did you come up with lyrics?

GARY Typically, we'd have some lyrical ideas that we'd experiment with in rehearsal. Managers would occasionally come to us with lyrical ideas and we'd say we like this one or we don't like that one; we'll try using this or we'll try using that. It wasn't a verses or entire songs on paper thing that you normally think of.

EDDIE Sometimes we'd start with a full song and deconstruct it to a basic meaning. The more we could take out of it the better.

LB&T You rhyme the word 'constipation' with the word 'complication' in one song [Complication], which came out as a single. What were you thinking?

EDDIE Constipation wasn't a part of the original lyric. In the studio Gary's going 'Complication, complication, complication,' and Gary got tired of it.

DAVE We were making a joke.

GARY That's how a lot of Monks music is. It is that kind of a reaction — just doing something and then saying 'To hell with this. I'm just going to do something you're not supposed to do.'

LB&T Were you aware when you were making the music and recording it that you were doing something special and unique?

EDDIE Yes. I was aware of it. I didn't know that anyone would *like* it...

GARY Or that it would live as long as it has.

EDDIE What I have learned is that anyone who hears our music knows it's us. We're the only ones that play that kind of music.

DAVE There was no name for our music back then.

EDDIE They called it anti-Beatles. My uncle didn't like it at all, when I got back to the States he said, "You're a punk."

LB&T When did you become aware of the cult status growing around your music in recent years?

EDDIE *Cult stages?*

GARY They started pirating the record [*Black Monk Time*] and kids started to get a hold of it — the record companies wouldn't touch it, and so it wasn't officially available in the US. It just started spreading around.

LB&T Did you get on well together in the band.

EDDIE No.

GARY Typically, yes. But our final days, no. The times were not good in our last year of existence.

EDDIE We had power struggles. Everyone wants to be the one who plays the loudest.

LB&T There is an album of outtakes called *Five Upstart Americans*. Is that how you perceived yourselves? As upstarts?

ALL No. That was somebody else's idea. [laughter]

Disturbo Music
By Andrew Darlington

MY TOP FIVE CLASSICS of rock weirdness...

1 King Tubby Meets The Rockers Uptown by Augustus Pablo (Island) Two-point-thirty-three minutes of prime and primal dub from 1975, inspired euphoric lunacy that changed the course of the studio mix-down, laying tangents and unexpected angles for lesser mortals to pick up on. Originally a throw-away B-side for straight vocal Baby I Love You cut on primitive J.A. technology, the mighty Pablo stripped it down and rebuilt it into a ganja sensory overload with fragments of voice escaping where you least expect them, "Baby I–I–I–I..." surfacing and submerging echoplexing and reverbing into an awesome nonsense of maniacal laughter. He did great things later, but seldom this deranged.

2 Say Man by Bo Diddley (Chess) Ellas McDaniel and Jerome Green at 2120 South Michigan Avenue, Chicago, with studio time to kill. They set the rhythm to a neolithic "BO DIDDLEY UM DUM/UM DUM DIDDLEY BO", and improvise some of the worst jokes in the history of Rock'n'Roll across the top of it. The result is precious insanity at its most incendiary. "Where yo from?" asks Jerome. "SOUTH AMERICA," says Bo. "You don look like no South American to me," protests Jerome. "Ahm *still* from South America!" "What part?" "SOUTH *Texas*," deadpans Bo. This is one historic oddity that never fails to crack me up.

3 Dead Man's Curve by Jan And Dean (Liberty) Genuine weirdness is rarely a conscious product. Pere Ubu, The Mothers Of Invention, Cabaret Voltaire, all set out deliberately to create weirdness by studio-mix trickery and contrived effects, and hence disqualify themselves.

The likes of Wild Man Fisher, Tiny Tim, or Napoleon XIV — being genuinely unbalanced certified basket-cases — also fall beyond the pale. But Jan And Dean in 1964, with a little help from pre-sandbox Brian Wilson, genuinely intended making a serious sob-in-the-throat death-disc in the Mark Dinning (Teen Angel) tradition, with car crash effects, "The last thing I remember, Doc…" narrative, and a miniature complete movie-for-the-ears all on one hit single. Bare months before Shadow Morton birthed The Shangri-Las' Leader Of The Pack, or Frank J. Wilson's morbidly sicko Last Kiss, Jan and Dean achieve dumb greatness of the highest order.

4 Morrison's Lament by Jimi Hendrix (Surprise/Red Lightnin') This track has a complex history. Inflicted live at the New York Scene Club during jams some time in 1968, the tapes were filched by Michael Cox of Eire Apparent (a Noel Redding spin-off) who leased them to become the *Woke Up This Morning And Found Myself Dead* album; but other bootleg editions of the same tapes proliferate. This night Hendrix swaps guitar snarls and whines with albino blues star Johnny Winter while Buddy Miles drums, but they're autowrecked on stage by the drunken juggernaut Jim Morrison who mumbles lewd and lascivious obscenity and abuse at everybody and nobody in particular: "Fuck you Baby/In the ass-hole," he howls. "Eat a little pussy." While Hendrix urges him, "Sing in that one there, that's the recording mic," before the Lizard King lurches incoherently off into the luminous night. Jim Morrison: Dismember him *this* way.

5 I Had Too Much To Dream Last Night by The Electric Prunes (Reprise) "We're not psychedelic," announce the Prunes in an "amazing outburst" to *Hit Parader* magazine (June 1967). Yet to me and most everyone who shoved this to a US number eleven and a UK number forty-nine, this immaculately structured control-led pandemonium *was* psychedelia, with all its promised excesses and madness compressed and distilled down into just two-point-fifty-five minutes of pure lysergic adrenaline. I *love* this record. Much later Lenny Kaye made it side one track one of his *Nuggets* anthology, calling the Prunes (and their svengali David Hassinger) a "calculat-edly commercial organisation"; and sure, it does build orgasmically through a roaring shattering maelstrom of cacophonous, but obviously premeditated segments with the contagious pulse of a Monkees hit. But it's irresistible, it's massive, it's terminal weird.

This chapter was first published in Headpress 18 *('The Agony and The Ecstasy' issue) under the second title and in a substantially different form. It was written mostly in response to the ongoing 'Moby Dick' section of* Headpress *and the across-the-board question they were asking their readers and contributors: Were Led Zeppelin Faggots? Anthony (X Factory) Petkovich and I were roused by the idea of a sounding board on Zeppelin since we both thought that, overall, they were crap. We brainstormed, sipped scotch, smoked cigars and goaded each other to engage on a kill-all campaign with our corresponding pieces. Petkovich's scathing, scatological prose poem 'Houses of the Homos?' ran alongside my original study. Since them days new material has come to my attention, and this has prompted a revision of my original piece. Besides, I felt it would be interesting (to me and my therapist at least) to comment and analyse some of my thinking regarding the original text. I've also discovered some outright mistakes and fixed them. Since the article's first publication I've also developed a curious attraction to both Zep and I B (which is how they'll be referred to from here on out) and I always take a keen look when something about them comes into my field of vision. For instance, I love Tiny Tim's version of Stairway To Heaven, not to mention the muzak version. Recently, low on funds, I had to pass another oddity: An electronic Zep tribute. I've also found myself reading obsessively about I B's most intriguing member: Philip Taylor Kramer. And I've now come to accept the contradictions I feel about these smoke breathing metal dinosaurs clanking around in the junkyard of my mind…*

WHY BOTHER COMPARING TWO OLD HIPPIE bands? Well, since *Headpress* was looking for articles about Zep I sensed that there was some deeper truth to be learned (the truth I learned was that I'm no musicologist, and I planned to avoid this field in the future). First off, both bands have lousy names. Both bands' signature songs — Stairway to Heaven, In-A-Gadda-Da-Vida — are part of our collective consciousness. But if I was locked in a room and forced to listen to one of those songs over and over again — say for two days — I would choose Gadda (I would prefer *Metal Machine Music*, if that was a choice, which is what I've chosen to play while work-

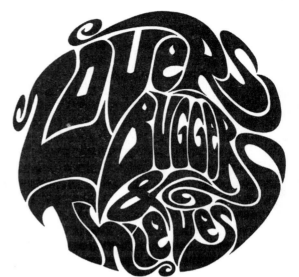

Satan yawns in the Garden of Eden

Led Zeppelin vs Iron Butterfly

By Johnny Strike

ing on this revamp). At least with Gadda I could trance out and barely hear it at some point. Not so with Heaven. Why? Because Zep tries to be complex, tries building a musical (mystical?) bridge or something with lyrics that, after a while, drive me batty. And if the words didn't accomplish this, then Robert Plant's vocals surely would.

THIS PAGE

Japanese reissue of Led Zeppelin's self titled first album.

NEXT PAGE

Deluxe 1995 rerelease of Iron Butterfly's *In-A-Gadda-Da-Vida*.

And this is the voice that inspired a million bean boys to imitate and form Zep-like bands? Somebody should be held responsible (Why? I don t know. Why not?) At the other end of the spectrum, Doug Ingle, the vocalist for IB, hardly had a great voice but it's moderately tolerable, forceful; at times reminiscent of Tom Jones. He stays within his range and it could grow on you (it could, but it doesn't), while Plant's becomes even more aggravating with each listen.

But let's drift back in time... Toke... Toke...

Well it's 1969 okay. I was twenty-two, a total stoner, ingesting psychedelics as fast as I could get 'em. Zep was touted as the next big thing. I was a dedicated follower of the British invasion: Kinks, Stones and Animals, etc. I dropped another tab, lit the

hash pipe, and put the Zep record on the turntable. I remember thinking, "There's something wrong with the vocals or the acid." Jimmy Page I knew from The Yardbirds, an exceptional rock and roll band. But even the music of Zep sounded somehow wrong. And when it did sound okay, in came that most annoying of vocals to ruin it. Why was he singing so damn high? Then there was the guitar: Some nice bits here and there, but then Page would go bombastic. And this spawned an endless legion of laddies to buy electric guitars and learn to overplay them: Just walk into any music store and there's always some fuck sitting there playing endless licks to the point you want to strangle him with his chord. Maybe Zep should have taken all of Page's strings away except for the low E. Plant should have had his vocal cords removed and made do with a voice box hooked up to a synthesizer. Now, listen to the IB's guitar. Psychedelic yet simple. Eric Brann gets down in an occasionally Blue Cheer style but doesn't get carried away with himself. He just plays the tune. Zep probably single-handedly inspired the thousands upon thousands of metal bands that continue (now in reunions!) to employ the high piercing vocals, overplayed electric guitar, and big hair.

As part of my research, I purchased the first Zep and the first (?) IB... Did they make more than one album? It turns out they did and *In-A-Gadda-Da-Vida* was actually their second LP. Now, if I ruled the world, bands would only be allowed to do one album, one tour, and no reunions... Ever! True, we would miss out on some great albums: *Their Satanic Majesty's Request* and *Raw Power* come to mind. Okay and let's see, *Forever Changes*, *Electric Warrior*, *Walking With Thee*, *Acid Eaters*, *Veni Vidi Vicious*, *Music, Martinis and Misanthropy*. Alright, so that wasn't such a great idea. But think of all the boring repetitive abortions that we wouldn't be subjected to. So I guess I'd need some kind

of a committee. I'm not interested in IB's other albums: I'm sure they're as horrible in different ways as Zep's (everything I've heard that they did after *In-A-Gadda-Da-Vida* has been awful). It's interesting that neither group's signature song is one of their first efforts. What's more interesting is that both songs are rooted in a spiritual environment (Heaven was supposedly a tribute to the left-hand path, and Gadda baby talk or a drunken pronunciation of in the Garden of Eden.)

First, I played side one of Zep. Oh man, that voice is even more irritating than I remember. Every time the music starts to sound okay, in comes that strangled ostrich squawk to ruin it. Maybe that's what prompted Page to overplay, mangle the music into the sorry, poseur blues-rock it is. Just listen to the end of You Shook Me. Plant's voice and Page's guitar are flat out abominations! The mirroring between the guitar and voice reach new levels of tediousness. They obviously felt they'd just discovered some wonderful thing, and they just keep doing it!

Now, on side one of *In-A-Gadda-Da-Vida* (album title same as signature song) what immediately comes over the speakers is a richer, more mind-bending sound. Most people I talked with didn't know that IB had written songs other than Gadda. The first tune is Most Anything You Want. A groovy sound is embellished by a druggie, fuzzed-out guitar that's short and sweet. A rinky-dink organ plays alongside adding an almost subliminal insanity. The background vocals give it an upbeat feel. The next song, Flowers And Beads, continues the whole groovy vibe. The tune has a pop nostalgia feel reminiscent of a first summer love going for it. Next up, My Mirage gets heavier and moves into an eerie funk mood. The words and pacing sound like the singer might lose it at any second as he sings about drawing a mirage on a wall (I might lose it re-reading this stuff). It drifts off then comes back to the cool funk completely unlike the practiced, pompous rock of Zep. Ingle croons on about "beautiful people" coming over to his house and seeing the mirage which he's going to paint on his wall. I guess he's talking to the mirage? There's even a hint of a Tiny Tim-like falsetto. It's kind of wacky (I'll give it that). Termination is up next and at first it seems a throwaway (good title, though), but everybody does at least one bad song. On repeated listening, Termi-

nation works well with the rest of the material. It even gets trippy with hippie chimes (or something) at the end (of course there is no repeated listening. I refuse). Are You Happy? (no) closes the side. It's bad. But on repeated listening, Happy becomes so bad I start to like it (not much). But it makes me chuckle, something Zep could never do (again not true; since then I've developed a lively sense of

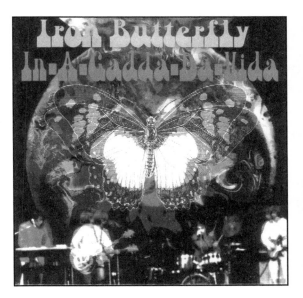

humour about Zep).

Onward heathen soldiers. I listened to the rest of the self-titled *Led Zeppelin*. You know what? Communication Breakdown is a really good song... If someone else was singing it!

Okay, it was now time for the big Gadda. My whole theory would be proven or discounted by listening to the song that is perhaps that era's Louie, Louie (except for the glaring difference that it was never covered). Note: It's come to my attention that it s been covered a bunch, most oddly by The Space Negroes, The Incredible Bongo Band, even a swing rendition by Swing Set. From the first note of Gadda you know who this is, the presence is so there. A cool organ starts the song off with a dreamy riff which leads quickly into the trance drone. To this day, some listeners are still trapped in those trances (If you doubt it, take a little cruise on the IB Message Board). Gadda reminds me of the *Get Smart* episode

where KAOS was trying to hypnotize youth with a psychedelic rock group (I think the group was called The Holy Cows). Later in Gadda (the song is seventeen-minutes five-seconds long) Ingle drops out and the other musicians take turns tripping out, which conjures up an acid-laced orgy. The dreaded drum solo turns out to be more of a trip beat thing. It's tight, almost slamming. Has anyone sampled this? (It could be down for the count for you funk-o-freaky playahs). Near the end, the sound gets spooky like a haunted hippie house. This group sounded like they had fun (no *Funhouse*, but fun). Then there's the acid freak-out and the song ends. I like to think of IB as an obscure lounge act that discovered LSD, freaked, renamed themselves, and transformed into IB. They probably never were a lounge act but if they had been they could've been called Doug Ingle And The Butterflies. Anyway in the long run they are more tolerable than Zep. If you only listen to Gadda. Once or twice should suffice.

I decided to get the low-down on IB. I had heard that they were originally from San Diego so I contacted my friend, Mike Stax, editor of *Ugly Things* and lead singer of the Loons. "Yes, IB are from San Diego," he told me. "One of the few claims to fame of this sleepy town. Prior to IB, the members were in two different garage bands: The Palace Pages and The Voxmen, both were supposed to be very tough and cool. The Voxmen were supposedly very dark, dressed in black with long hair, goatees, and with a serious biker following. They had sort of a Music Machine vibe, I guess not surprising as a lot of the early IB stuff follows the Music Machine formula big time. Unconscious Power (my fave IB song) could easily be a Sean Bonniwell song."

So maybe the first album *is* the real gold. And two cuts from it (Unconscious Power and the Iron Butterfly Theme) ended up in the insane-sounding 1968 biker flick, *The Savage Seven*. IB, like their contemporaries Steppenwolf, did have a strong biker appeal. In more recent times Gadda was used to good effect in *Manhunter*, which included the first screen appearance of Hannibal Lecter.

One night at the local pizza parlour I was munching away and half listening to the piped-in fare of classic rock. And there came Stairway To Heaven, over the speakers. I listened and listened and I'm here to tell you that Gadda blows it out of the fuck-

ing Thames (well, it's easier to listen to anyhow. The CD I have also has the bonus tracks of a live Gadda and the single version. The live version sucks with horrible wah-wah guitar. The single is too short). So, could I also boil down Zep's career into one song? Sure, Whole Lotta Love, for the riff and the drum sound. It should also be noted that a number of others whom I have talked with repeatedly noted *Physical Graffiti* as a decent album, even those who weren't fans.

For further research, I went to the book section of my local record store. Of course, there are no books on IB and far too many on Zep. I began to feel queasy thumbing through these glossy, indulgent affairs. I picked up a small Zep bio, filled with quotes: There was a slam from John (Rotten) Lydon as well as one from one of the blokes from the Clash. One of the members of Zep says the reason Zep does it is because of the rush they get from playing to large audiences. Another mate admits to never listening to any other 'heavy' groups (No IB I guess), he prefers more mellow music. Wait a minute, these are quotes from the band that inspired a drooling, religious-like following? There just isn't anything there. Dead and empty as a radioactive arena (Angie Bowie remarked in her book that David hated Zep. Angie loved them. And while Zep engaged in their many debaucheries IB performed on *Playboy After Dark* and hung out with Hef).

I recently came across two stories and I don t know if either are totally true. One is that Zep actually opened for IB early on and that IB refused to play because Zep was so heavy. The second story is that Zep refused to play at one early stateside show because the crowd was so heavy. I considered renting the Zep film but decided that I'd already subjected myself to enough. There was also an IB flick, *Musical Mutiny*, but impossible to find. Gadda became so big (the first platinum LP! A rabid IB fan screamed at me in an email) it was later considered almost a joke. But today's psychedelic groups could learn a thing or two here. A few years back I was walking by a Virgin Megastore and was taken aback, aghast when I saw a blow up poster announcing the reunion of Plant and Page. Except for the puffy wrinkled faces, the hair and the clothes looked exactly the same (we all grow old and get wrinkles. It was the sameness in hairstyle and clothes that

freaked me out).

Like a lot of people, I found it interesting that Page was into Aleister Crowley. And perhaps Plant's voice was the result of some occult ritual gone awry. I found a story on the net called *Anger Rising*. Later I found that it had been mostly lifted from R Gary Patterson's *Hellhounds On Their Trail: Tales From The Rock N Roll Graveyard*. It told the story of Jimmy Page meeting occultist/filmmaker Kenneth Anger at a Sotheby's auction. They were both interested in buying Crowley's old boots and stuff. They continued to meet at Crowley's mansion in Scotland, the Bolekine House that Page had purchased. A relationship developed between the two men but eventually turned sour over Page's failure to complete the soundtrack for *Lucifer Rising*. When Page was asked about the falling out he pointed to Anger's bitchiness as the problem. Anger supposedly put a curse on Page and Page according to different accounts either scoffed it off or just seemed to find the whole thing annoying.

Punk was, among other things, a reaction against groups like Zep and IB: Yet punk connections there are. For a short while Jimmy Page courted Johnny Thunders. Some felt Page was considering taking him under his wing while others speculated that they were just discussing hair sprays and holding gels. But hey, tell me it wouldn't be rad to see Jimmy Page return to his roots in the occult and do a new soundtrack for *Lucifer Rising*. As a starting point he could take the Heaven riff, distort it beyond recognition and run it backwards. Instead of P Diddy or The Black Crowes, Jimmy could collaborate with Burzum or other notorious Black Metal dudes. I'm told that Page's soundtrack for *Deathwish II* is intriguing.

Philip Taylor Kramer, the most mysterious member of IB, was said to have been in the band Max, in Ohio, which included pre-Dead Boys Stiv Bators. Cheetah Chrome remembers: "Yeah, Stiv knew Phil. I'm not sure they were in a band together, but I met Phil through Stiv in like 1975, when Rocket From The Tombs opened for IB. Weird how he disappeared and all that, eh?"

And this is IB's strange connection to the otherworldly. One time bass player Philip Taylor Kramer (they've had something like twelve different members so far) subsequently disappeared. Four years later his skeletal remains turned up. Apparently he had driven off a 200-foot cliff into a ravine in (where else?) southern California. Hikers who had found his remains in his Aerostar mini van also reported a small cocoon-like bag that evaporated when they pried open the door. This item however was missing from all official reports. It turned out that Kramer's father was connected with the Philadelphia Experiment. And IB'er Kramer was a computer whiz who'd worked in aerospace and started some mysterious company called Total Multi Media. TMM had discovered how to travel in time with magnetic waves and Kramer supposedly had developed the formula. IB fanatics are left weaving endless speculation about this X-file, black bag operation directly related to his demise. Gadda Gadda Hey! Kramer disappeared after a drive to LAX. He had placed two phone calls to friends saying he was going to the other side (to see Jim Morrison?) following a bizarre 911 suicide call.

Kramer had formed his first rock band, The Concepts, when he was twelve. This is the same year he won the science fair for his laser. My advice here: Current IB members should shave their heads and develop all-new material based around the mysterious case of the real IB: Philip Taylor Kramer. Gadda and Unconscious Power could be trotted out for encores.

So there you have it. Jimmy Page re-emerging as a black metal priest, turning old Yardbird riffs into demonic screams from hell; and whoever is calling themselves IB these days reappearing with goatees, shaved heads, black suits, and carrying the techno-death banner of Philip Taylor Kramer. Hey, I'd go to that show!

Disturbo Music

By Joe Scott Wilson

By Jove! Here's something to think about the next time you're flipping through the albums at your local record exchange emporium: Joe Scott bought this and it was much cheaper then. I'm referring of course to those worthless oddities that get slapped with 'collector prices' simply because they have a psychedelic cover, or were made in the seventies. Wait until you get your expensive record home, place it carefully on your turntable expecting to experience a lost work of unmitigated genius — that *you* have discovered — and all you get is drivel.

There was a specific period in the recent past when a whole bunch of bargain basement obscurities hit the collector stores; albums by bands like The Road Home and The Artie Kornfeld Tree were popping up everywhere at increasingly inflated prices. The stock was evidently a warehouse discovery and many of the records came still sealed in their original shrink-wrapping. Musically, these albums were very much products of the era in which they were made, following the trends and sounds of other, more successful bands. The Road Home's *Peaceful Children* [ABC/Dunhill, 197?], for instance, is for the most part a good album, not dissimilar to Crosby, Stills, Nash And Young with some fine keyboards and a cult soundtrack feel to it. The Artie Kornfeld Tree's *A Time To Remember!* [Dunhill, 197?] on the other hand snags onto Sly And The Family Stone's shirt tails, being energetic with much funk and a lot of "oom oom"-type vocal punctuation.

Solo artist Jove is the exception. Also a warehouse find, his *Into The Shrine* album was made in 1977 but doesn't seem comparable to anything else going on in that era (outside of drugs). If anything it seems completely out of step with it…

Jove: *Into The Shrine*

[Aleph Records, 1977] Funny title but brace yourself for ego-overload! *Into The Shrine* is a good indication as to why bands have more than one member and record companies have board meetings. Jove is a solo artist, designing his own album packaging and releasing his own records. Nothing to keep him in check but his own conscience. Onto the front sleeve of Jove's record goes a really ugly sculpture that Jove himself has made; onto the back sleeve goes mystical garbage that means nothing to anyone but Jove; and onto the vinyl itself goes Jove singing songs he has written. And if that isn't enough, Jove presses the record on white vinyl. This is record No. 234 of a limited edition of 1,000 copies, signed by Jove himself (that's right, I have Jove's autograph!) All of which would be palatable if the noise that came out the grooves was quirky, or idiosyncratic or at least bad enough to be entertaining, but it isn't. It's just ballad material. Stuff that really suits titles like Game Of Love and Love And My Life. Imagine an untalented Donovan but with shorter songs. Where are the songs that would compliment the weird sculpture on the sleeve? Then again, there can't be many songs in the world that *would* compliment a die cast man-beast holding a piece of cord with Jove's face superimposed on its head.

Not that this is entirely Jove's fault: His friends are encouraging him. Take for instance Ed Ochs, supposedly editor-in-chief of a publication called *Rock Around The World*. His liner notes (beneath the heading 'Liner Notes') state that it

> has been three years since Jove's *Sweeter Song* album went out into the world, and only now is the world beginning to catch up with it.

After determining that the future freedom of mankind is at stake, and that Jove believes a "wake-up call" is at hand, Ed continues:

> Jove's music constitutes a modern life support system (see album #1) on the one 'hand' stirring the inner heart to new wakefulness and on the other urging the recognition of human-spiritual priorities. In this 2nd album we see something of Joves [sic] personal life and the integration of personal and divine love.

Where this integration takes place I'm not at liberty to divulge, although I am inclined to believe it has more in keeping with vinyl and waste bin, than it does with personal and divine love. It's a shame that Jove's music is such a let-down, because everything else about *Into The Shrine* is interesting, from the strange sleeve design right through to the white vinyl pressing. The album was released in 1977, the year in which punk broke, and while Jove fits very much into the do-it-yourself ethic of that era and uses coloured vinyl (well, vinyl that is not black) he manages to be terrifyingly out of step on every other conceivable punk point.

I'll save you the revelation that comes after Ed Ochs meets Jove in the Nashville Bus Station one day. Okay, I won't: Ed bumps into Jove one day in the Nashville Bus station and Jove says to him: "Love must be understood, not just experienced, if anyone ever hopes to rise above."

The prospect that Jove may have released an album prior to *Into The Shrine* is not a wholly engaging one, but it would be nice to know what he might have had on the cover.

PREVIOUS PAGE
Into The Shrine — the front cover.

THIS PAGE
Jove as he appears on the back cover.

My Shadows Are Running Fast

Charles Manson & the LIE LP

By Simon Collins

I'm not into dying and fear, I'm into music.[1]

1. The Long and Winding Road to Cielo Drive

It's 1969, OK, all across the USA…
It's 1969, baby.

TO BE MORE PRECISE, it's around midnight on August 8, 1969, and four people dressed in black — Charles 'Tex' Watson, Susan Atkins a.k.a. Sadie Mae Glutz, Patricia 'Katie' Krenwinkel and Linda Kasabian — enter a property at 10050 Cielo Drive, in Bel Air, Los Angeles. This house is currently rented by the film director Roman Polanski and his film starlet wife Sharon Tate. The four people shoot, bludgeon and stab to death five other people: Teenager Steven Parent, who had been visiting the caretaker and was just leaving, coffee heiress Abigail 'Gibby' Folger and her lover Wojtek Frykowski, who are house guests, along with Jay Sebring, a Hollywood celebrity hairdresser, and finally Sharon Tate, who is eight and a half months pregnant. Roman Polanski is location scouting in London at the time. The killings are remarkable for their savagery, with dozens of stab wounds being inflicted, and for the word 'PIG' printed in blood on the front door.

This bloody episode subsequently becomes known as "The Tate murders" or "The Manson murders", after it emerges that the four killers were acting on the orders of a charismatic guru and conman named Charles Manson. There were other murders — possibly many other murders — associated with Manson and his band of followers, known as 'The Family', but the murders at Cielo Drive are the ones destined to be most remembered.

Rewind a year now to August 8, 1968: Manson and his girls are in a recording studio, laying down demo tracks that will later be released on an album called *LIE*. Huh? What happened? How did these aspiring musicians become notorious murderers? It's a long story…

Charles Manson was born on the wrong side of the tracks in Cincinnati, Ohio on November 12, 1934, the illegitimate son of a prostitute called Katherine Maddox. He was referred to as 'No Name' Maddox on his birth certificate, and his true pater-

nity has never been definitely established. The surname Manson came from a subsequent short-lived marriage of his mother to a man named William Manson. Charles Manson's childhood was chaotic and abusive, with frequent spells in reformatories and orphanages, where he became thoroughly institutionalised and brutalised. He also developed a keen interest in dominating and controlling people, though as he was small and physically weak, he had to rely on psychological manipulation or catching people off-guard.

As a young adult, Manson graduated into car theft and pimping, and he was ultimately sentenced to ten years in 1960 for a series of parole violations. He was sent to McNeil Island Penitentiary in Washington State to serve his sentence. At McNeil Island, Manson became increasingly interested in playing music, and his mentors included Alvin 'Creepy' Karpis, a gangster from the 1930s and a former member of the Ma Barker gang, who taught Manson guitar. Also at McNeil Island, Manson studied Scientology, hypnotism and mind control techniques. His idea seems to have been to attempt to control people through music — a natural extension of his reform school pecking-order struggles and his pimping proclivities — and he was very impressed by the degree of influence that The Beatles in particular exerted over young people. As Alvin Karpis remembered it:

> He was constantly telling people he would come on like the Beatles, if he got the chance. Kept asking me to fix him up with high-power men... Anyone who could book him into the big time when he got out.[2]

In 1966, Manson was transferred from McNeil Island to Terminal Island in San Pedro, California. Here, Manson encountered one Phil Kaufman, who was doing time on a federal marijuana smuggling charge. In Kaufman's own words:

> I was in the Terminal Island penitentiary, or correctional facility if you will — being corrected for my importing of marijuana. And Charlie was in the yard singing, and I had some friends in the music business, and I heard Charlie singing. He was rather like a

young Frankie Lane. He had that kind of lilt to his voice. I thought his voice was good, and it was during the folk period, and the young hippy stuff and the new music, and I thought he would fit in.[3]

Kaufman had music industry connections, and subsequently became a road manager and general factotum for major acts including The Flying Burrito Brothers, Frank Zappa, The Rolling Stones and Emmylou Harris. He provided Manson with Hollywood record company contacts, and would later produce the *LIE* album (see Part II, below).

Manson was released from Terminal Island on March 21, 1967: The spring equinox, an auspicious time for the beginning of new ventures. Legend has it that Manson begged not to be released. He was thirty-two years old, and had spent over half his life in institutions of one sort or another. Life on the inside of prison walls was what he was used to, and the outside world daunted him. However, the naïve young flower children who were gathering in California at this time were to prove easy meat for a seasoned operator like Manson. He travelled up and down the West Coast, acquiring a motley band of followers, mostly female, mostly much younger than himself. The group spent time in San Francisco's Haight-Ashbury district during the 'Summer of Love' of 1967, before moving south to Los Angeles and Hollywood, where Manson attempted to develop his musical career. In November, Manson contacted a man called Gary Stromberg at Universal Studios in Hollywood to arrange for some recording sessions. Stromberg was a friend of Phil Kaufman's. After one three-hour demo session, Manson enjoyed a short-lived stint as a technical adviser to an abortive film project that Universal was currently developing, concerning the second coming of Christ as a black man in the deep South. Manson's input was evidently valued due to his emergent bearded guru status and his propensity for quoting the Bible, but the project foundered and Manson's involvement with the movie business ended with it.

After the Universal Studios interlude, the Manson Family upped sticks once more and travelled widely in an old school bus which had been painted black and equipped for living in, eventually settling into a property in Topanga Canyon. Phil Kaufman

Right Cover of the *LIE* album.

Below The Beach Boys single Never
Learn Not To Love, a Manson penned song
— Cease To Exist — with lyric changes.

Bottom *Rolling Stone*, June 25, 1970.

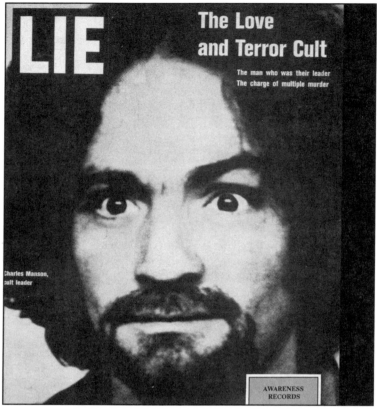

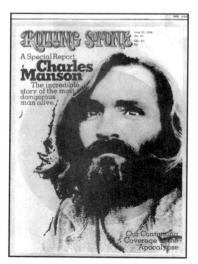

was released from jail in March 1968 and spent time off and on with the
Family, though he never became a committed member, being too much
of a character to accept the reverence in which Manson was held.

 The next major music industry contact made by Manson was with
none other than Dennis Wilson, the drummer of multi-million-selling
surfer-boy superstars The Beach Boys. Wilson picked up a couple of
Family girls who were hitchhiking, and shortly thereafter came home
to his mansion at 14400 Sunset Boulevard to find the entire Family in
residence. Wilson took to Manson, and let them stay. The easy avail-
ability of both drugs and sex around the Family seems to have been a
key factor in this. Wilson tried hard to boost Manson's musical career,
and the first mention of Manson in print comes from an interview
Dennis Wilson gave to a British music magazine around this time. In
retrospect, his words seem a mixture of heartbreaking naivety and a
chilling parroting of Manson's Scientology-inspired psychobabble:

 I have a friend, Charles Manson, who says he is God and the
 Devil, and he likes to be called 'The Wizard'. The Wizard
 frightens me. Fear is nothing but awareness. It all comes from
 within. The Wizard sings, plays guitar, writes poetry and may
 be another artist on Brother Records.[4]

Through Dennis Wilson, Manson met other music industry bigwigs, among them Terry Melcher, the son of Doris Day and a producer for Columbia Records. Melcher was living at this time at 10050 Cielo Drive, shortly to be the scene of much Manson-inspired carnage. Gregg Jakobson, one of Melcher's employees, became friendly with the Family and recorded Manson's music on several occasions. It is surely more than a coincidence that the Tate murders took place at the Melcher's former residence, and several witnesses have testified to Manson's presence at 10050 Cielo Drive, on more than one occasion, before the murders took place. But equally, a number of sources have stated that Manson was well aware that Melcher was no longer living there, having moved out some six months earlier. It seems as if the house might have been chosen simply because Manson was familiar with its layout.

Manson also met and partied with other musicians, including John Phillips and Mama Cass Elliot of The Mamas And The Papas. Frank Zappa was approached by Mansonite Bobby Beausoleil. One would have thought that if anybody could have spotted the cult potential in Manson's whacked-out mind-game music, it would have been Zappa (who discovered Alice Cooper, among others), but he was uninterested, for reasons which have gone unrecorded. Another Manson follower, Catherine 'Gypsy' Share, approached Paul Rothschild, producer of The Doors, but he too couldn't be persuaded to take an interest in Manson, presumably feeling he had quite enough on his plate trying to keep Jim Morrison under control. Another major star who went on the record as admiring Manson's music at this time was Neil Young, who was then a member of Buffalo Springfield:

He wanted to make records. He wanted me to introduce him to Mo Ostin at Reprise. He had this kind of music that nobody else was doing. He would sit down with a guitar and start playing and making up stuff, different every time. It just kept comin' out, comin' out... Then he would stop and you would never hear that one again... Musically, I thought he was very unique. I thought he really had something crazy, something great. He was like a living poet.[5]

The Beach Boys, under the uncertain leadership of the brilliant but unstable Brian Wilson, were finding the transition from clean-cut surf pop high school favourites to cosmically aware acid rockers á la Beatles traumatic, and Charles Manson's influence over Dennis Wilson at this time had some effect on their musical direction. One of Manson's favourite self-penned songs was called (believe it or not!) Cease To Exist, a title inspired by the Scientological concept of ego-death. Dennis bought or traded the publishing rights to this song from Manson (accounts differ as to the exact arrangements), and worked it up in the studio with the other Beach Boys. The title was changed, firstly to Cease To Resist (as in "Cease to resist my romantic blandishments"), and then to Never Learn Not To Love.

This track was eventually released on a single, as the B-side to Bluebirds Over The Mountain, in December 1968, and subsequently on the album 20/20. The Beach Boys were at a low ebb creatively, and the single performed disappointingly, peaking at number sixty-one in the Billboard chart. Nonetheless, this release placed the music and words of Charles Manson in the hit parade for the first time (Manson would return to the album charts courtesy of Guns N' Roses in 1993, as detailed in Part 3). Although Never Learn Not To Love was given the usual slick Beach Boys studio treatment, a certain disturbing resonance was still evident in such lines as "Submission is a gift/Give it to your lover". Manson, though, control freak par excellence that he is, was less than delighted with the lyrical changes that The Beach Boys found desirable. In a later interview given in jail, he commented, in his uniquely rambling and allusive way:

It's a meditation song. I'm walking backwards and forwards in my cell and I'm saying, "The will and the mind, the body and soul, the will and the mind, the body and soul, the will and the mind, the body and soul," and I'm fighting against the cell, I'm trying to keep my will up, because years and years in a cell is difficult. So it becomes a song, and I write the song out, I send a tape to someone, they send a tape to Brother Recordings, and then when you hear the song, it's, "Ain't no sunshine when she's gone," you dig?... They changed it, all the

sound and the soul that comes off of prison. When it gets to your ears, it comes off, "I've been so lonely baby, Heartbreak Hotel," you dig what I'm saying? In other words, you hear the bottom part of what's really happening on the top. Hollywood plays music for little girls. I don't play little girl music, I play music for God, I play music for myself. Then when I come up with a song and they change the words, I say, "Don't change the words, if you change the words, my shadows are running fast, man."[6]

Throughout the summer of 1968, the Family free-loaded in grand style at Dennis Wilson's place, eating his food, wearing his clothes, helping themselves to gold discs and whatever else was lying around, and writing off his cars. Also around this time, Manson did several recording sessions at the home studio of Brian Wilson, Dennis's brother, which was situated on Bellagio Road, Bel Air, at the behest of Beach Boys manager Nick Grillo. The recording engineer for these sessions was Steve Despar:

Dennis came in with this guy Manson and he had about three or four of his ladies with him, and really all Charlie could do was play the guitar, and so he was going to lay down some guitar tracks with the vocals… Well, Dennis and he got along OK, but when it got to creative things, if Dennis was producing and Charlie was the artist, then any suggestions that Dennis had to make should have been at least considered by Charles, in those rules. But Charlie was not going to be produced. He wasn't. He had no idea what recording sessions were about, how to make records, how to deal with people that way. He took it all very personally, and he was not a professional artist.[7]

The recording sessions were called off after a couple of nights, not only due to the prodigious amount of drug taking and sexual activity that went on during them, but also because Steve Despar got nervous when Manson started pulling a knife on him during conversations. Despar complained to Nick Grillo, who pulled the plug on any further sessions, and subsequently threw the Family out of Dennis Wilson's house, after his investigations into Manson's background convinced him that Manson was not a fitting consort for a Beach Boy. The Family then moved into Spahn Movie Ranch in Chatsworth, a dilapidated property which had formerly been used as a location shoot for Westerns. It was from the Spahn Ranch that Manson's minions would set forth on their murderous errands.

Dennis Wilson did not sever all ties with the Manson Family at this point, however. He and Gregg Jakobson arranged further recording sessions for Manson at Westwood Studios in the spring of 1969. Terry Melcher was also present for these sessions, and has recounted how disturbed he was by a spontaneous jam of Charlie's, in which his free-form singing of nonsense syllables gradually coalesced into a refrain of "Die today, die today, die today."

By the summer of 1969, Manson and his Family were in full-tilt apocalyptic death cult mode, and Manson's plans for rock stardom were set aside in favour of weapons drill, survival training sessions and gearing up for 'Helter Skelter', the revolutionary race war that the Family believed was imminently about to engross America. By late autumn, Manson and those Family members who had participated in the murders were all in jail awaiting trial and the world's media were filled with sensational reports about the drug-crazed hippy killers.

What caused this attitude shift in the Family? It seems as if music played an important part, in that the so-called 'White Album' [a.k.a *The Beatles*] released by The Beatles in December 1968[8] was regarded by Manson as an inspired prophecy of Helter Skelter and a message of solidarity sent from The Beatles directly to the Family, in particular the tracks Revolution 1, Revolution 9 (which Manson associated with Chapter nine of the Bible's Book of Revelation), Sexy Sadie, Blackbird, Piggies and of course Helter Skelter. Phrases and words from the 'White Album' were daubed in the victims' blood at Family murder scenes.

The night following the murders at Sharon Tate's house, Tex, Sadie, Katie and Leslie went out again, this time accompanied by Manson himself and Steve 'Clem' Grogan, another Family member. They travelled to 3301 Waverley Drive in Los Feliz, and murdered Leno and Rosemary LaBianca, a

prosperous middle-aged couple, leaving the word 'WAR' carved on Leno LaBianca's stomach, and a number of messages in blood: 'DEATH TO PIGS' on a wall in the hallway, 'RISE' in the living room, and the misspelled 'HEALTER SKELTER' in blood on the refrigerator door in the kitchen.

Again probably not coincidentally, 3301 Waverley Drive was next door to 3267 Waverley Drive, an address formerly rented by Harold True, a friend of Phil Kaufman's. Manson and other Family members had visited this house during the previous summer.

There is almost an embarrassment of motives for the Tate murders in particular. Theories offered over the years include not only the "random murders committed to precipitate Helter Skelter" scenario successfully pursued by prosecutor Vincent Bugliosi in the murder trials, but also the following:

(i) Revenge for a drugs deal gone bad, and/or a power struggle for control of the local drugs market. Jay Sebring and Wojtek Frykowski were both major drugs dealers with powerful Hollywood connections. It also seems that the landlord of 10050 Cielo Drive, Rudy Altobelli, may have had connections to organised crime.

(ii) Revenge for the failure of Terry Melcher to help Manson further his musical ambitions. Melcher had been present at Manson recording sessions, and had travelled out to Spahn Ranch to see the Family perform Manson's songs *en masse*, but had not been forthcoming with a recording contract. As prosecutor Vincent Bugliosi recounts:

> Manson prevailed upon Terry to give him an audition, which Terry did, and Terry told me that Manson had some ability, but not very pronounced, and he gave him $50 and walked away.[9]

Gregg Jakobson had arranged for Melcher's trips out to Spahn Ranch, and his account concurs:

> I think Terry showed some interest in the music, but there was nothing positive. There was never any, "Yes, I will record you" talk going on. It was like that was the preliminaries and nothing ever came of it.[10]

Be that as it may, it's entirely possible that Manson took Melcher's visits to Spahn Ranch much more seriously than did Melcher himself, that he construed the $50 Melcher gave him as an advance (Melcher claims it was money to buy food, because he felt sorry for the ragtag crew of young runaways), and that he took grave offence when a recording contract failed to materialise. At the very least, it can hardly have slipped Manson's mind that 10050 Cielo Drive was Melcher's former residence when he told Tex and the girls to go there and kill everyone they found inside the house. Following the naming of the murderers, Melcher was evidently wracked with guilt, and spent years in therapy, obsessed with the thought that he might have been in some way responsible.

(iii) Copycat killings to help get Family member Bobby Beausoleil out of jail, where he was awaiting trial for the earlier murder of Gary Hinman in a dispute over a drugs deal.

(iv) Black magic sacrifices. Several people at Cielo Drive were heavily involved with the occult, and Manson's connections to satanic cults active in the Los Angeles area have been well documented.

MANSON WAS ARRESTED on October 12, 1969, at the isolated Barker Ranch in Death Valley. The Family had fled to this remote area following earlier police raids on the Spahn Ranch. Linda, Sadie, Katie and Clem had been arrested a couple of days earlier, along with many other Family members. They faced a number of charges between them, including car theft, arson and firearms offences, but weren't at this time suspects for murder. They were charged with the Tate-LaBianca murders following Sadie's bragging to a cellmate about her involvement in the killing of Sharon Tate. After a lengthy and highly publicised trial, Manson and the three of the girls were found guilty on March 29, 1971, of a total of twenty-seven counts of murder. Linda Kasabian, who did not directly participate in the killings, was offered immunity from prosecution in return for her testimony. Each of the defendants received a death sentence, but these were commuted to life imprisonment the following year, when the state of California abolished the death penalty.

Tex Watson was tried separately, having been arrested in November in Texas and extradited. He was in a debilitated mental state, and didn't stand trial until August 1971. Once again, Linda Kasabian was the prosecution's star witness. Watson was found guilty and sentenced to death in October 1971.

Clem Grogan stayed in the car on the night of the LaBianca killings, but he was convicted of the murder of a Spahn ranch hand named Shorty Shea. Grogan's sentence was less severe than those of the others, as the judge considered him too stupid to be given the death penalty, and he was paroled in 1985.

As of this writing, all the other Family members convicted of murder are still incarcerated.

2 The LIE Album

THE LP OF CHARLES MANSON songs which has come to be known, from its cover text, as *LIE* must be one of the strangest benefit albums ever recorded. On March 7, 1970,[11] Kaufman presided over a press conference at the Spahn Ranch to launch the *LIE* album. Having failed to find a major label willing to release *LIE* and endure the barrage of moral opprobrium which would inevitably have followed, Kaufman paid for the record to be pressed himself,[12] as he evidently felt a moral obligation to help with the defence costs of Manson and his followers. He didn't believe Manson was guilty:

I don't think [Manson] ever did physically murder anyone. He planted the seeds and other people did it. I looked after some of the girls after Charlie's arrest because I didn't think any of them were guilty. When I looked at the papers and read the names of the perpetrators and their accomplices, I realized that I'd had sex with every one of those murderesses.[13]

Kaufman, however, like so many others whose paths crossed that of the Family's, soon had cause to rue his generosity. He started to receive unwelcome nocturnal visits from Family members trying to extort money from the record sales. These incidents culminated in guns being fired to scare off the intruders on two separate occasions.[14]

There seems to be some doubt as to the exact provenance of the recordings on *LIE*. The 'official' *Access Manson* website and various other sources claim that the recordings were made on August 8, 1968, which would indicate that they are taken from the sessions recorded at Brian Wilson's home studio by Steve Despar. However, this is contradicted by accounts in Ed Sanders' *The Family* and elsewhere, which state that when Squeaky Fromme visited Dennis Wilson in December 1969, in an attempt to obtain the tapes of Manson's Brother Recordings demos, Wilson lied and said the tapes had been destroyed. In fact, they had been placed in a vault by Beach Boys manager Nick Grillo, where they presumably still reside, alongside Brian Wilson's legendary *Smile* album and other deep dark secrets of The Beach Boys. Squeaky Fromme has stated that Manson and the girls made additional recordings with "another producer" during the summer of 1968,[15] possibly at MCA Records,[16] so it's possible that the *LIE* masters are taken from these sessions. Ed Sanders states that, after Squeaky's visit to Dennis Wilson proved unproductive, Phil Kaufman obtained tapes from "another source",[17] and added overdubs and harmonies from non-imprisoned members of the Family before mixing the album.

The cover of *LIE* is a brilliantly simple piece of what Guy Debord and the Situationists dubbed *détournement*, that is "diversion", the appropriation and redirection of the mass media's images and discourse. The famous *LIFE* magazine cover of December 19, 1969, bearing the wide-eyed image of Manson on acid that has appeared on nearly every Manson artefact produced since, is reproduced verbatim, with the only change being the substitution of the word 'LIE' for 'LIFE', a subversive gesture on a par with Jamie Reid's famous Sex Pistols image of the Queen with her lips pierced by a safety pin.

Phil Kaufman (who is credited as producer on the sleeve of *LIE* under his prison number from Terminal Island days: 'Phil 12258 CAL') credited his co-producer Al Swerdloff (dubbed 'Sunshine Al' on the *LIE* sleeve) with the inspiration for this:

The idea was that the entire press was lies. We tried to find the most offensive of the yellow

journalism and present it… But it was also to let you know it was a lie, and that's the point of the *LIE* cover.[18]

Whether it was the intention of the sleeve's creators or not, I can't help feeling that the single word 'LIE' raises questions. They are accusing *LIFE*, the mass media in general and 'The System' of telling lies about Manson, of course, but doesn't the sleeve seem also to suggest that Manson too might lie? Is it an invitation? A confession? A command? An invocation of the Father of Lies? Manson's big round eyes stare out in parallel, locked on infinity, giving nothing away.

The irony of song titles such as People Say I'm No Good, Don't Do Anything Illegal, Big Iron Door and of course Cease To Exist is considerable. The less thoughtful people to whom I've played *LIE* have sometimes expressed surprise or disappointment that it isn't an intense explosion of pure sonic evil, but of course the Family didn't see themselves as advocates of evil, and thus didn't find it necessary to invent black metal fifteen years ahead of its time. In fact, *LIE* sounds like a lot of the mellow country rock that was around at the time of its recording. The closest comparison would perhaps be to Donovan or Arlo Guthrie, though there is a lot of traditional folk and blues influence in there as well. Manson sings mostly in a smooth, mellow croon, with occasional gawky country inflections. Sandra Good, to this day one of Manson's most faithful followers, offered this testimonial to the mellifluous quality of his singing:

> The music would take you into another dimension, and his voice is rich. He could be a crooner like any of your Las Vegas type torch singers. He can do that type of singing, very articulate. He has a rich, fine voice. I thought of the image of golden liquid sunshine, it's so rich. It's like the gold of his eyes, the deep gold brown of his eyes. And it's so full of feeling.[19]

Manson's vocal delivery has many attractive characteristics, but the most evocative song on *LIE* actually features none of Manson's own singing or playing, and is barely forty seconds long: I'll Never Say Never To Always a.k.a. Always Is Always. This eerie, lilting, a cappella nursery-rhyme style ditty was evidently something of an anthem for the Family, and film exists of the female murder trial defendants singing it together, as well as the dedicated band led by Squeaky Fromme and Sandra Good who kept vigil outside the court building. Printed and internet sources give various renditions of the lyrics, and they are a little indistinct as sung on the *LIE* album, but here they are in their entirety, as far as I can make them out:

> Always is always forever
> Cause one is one is one
> Look inside yourself for your father
> All is none all is none all is one
> It's time to call time from behind you
> The illusion has been just a dream
> Valley of death and I'll find you
> Now is when on a sunshine beam
> So bring only your perfection
> For there love will surely be
> No cold, pain, fear, or hunger
> You can see you can see you can see

A couple of longer and more elaborate versions of this song appear on the *Family Jams* CD set, which consists of material recorded subsequent to Manson's final arrest. Here, the lyrics are more audible, and confirm my interpretation of the *LIE* version:

> I'll never say never to always
> I'll never say always to none
> To seem is to dream a dream, my love
> Cause one is one is one
> For always is all is forever
> Cause one is one is one
> Look inside yourself for your father
> All is none all is none none is one
> It's time to call time from behind you
> The illusion has been just a dream
> Valley of death and I'll find you
> Now is when on a sunshine beam
> So bring only your perfection
> For there love will surely be
> No cold, pain, fear, or hunger
> You can see you can see you can see

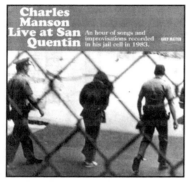

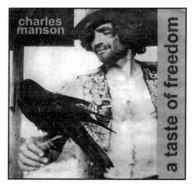

Top and centre *Son of Man*, recorded at
Vacaville, and *Live at San Quentin* are two
Charles Manson albums featuring acoustic
material recorded in prison.
Above *A Taste of Freedom* is a series of tape
recordings of phone calls bewteen Manson
and a fan made in 1999 and 2000.

This song was subsequently covered by Psychic TV, the band
fronted by long-time Manson buff Genesis P-Orridge, on their 1983
Dreams Less Sweet album, under the title Always Is Always.

At first glance, the lyrics of I'll Never Say Never To Always are in-
nocuous enough, encompassing some unexceptional mystical insight
("All is one") with a redemptive, utopian vision ("For there love will
surely be"). There are also references to ideas more specific to the
Family ("Valley of Death", i.e. Death Valley National Park, where the
Family planned to hole up for the imminent apocalypse, and "Look
inside yourself for your father": One of Manson's pet themes was the
necessity of rejecting parental programming, and he frequently asked
his sexual partners to imagine he was their father). Ultimately though,
the all-is-one/all-is-none strand in Manson's philosophy led not to Zen
enlightenment, but to a beyond-good-and-evil antinomianism in which
there was no good reason not to kill someone, because it was all the
same whether they lived or died anyway. The most disturbing aspect
of I'll Never Say Never To Always as recorded on *LIE*, however, is
the production, in which ghostly, echoing female harmonies float over
crying babies, disembodied whistling, whispered asides and various
other noises off. It's a masterpiece of unease.

The *LIE* album failed to have the seismic impact of the Tate-La-
Bianca killings — it could hardly have been otherwise — but it has
remained available in a variety of formats and degrees of legitimacy
for over thirty years now. Various other Manson recordings have ap-
peared from time to time since then, including *Live At San Quentin*,
Commemoration, *Son Of Man* and *Way Of The Wolf*, but none is as
interesting or compelling as *LIE*. One obvious reason for this is that
Manson hasn't been into a recording studio since his arrest. All the
later albums are culled from material recorded clandestinely in prison,
and the quality ranges from rough to rougher. These recordings have
also not been subjected to a relatively sophisticated production process
such as that applied to *LIE* by Phil Kaufman.

Irwin Chusid, music historian and authority on outsider music,
ventured the opinion to me that *LIE* would have been a classic cult
album even if the Family had never committed the Tate-LaBianca
murders, but it's really impossible, at this point, to disentangle
Manson's music from his crimes. Musicians have had occasional
brushes with the law ever since rock 'n' roll was invented, and even
before, and some musicians have been involved in crimes of violence
(Leadbelly, Sid Vicious and, currently *sub judice*, Phil Spector), but
the only even vaguely close parallel to the music/violence nexus
surrounding the Manson Family is to be found in the wave of murder
and arson that engulfed the Norwegian black metal scene in the early
1990s, where, most notoriously, Varg Víkernes of one-man band
Burzum stabbed to death his erstwhile friend, member of the band
Mayhem, and record label boss Euronymous on August 10, 1993.[20]

There's no way to listen to Manson's music without thinking about
the enormous pain wrought by his personal quest for vengeance against

a brutal and uncaring world. As you listen to *LIE*, deep down in the mix, below the acoustic guitar and the jolly campfire choruses, and vying for attention with all the whispers and giggles of Charlie's girls, you might just be able to discern the voice of Sharon Tate, pleading for the life of her unborn son.

3 Aftermath

IN THE DECADES following the guilty verdicts returned on Manson and his co-defendants, Manson's cult has grown like a tenacious and malignant weed in the shady corners of the counter-culture. I don't have space here to detail all the curious twists and turns of this still-unfolding narrative, but I'll mention a few of the more notable music-related events. Manson really came into his own in the early 1990s, as a parent-frightening icon for the grunge generation. Phil Kaufman astutely summarised his appeal to the young nihilists of Generation X:

> … Young people who don't dig the establishment but don't have an alternative would dig him.[21]

There was a brief spate of bands doing cover versions of songs from *LIE*. The Lemonheads did Home Is Where You're Happy on *Creator*. Redd Kross did Cease To Exist on *Born Innocent*. And most notoriously, Guns N' Roses, who were at that point one of the world's biggest rock bands, included Look At Your Game, Girl as an uncredited 'secret' track at the end of their 1993 covers album *The Spaghetti Incident?* There was an outcry when it was realised that publishing royalties from this track might reach Manson, as he'd composed the song before committing the crimes for which he's currently incarcerated. In the event (as recounted by Vincent Bugliosi in his updated 1994 edition of *Helter Skelter*), the money went to the son of Wojtek Frykowski, who'd been awarded damages in a civil case against Manson and his co-defendants in 1971. A first royalty cheque for $72,000 was issued in February 1994, making this easily the most lucrative of Manson's musical ventures.

Aside from direct covers of Manson's songs, many

other bands have also written songs dealing with the Manson Family and its crimes. A (very incomplete) list includes Sonic Youth's Death Valley 69, Current 93's Beausoleil, Tin Omen by Skinny Puppy, Bloodbath In Paradise by Ozzy Osbourne, Black Bus by Electric Hellfire Club; and songs by Meat Beat Manifesto, White Zombie and Pantera. Trent Reznor of Nine Inch Nails recorded his classic *The Downward Spiral* album at 10050 Cielo Drive (though Reznor claimed to be unaware of the house's history), and of course Brian Warner 'borrowed' Manson's surname and became Marilyn Manson.

Could Manson have made it as a musician, and if so, would the crimes now indelibly associated with him and his followers never have happened? It's hard to say. Manson, as amply attested by many people who witnessed his performances, had some musical and songwriting talent, not prodigious, perhaps, but certainly as much as was possessed by some of the lesser musical sensations of the late sixties. Militating against this, however, was Manson's personality disorder born of his horrendous upbringing, which resulted in his compulsive need to manipulate and control and his unpredictable surges of violence. Rock history is replete with instances of more or less dangerous and possibly psychopathic personalities kept in check, at least for a while, by creative and commercial success and the firm paternal grasp of their managers, so maybe Manson could have been kept in line long enough to cut a hit album. But in the final analysis, what would Manson have gained from musical success? He already had all the sex, drugs and adulation he could handle. He had followers willing to kill on his command, which is more than even the biggest rock stars can boast. And for the past thirty years, he has continued to enjoy a considerable cult following: Far longer than he could reasonably have expected to stay in the spotlight as a recording star. Manson receives more post than any other inmate of the American prison system, and can probably lay claim to being the most notorious criminal of the twentieth century, excluding heads of state such as Hitler, Stalin, etc. In a way, Charlie has made the big time. Not bad for a guy who started life as 'No Name'.

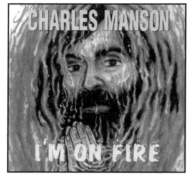

From top *LIE* back cover. I'm On Fire c/w The Hallways Of The Always, a 45 on White Devil Records with art by Nick Bougas

Further Information

THIS IS IN NO WAY a complete list of Manson-related artefacts, merely some that I have found useful in the preparation of this article, and others which, whilst not directly contributing to the article, are worth drawing to people's attention. Insatiable Manson-fanciers are referred to *Headpress* 21, which contains many more reviews of related items, by myself and other people.

Books

■ I'm not going to list the standard texts, such as *The Family* and *Helter Skelter*, which you've more than likely read long since. Here follow some more esoteric items worth tracking down.

■ 'Rot in the Clockwork Orange', article by RC Zaehner, appears in *Rapid Eye Three*, ed. Simon Dwyer, (Creation Books, 1995). This piece is reprinted from Zaehner's long out-of-print book *Our Savage God* (Collins, 1974), and is one of the more thoughtful explorations of the occult, religious and philosophical strands in Manson's antinomian thought. Similar ground is also covered in Stoddard Martin's *Art, Messianism And Crime* (Macmillan, 1986). The first volume of *Rapid Eye* contains a complete transcript of Manson's notorious courtroom testimony.

■ *The Manson File*, ed. Nikolas Schreck (Amok Press, 1988). Something of a collectors' item these days (I don't own my own copy) but a very interesting read. Contains a lot of artwork, poetry and lyrics by Manson and Family members. Rather pro-Manson in bias (see also *Charles Manson, Superstar* below).

■ *The Shadow Over Santa Susana*, Adam Gorightly (iUniverse.com, 2001). A highly readable conspiracy theory-oriented account. For extracts which will give you a flavour of this book, check out the promotional website [**w**] www.mansonmythos.com.

CDs

■ Charles Manson, *LIE: The Love and Terror Cult*. Available in a profusion of editions over the last few decades. My copy came from Awareness Records (PO Box 5241, Kendall Park, NJ 08824, USA), catalogue number AWARE 1 CD. This isn't hard to find. Sick City is listed as 'Slick City' on the back cover, Cease To Exist becomes 'Cease to Exit', and 'I Once Knew A Man becomes 'I Once Knew Knew A Man' (I mention these typos in case they can help people distinguish

between different editions).

■ *The Family Jams*. AOROA Records, PO Box 420464, San Francisco, CA 94142, USA. A lavishly-packaged double CD of Family members singing Charlie's songs. Reasonable sound quality, but doesn't contain any of Manson's own singing or playing. Great booklet full of rare photos of Family members, quotes and pictures of Charlie's embroidered ceremonial waistcoat.

■ *Charles Manson — Commemoration*. White Devil Records, PO Box 85811, Seattle, Washington 98105, USA, catalogue number WDCD 3 10666 2. Subtitled "Commemorating Sixty Years of Struggle Against Cowardice, Stupidity and Lies", and featuring a disturbing Manson-as-Hitler-on-a-postage-stamp cover image, this album was released to celebrate Manson's sixtieth birthday in 1994. The music was recorded surreptitiously in Vacaville Medical Facility in 1982-5. There are sixteen tracks, and none is a repeat from the *LIE* album. As far as later Manson releases go, this is one of the more worthwhile ones. Sound quality is reasonable, considering the circumstances. Manson's speaking voice sounds eerily like Dennis Hopper's. *Commemoration* bears sleeve notes from hardcore Mansonites James Mason, head of the Universal Order and possibly the only person ever to be expelled from the American Nazi Party for being too right-wing, and 'Michael M. Jenkins', i.e. Michael Moynihan, of Blood Axis and *Lords Of Chaos* renown/infamy.

■ John Moran, *The Manson Family: An Opera*. Point/Philips, catalogue number 432 967-2. OK, admittedly this wasn't essential to the writing of this piece, but I thought I'd mention it, as it's not bad and it doesn't get much attention. Performed at New York's Lincoln Center in 1990. Features a certain Mr Iggy Pop as 'The Prosecutor'. Iggy completists: On your marks, get set, go!

■ The Beach Boys, *20/20*. Capitol Records, catalogue number 7243 5 31638 2 2. This album, originally released in 1968, contains the track Never Learn Not To Love, which is credited to Dennis Wilson but was in fact written by Manson under the title Cease To Exist. Manson's version appears on the *LIE* album. Compare and contrast. The other track on *20/20* to display a heavy Manson influence is the Dennis Wilson solo production Be With Me. Accounts differ as to the level of Manson's involvement in the writing of this track, but it has a very spooky vibe about it. My copy of *20/20* is on a back-to-back CD with The Beach Boys' previous album *Friends*. The liner notes assiduously avoid any reference to Charles Manson, merely noting that Dennis Wilson "was going through very tough personal times in 1968". Uh, yeah.

■ Bobby Beausoleil and the Freedom Orchestra, *Kenneth Anger's Lucifer Rising*. MOD, PO Box 2903, London, N1 3NE, catalogue number DISGUST 2. This is the soundtrack to Anger's remade version of *Lucifer Rising*. There are differing accounts as to what happened to the first version of the film: Anger has always claimed that Beausoleil stole the film stock and buried it in Death Valley, whereas Beausoleil maintains that Anger destroyed the film himself. This album was composed and recorded in prison, where Beausoleil is serving time for the murder of Gary Hinman. Fellow Family member Steve 'Clem' Grogan provided electric guitar. The album has an impressively foreboding psychedelic-satanic atmosphere to it.

■ Guns N' Roses, *The Spaghetti Incident?* Geffen, catalogue number GEF24617. This stopgap covers album is the crappest G N' R album by some way, but it does contain Axl Rose's 'secret' — and very faithful — version of Look At Your Game, Girl. Rose says "Thanks, Chas," at the end of the song, then "Jack". Who's Jack?

Websites

There are tons. These are some of the best:

■ **www.amystrange.com/atwa** This is *Access Manson*, the nearest thing to an official site, maintained by true believers Sandra Good and George Stimson (there's an interesting interview with Stimson by Richard Metzger at [**w**] www.disinfo.com/pages/article/id599). *Access Manson* was previously at www.atwa.com, but moved suddenly for some reason, and I wouldn't be at all surprised if it's somewhere else again, or nowhere at all, by the time this book is published. Functions as a mouthpiece for ATWA (Air, Trees, Water, Animals), Manson's genocide-advocating 'environmental' organisation. Also contains a heap of useful info on the music:

Lyrics, discography, etc. As of May 2003, the ATWA site seems to have disappeared again, though there is an alternative of sorts at [**w**] www.4a4r.com

■ **www.charliemanson.com** Very useful links and current news pages. Do not confuse with charlesmanson.com, which for some reason is a porn site!

■ **www.holyterror.com/aesnihil** Homepage of Aes-Nihil Productions, who peddle all manner of Mansoniana, including parole hearing transcripts and suchlike.

■ **www.phkauf.com** Homepage of Philip Kaufman, producer of the *LIE* album, illicit cremator of Gram Parsons and all-round rock 'n' roll legend. His memoir, *Road Mangler Deluxe* (White-Boucke, 1993), in the manner of *This Is Spinal Tap*, captures "The sights, the sounds, the smells of a hard-working rock band on tour." Kaufman currently works as Emmylou Harris' road manager, which has got to be less nerve-wracking than telling Charles Manson he's out of tune. At the time of writing, a film entitled *Grand Theft Parsons*, starring Johnny Knoxville of *Jackass TV* renown as Phil Kaufman, is on general release in the United States. For a brief account of the demise of Gram Parsons and subsequent events involving Phil Kaufman, check out [**w**] www.straightdope.com/classics/a5_014.html

■ For excerpts from *Road Mangler Deluxe*, check out [**w**] www.white-boucke.com

■ **www.crimelibrary.com/manson/mansonmain.htm** A decent online account of the basic facts of the Tate-La Bianca murders, with many photos.

Films

■ *Helter Skelter Murders* (1971) aka *The Other Side of Madness*. Rather creepy and effective b&w exploitation quickie directed by Frank Howard and released whilst the Family trials were still taking place, resulting in the film being banned in Los Angeles for a time. No characters are called by their real names, due to the *sub judice* nature of the events depicted. Some filming took place at Spahn Ranch. Manson's own versions of Mechanical Man and Garbage Dump appear on the soundtrack.

■ *Manson* (1972). A documentary directed by Rob-ert Hendrickson and Laurence Merrick, featuring interviews with disaffected Family members as well as true believers like Sandra Good and Squeaky Fromme. *Manson* contains a lot of footage of happier, more peaceful times at Spahn Ranch, before Helter Skelter apocalyptic thinking predominated, and is probably the best insight into the everyday life of the Family. The most telling comment comes from former Family member Paul Watkins: "He said there was no death, he said death was love. Charlie had no idea what love was. Charlie was so far from love it wasn't even funny."

■ *Charles Manson, Superstar* (1989). Produced by Video Werewolf and narrated by Nikolas Schreck, this is in many ways the video equivalent of *The Manson File* book. Many of the same people were involved in the production of both. *Charles Manson, Superstar* is basically a documentary, but with no real pretence at objectivity: the misdeeds of Manson and the Family are minimised and justified, and there is much finger-pointing at 'the system'. It largely consists of a lengthy prison interview with Manson in San Quentin, interspersed with archive footage of the murders, arrests and trials, and present-day footage of Spahn Ranch, Barker Ranch, Death Valley, etc. Manson appears just about as crazy as a loon and in need of medication, twitching, jerking, dancing around and talking frenetically. James Mason of the Universal Order also appears, getting all misty eyed about Hitler and Manson in equal measure. There's also great cover art by Joe Coleman. This film is nearly two hours long, and provided you bear in mind the pro-Manson bias of the makers, it's probably the single best film on Charles Manson, and is well worth hunting down — I found my copy on eBay for not too much.

Disturbo Music

By Martin Jones

THERE IS MUCH to enjoy in the film *Killer Nun*, but it is not for this book. All that needs to be asked is: How could you not love something that features a nun shouting "Disgusting! Disgusting! Disgusting!" whilst breaking an old granny's false teeth under a plimsoled foot? We're talking religious mental breakdown here, bought on by drug addiction. *Killer Nun* is a tumour of 1978 Italian sleaze, starring former *La Dolce Vita* bunny Anita Ekberg. With something for everyone, *Killer Nun*'s music is similarly Catholic: The sub-*Omen* choral theme (complete with descending piano keys uncannily similar to Sense Of Doubt, a 1977 David Bowie instrumental) soon gives way to doomish piano/flute/theramin breaks, but then is happy to launch into a breezy love song the moment Sister Gertrude (Ekberg) goes off to the city in mufti. When she picks up a man — who resembles the British novelist Martin Amis — for casual sex, the score shifts easily to a plink-plonk upbeat number, as if music is still following Ekberg from her cosmopolitan *La Dolce Vita* days...

But Gertrude is a morphine addict, and thirty minutes into *Killer Nun*, withdrawal symptoms kick in, both visually and aurally. Stinging, fragile acoustic guitar — a spider's web for the ears — accompanies her dream of an operation (to remove a cancer) and molestation of a naked male on a morgue slab. Five minutes of madness in cerebral and physical worlds, which culminate in an old man being battered to death with a lampshade and then pushed out of a high window. All this is followed — like a lunatic in the shadows — by escalating music, distant yet intense: Thin, echoing guitar chords, a beat tapped out on its body, multiple strings threatening, along with the hint of irrepressible keyboards. As with victim Gertrude, the guitar soon goes over the edge, haywire... The keyboard screeches, like the wind blowing notes through her junkie mind. Mutated beyond its own limitations, the guitar turns on the rest of the instruments with an alien wah-wah resonance. Gigantic church organ keys — like the intervention of an angry God — signal the end of Gertrude's hallucinations. A drawn out but all-powerful full stop.

One hour twelve minutes into *Killer Nun*, it happens again, this time over her search for morphine: The scatty guitar, the slowly rising keyboards (keys as succubi crawling from the pit), the probing chords, like a needle investigating old wounds, trying to find the safe distance between a fix and death...

But in my mind's eye I see another film for Alessandro Alessandroni's score, shot on some desecrated wasteland between the abbeys of Ken Russell and Luis Bunuel. Here, in one bare room, a jug band of the insane play, ragged figures dragged from solitary confinement and handed the instruments of their own madness. And in the room next to them? Behind a closed door, Sister Gertrude tears shards of faded, flower-printed wallpaper off damp walls with her teeth, whilst behind her two novices with hourglass figures and milky skin, cropped dark hair and voluptuous lips, shed their habits and dance together in sylphlike grace, creating a new religion between connecting flesh...

The film has no title, but the music and the girls dance on forever.

Forgotten Freaks

The Wild

By Sleazegrinder

IN THE SUMMER OF 1983, I picked up a curious looking, self-titled, one-sided yellow picture disc from a hopelessly obscure Hollywood hard rock band called The Wild. I had read tiny blurbs about the band in Californian metal 'zines like *Headbanger* and *World Metal Report*, where they were touted as "monster metal" sensations, an outrageous new form of shock rock that the band invented themselves. Monster metal? Listen, I was fourteen at the time, so you *know* I was in. The picture disc featured the most bizarre looking band of creatures I had ever seen. It prompted howls of laughter from my friends, who quickly pointed out that two members of The Wild bore a striking resemblance to Mr Heatmiser and Mr Snowmiser from *The Year Without A Santa Claus*. Undaunted, I took the record home, flipped it over onto its black vinyl side, and hoped for the best.

I can still sing the four songs on *The Wild EP* (Erika Records) word for word. The Wild were indeed a whole new strain of rock and roll, one that straddled punk, metal and glam rock with ease, one so bulging with swagger and testosterone that it brought a whole new meaning to the previously derisive term "Cock Rock". Cock rockers they were, and proud of it. Even Rocky Shades and his spiked codpiece trash queens in Wrathchild would have been impressed with all the sausage-swinging on this amazing record. And if they didn't look so jaw-droppingly stupid, they just might have been the new KISS before the inferior Motley Crue slithered onto the shock rock throne and ruined it for everybody.

Over the years, I have literally stared at the precious few photographs of The Wild on their picture disc for hours at a time, and I *still* can't get over it.

James Nitro's teeth look like a serrated steak knife caught in a garbage disposal, and they are barely contained by his thick, rubbery lips. His bushy eyebrows are caked with clown make-up, his vertical frightwig is an electrified afro from Hell, and his neckpiece — shreds of vinyl glued onto a black plastic collar — is the kind of thing a disturbed child might concoct during arts and crafts day at the local paediatric psychiatry unit. He is Jamie Farr kidnapped by the gay circus. He is a rock star, in the most absurd sense of the term. Nitro towers over his band mates on the picture disc

cover, that drugged snarl of his made all the more perverse by the slathered purple lipstick. To his left, the blue-haired Johnny Rat swings a plastic mace in one hand, and holds his black Flying Vee in the other. One of the very few Arabs in rock and roll, Johnny is a swarthy fellow with darting eyes and an extremely dumb looking costume, which consists of a full body, long-sleeved red leotard covered by a black trash bag. Frontmen Rick Storm and Spider Webb fare slightly better, but not by much. Rick at least gets a Dracula cape, but the electrical tape wrapped around his chest like a low-rent bandolero had to be a bitch to remove. His knee-high boots are covered in floppy red spikes, and he appears to be wearing a Batman belt. Bass player Spider Webb kneels in the foreground, his red hair flaring upwards like an angry volcano. As his rock star name would suggest, he has fashioned his costume to resemble a spider web. His shirt consists of tied together rags, and a web is drawn on his cheek. Curiously, a detached pair of hands grip his black booted leg. Is this to imply the many legs of a spider? If so, why use hands? And why only two? If you look closely enough, you'll notice what a slipshod piece of work this cover actually is: Half of Johnny Rat's face has been whited out, and the photograph was obviously cut by a pair of shaky scissors. The bright yellow background is even more of an eyesore than the band, and of course, they neglected to actual print 'The Wild' on the picture side of the disc. You know, like any *sane* band would do.

Still, even with all its obvious flaws, *The Wild EP* practically *screams* rock and roll. Even if this band was as terrible as they look, it wouldn't really matter. Their 'image' is so over-the-top, it's almost sublime. They look very much like a bunch of Persian rug salesmen caught in some perverse, Coffin Joe-esque nightmare. In a cartoonish arena like hard rock, where outrage and outlandishness is matched only by stupidity and bad taste, The Wild are the King Fools of them all. Even Brit biker metal titans Rogue Male, in their regrettable *Mad Max-meets-Flashdance* period, pale in comparison to the jaw-dropping nonsense of The Wild. They obviously had a grand sense of purpose — and a great sense of humour — when they concocted all this insanity. If it was only a tiny stab at infamy they were after, that much would have been secured before

they stumbled into the recording studio. But even though their threadbare freak show image would loudly suggest otherwise, the goofy sons of bitches could actually rock like fuck, too.

In a very real way, the music of The Wild was so far ahead of its time that nobody's even caught up with it *yet*. Sure, there's been a bloated cottage industry of self-assigned "punk'n'roll" bands clogging up college radio and greaser-hipster CD collections for years now, most of which had the same vague idea: What if Motley Crue were punk? What the fuck would *that* sound like? Well, it wouldn't sound like Motorhead, which virtually all of those bands do. It would sound like The Wild. 1983 predated the raunch-metal swagger of bands like Guns N' Roses and Faster Pussycat, as well as the poppy arena rock punch of glam tyrants like Poison; and even the Crue were still just a ragged, punky garage band at the time. The opportunity for a band to come along and merge the hooky, larger than life hard rock crunch

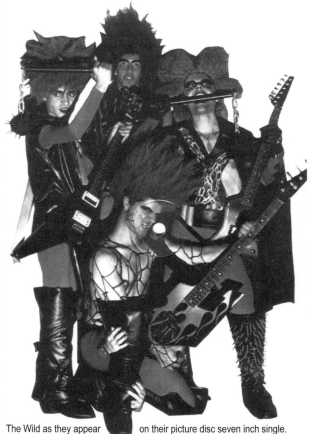

The Wild as they appear on their picture disc seven inch single.

RICK STORM
(Lead Vocals, Lead & Rhythm Guitar)

JOHNNY RAT
(Lead & Rhythm Guitar)

of KISS with the snarl and spit of The Sex Pistols was wide open, and The Wild gave it their best shot with this four song EP. Admittedly, these songs are hampered somewhat by the band's inability to play very well, and the gang chorus shout-alongs do their best to mask the fact that Rick Storm couldn't really sing, but beyond the musical limitations of The Wild, there is a powerful blast of highly effective rock and roll here. The songs are dumbed-down anthems for party crashers and home wreckers, a quartet of catchy, blood boiling cock rockers that have become the most obscure of proto-glampunk classics ever.

Opener Get Wild Tonight is their blistering statement of intent. Over a twisting Pistols riff, Rick Storm explains their simple philosophy on Rock'n'Roll:

Got dirty minds
Never get enough

Drinking all the time
You know that's us

Johnny Rat slams home a driving Johnny Thunders solo, the whole band screams "Get Wild Tonight!" for two minutes straight, and it's over. Rock and roll is changed forever, and nobody notices. Get It In, the perverse fan favourite, follows. With its sinister guitar lead and call and response verses, it predates the dark sleaze metal menace of Buckcherry by fifteen or so years. The lyrics are pretty stupid — "Get it in/I'm gonna walk right in/Get it in/Oh baby, let me in" — but it ends in a stark, almost doom metal swell of crashing power chords, and sounds more criminal than horny. Stay Up All Night continues the rather brilliant system of swiping a punk riff and metallising it. One of the more remarkable things about The Wild's music is that they sound much too serious for their own good. Stay Up All Night is supposed to be a light-hearted

SPIDER WEB
(Bass Guitar, Backing Vocals)

JAMES NITRO
(Drums, Backing Vocals)

ode to rock'n'roll debauchery, but with Storm's desperate bellow of "I'm never gonna sleep/I'm taking you deep," and Rat's goth-glam guitar leads, the song sounds more like angry, meth-fuelled madness than a party invitation. As the song eerily echoes out, it becomes obvious that The Wild had more on their minds than booze and girls: These fuckers absolutely meant to bring rock'n'roll to its knees. This is even more evident on the sleazy closer Hungry For Love. Although the song is derailed completely by a Gary Glitter-y goofball chorus, Hungry For Love is a high intensity blast of mean spirited cock and roll with squealing guitars, a slam-dancing hypergroove, and a shredding, apocalyptic climax.

OK, so the production is thin, runny garbage, and The Wild have less control over their instruments than a drunk monkey has over his sexual impulses, but under it all, there's a lethal rock'n'roll killing machine here. I hear thousands of new bands attempting this kind of ramshackle debauchery every

year, and very few even come close. The Wild were a *great* band, and it's one of rock's many, many tragedies that these four songs are all we'll ever hear of them. And believe me, I looked.

Prior to writing this piece, The Wild were a mere teenage memory to me, but when the opportunity to write about them popped up, I decided to dig in deep, to see if I could find out what happened to Storm, Webb, Nitro, and Rat. I found a copy of the EP from a dealer in London for less than five dollars, and when it arrived a few weeks later, I pored over the text on the back, searching for clues. The band never revealed their real names, and when I checked BMI for songwriting credits, they told me that the songs were written by... Well, *Rick Storm* and *Spider Webb*. My wife had the brilliant idea of doing an internet search on everyone in their thanks list and, miraculously, she struck gold on the first try.

The first person listed was Bruce Duff, a well-

known West Coast music journalist in the eighties. His name still comes up a lot in LA rock conversations, so he was easy to locate. Duff works at the Knitting Factory LA these days as a production manager, so I called his office one afternoon. After a couple of quick call transfers, the affable Californian greeted me with a friendly "Yello!"

"Hey Bruce, this is the Sleazegrinder... This might be a weird question, but do you remember a band from the mid eighties called The Wild?"

Duff didn't miss a beat. "Dude, my old band used to rehearse across the hall from them. Sure, I remember them!"

I swear to God, I love rock'n'roll. I hashed out a time to interrogate Bruce, and later that week, we finally got the time to talk all things Wild.

Besides writing for every music magazine in LA and serving as band manager and/or producer for countless old-school punks since the early eighties, Bruce Duff has played bass for many, many bands over the years, including The Twisted Roots, Sister Goddamn, Jeff Dahl and the legendary ADZ (formerly The Adolescents), with whom he still plays. In 1983, he was still in the early stages of putting together The Jesters Of Destiny, a band which also featured Sickie Wifebeater from The Mentors, and whose seminal album *Fun At The Funeral* (1986) is widely regarded by critics as the first 'alternative metal' record. Whatever the fuck *that* means. In 1983, The Jesters were still going under the glammier name of Sleeping Beauties, and it was during these early days that Bruce met The Wild...

LB&T Goddamn. You actually knew The Wild.

BRUCE DUFF There was this place on Kawanga called Wada Pro. This guy named Chuck Wada owned it. It was above these offices next to a pizza place, next to a newsstand, which is still there. Anyway, it was around 1983... The Bangs played there, before they were The Bangles. The Longryders, The Shadow Minstrels, The Motels... All kinds of bands practiced up there. This was a little bit before The Jesters Of Destiny; we started around 1986. Ray (Violet, guitars) and I, the two main guys in Jesters, had this band called Sleeping Beauties with Ray's then-girlfriend singing lead. We practiced across the hall from The Wild. I think we did a few shows

with them, and we sorta became friends with them. When we would play, they would roadie for us, and when they would play, oftentimes our guitar player Ray would do sound. He took it kinda to another level with them. He was somehow able to get great sound at excruciatingly loud levels in small rooms. I don't know how he figured it out, but he was able to push PAs into doing things they shouldn't have been able to do, and he just turned those guys into this unbelievable hard rock powerhouse. They were pretty good; they weren't really coming up with anything that new, musically, but the songs were pretty catchy. We really liked Get It In and Hungry For Love. Those were our two favourites.

LB&T Did they have any kind of a following?

BRUCE DUFF It wasn't huge, but they did have a following, yeah. We went to all their shows, and there seemed to be quite a few other people like us who were either getting the joke, or enjoying it whether or not they got the joke.

LB&T What kind of look were they going for?

BRUCE DUFF Well, you've seen the picture.

LB&T Yeah, but Christ... Where would they fit in, looking like that?

BRUCE DUFF They didn't fit in with anything. That's one of the reasons it kinda worked, though. It was kind of funny, but they weren't making that big of a joke. They *did* look silly, but part of the reason was because the costumes were the best they could afford. I remember one of the guys, I think it was Johnny Rat — he was the Iranian guy, who was the lead guitar player — he had plastic rats glued to his boots. I mean, that was pretty cheesy. Everything was made out of plastic, just junk. I think they bought regular wigs and just egg-whited them into these crazy positions. I mean, everything was just on a really limited budget. But, I don't know if 'serious' was the right word, but they were really into their songs. *They* thought that they rocked, and they kinda *did* rock.

LB&T Were they strange characters?

BRUCE DUFF As bizarre as they were, and as strange as they looked, the real life band, unmasked, and un-made up, and not in their outfits, was even *more* bizarre. Rick Storm and Spider Webb — I can't remember their real names — were the two most *identical* twins I ever saw in my life. You could not ever tell which one you were talking to. There was this rumour — I can't remember if one of them told me, or it was just circulating through the rehearsal space — anyway, the rumour was that they had swapped girlfriends, and the girls didn't know. I don't know why they didn't do something more with that, instead of always trying to look different from one another.

LB&T Did women go for them?

BRUCE DUFF Women did *not* go for them. Their audience was mostly teenage guys, and older guys like us, who thought it was funny. Funny in a cool way. We weren't laughing *at* them, we were laughing *with* them. But I'm not sure they were presenting a full-fledged joke. I think in their mind, they had come up with the next wave of heavy rock, *a la* KISS, with a punk edge. Which was probably a good idea, but they were only able to present it at a B-grade level. It wasn't like Motley Crue, even though they were just as cheesy in terms of how they put their costumes together. At least with Motley Crue, they had real metal chains, instead of *plastic* ones. That may not seem like a very significant thing, but it made them look more like a street gang than some guys in plastic costumes.

LB&T Was there ever any chance for these guys?

BRUCE DUFF In their mind, yeah. It's a common thing for Hollywood bands, once they get a rehearsal space and start playing, and somebody puts out a picture disc, you figure you're on your way. Their record was not really embraced locally; I think there were two reviews of it. I probably wrote one of the two.

LB&T So, what happened to them after the EP?

BRUCE DUFF They were from back East, or maybe the Midwest, and I think maybe they just went back there. After we stopped playing at Wada Pro, and our band broke up and their band broke up, I never heard from any of them, except their drummer (James Nitro), who pretty much got rid of his drums right way and became a life insurance salesman. That was the last I ever heard from any of them.

LB&T So, I guess this picture disc is the only remaining evidence…

BRUCE DUFF That's the only thing they ever did, and it's interesting, because it really wasn't taken very seriously at the time, but it's a record that people still mention to me from time to time because they saw my name on it. They get a hold of it, and they really treasure it. I think those guys might have really had something, but I guess they just missed the boat.

LB&T Do they seem like the kind of guys that would have continued on somewhere else?

BRUCE DUFF Well, they were very enthusiastic, so it's possible.

Bruce promised to call if anything came up, but I have yet to hear back from him, and even with an enormously thorough resource like the internet, nobody seems to have heard of two twin brothers in the Midwest or anywhere else who used to dress up like ugly monster clowns and play punky hard rock. All that's left of The Wild is a few gloriously ridiculous promo pics, and four kick ass songs. Not much to build a legend on, but close enough for rock'n'roll. I think the whole story can be summed up best by the band themselves. From the back of their record:

> The Wild are guys who like loud rock, having fun, and staying up all night. You know the type, the kind of person who likes fast cars, horror movies, and all those house parties. If you're that type of person, then this record is for you, because it's dedicated to metal munchers and headbangers everywhere. The Wild loves you.

I love you too, you goofy motherfuckers. Long live monster metal.

Messiahs Of Voltage

How The Stooges Died For You

By Rik Rawling

The people just have to die for the music. People are dying for everything else, so why not die for the music? Die for it. *Lou Reed*

We got so good, we had to die. *Iggy Pop*

THEY WERE JUST another band. Just another bunch of drug addicts and pussy hounds in their early twenties who reacted to their stultifyingly boring urban existence with bad voltage and primal screams. Just another cluster of refried dreams and egos in collision. Mutant creatures crawling out of their parents' basements, drawn by the scent of cheap ganja and poon-tang to take to the stage and obliterate their souls and their psyches in the name of entertainment. Hardly unique, so what's the fucking deal with The Stooges?

Their name is evoked by music fans and rock bores the same way devout Christians evoke the holy name of Jesus Christ and his Disciples. Iggy Pop is hailed as the 'Godfather' of every generational shift in music fads: From punk to grunge and back to punk again. Their music is sampled *ad nauseum* by bollock-brained advertising maggots to coat their shoddy product with some vapid gloss of 'cool' and 'edge'. They have become the stock reference for failed-musician rock 'journalists' who, when faced with a bunch of thin white boys with guitars who make a bit of a racket, pull out the *Raw Power* clichés and then shuffle off home to weep into their bitter pillows. And their three albums (discounting all the cheap cash-ins that have emerged over the years) are regarded as the chunks of rock that were lost when the stone tablets bearing the Ten Commandments were smashed.

How could a band have such a long-lasting effect over subsequent generations?

This isn't an essentially populist act like The Beatles or The Rolling Stones; this was a bunch of reprobates who made the kind of noise used to psychologically destroy the enemy in a siege. What is it about their legend that makes them such an enduring prospect for hormone-driven release?

To try and get the bottom of this we first have to go back, way back, deep into the heart of that most fabled and misunderstood of decades when strange forces were at work, urging young men on towards their destiny.

THE HISTORY

For many are called, but few are chosen.
St Matthew

1965 The year of the assassination of Malcolm X and the release of Russ Meyer's *Faster Pussycat! Kill! Kill!* It was also the year that America was about to lose what little 'innocence' it pretended to have left deep in the jungles of South-East Asia. Meanwhile, back home, there were riots in the cities and a wind of change blowing through the streets. The quiet suburbs became a Petri dish where strange new specimens could take form. One such specimen was Ronald Asheton, a Detroit teenager raised in a household of musical influences. His great aunt played banjo and put on shows at family parties where the young Ron would accompany her on an old violin. He went on to learn the accordion and take guitar lessons and entertained himself with the vague dreams of 'stardom' that all kids raised in the cathode glow of TV secretly harbour. When puberty kicked in he lost interest and his dad tried to prevent him drifting into Wasterville by encouraging him towards a military career, but once The Beatles hit America, coupled with the death of his father, it was clear what Ron intended to do with his life.

In eleventh grade he blew school in and went to England with his mate Dave Alexander, a red-haired, acne-blasted creature who was already developing a liver-lacerating taste for booze. Unbelievably for sixteen-year-olds they were given permission to go so they sold their motorcycles for the airfare and went to the Holy Land where their dreams of starting a band could be realised in the same streets and the same clubs as where The Beatles and The Stones had been before them.

The lads expected rock'n'roll nirvana but ended up in Southport, which must've been something of a disappointment. But it was only a train ride from Liverpool, which for young Yanks back in those days was a bit like how we Limeys now view Detroit. They saw local bands play The Cavern and were generally awed by the burgeoning scene. On a one pound all-nighter they got to see The Move and The Who, just as My Generation was sticking its cock into the charts, and they were treated to the spectacle of Pete

This case, I think we have to go all out. I think this situation absolutely requires a really futile and stupid gesture to be done on somebody's part. And we're just the guys to do it.
Otter, Nation Lampoon's Animal House

Townshend smashing up his Rickenbacker. That night altered Ron's entire perception of reality:

> It was my first experience of total pandemonium. It was like a dog pile of people, just trying to grab pieces of Townshend's guitar, and people were scrambling to dive up onstage and he'd swing the guitar at their heads. The audience weren't cheering, it was more like animal noises, howling. The whole room turned really primitive — like a pack of starving animals that hadn't eaten in a week and somebody threw out a piece of meat. I was afraid. For me it wasn't fun, but it was mesmerising… Never had I seen people driven so nuts — that music could drive people to such dangerous extremes. That's when I realised, this is definitely what I wanna do.

When they went back home Ron's perspective on life was totally changed. There was no way he could go back to sitting in classes bored out of his fucking mind. He needed to act on this burning new imperative: To make music.

The greatest lesson in life is to know that even fools are right sometimes.
Winston Churchill

1966

This was the year the Black Panthers were established, The Beach Boys released *Pet Sounds* and the first episode of a new television programme called *Star Trek* aired. It was also the year of mass draft protests across the USA, as Vietnam was really starting to kick off by now. One James Osterberg was especially disgusted by the war fever he saw going on around him and was even more appalled to discover he'd been drafted: "I couldn't stand the idea of being a pawn of this sick society of America." Iggy turned up at Fort Wayne dressed especially straight with his secret plan being to "queer out." When they asked him to strip for the medical he stroked up a boner and pretended to be a raging homo, which so appalled the square-jawed captain that they asked him to leave. Scott Asheton went one better when it was his turn: He had been awake for the previous forty-eight hours, drunk and crazy throughout. He turned up with a lightning bolt painted on his face with lipstick, dumped a beer can at the front gate and they hauled him straight into detention. Just over an hour later he was back on the street.

By flashing his cock before the officers at Fort Wayne, the young Jim learnt an important lesson, which he later incorporated to great effect in his stage act: The ability to shock people into paying attention and forcing them to reassess some of their comfortable assumptions about the world. Besides, he couldn't be wasting his time killing gooks, he was far too busy playing in the local gig scene as drummer for a band called The Iguanas, through which he got his now legendary moniker 'Iggy' (he copped the surname 'Pop' in a warped homage to a local junkie, Jim Popp, who had a nervous condition that caused him to lose all his body hair. The first time the band saw Iggy shave his eyebrows off the 'Pop' name stuck).

The Iguanas had formed in high school in 1962-3 and went "Pro" in 1965, eventually playing support gigs for The Shangri-La's and The Four Tops. Iggy had sung on a couple of their songs and built a small teeny following that he believed would be enough to support his bid for solo stardom. He quit the band in 1966 and released a self-produced single, a cover of Bo Diddley's Mona in August of that year. The fact that you never even knew that and have never heard it tells you how successful it was.

After The Iguanas fizzled, Ig joined The Prime Movers, a member of whom was Scott Asheton (a.k.a. 'Rock Action'). Scott allegedly taught himself to play drums on an actual drum-kit whilst still at school but Iggy tells a better story of what really happened: "Using 55-gallon oil cans, which I got from a junkyard and rigged up as bass drums, I homemade a drum set. For drumsticks, I designed these semi-plastic moulded hammers. Scotty beat the shit out of those cans. It sounded like an earthquake — thunderous." They lit these drums with a black light and scrawled obscenities like "Tits" and "Pussy" across them. On the front of the drums were written Indian symbols, totally right-on and far-out shit like "Love" and "Regeneration." Then they would just crank it up and *go*.

Scott, his brother Ron, Dave Alexander and Bill Cheatham had a high school band called The Dirty

Shames, "Where basically we just got together, chain-smoked cigarettes, drank a lot of Coca-Cola and played along with records." They tried to pick out obscure B-sides to master and "claim as their own" but, by their own admission they were crap and more concerned with the look — Brian Jones haircuts, cool boots — than actually playing. They hung around outside Discount Records, the shop where Iggy worked from time to time, and got local praise but it was more a joke than a statement of fact. No one had heard them play. They just stood outside the shop spitting on cars and affecting some skewed stance of 'Cool'. The guys who had formed The Dirty Shames were your archetypal teenage delinquents. They were ugly, pasty, white, underfed trash with no future and no hope.

Described by even themselves as "stone punks" and by Iggy as "the laziest, delinquent sort of pig slobs ever born," they were the unpopular guys, the 'different' guys — with no friends and certainly no girlfriends — who would regularly get beer cans thrown at them by the frat twats and the jocks (so, in some way, The Stooges' five year sonic assault was their 'Columbine', their revenge).

They bonded through a shared sense of diminished potential and skulked around the hallways at school looking sullen and pissed off. Ron took his anti-social stance all the way by dabbling in Nazi imagery, wearing SS badges and taking German classes so he could recite Hitler speeches. It was just totally unfocussed teenage rebellion to piss off the squares that would have landed them in jail had they not had the shared love of music to give them something, anything beyond the total zero of their futures to focus their energy on. Unsurprisingly their clothes, their hair and their attitude eventually got them thrown out of school. Like, who gives a fuck?

Ed Sanders made the point that within the 'counter-culture' of that time there was a schism between those who had families to fall back on when the Summer of Love turned to shit (as it inevitably did) and those who had to live by their wits because there was no safe family refuge to run back to. These dispossessed were trapped by the poverty of their circumstances and felt entirely removed from what the popular media championed as 'flower power'. They were the flowers in the dustbin or, as Sanders described them, "Lumpen hippies, hostile street people — the precursors of what became known as 'punk'".

Later Ron played in The Chosen Few, the most popular band in town. They played covers of the Stones, Beatles, Pretty Things, Yardbirds, all the popular stuff of that time, but eventually reality intruded, and it was time for them to go on to college.

But not Scott and Ron.

The lads had known Jim/Iggy from high school, having seen The Iguanas play in the eleventh grade. They went from nodding acquaintance in the hallway at college to actually hanging out together. Iggy had been a real square in school, with a straight haircut, cashmere sweaters, chinos and penny loafers, and The Iguanas had been a straight kind of band that would get invited to play at schools and 'proper' venues.

But despite his straight look Iggy had more in common with Ron and Scott and was entirely impressed by their stance outside Discount Records. He started to hang out with them and come over to their house where Iggy would be doted on by Ron's mother and fed to bursting point. After his solo single effort Iggy was at a loose end and ended up drumming for another local band — The Prime Movers — a band that played the same circuit as the MC5. The Motor City 5 was a shit hot act who played tight but brought an energy and excitement with them. And they played loud. The amps went up to ten and they let it rip. They were popular and they got the chicks: One of 'em being Kathy Asheton, the younger sister of Ron and Scott. She brought Fred 'Sonic' Smith home one night, much to her mother's horror, and when Ron came steaming out to deal with this punk violating his sister he clocked for this long haired freak: Just like himself. They got on fine.

Iggy had always nurtured the dream of being a for-real, honest to God blues drummer and fucked off to Chicago on the advice of a guitarist in The Paul Butterfield Blues Band who had told him that if he really wanted to make it, he was going to have to go to "the Home of the Blues". So he hitched a ride to Chicago and washed up in the black part of town, standing out like shit in an ice-cream factory. He hung with black musicians and learnt an important lesson: Whilst these guys were naturals and play-

ing from the heart, the white boys that slavishly emulated their blues sound were having to try so hard for 'authenticity' that they were draining all the soul and all the balls from the music.

Iggy realised he was an artist because he wanted to detail his own experience with his own music. It was a turning point for him, emphasised by his first dabblings with marijuana, which seriously helped in loosening up his thinking and sent him down the long rocky road to self-destruction.

He had to get back to Detroit to take his new ideas further and he needed other musicians to help him. He called Ron Asheton to give him a lift back from Chicago and while he was on the phone said, "Hey, let's start a band." So they did.

If you can't convince them, confuse them.
Harry S. Truman

1967 The year of the first ever Superbowl, the first ever heart transplant and the first Jimi Hendrix album, *Are You Experienced?* Che Guevara died, John Coltrane died and three US astronauts were killed during a simulated launch. And The Beatles gave us *Sgt Pepper's Lonely Hearts Club Band*. Meanwhile, somewhere in Michigan, four young men were about set out on a fantastical and terrifying journey of discovery.

According to Iggy, "We formed a band and did nothing but talk bullshit for months and months. I actually provoked the fellows into practicing by, mainly, scoring a quantity of grass or hash. We were young and just getting into smoking, you know, we loved it." The Psychedelic Stooges were born, the name coming to them after a night spent dropping acid and watching re-runs of The Three Stooges on TV. They sounded, according to Iggy himself, as "A cross between ELP and ELO!" After playing contemporary songs in their various prior bands the desire was to do something completely different, to just evolve new ideas about what sounds it was appropriate for a band to make. A major inspiration was seeing The Doors play for the first time in Detroit. Iggy was the only one to get in where he was treated to the spectacle of a pissed-up Lizard King looking some fallen Hollywood drag queen, deliberately fucking up the songs by singing falsetto purely to

antagonise the meat-heads and the frat boys in the crowd who had come to be entertained. This was not entertainment, this was contempt. Morrison might as well have come out and asked them to blow him, they were that steamed. To Iggy this was a revelation: "That's when I thought, look how awful they are, and they've got the number one single in the country! If this guy can do it, I can do it. And I gotta do it now. I can't wait any longer."

They got a band house where they all lived, christened the 'Fun House'. Here's where they listened to insane amounts of music and talked about their dreams and their hopes for the band. Their tastes were varied, everything from Ravi Shankar to Harry Partch to Buddhist temple music and even Gregorian chants (Iggy's favourite). They experimented with instruments, everything from Farfisa organs to timbales and went even further by inventing their own: Strapping contact mikes to blenders, washboards (upon which Iggy danced wearing golf shoes) and even crashing old amps with the reverb cranked full-on to make a noise "like a thunderstorm". Though they lived together in the same house they often rehearsed in the basement of Ron or Dave's parents. Returning home from a day spent with the nose to the wheel, mom would find Apocalypse raging under the house:

> We were making sounds that to them, they would have called the mental institution to pick us up or something. My mother would come home and we'd just be blasting. She's had a stressful day at the office and she comes home to WRRRRANGG, BEEEEP, ZZZZZZZZ. I could tell she was looking like "Is there something wrong with your equipment?" We'd say "Yeah, wasn't that cool!"

It evolved from there, like a fungus growing in the dank, dark confines of a cellar. Dave took to the bass, Ron applied his years of guitar lessons to the lead, Iggy concentrated on singing and they set about evolving their own sound in a totally organic and almost instinctual form. "We would play for about ten minutes," says Iggy. "Then everybody would have to get really stoned again. The entire band, after ten minutes, would be blown. But what we had put into that ten minutes was so bold and so very savage, the

earth shook, then cracked and swallowed all misery whole." Or, as Ron Asheton explains:

It was high-energy blast. It would start out with, say, the riff from Little Doll but even faster. Big slashing power chords, and then it would just erupt into total, John Coltrane chaos, where saxophone was screaming, but just imagine everyone's screaming. My brother's doing this poor Elvin Jones imitation. I got way into feedback and I'd go back there and just try to yank these sounds out of the guitar, while Dave'd be holding down some kind of riff and it'd just go. That's how some of our sets were just eighteen minutes, because we'd start off with this riff and I'm goin', "Okay, we've gotta hold it down long enough so Iggy can start doin' his little antics," y'know…let him work the crowd. We'd let him go out and do his thing. And the show would just sorta build. As he got a little more frantic, the music got a little more frantic. Or if we got a little more frantic, he got a little more frantic, and then it would wind up just total power and chaos.

They wanted to be totally original. They didn't know how to 'play' in the conventional sense and that was the beauty of it. With no template to follow they were utterly free to go in whatever direction they chose. Like eager chemistry pupils they went full steam ahead into alchemy, heaping ingredients into the pot — some Hendrix, Mothers of Invention, Harry Partch, Pharaoh Sanders — and applied the heat of their own madness and ineptitude, to create something no one had ever heard before.

Their first gig was on Halloween Night 1967 at the Grande Ballroom in Detroit. The guys drove to the venue and picked Iggy up along the way. His stage outfit for the night was an old ankle-length nightshirt, a face painted white and an Afro wig made from aluminium foil.

It was not going to be a normal evening.

They smoked joints to calm their nerves but a bunch of shit-heads tried running them off the road so by the time they go to the venue they were hyped to the hilt when they took to the stage. They used all the instruments they had made themselves — even finding a use for Ron's mom's vacuum cleaner — and proceeded to blow the minds of everyone who was there. John Sinclair, manager of the MC5, stood watching the entire show with his mouth hanging open. Afterwards he said, "It was just so fucking real it was unbelievable. Iggy was like nothing you ever saw… It wasn't rock'n'roll."

Or, as Scott Asheton put it: "That was the master plan — knock down the walls and blow people's shit away. All we wanted to do was make it different."

I mean, it's real hard to be free when you are bought and sold in the marketplace.
Easy Rider

1968 The year of the tet offensive, the election of Richard Milhous Nixon and the release of *Electric Ladyland*. Martin Luther King Jr. was assassinated, Robert F. Kennedy was assassinated and The Beatles went to seek "absolute bliss consciousness" with the Maharishi Mahesh Yogi in India.

The Stooges, still firmly rooted in Michigan, began playing the circuit but never the teen clubs, 'cos the teen clubs wouldn't have 'em. They became regulars at the Grande Ballroom in Detroit but still supported acts like Ten Years After and local heroes the MC5, who inspired them away from the free-jazz skronk-a-thons towards something approaching 'songs'. The MC5 also got them turned on to the big guitar sound, achieved by cranking the Marshall stacks up to ten. Post-Donnington generations might think "big deal" but back then this was unheard of. It was just too loud.

They worked hard at their sound and overcame their initial inabilities through sheer perseverance though the majority of bands, audiences and rock 'critics' thought they were a joke. "A Clown band. A Novelty act." Just Iggy doing his spastic freak thing at the front and a bunch of cavemen fumbling with instruments behind him. But even though they had progressed enormously from their early days where they played perfect and hilarious pastiches of Ted Nugent and Bob Seger and other 'traditional' rock acts, which some still saw as nothing more than a convenient way to hide their own ineptitude, once they had to deliver their own music without a screen

of irony to hide behind they came up against it. Dennis Thompson, drummer for the MC5, thought they were shit and couldn't understand why a class act that was going places like the MC5 were taking these no-hopers under their wing. But the MC5's manager John Sinclair could sense the real potential they had: "They were taking this sterile European avant-garde stuff and translating it into something kids could listen to. It was electric." The Psychedelic Stooges were 'free-form', playing repetitive riffs and rhythms. Ron used the influence of Townshend and Hendrix, mixed with his own jazz tastes, to create simple, powerful structures that the band could build upon, leaving Iggy free to howl around them like a hurricane, gathering momentum all the time. The sound they made was so unexpected and so unpredictable that it could have hardly have been something the kids were going to abandon The Monkees for. So, of course, they got the freaks, the weirdos, the whole urban detritus stumbling shell-shocked through another day in Paradise. "When we started out our fans were just a MESS," says Iggy. "It was like early Christianity. It was the ugliest chicks and the most illiterate guys — people with skin problems, people with sexual problems, weight problems, employment problems, mental problems, you name it, they were a mess." As an audience, The Stooges got what they deserved. They sang about the half-life that slithered in the glow of late-nite diners and broke windows in abandoned factories and crawled under hedges to catch a glimpse of the young mom next door getting out of the bath. Their sound, their look, their smell was only going to be palatable to those like them. Lost in a future of no hope these beasts of the same fang huddled together in the corner, hoping for oblivion or a change of channel, whatever came first.

To me, the nut of the thing is that is what you make is hard like a diamond you can put it anywhere. You can put it up your ass and it will still be beautiful. *Iggy Pop*

1969
The year of woodstock and the moon landings, the arrest of Charles Manson and his 'Family' and the first airing of *Sesame Street*. The decade was stumbling to a dark and un-

pleasant finale, while the seventies loomed ahead, of which no one could know what to expect, least of all one Danny Fields, who was employed by the Elektra record label as an A. & R. man. The Elektra management were all old squares who thought Dean Martin was still the cutting edge and simply could not get their heads around what kids wanted in these brave new times so they had Danny as a 'company freak' to vouch for what was saleable to the ever-gullible teen audience and the newly-emergent demographic of the *Rolling Stone* reader: A crowd of older music fans whose balls had dropped when The Beatles first hit and now wanted more. He had the hair, the bell-bottoms, the drugs and the connections in all the major cities to get him into the venues and the parties where the new scene was emerging and the key players of the time would make their presence felt. He was in with the LA scene, he was in with Warhol's Factory freaks in New York and he was in Detroit to sign the MC5. Wayne Kramer introduced him to The Stooges. Danny Fields:

I went to see The Stooges play at the student union on the campus of the University of Michigan. It was September 22, 1968. I can't minimize what I saw on stage. I never saw anyone dance or move like Iggy. I'd never seen such high atomic energy coming from one person. It was the music I'd been waiting to hear all my life.

He signed them right there and then, for $5,000, hooking the higher profile MC5 as well for $20,000, figures that made the managers nearly shit themselves when they heard. That's how hot Elektra were to cash in on what they'd got from The Doors and they trusted Fields to deliver. He saw the potential festering behind the feedback and the lunacy and convinced the stiffs at Elektra to put a commitment down. It was only when they came to record the first album that they had to actually start putting a structure to some of the riffs and scraps of lyrics they had. Elektra brought them to New York and set them up in that citadel of scum, the Chelsea Hotel. Iggy and Ron had been to New York before, when Iggy took STP for the first time.

"He didn't know it was a three day trip," says Ron. "So guess who got to watch him? Me. I tied a

rope around his waist and led him around town. Iggy kept saying, 'Wow, I can see right through the buildings, man.'"

When they went in to record the first album only Iggy had been in a studio before, when The Iguanas cut some forty-fives in their very early days. John Cale was brought in as producer, his first time in the role, and immediately commented on the lack of actual songs after listening to an initial mix. No problem. Ron went off to a hotel room and in an hour he had more, with Iggy dashing in and out to add lyrics. After one rehearsal they slammed all three songs down in one take! The whole album itself took four days to complete, a speed of process based on budget constraints and the sheer eagerness of the band to get it done and get it out there. The one track that still triggers fevered debate amongst Stoogers is the ten minute We Will Fall. It's always been alleged that it was hurriedly cobbled together and bunged in to pad out the rest of the material to a justifiable album's length. The song itself was triggered by a chant Dave Alexander had come up with, along the lines of "You'll get high, man..." around which they built the entire piece.

As Ron admits, "I guess we did get high even though we smoked a *bunch* of hash while we were doing it!" They had candles going and incense, the whole deal, and got so into it that Cale and the engineer had to actually stop them as they were all so locked into the chant, "OOOOOHHmmm, *ja ja, ja ja.*"

One look at the cover tells you all you need to know about what Elektra had in mind for The Stooges: A lucrative cash-in on the success of The Doors' first album. The similarities between the photomontages and the rounded text cannot be ignored. But such blatant tactics were doomed from the start, because not only did The Stooges have an altogether harsher agenda — and a distinct lack of poetic pretension in their lyrics — but their front man, for all his deranged appeal, was somewhat lacking in the smouldering looks department.

The Doors had a Heathcliff/Byron figure, wrapped in leather and mystery, while The Stooges had a sickly lunatic who looked like he'd been raised by junkyard dogs. But at least The Stooges were honest. Iggy was mad and unpredictable and clearly unhinged, but this wasn't just a stage act: this was

every minute of his waking life. Morrison was a vain pisshead who tried to play with the Dionysian myth, only to end up with his dick caught in his zip and his gut hung over his belt. He died young, fulfilling the yearning for a new Jesus in the collective unconscious of moody teenagers everywhere, and his fairly ordinary backing band entered the popular mythology.

And then Iggy went and got married. Dave Alexander bought new tennis shoes for the special occasion and said, "I bet these tennis shoes last longer than Iggy's marriage." An uncannily accurate prediction from one so persistently pissed, as it turned out.

Danny Fields wasn't impressed with Iggy's matrimonial intentions. "Iggy, what are you doing? Think about your image!"

The bride-to-be, one Wendy Weisberg, was a "tomboy Jewish girl with Indian blood from her mother's side" that Iggy had met at college where he attended for just one semester. He wooed her over hamburgers and they were wed on the front lawn outside the Fun House. The best man was Ron Asheton, dressed in full SS Colonel's uniform, and Jimmy Silver was the minister, having been ordained as such by the Universal Life Church after paying his regulation twelve dollar fee.

Ron Asheton ran a Sears and Roebuck flag up the pole outside the house. The cops came by to respectfully remind them that only an American flag could be flown. So Ron took it down and put a Swiss flag in its place. The cops didn't like that either. So Ron decided that if he was going to get busted he might as well get busted for something, so he ran up the Nazi swastika.

The marriage as predicted went to shit quickly. Wendy confessed to having a dream about the ruggedly handsome Scott Asheton, which freaked The Ig out immensely. Then she started slagging off the band and told him not to smoke pot. "I couldn't believe my ears," said Iggy. "That this fucking nobody, this underachiever, could so grossly overlook the limitations of her role."

So she was told to get out, and left after only a month. The divorce papers came through and were hung on the wall at the Fun House. They stated that the marriage had never been fully consummated and that Iggy was a homosexual. Iggy didn't care.

He was free to cruise the kids' hangouts and get material for his songs. And pick up teenage girls. One girl that really caught his eye was Betsy, but even Ron was disgusted by this new low in debauchery. "'Goddamn it Iggy,' I said. 'She's been here for two fucking days and she's only fourteen years old.' But then Iggy introduced me to Danielle, who was Betsy's best friend. And I'm going 'What am I doing, man? I'm fucking a fourteen year old girl!'"

There were always women around at the Fun House now that the band's star was in the ascendant. Scott Asheton got a startling insight into the power a 'star' has over his audience. "It would blow my mind how Iggy could get the girls to just flock around him. You know, they'd sit and watch him eat boogers." One time he saw Iggy, surrounded by a gang of doe-eyed, adoring groupies, sneeze real chunks into his hands and then scoop the load into his mouth. The girls still loved him. Maybe it was the drugs? "Iggy would give girls acid for the first time," says Ron. "One of the girls that flipped out disappeared. She had been totally straight and she came back a month later, wearing suede hip huggers with a halter-top, and carrying tons of hash, man. I got fucked up with her and she said, 'I wanted to thank you guys for turning me on.'"

The Stooges reached number 106 in the US charts and the band set out across America to tour. And tour. And tour. Until the fucking wheels fell off. They played the New York State Pavilion with the MC5 where promoter Howard Stein claimed The Stooges gave his wife a miscarriage.

Whilst in New York recording the first album, Iggy met Nico. They'd been introduced to Warhol's Factory crowd and made a suitably harsh Detroit assessment. Nico, meanwhile, thought Iggy was The Shit. As Danny Fields put it: "Nico fell in love with everyone who was extremely brilliant, insane or a junkie." Iggy, therefore, was perfect for her. She came back to the Fun House and stayed for three months, during which time she would cook curry for the lads, introduced them to fine wine and taught Iggy how to eat pussy. Being an innocent country boy this was all new to him and he took to it like a duck to water, locking Nico in his attic room to keep her all for himself. Only after she was gone did Iggy take Ron aside to ask him something of a personal nature. Ron took one look at the oozing goo dripping from the end of Ig's cock and confirmed that the boy had copped for his first dose of clap.

Meanwhile the sixties were fizzling out under a black cloud. Vietnam was escalating beyond everyone's expectations, Manson and his Scooby Gang were at large in Death Valley, Jimi Hendrix, Janis Joplin and Jim Morrison were stumbling towards the grave of cheap legends and Christmas box set cash-ins, Altamont ended in bloodshed, students were dead at the hands of their own National Guard, the President was a bastard and freaks were all over the streets coming down hard. Talk about bad vibes. With the benefit of hindsight it's clear that whatever sort of a decade the seventies were going to be, this was for sure: It was going to be fucking awful.

We are sixty days from the end of this decade, and there's gonna be a lotta refugees. We're about to witness the world's biggest hangover. *Danny, Withnail & I*

1970 A new decade dawned across the land of the free. In its first year we had the launch of Apollo thirteen, The Who performing *Tommy* at New York's Metropolitan Opera House and City Lights bookstore in San Francisco busted for selling *Zap Comix*. Paul McCartney left The Beatles, while down in Mississippi *Sesame Street* was taken off-air because of its "multi-racial themes". Manson's *LIE* album was released, Alvin Toffler's *Future Shock* was published and US air forces began their first bombing raids in Cambodia.

And, perhaps most ominously, Dr. Robert Moog unveiled his wonderful invention, the Moog Synthesizer. Things would never be the same again.

Acid was replaced by downers, heroin flooded in from the Golden Triangle and The Stooges were caught in the whirlpool, about to be sucked down into the hole.

But not before they came screeching off the road for two weeks in Los Angeles to record the album of their lives and the definitive document of what it was like to be trapped between those two decades with no obvious way out.

For the best part of two years the band had been on the road almost constantly. Ron: "During the short span of time between the first and second

record we progressed amazingly. That comes from just... Sheer playing all the time. When you're young and you're hungry that's what you do and you love doing it."

By the time they were ready to record *Funhouse* Elektra saw real dollar potential in the band and brought in Don Gallucci to produce. The engineer was Ross Meyer, who had just finished working on Barbara Streisand's album. Yes, from Streisand to The Stooges: Exact opposites with galaxies in-between! Meyer's mind must have been reeling from the shock, but he rose to the occasion.

Whilst touring, The Stooges had really tightened up their shit and confidence was high. They still had the orgone energy they been summoning up in their parents' basements and now they could deliver it with a raw competence that was still a whole butcher's block removed from the cloying and slick 'musicianship' that would dominate the seventies, particularly in America. Gallucci and Meyer worked well together and knew exactly what they wanted from the sessions. The idea was to basically have them do their stage show straight to tape, and when you listen to the full *Funhouse Sessions* you can hear exactly what it is they were trying to capture, nothing less than lightning in a bottle.

During their time in LA the band were based in the Tropicana Motel on Santa Monica Boulevard, Ground-fucking-Zero for all the scuzz action the City of Angels had to offer. Band manager Jimmy Silver, the lads and Steve Mackay, their sax player, shared sleazetastic six-dollar rooms, surrounded by prostitutes, pushers, street freaks and, just down the corridor, Ed Sanders of The Fugs who was hammering out his definitive book on Manson, *The Family*. Sanders was totally freaked out from all the research he was doing and placed sinister significance on the red dog-collar that Iggy had started wearing. Warhol, Paul Morrissey and the whole Factory freak show were staying there too. How could it have not got weird?

After busting their asses on day-long sessions with Gallucci, the band would loosen up on Sunset Strip where they got tattooed, helped Jim Morrison get so wrecked that he'd piss himself at the bar or cruise for porn strumpets.

This was the worst possible environment they could have been in, as the thin veneer of squalid but essentially harmless decadence gave way to more dangerous and damaging practices. Jimmy Silver gradually faded from the scene (to concentrate on flogging his macrobiotic food mail order business), to be replaced by the road manager John Adams. A strict non-smoker, non-drinker, Adams was the son of a wealthy family who lived on a severe macrobiotic diet. But he was also a former hardcore smack-head who was drawn to the Sunset Strip scum bucket like a moth to the flame. He introduced the band to the coke and then inevitably, heroin. Up to that point the band had been habitual dope smokers and beer drinkers, with a little acid on the side when the mood took them. Adams convinced them that the highs they'd had so far had been lame in comparison to what heroin had to offer. As Scott Asheton recalls: "It was the beginning of the end."

In the past much has been made of James Williamson's negative influence on the band, but it was really Adams who proved to be the catalyst for destruction. Williamson had hovered on the fringes of the band, having been in The Chosen Few at around the time Ron was involved with them, and he was always seen as a shady character. Ron had bumped into him at the notorious Chelsea Hotel where the band holed during the recording of the first album and his Spidey-sense started twitching even then. Once the heroin was around, so was Williamson, a man prone to addiction and excess. Kathy Asheton tells of one time when she went over to the Fun House and found that some guy had broken in and was just hanging around waiting for the band to come home. "In retrospect, " she says, "he was like a black cloud descending."

Ron Asheton was the only band member to stay clean, and took on the role of janitor, scouring the Fun House after everyone had passed out to make sure there weren't any lit cigarette butts igniting mattresses. Ron had a girlfriend in the house too, which further ostracised him. "I was no longer part of the band, it was like 'Yeah, he's with her, man, he's not with us,' and I'm like 'Yeah, right, assholes, I wanna be filthy and covered with impetigo and having to spend two hundred dollars a day... Yeah, you guys are really cool.'"

After the *Funhouse* sessions, in the early days of the smack, the band were on a high and went back to Ann Arbor, to the Fun House, brimming with

confidence and basking in their new found status as the coolest band in town, now that the MC5 were into their rapid decline. The legendary Fun House (a.k.a. Stooge Hall) was a decrepit farmhouse on the outskirts of Ann Arbor. Other musicians, other bands, who thought the band were shit and just could not understand the fuss surrounding them were even more appalled to see how many women came flocking. Whilst the MC5 were now drawing the munters and street hogs, the dark and dangerous mystique of Ron (who'd already taken to sporting one of his sixteen Nazi uniforms on a nightly basis) and the feral ferocity and bare-chested sex appeal of Iggy, brought the lookers and the mystery girls in droves. The band took this as a sure sign that they had Made It.

But the peal had been reached too quickly and typically the fall was sudden and grimly spectacular.

Funhouse was released in July 1970. It received zero airplay from radio stations obsessed with the likes of *Bridge Over Troubled Water*. There was no way something as raw and uncompromising as *Funhouse* was going to get a look-in.

Disillusioned by the general dismissal of what the band knew in their hearts was a great record, they fell further into junkie oblivion. Jimmy Silver had been a powerful restraining influence on the band, but with Adams now basically rolling out lines of H for the guys to snort, it was all over.

Steve Mackay, the unofficial fifth member of The Stooges, was sacked in October of that year, at which point he was on the downhill slide into total addiction. The timing of this move may well have saved his life: A fact missed by Nick Kent who went on to report that Mackay and others were terminal victims of the band's capitulation to smack. Away from the terrible vortex of the Fun House, Mackay managed to kick his habit and get his shit back on track. Others were not so fortunate. Zeke Zettner, who replaced Dave Alexander, died in 1975. Alexander himself, a man described by Iggy as being "too drunk to live" copped for it in 1975, pneumonia beating his booze-blasted body into an early grave.

Ron watched it all happen before him, like a slow-motion car crash. He was disgusted by Iggy's addiction and saw it wholly symbolic of the pathetic weakness that festered at the core of the man. Iggy thought Ron was jealous because he was getting top billing over the other Stooges and considered himself the major creative force and motivator for the band. He dismissed Ron as a slacker who did nothing but smoke dope and watch TV and didn't want to grow as an artist, but Ron was appalled and helpless to intervene as the band disintegrated: failing to turn up for rehearsal, taking smack as pay-off for gigs and even selling their gear to buy more 'gear'. As Ron describes it: "I saw my whole world crumble. Friendships, the music. I'd wake up and 'Oh, I think I'll go down and play the piano today.' The little Farfisa. 'Hello?' It's gone. Iggy traded it for a spoon of dope. Iggy would just take equipment and sell it for drugs. It was just terrible man."

As a result of this collapse into addiction the band had quickly fallen from grace and were now regarded as a joke by their own audience, a spectacle of ruin onto which they could project their own feelings of inadequacy and self-loathing. Because no matter how shit their lives were, here was someone clearly far worse off than they were, and he was meant to be a 'rock star'! How fucked up is that? They knew Iggy was a hopeless junkie and would turn up just to see his latest state of degradation — throwing up on himself, falling over the drum kit, falling into the crowd — too numb to feel anything and too far gone to care.

By now the Dracula-like presence of James Williamson was a firm feature of the band. He'd previously played alongside Ron in The Chosen Few and now here he was again, this time on second guitar. Ron had told the band he wanted to fatten up the sound. "It was a stupid move," he says now. "I wish I would have never done it. He was supposed to be a helper for me but he totally usurped my position and eventually kicked me out from playing guitar."

The band moved out of the Fun House and into the University Towers, a high-rise in the centre of Ann Arbor, mainly to be near the dealers. Except Ron. Ron stayed on until the bitter end, when the place was finally condemned to make way for the construction of the Eisenhower Parkway — its destruction pathetically symbolic of all that was lost after the glory days of the *Funhouse* sessions.

But Iggy, Scott and James were oblivious, sky-high in junkie heaven. "Me and James had a room on the seventh floor, and Iggy had the top floor and

that was cool," says Scott. "We had a great time. We had two maids that came in once a week, both of them foxes, to clean the apartments and we had great wild sex with them. It was happening man, we were on top of the world."

He who makes a beast of himself gets rid of the pain of being a man. *Dr Johnson*

1971 It was the same year that manson and his Family went down, the My Lai trial found a US army lieutenant guilty of massacre, the Attica prison riots and the arrest of American Indians after their eighteen-month occupation of Alcatraz. In the same year Jim Morrison, Louis Armstrong and King Curtis died, *Led Zeppelin IV* was released and Disneyworld opened in Florida. And while war protestors took to the streets of the nation's capital, Peter Cetera of the group Chicago got beat up at a baseball game, when thugs objected to the length of his hair.

America was left reeling after the fallout from the dreams and disasters of the previous decade.

The Stooges themselves had been left reeling. The "commercial impracticalities" of the *Funhouse* album made it impossible to promote or get airplay for. 1969 was the year they'd said was "Another year for me and you/Another year with nothing to do." But now here they were, stranded on an island of their own making, with seemingly no other direction to turn but inwards. Without distractions, without direction, the drugs became everything.

There were rumours that they had taken to holding up gas stations on a weekend to raise cash for the rent owed on The Fun House itself.

Then Scott ended up owing money to some biker gang, who came to collect and found Stooge Hall turned into a siege, with boarded up windows and the men inside armed to the teeth with shotguns, pistols, rifles, the lot.

Then Scott went and crashed a van into the Washington Street Bridge whilst on Reds, putting himself in hospital under the gaze of the local fuzz. The impact point on the bridge is still visible to this day.

Then the IRS finally came knocking, asking about monies owed in back taxes. Fortunately it was Ron who took the call and deftly deflected them by saying: "Hey look man, we're all drug addicts, we don't know where the fuck the money is." The IRS never bothered them again after that.

These horror stories and more besides made their way back to Elektra boss Jac Holtzman who promptly despatched VP and art director Don Gallucci to Ann Arbor to find out what the fuck was going on. There were rumours of gigs missed, sackings from agencies and trouble with the law — in particular a certain incident in St Louis where an underage girl was found in Iggy's bedroom — and the terrible reality of the situation came crashing home when Gallucci was finally confronted with Ron's bedroom. The man may have been the only band member not on smack but all that Nazi paraphernalia and those Gestapo outfits in his closet did him no favours and after finally meeting the 'legendary' Iggy at the rehearsal room — an absolute ruin of a specimen, crawling with lice and various unsavoury infections — the Elektra guys didn't hang around to hear them play.

Four weeks later, they disbanded. Their 'last' gig was a farce from start to finish. Of the intended line-up only Ron and Scott bothered to turn up. In Iggy's place they found the willing intervention of a fan called Steve Richards who provided an impromptu precursor for Stars In Their Eyes, Junk In Their Veins. Iggy, in the meantime, had 'retired' to Florida where he worked cutting lawns and allegedly sharpening up his golf stroke. It seemed like it was all over.

There's a problem with opening your act to the gutter. I mean, it's like dabbling in Satanism... I mean, I'm not a religious person, but you open up that crack, it can get you. So you have to be careful. *Ed Sanders*

1972 Strange days indeed... J. Edgar Hoover finally died, *Superfly* opened in cinemas, and five shady characters were arresting during a break-in at the Watergate Hotel. In San Antonio the Mayor declared August 11 to be Cheech and Chong Day, while in LA DJ Robert W Morgan played Donny Osmond's Puppy Love non-stop for ninety minutes until cops — called in by irate listen-

ers — raided the station. And on August 12 the last US ground forces were withdrawn from Vietnam.

As for The Stooges, they had lost the battle and the war. They retreated back to their family homes, shell-shocked and damaged on every level: Physical, emotional and spiritual. In the vacuum of any guiding force the remnants of the band were wide open to controlling influences from any quarter... Which is where Bowie comes in.

As Ron tells it: "Around early '72, the band was totally broken up, scattered into the wind. Iggy had gotten big time into junk and did his drug thing. I mean, he's no dummy. He acts like a dummy but he's no stupid person. So he got his shit together and went to New York. He said 'I'm gonna get myself something.' It worked out that Bowie was there. He was a fan, he liked The Stooges, the management was there. He got the deal." Iggy met David Bowie at Max's Kansas City in New York and, like some glam Fagin, Bowie took Iggy on as his own little Artful Dodger to shape and to mould and, being the magpie that he was, to shamelessly rip-off (otherwise, where do you think *Aladdin Sane* came from?) Bowie started a damage limitation exercise and in the hunt for a scapegoat, Williamson was sacked. Bowie was eager to tap into what Iggy represented — an unmistakable dose of rock'n'roll reality that he actually lived twenty-four-seven — and which Bowie, being a soft-arsed art student from London, could only ever hope to emulate in a pantomime fashion. Iggy was born into it; Bowie had to buy it.

Bowie introduced Iggy to his manager, Tony Defries. Defries went to CBS and got Iggy a $100,000 record deal. That's how much it cost Bowie for his dose of reality.

He had no idea what he was really buying.

Iggy found Williamson working in a porn theatre in Hollywood and persuaded him to re-join a new Stooges line-up where he would be the lead guitarist. "James was a super-thug," says Iggy. "I heard him play and he had all the attack that Ron lacked but, more than that, I could hear ambition in his playing, and that's what I knew I needed to carry on."

At around the same time, Iggy, Williamson and Ron Asheton were at a party in Detroit.

Iggy suddenly said to Ron: "Oh yeah, by the way, I signed a deal. James and I are going to England." Ron went outside, burst into tears and then walked home fifteen miles in complete shock. He couldn't believe the callously casual nature of dismissal at the hands of Pontius Iggy, who had decided he was moving on up and wasn't going to need his old cronies holding him back from the glory and stardom that surely awaited him. Even if it was case of drugs and ego talking it was a devastating blow to Ron, who figured that for all their troubles the gang was still going to roll on as they always had. Ron and Scott were dumped like a pair of old boots while Iggy and Williamson stomped off to London with their new mates, off for a taste of the high life that they had worked so hard for.

Iggy and Williamson had been in London a while trying to figure their next move, and the only people they were being introduced to were from the English rock scene that may have spawned Bowie but was still rolling around in the lumpen sludge that had oozed out of the cracks formed when the sixties fell to bits. You can just picture those furry hippies and Clapton wannabes coughing up chunks of bong-fuzzed blues and piss-poor Hendrix riffs, totally at odds with what Iggy wanted. Nobody could play at the level required, so Williamson suggested that they already knew two guys who really could play with the kind of physical attack they were looking for: Ron and Scott Asheton. And so the two old troopers, so coldly dumped by their former friend, were nonchalantly asked if they wanted to join The Stooges again.

Ron's initial reaction was "You Motherfucker!" But as appalled as they were at the treatment they'd received from Iggy they really had nothing else to do, and so went to London to work on the sessions for what would become *Raw Power*. The guys got the basement room in the house at Seymour Walk, but their new circumstances got off to a shaky start when Bowie came round and tried to grab Ron's straight-as-a-die ass and kiss him. Ron nearly decked him. But the band soon got it together, jamming in all-night sessions and hammering out the raw material that Iggy and Williamson had written into what became the eight songs on *Raw Power* and the later slew of shoddy cash-in releases.

They recorded *Raw Power* in sessions that ran from midnight until six a.m. It was all work and no play, very serious and business-like. The guys did not have a blast like they did in LA making

Funhouse. They had become part of the ruthless Main Man machine that wanted a solid return on its investment, so the schedule was work, work, fucking work with only Sundays off. Ron and Scott hung out together when they had time out but Williamson was off banging skanks and playing the loner.

Iggy was busy being groomed by Bowie and Defries, the latter taking him for rides in his limo and pitching film projects at him such as, if you can believe it, *Peter Pan*!

"I ain't no fuckin' Peter Pan!" said Iggy. "We're gonna do Manson! Charlie Manson! I'm gonna be Manson! I *am* Manson!"

After the album was recorded, the lads found out you could get liquid codeine over the counter in Britain. They went at like fiends: codeine, heroin, downers, coke. They wrecked the house and got kicked out. Afraid that Iggy might actually get deported for his behaviour the management quickly shipped them back to Michigan. At this time Ron was shagging Bowie's wife Angie and she came back with him to Ann Arbor.

The fucking you get isn't worth the fucking you take. *Iggy Pop*

1973 The year kiss played their first gig, Picasso died and Pink Floyd released *Dark Side Of The Moon*. *Raw Power* itself was released in May and struggled to find any appeal against a popular mood for The Eagles and 'mellow vibes', something The Stooges couldn't hope to compete with. Stadium rock was here to stay; toilet rock was waiting to be flushed away. Undaunted, the band geared up to start recording for a forth album (featuring tracks such as I Got Shit, Cock In My Pocket and Open Up And Bleed, all now part of their live set) but arguments quickly ensued between the band and the label and it was quietly shelved. But still the band played on. They didn't need to be recording anything to justify their existence. They hadn't needed contracts or shit like that when they'd been jamming in the Asheton's basement and they didn't need it now. They would just take the freak show on the road, so they did. They played anywhere, real firetraps and toilet venues. They even played Nashville, where they were

on the bill with a band put together by The Allman Brother's fucking roadies! They took one look at The Stooges in their skin-tight cut-away sleaze-glam costumes and decided they were homos. They hurled their homophobic indignation at the guys who were forced to lock themselves in a closet. After the show the roadies apologised to them as they'd just seen their stage act and didn't realise that such faggoty looking twats could rock so hard.

And I guess no history of this band would be complete without mention of the legendary incident at a show in Atlanta where the band had snarfed down handfuls of angel dust. Elton John, desperate to sign Iggy or drum up some press came onstage dressed as a gorilla and attacked Iggy from behind. Iggy was so blasted he thought it was a real gorilla and fought back. If only someone had caught that on video.

Anyway, the CBS advance was soon pissed away in a Beverley Hills hotel, where Iggy went into hiding with The Doors' former lackey Danny Sugerman (another drug fiend, see *Wonderland Avenue* if you doubt it) who had to bail him out time and again from one deranged incident after another. The drug lunatics had taken over the asylum that was the band's collective brain, the madness escalating beyond all measure and the tour just ground on and on and on... Until by Christmas of that year they found CBS would not release any more Stooges records. The band had been on the road solidly for six months, trying to repair their damaged reputation and raise some desperately needed cash. They were fucked, and they knew it, but with nothing else to do with their lives they could only go on. It was like a bad film that you couldn't turn off because the unfolding disaster was just too compellingly awful.

Without obscenity our cities are dreary places and life is dull. *Greg Araki*

1974 A hell of a year. As the war in Vietnam sputtered to a halt, Patty Hearst was kidnapped by the Symbionese Liberation army, Evel Kenievel failed to jump the Snake River Canyon; Nixon resigned and The Ramones played their debut gig at CBGB's in New York.

The Stooges, meanwhile, were dealing with conflicts of their own. The group dynamic was now

one of open hostility, both amongst themselves and towards their rapidly declining audience. While Iggy explored the fabled Road to Enlightenment — frequently stopping off along the way to visit the Toilet of Debasement — injecting, snorting and licking up practically everything he could get his hands on (and there are stories of everything from THC snorted to cobwebs smoked), Williamson treated the whole sham as a 'job', no less of a chore than his gig at the porn theatre. Ron, meanwhile, was bored and channelled all his energies into his sole aim: "Ignore everything and pork every woman I can."

Scott Thurston joined the band on keyboards, an instrument introduced during the *Raw Power* sessions and used extensively throughout their live set, which now resembled a deconstructed boogie rock. Thurston saw what The Stooges had become with a fresh pair of eyes, and received a crash course in what rock'n'roll oblivion can do to the mind and soul. It was Iggy who was now sole leader of the band and only Iggy who could bring the debacle to an end. As permanently wasted as he was he knew the stark reality of the situation and recognised that the only way to go out was just like *The Wild Bunch*, outnumbered and outgunned by an unstoppable foe. In the case of The Stooges it wasn't the Mexican Army, it was the crowd.

Much has been made of the final gig The Stooges played, particularly the story of Iggy's baiting of a notorious Michigan biker gang called The Scorpions. And depending on who you choose to believe, Iggy either sang a customised version of Louie Louie ("You can suck my ass/You biker faggot sissies") that upset the bikers somewhat, or he went out live on a radio show challenging the gang to come on down to their next gig in Detroit for a showdown. Whatever the truth may be, one thing is clear from the recording of that gig — *Metallic K.O.* — The Stooges went out fighting.

When the dust settled the band was found holed up in Hollywood, in a house off Mulholland Drive. At first the guys had a blast: naked girls in the pool, Cadillac in the driveway, maids, pot on tap, money, and the chance to take turns with the legendary groupie Sable Starr. As idyllic as their situation was, there were rumblings of something coming down from Main Man management. Tony Defries wouldn't let them play any dates because they couldn't be trusted not to create havoc and he was desperately trying to control a situation that was, by the very nature of the personalities involved, totally fucking uncontrollable. Iggy was, by now, totally losing the plot. The whole situation came to a head when Iggy stripped off at a live radio show and jacked off on air, before trying to rape a groupie in the lift. Defries went apeshit, the station nearly lost its licence and the end was in sight.

In a denial of the inevitable the band spent their final days sat around the pool, drawing on the last few drags of the soggy fag end of their prospects. Kicking back with whisky and ginger they could almost believe they still had it going on… But they were fucked and in their hearts they knew it. They had their payoff cheques sent round, along with tickets back to Detroit, courtesy of Tony Defries, and told to get the fuck out of the house. Now. Fortunately Ron had been stashing cash in his mattress for just such a rainy day — almost $5,000 — and he paid for Iggy, Scott and himself rooms at the Riviera Hotel.

Iggy hit the streets, off his tits and down on his luck. He was falling in the gutter and no one was stopping to pick him up. He wasn't a rock star, he was a joke. Even so, he still had the wits about him to sleaze his way in with Bebe Buell, Todd Rundgren's girlfriend at the time, in one of those curious seventies 'open' relationships. Was it his big puppy-dog eyes, all bloodshot and yellow? Was it his gift of the gab, sweet nothings oozing from his scab-encrusted mouth? Who can say, but while Todd was off doing his band thing, Iggy and Bebe were doing the Wild Thing.

A pussy hound and smack head he may have been but music was still the most potent drug for the man, and a powerful enough draw for him to get it together with a bunch of floater musicians and start throwing together influences from The Doors to free jazz to Hendrix and the now-stale glam rock sound: a foul mash that was intended to present to CBS at auditions. Of course, Iggy blew it and his nose-dive into the gutter was almost complete.

The now legendary picture taken at Rodney's English Discotheque in August 1974 is rock'n'roll's own take on The Crucifixion: Iggy, flat on his back with his chest horrifically gashed open, squirming like a bug under the brutal black boot-heel of Ron

The Edge... There is no honest way to explain it because the only people who really know where it is are the ones who have gone over. The others — the living — are those who pushed their control as far as they felt they could handle it, and then pulled back, or slowed down, or did whatever they had to do when it came to choose between Now and Later. *Hunter S. Thompson*

THE RECORDS

The Stooges

Asheton in full Nazi regalia, wielding a whip and looking like the absolute personification of malevolence behind his orange-tinted glasses. This is as far as 'rock' could go and despite the trends that have been and gone since and all the technological advances, the music, the fashion, the lifestyle all reached critical mass with The Stooges. The drugs, the squabbles, the damage, the waste, the bodies, the horror, the horror.

But still it wasn't over. Throughout LA stories began to circulate of a strange presence haunting the streets, an unpredictable poltergeist emerging from the shadows. Disciples saw what they wanted to see, but the truth was it was only Iggy, off his tits again. Nights found him pinballing from bar to dealer and back again. In the mornings he woke face down in the gutter or under a bush, covered in bruises and fluids with his cock hanging out, oozing green stuff. How long would this have gone on before the inevitable OD, who can say? Deep down under the psychosis was the faint glimmer of a man who knew he had more to offer. But who would save the saviour?

On the last night of his epic Vision Quest Iggy loaded up on Quaaludes and Thunderbird and set about freaking out the good folks eating in a hamburger joint. The cops were called, and came to find what might once have been a man, wearing a polka-dot mini dress and covered in generous measures of his own vomit, teetering on the brink between ennui and oblivion. He was given two choices: Lock Down or the Loony Bin.

Guess which one he went for?

[Elektra CD 7559606672] 1969 / I Wanna Be Your Dog / We Will Fall / No Fun / Real Cool Time / Ann / Not Right / Little Doll

It's too late for spiritual enlightenment. Fuck that hippie shit. *Henry Rollins*

THE SOUND of sea creatures making their first Darwinian crawl up the beachhead, a slime-encrusted coastline littered with broken bottles, spent syringes and rusty coke cans. The first glimpses of this shambling chimera had been found in The Sonics, The Troggs and the rawest, most unpalatable strain of the garage rock bands that emerged in the wake of The Beatles and the Stones, but no one had really been ready for this freak show.

That they couldn't play when they first went into the studio with John Cale is debatable. I don't buy the story of this effete string tickler explaining the difference between a guitar and drum kit to four slovenly suburban morons. The Stooges were already established as a dynamic force and if they couldn't cut it like Jefferson Airplane, who gave a fuck anyway? That they weren't already rooted in joyless proficiency and tedious virtuosity was what made them so vital. All Cale had to do was put smooth edges on the rough-as-fuck ideas they had, ideas that no aged whiskey-soaked old record exec would tolerate five seconds of, no matter how desperate they were to cash in on the buzz. But even with his clammy, fatherly hand to guide them, the boys just couldn't help letting rip. The standout tracks are the classics — 1969, I Wanna Be Your Dog, No

Fun — and they still sounds strong today. Even up against The Doors, Hendrix, The Beatles, who had heard anything like this?

Anything this honest? Anything this pitiless? Anything so prematurely jaded with life, or at least the life offered in the grey suburbs? Boredom, ennui and a slow suffocation of the soul are what The Stooges were working against, and perhaps already dimly aware that it was a losing battle, but what did they have to lose? They were still young and still hungry for some entertainment and some distraction from the creeping horror of their immediate futures. So why not get loaded? Why not creep in the back door and fumble your way into the babysitter's pants? Why not sit on the street corner hanging spit strings into the gutter from your bottom lip? What's the alternative: go to college, get a job, get a wife, mate, spawn and die? No fucking way. Rock'n'roll may be just as much of a stunted option but back then it still held some potential for things to turn out different, even if it was dead at the end of a rusty spike or floating face down in your pool.

So why didn't this connect at that time? Surely they were singing their audiences' song? Or had the machine already kicked in to high gear, thrusting the likes of Light My Fire in the kids' faces? "Another year for me and you/Another year with nothing to do," sang Iggy, and who at eighteen with no hope of getting into university and no rich parents couldn't get with that?

The actual making of the album is a tribute to the spontaneity and enthusiasm of the young artist. Jac Holtzman (Elektra's man) and Cale both thought the initial mix was "kinda short on songs." They asked for more. As Ron tells it: "I had to write Real Cool Time, Not Right and Little Doll. Sitting in a hotel room in about one hour, Iggy comes down and says 'How ya doing? What you got for me, man?' He would listen to it and then he would go and write some lyrics. I think we rehearsed one time and then went to the studio and did those three songs in just one take. It was a real budget scene. It took a couple of hours to get those guys up to speed and that's all we needed. We just hammered 'em out."

If you come to The Stooges via the route I took — *Funhouse* first — the first album sounds really tame, almost 'pop' in places. I've often wondered why, and couldn't accept that it was just first album

nerves. Bands usually mellow with age, not start out that way and then go crazy, but I guess this is The Stooges we're talking about.

As Ron explains it: "We'd never been in a recording studio before and we set up Marshall stacks and set them on ten. So we started to play and John Cale just says, 'Oh no, this is not the way…' We were like, 'There is no way. We play loud and this is how we play. We had opened for Blue Cheer at The Grande, who had like triple Marshal stacks, and they were so loud it was painful, but we loved it — 'Wow, triple stacks, man.' So our compromise was, 'Okay, we'll put it on nine.'"

So that capitulation to Cale's sensitive sensibilities is why the first album doesn't shred your speakers like all the later efforts do. There is a subdued, smothered atmosphere running throughout the whole album with only Ron's occasional revs of guitar to break through the jaded NYC junkie fuzz, as if the kids had to be numbed somehow, thus sparing the nation's ears from a dose of what these boys could really do with their hands and their mouths. We Will Fall, the ten minute 'filler' track, sounds initially like a Doors rip-off and can be dismissed as such for the first couple of minutes… But once you realise it's not going to go away until you give it your full attention it starts to work as a hypnotic counterpoint to the rocking numbers. Cale's viola at the end is unexpected and brings an almost sombre note to the proceedings, but his real stamp is spread in a thin coating all over the surface of the album. His classical indulgences reined the Velvet's back from the absolute edge (they themselves had come pretty close with Sister Ray) and served to make The Stooges' raw meat into something you could at least serve up to a hungry teenager. Iggy's vocals are, for the only time on a Stooges album, totally clear and intelligible and for all Ron's efforts there's nothing to knock granny out of her chair. However, a persistent ear will detect traces of what was festering under all that crisp icing — Ron and Dave's jamming on Real Cool Time, the rumble of Little Doll, Iggy's barks of "Come on!" in No Fun and the strangled slavering fit that 1969 ends with — that all hint at a wilder purpose than just turning the kids on.

For all it's potential, the leash applied by Cale makes this almost a 'pop' album (certainly when compared to what came later) but it's always

writhing within its skin, eager to mutate into something else, and with the benefit of hindsight and a knowledge of their influences at that time, it's easy to say that whatever they would do after this, provided they were given more control of the end product, would sound unlike anything else that had gone before.

However, for all its limitations, many people prefer this album to all other Stooges releases. Those who can't handle the skronk on *Funhouse* or the shades of glam on *Raw Power* prefer to wallow in the glow of their early promise.

Funhouse

[Elektra CD 7559606692] Tracklisting: Down On The Street / Loose / TV Eye / Dirt / 1970 / Funhouse / L.A. Blues

I dunno what's in there but it's weird and pissed off. *John Carpenter's The Thing*

IN THE TIRED, overworked and, by geological terms, pathetically brief history of rock music, the importance and significance of the *Funhouse* album cannot be overestimated, and no amount of hyperbole from me can hope to do justice to it. The whole 'classic album' debate has become arse-quakingly tedious but you can't help casting your eye over these lists and wondering why *Funhouse* isn't recognised alongside the likes of The Beatles' *Revolver*, Nirvana's *Nevermind* or Radiohead's *The Bends* as the seminal work it is? But then I'm in the minority that thinks that The Stooges are still perfectly accessible for most people.

Listen to the full six-disc set of the *Funhouse Sessions* and you'll hear nothing less than the sound of Stone Age man making the wheel. On their first album they'd nicked all the parts they needed to assemble a kick-ass hot-rod death machine from Hell but didn't have a clue how to make it go. Producer Don Gallucci did have a clue and just strapped the guys into the studio and fired the engines. The result is one of the greatest complete albums ever made and one of the very few in the 'rock' genus that has to be heard in its entirety.

It cannot be broken down into its component tracks. The album works only as a seamless whole. It's less than forty minutes of your life as a listening experience, but if you're really dialled into it it's a life-changing, life-affirming experience, one to chalk up alongside your first wank, your first cider binge, your first kick in the knackers.

Between May 11–25, 1970 the band recorded twelve full reels of material. During those two weeks they worked on nine songs, seven of which made it to the final album and two that have been consigned to the dustbin of history. And those seven tracks were unlike just about anything that had gone before them. The new jazz that had emerged throughout the sixties had become ever more complex whilst most rock remained idiotically simple and hence more accessible. Basic melodies, repeated over basic beats employing the bare minimum of basic chords to ensure ease of access to the frontal lobes. Which is why you don't hear builders whistling Pharoah Sanders' Sun In Aquarius while they put up a wall. But what would happen if someone fused the free-form skronk of Coltrane, Ayler and Sanders with the mastodon-charge of Blue Cheer or Hendrix at full tilt? Ok, so there was *Trout Mask Replica* but its heart and what little mind it had left was still beholden to jazz. To qualify as 'rock' it would need less of the acid-casualty cut-up tomfoolery and more of the hot bollocks thrust that true rock is driven by. The Stooges were up to the task, as was abundantly clear from their first album, however stifled they may have been by Cale. They were part of a long tradition of American music made by the people, for the people that stretched right back to the string bands and the porch twangers: Self-taught and unhindered by any accepted wisdom that only the God-gifted can and should be allowed to play to a paying public.

They came into the studio for the *Funhouse* sessions with nothing but amps and attitude and the confidence in their abilities forged on the road.

Whilst there are great individual 'songs' on the album there are no 'hits' as such to be singled out from the 'filler': It's all one continuous assault that comes in two waves. The first three tracks are the 'traditional' rock songs, the forth is the spine and after that it's all downhill into the festering pool of scum that sits at the heart of LA. This album couldn't have been made anywhere else, at any other

time. It was a right here, right now kind of deal. The times were a-fuckin'-changing and there was storm clouds brewing on the horizon. The Stooges found Sunset Strip rising to meet them at crotch-level, with its streets stained in the baked yellow glow of a junkie's shooter held up to the jaded Californian sun. Listening to *Funhouse* you can smell the grease, the exhaust fumes, the gunpowder, fried gristle, stale sweat, dried spunk, spilt blood and a need that can't be named. The stench is etched into every groove and makes your eyes sting if you lean in too close. As a sonic travelogue its detail is grimly spectacular and reinforces the power of their intent, which was to do nothing less than mash the face of America into a pool of its own vomit. LA was the puke bucket and The Stooges were wearing the knuckledusters. It was never going to be pretty.

The album starts casually, the riff to Down On The Street strutting in like a greasy stud uninvited to a slumber party. Iggy tells the spawning of the song like this: "So one night I got an idea for a song — just right there in the middle of the night — but here's this woman in my bed. I then proceeded to write one of my best tunes ever, Down On The Street. I went into a closet with an amplifier and played my guitar muffled and all quiet. But then I wanted to go to the next musical idea for the song, and I thought, oh, I gotta be quiet. And then I thought, No Man, you don't gotta be quiet! So I stepped out of the closet and the next part was this huge noise — a thundering fucking chord. That shattered her immensely. But that was okay: I had the song stuck together."

And what a song.

Loose, the second track sounds so simple at first, such a pure distillation of what makes a 'rock' song that you wonder why it hasn't been covered since. I'm sure it has, I've just never heard a recorded version by any other band, and wouldn't want to. This is a song only The Stooges can do and anyone else attempting the feat should be quickly wrestled to the floor and instructed as to the error of their ways.

Despite Ron Asheton's assertion that every track on *Funhouse* took only five or six takes at the most, the *Sessions* CDs reveal the truth to be otherwise. Loose itself took twenty-eight takes (including a few false starts) and while the song structure and the guitar solo never really changes from the version

played in take one, the lyrics did start out in an entirely different form to what we hear today: "I'm flyin' on a red hot Weiner/Yeah I'm flyin' on a big hot dog/It's a thing that's slick and greasy/It's a thing that's thick and long/I stick it deep inside/Stick it deep inside/'Cos I'm loose."

And I kind of wish they'd stuck with that version which, let's face it, really does suit the sleazy crotch riff and amphetamine burn of the music. By take twenty it's clear that the band are wondering if they're ever going to get this fucking song down but they stick at it, driven by a relentless commitment that you just do not hear anymore in this vapid age of the digital splice and sample.

If you ever wondered where the title for track three, TV Eye came from, here's the story from Ron's sister, Kathy Asheton: "TV Eye was my term. It was girl's stuff. My girlfriends and I developed a code. It was a way for us to communicate with each other if we thought some guy was staring at us. It meant 'Twat Vibe Eye'. Like 'He's got a TV Eye on you.'"

This track goes through a similar evolutionary process to Loose, though perhaps a regressive gene is passed down through each take as the song grows increasingly wilder and more deranged with each play. Iggy howls and snarls his made poetry over the sound of a street battle, perhaps singing about the inversion of the pornographic gaze, perhaps just spewing out the first thing that came into his head. Does it matter which? This song rocks like all holy fuck and ends on a bestial scream of pain that cuts through all the shit. Frank Black (ex-Pixies) is on record as saying that rock'n'roll can be defined quite simply by Iggy's barks of "Brother!" and I'm not about to argue with that statement.

Dirt is a slow grind, a self-loathing hate wank drawn taut over broken glass by Ron Asheton with his raked wah-wah guitar work and Dave Alexander's Mustang engine bass rumble. Iggy feels his disease burning him up, scarring his DNA, and he wants you to feel it too, to press your palms against his sweaty flesh as the poison oozes out of his pores and into the charred ether.

"Peace and love wasn't a big part of it," says Ron. "We really didn't care much about trying to make someone feel good. We were more into what was really going on, and how boring crap was, and how you're really treated. Dirt is a perfect example

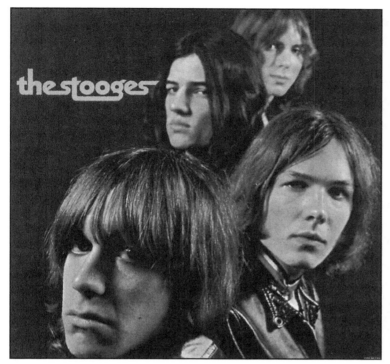

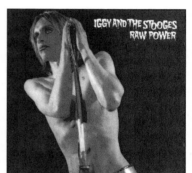

of what our attitude was. You know, 'Fuck all this, we're dirt, we don't care.'"

"Out of my mind on Saturday Night!" Top that for an opening line. The backbeat is deranged and barely sustainable as Iggy reverts to his bestial state screaming, "I feel alright! I feel alright!" when he obviously isn't like alright. 1970 is the berserk sequel to 1969 and gives the first hint of what's to follow as Steve Mackay steps in with his sax and lets rip. We've almost got used to Ron's guitar wig outs by this point and the only way to take it further is to *Bring The Skronk*!

Funhouse, the title track, is a warped and predatory anthem of love, wrapped in dirty celluloid dreams of hot freaks copping a feel in the shadows of a broken-down fun fair. Distorted mirrors, sweaty palms and torn blouses. Oily puddles, painted faces and the heat from eager crotches like a summer's night full of thunder. "I came to play," says Iggy and we all know what he means.

The take of Funhouse they settled on is actually quite restrained compared to the version that precedes it in the *Sessions*, a delirious ten-minute explosion that that blows all the fucking doors off. They just don't know when to quit with Iggy, Ron and Steve trading aural blows throughout; horror noises in the Fun House of Horror that is America's streets, America's bedrooms, America's heart.

L.A. Blues is, for most people, totally unlistenable. "That was our tribute to ourselves, our original roots," says Ron. "I was *deeply* into John Coltrane and Pharaoh Sanders. It was our *freak out*! Our whole

set was a freak out. We'd say 'Now it's time to freak out.'" And it was originally called Freak Out and intended as a capture of the free-form wig out that represented the culmination of their live act. Ron Asheton reckons it doesn't even come close to how crazy it got when they played it live but that's how Gallucci wanted it.

It's not a 'song', that's for sure. This is where the band dispensed with all attempts at higher mammalian communication and decided that a cacophonic wall of refusal was the only sane response to a world gone mad. It was actually commercial suicide to put this track at the end of the album. What proceeds is full on but still recognisable as rock, albeit of a totally mutant strain, but this is just... something else entirely. Free jazz had its audience, so had rock, and the two rarely got in bed together. Those drawn in by the first album are usually having nothing to do with L.A. Blues and I must admit when I first heard the whole album I wondered why they had done it, but I can now see that it's the only 'logical' conclusion to the album. The point had surely been made with the other tracks but just in case you didn't get it, to hammer the point home, here's the biggest, most unequivocal "Fuck you" ever uttered.

Raw Power

[Columbia 4851762] Search & Destroy / Gimme Danger / Your Pretty Face Is Going To Hell / Penetration / Raw Power / I Need Somebody / Shake Appeal / Death Trip

Too much is always better than not enough.
J. R. 'Bob' Dobbs

MOST ROCK MUSIC is self-indulgent masturbation. *Raw Power* is self-imposed annihilation. It's a controlled debasement of the id, a punishing collapse of the last traces of human grace and dignity. Look at the track titles: Search And Destroy, Penetration, Death Trip. Look at the picture of Iggy on the cover, his facial expression caught somewhere between absolute terror and abject boredom. It's the face of a man caught in the eye of the hurricane that is his own psychosis, a festering reptile intelligence mangled in a Burroughsian narcotic cut-up.

For years it was the classic "could've been" album, chock full of tunes you really wanted to cut loose to, but instead is lost in the fog of Bowie's narcoleptic production job.

It took over twenty years until some genius finally got the master tapes to Iggy, who set about tearing the album a new asshole and while some have argued that all he did was turn everything up to eleven and go get some lunch, there's no doubting that this is how *Raw Power* should have always sounded. Had it come out of the gate in this form in 1973 it would have blown the fucking doors wide open, the glam rock ship would've gone down with all hands and we wouldn't have had to put up with any shit from Malcolm McLaren.

This album doesn't 'start', it *explodes* out of the speakers like a scud missile slamming into the room. The initial blast of Search And Destroy is one of those rare moments when man is powerless in the face of an art so uninhibited and so forceful that it demands total obliteration of the senses. It's as loud as it needs to be, which is fucking loud, and the thrust and rip of the guitars sound like something mad and dangerous tearing its way in from another dimension. "I'm a streetwalkin' cheetah with a heart full of napalm/I'm the runaway son of the nuclear A-bomb/I am the world's forgotten boy/the one who Searches and Destroys." Who else wrote better rock'n'roll lyrics than Iggy Pop? You can take your all-time top ten and your John Lennon's Imagine and you can shove 'em up your arse sideways because *this* is how you do it. Iggy claims the lyrics came from his brain-bombed days walking the streets of London in his leather jacket with a cheetah's snarling head on the back, taking abuse and fending off the attentions of suits who figured he was up for rent.

Streetwise, pissed off and smarter than he looks, Iggy glowers out from the cover of the album, his face painted like a Hollywood drag queen, his body nearly as thin as the microphone stand he's holding, utter darkness behind him, as if he were the gatekeeper to some Other Place where all of this crazy shit makes even less sense but, guess what, it doesn't matter!

Considering everything they had gone through, the band sound amazingly tight and driven, which you can put down to the Olympic-standard rehearsal

sessions they endured prior to recording. But there's that something else in there too, that something indefinable, that Faculty X which is required to tap into man's latent potentials and dredge up the awesome. And Iggy knew they had it. "That band could kill any band at that time... You had a rip-snortin' super-heavy nitro-burnin' fuel-injected rock band that nobody in this world could touch at that time, nobody could rock like that band does, no band that anybody had."

James Williamson knew it too. "Our sound in those days, even with 'Raw Power,' was so far out for the average A&R guy. It just blew their minds when we brought them to Ann Arbor and had them listen to what we were doing. They were *appalled*. Truly, it really was bad... I'm not saying that the music was bad, but they really could not relate to it at all."

Maybe it was Gimme Danger they played to the A&R boys? As I type this it's playing on my CD player and it sounds fucking great. Acoustic jangle offset with Iggy's groans and curses and Williamson's shark frenzy riffs.

"Swear you're gonna feel my hand." Where, exactly? A slap across the face? A grip round the throat? Or a dirty, greasy palm sliding down your pants, nestling up against your genitals like a lizard looking for warmth on a cold desert night?

Your Pretty Face Is Going To Hell is the first song I heard where a man is trying to get a woman to fuck him by telling her she'll eventually be a ropey old hag so she might as well get it now while it's still all up there. Hardly your conventional wooing technique and quite a shock after growing up to the sounds of Racey ("Some girls will/Some girls won't/Some girls need a lot of lovin'/And some girls don't"). It's got an absolutely demented riff that sounds like some garbled signal from outer space compressed through inferior human technology and tears along like something after a new land-speed record. The sheer energy of this song could power the city of New York for a whole fucking year and if it doesn't raise a smile to hear Ig screaming "I tell ya honey it's a cryin' shame/All the pretty girls really look the same" then you might as well give up now.

With Penetration the jury is still out as to whether Iggy is opening up to his feminine side, fumbling with metaphors or just finding a good excuse to use a word he clearly likes a lot. The pace slows a little

for this one, which only makes it more effective as it gives Iggy chance to drop the voice down to a grunting rasp, as if he's singing while hunched over the willing body of a young female, thrusting into her hot folds while he works the microphone like it's a cock. Confusion abounds with lyrics that Iggy alleges were lines from Burroughs' *Soft Machine* or *The Ticket That Exploded* but it doesn't really matter. It's a song about cocks and holes and that's all you need to know.

Raw Power was covered by PJ Proby during his association with the Savoy people and it was actually the first time I'd heard the song. Iggy describes it as "real basic rock" and if I'm to be pushed on the matter I'd say it's the weakest song on the album. There's none of the screaming energy or surprises or lyrical ambiguities: It's just a "Fuck off, I wanna be a beast" anthem and is effective enough but is very much the band coasting. Only when Williamson unleashes his guitar at the end does it start to work but it's too late.

Skip straight to I Need Somebody. Iggy insisted there had to be two 'ballads' on the album, Gimme Danger and this. These aren't ballads in the Michael Bolton sense of the word though, but it's on this song that Iggy let's his guard drop and admits that "I'm losing all my feelings/I'm running out of friends/You lied to me in the beginning/And now you're gonna try to bring me to the end but shit I don't mind 'cos... I need somebody baby/Just like you..." The acoustic guitars are in there again, working against Ron and Scott's lead foot back beat, with Williamson throwing Keef shapes on the electric as it fades to black.

Shake Appeal is a homage to the full-on old skool late fifties rock'n'roll from the likes of Jerry Lee Lewis, Link Wray, Little Richard... "Stuff that *roars*!" says Iggy. It's even got fucking hand-claps, for fuck's sake! The whole thing sounds intentionally funny, with Iggy camping it up with drag queen "Ooh-ooh"'s and squeals of orgasmic delight.

And it all comes to an end with the suitably titled Death Trip. Iggy claims he knew the record was doomed a this point, with zero prospects for promotion or airplay, and yet in his heart he knew it was absolutely the best music around, so all that frustration was hawked up over this mad thrash. Williamson's guitar playing is completely over-

the-top, a relentless caterwauling screech and grind that renders about ninety-nine per cent of the 'punk rock' that followed as being completely meaningless.

As already stated, this record was saved by Iggy's intervention. Anyone who thinks Bowie's production job is better is taking the piss. Iggy had the right idea. He's always loved the music on this album and wanted it to finally shine through. He instructed the engineer with him to crank it up all the way. Then the label heard it and "it freaked 'em out", says Iggy. "It sounded like the speakers were gonna explode, bleeding and melting distortion." So a more tolerable version was made, which sounded as limp as an old man's cock, and they went back in to crank it up again, shaving maybe half a decibel off of Iggy's original Heavy Heavy Monster Sound version, and leaving us with the throbbing monster of an album we have today. *Raw Power* would have been the fitting last gesture for The Stooges but there was still something that needed to be heard: The band in their element, live before an audience.

Metallic K.O.

[Munster Records] Heavy Liquid / I Got Nothin' / Rich Bitch / Gimme Danger / Cock In My Pocket / Louie Louie

Better to reign in Hell than serve in Heaven.
John Milton, Paradise Lost

METALLIC K.O. is a Sven Hassel novel set to music. It's the retreat from Stalingrad with guitars instead of machine guns and beer bottles as mortar fire. Never has stupid, pointless rock'n'roll sounded so dangerous, so vital, so close to tearing through the fragile veil of conscious reality and revealing the horrific visage that lurks underneath. It might have been their final gig but the level of aggression towards the band and, to a certain extent, within the band itself, had been threatening to split them for a long time prior to that fateful night; but, as Ron Asheton said, "Hey, it's the band, man. You don't quit in combat. Just because your band's on the point, because you're in combat, you can't bug out on your buddies. It was literally war we staged

until the bitter end."

Metallic K.O. is, in its most recent release, a two-disc set, documenting the last gig the Stooges ever played on February 9, 1974 at the Michigan Ballroom in their hometown of Detroit. In five years they had gone around a sizable portion of the Western world only to find themselves stumbling back home, battle-hardened, their nerves cauterised by too much of anything that human beings could pit themselves against. Their sorry saga reminds me of an old Alan Moore comic strip from *2000AD* , 'The Last Rumble Of The Platinum Horde', where a battalion of space marauders head out from their own planet to conquer the universe. They take each planet by force, decimating entire populations and laying waste to ecosystems, before launching themselves towards the next world that stands in their way. This goes on for hundreds of years until they find themselves on a destroyed world that looks strangely familiar, only to find that it is their home planet. In their endless warmongering they had lost all memory of the very reason why they had set out to conquer in the first place. With nowhere to fight for the glory of anymore, all they had left to live for was war itself.

Never intended as an 'official' release, it took the dogged determination of a demented Stooges fan to eventually get this pressed to vinyl by Skydog records and distributed to a bewildered audience who quite rightly asked, "What the fuck is this?"

Even mastered for CD there is no way to improve on the ruined quality of the sound on this disc. And you wouldn't want them to. The more fucked the better, if you're going to be able to fully project yourself back in time and space to that night when something never witnessed before or since in the hoary annals of rock took place.

There's no gradual fade in of the crowd roar and then a smooth intro to the opening number like you get on most live recordings: the thing stumbles in halfway through like a gang of drunks crashing a party, as the band make a shambolic thrash through some indefinable sludge jam. There's no synch to any of the players and Iggy is just making it up as he goes along. You can picture him: shirtless, skin-tight jeans cut to the base of his cock, smeared in fluids and sporting the wide-eyed look of the truly insane, both pupils gone and replaced by the kind of question

marks you last saw on the Riddler's costume in TV's *Batman*. Flailing around, lost to the momentum of his own idiot urge and yet still somehow smarter, sharper and more totally aware of what's really going on than anyone else under that roof.

You can picture the stage as well, with Ron and James stood as far back from the missile barrage as was possible, huddled up against the drum kit, playing on when every last shred of sense should have been telling them to get the fuck off that stage.

You can even picture the crowd. A writhing mass of humanity, bored, dirty, pissed off and reduced to the level of fighting dogs, hurling missiles at the stage and spewing death threats in the direction of their chosen victims: the band that had brought them there that night, the ones they felt compelled to stand up to, to wage war against.

But what were they fighting for? What was the point of it all?

On *Metallic K.O.* The Stooges held a mirror up to the audience, and the bastards did not like what they saw, which is why they reacted the way they did. And it's so cosmically perfect that after spitting out deranged boogie-rock versions of their own songs they should bring it all crashing down around them with a pointless, death rattle run through of Louie Louie. Up until that point The Stooges had at least tried to keep it together, rumbling through Heavy Liquid and Gimme Danger and probably the only time in the show where it sounds like they're winning is during I Got Nothin' (announced as I Got Shit and dedicated to "All the boys and girls who wanna slow dance") where it really does sound like they've got a fair approximation of the blues going on. Actually, the "Ooh Ooh"'s make it sound like the fucking Stones with Iggy doing his best Mick impersonation and JW in full Keef mode, and you're forced to wonder if this is some unconscious pastiche or a once fierce proposition now cast adrift from their hunger.

Fortunately, the next track dispels all such doubts and reminds you what's really going on. "Our next selection for all you Hebrew ladies in the audience is entitled Rich Bitch." An infectious boogie-piano starts up and the rest of the band grinds into gear behind it. Iggy gets some more abuse from the crowd. "You're paying $5 and I'm making $10,000, so SCREW YA!" The band settles

into a rumble, all the better to hear Iggy deliver the priceless first verse:

When your Mama ain't around to buy your pills / And your Daddy's too old to pay your bills / And when your cunt's so big you could drive through a truck / And every man ya meet Baby knows you sure been fucked / Whatcha gonna do about it, baby? / Whatcha gonna do?

And it degenerates from there.

As the song slows to a faint drumbeat it's clear the audience is not warming to the band's performance. As more shit gets thrown at the stage, Iggy takes the opportunity to further bait the surly assembly of combatants. "You can throw your goddamn cocks, I don't care. You pricks can throw every goddamn thing in the world… And your girlfriend'll still love me, ya jealous cocksuckers!"

The band eventually falls into the beat of Gimme Danger, and it sounds like they're playing underwater. Everything is cymbal and bass. The guitar sound, which should be so strident in this song, is right at the back. Everything is on Iggy and what he has to say. The deceptively spartan beginning warms up when Ron kicks his bass into a higher gear and the band begin to surge behind Iggy's tortured confessions. Considering the barrage they were under it's a testament to how strong an act they were that they could do this song with such passion. It's the only time in the recoding that they sound real, or vital. At one point Iggy demands that "I'm gonna be touched, and I'm gonna be loved… And I ain't afraid to say it… 'Cos I need ya, more than you need me" and it's really not expected under the circumstances. Every note of this song is one of defiance in the face of overwhelming odds and can't be doubted as being anything other than The Truth.

After that, it all goes to pieces. After the Tragedy we get Comedy. "This is a song I co-wrote with my mother entitled 'I Got My Cock In My Pocket'… A 1-2-FUCK YOU PRICKS!" The band rip into a generic boogie-rock beat that thuds along moronically, sounding like a band at a high school dance, not that such an event would tolerate lyrics like "I got my cock in my pocket/And it's pushing up through my pants/Well I just wanna fuck/This ain't

no romance."

By this point, you know they're doomed, as do they themselves. Iggy promises "It'll all be over soon," the words of a man who is fully aware of the reality of his situation. "Anybody got any ice cubes, jelly beans... Grenades they wanna throw at the stage?" He asks as eggs rain down upon him. But he just doesn't know when to quit.

"Is it time for a riot, girls? A riot!" Light bulbs and paper cups quickly follow and it's clear the inevitable cannot be put off any longer.

"I think a good song for you would be a fifty-five minute Louie Louie... You want us to go through and finish our set or do you wanna hear 'Louie Louie'?" And so The Stooges went out boogieing to Louie Louie. Recognition of where they'd come from and perhaps an acceptance of their failure? Defeated by the very rock they tried to make their own? Or an inevitable casualty in the war against mediocrity, banality and bullshit?

"I never thought it'd come to this, baby," says Iggy, but deep down he must have suspected that he and the other Stooges could never have really gotten away with it. The odds were always against them, right from the start. But they fought a good fight and their sacrifice is there for all to see.

THE LEGEND

This was living and being born and coming for your fucking children in the middle of the night in front of you... From then on rock'n'roll could never be anything less to me. Whatever I did — whether I was writing or playing — there was blood on the pages, there was blood on the strings, because anything less than that was just bullshit, and a waste of fucking time.

Scott Kempner on The Stooges

SO, WHAT'S LEFT TO SAY? It's nearly thirty years since they crashed and burned and in that time what have we learned? Where do we go from here? And in the absence of relevant gods — and let's acknowledge the fact that man needs his Gods, even if it's Bono, Buddha, Beelzebub, Bugs Bunny or a giant Beard in the sky — do we look for significance and meaning in rise and fall of a fucking rock band which, in the final searing heat death of the Universe won't amount to the sweat on the balls of an atom?

The Stooges were just a band, one amongst thousands, maybe even millions by now, who tried, and failed to do... Something that rightly and justly remains beyond the means of expression we currently have to hand. They were very much a product of their time and place in a world grinding ever onwards towards an increasingly unpredictable future. They were borne of circumstance and a culture that had bloomed too quickly and was already turning to rot. Iggy was smart enough to see what was going on. He'd read his Dostoevsky. He saw the vampires and the leeches crawling out their boardrooms, ever hungry for another percentage, another deal, another franchise. Iggy worked against the notion of the 'super group' and the 'superstar', trying to bridge the gulf between the stage and the audience, using his body, his voice and the sum total of his frustration that none of it was really going to make a difference, that it wasn't going far enough to the edge of what he suspected lay waiting at the Borderlands of raw honest experience, which had become a place of exile for those locked out of the 'reality' of life as defined by *Time* magazine and the withering husks still clinging to the vacuous dreams of Camelot. He saw that rock'n'roll was running out of places to hide and virtually everything that was now recognisable and quantifiable had been shackled to the Cool Machine and flogged within an inch of its life. Conform, perform and die. The money being made was increasing in direct proportion to the amount of coke being hoovered up the noses of jumped-up petrol pump attendants who had been convinced by the slimy tongues of A. & R. creatures and the willing orifices of gullible strumpets that knowing a G from an A chord gave them a seat on Mt Olympus. There was more than a whiff of the Fall of Rome about it all and, right on cue, came the Visigoths to sack the place, in the form of The Stooges.

Or so they thought.

While it might not have been their overriding ambition to bring it all down — their brothers in the MC5 had taken on the 'Revolution' chores — they must have been motivated by the appalling

spectacle of something wild and protean now caged and displayed in stadiums. King Kong had been captured and brought back to 'civilization' for the masses to gawk at the part of themselves lost in the womb. Adding to the frustration was the fact that the planets had aligned for them and everything was in place for rock'n'roll to transcend the boundaries already being erected by The Fucking Bastards. Jazz had led the vanguard throughout the sixties, moving away from time signatures and structure, while rock was still dawdling behind, shackled to the bones of Bill Haley And The Comets. The Who had the feedback, Bob Dylan had proven that you didn't actually have to be able to 'sing' in any conventional sense and The Velvet Underground had shown that you could even dispense altogether with 'ability' and still create something vital and engaging, perhaps more so than those fuckers still obsessed with technique and tradition and tedium. Who would pick up the spare ammo left by these initial raids on the castle and form a new line of attack?

Ultimately, there is nothing left to say about The Stooges, about rock music, about anything. It's all been said so many, many fucking times before that everything I'm about to write is already irrelevant.

And yet I feel I *have* to do it.

Which is exactly my point about The Stooges. They *had* to do it. There was no choice in the matter. Rock or die.

Imagine being compelled by that kind of burning imperative. Consider the will involved to perform in the face of almost total indifference from the fans and critics alike.

It's truly awe-inspiring and it's that sheer will, that teeth-grinding determination to *do it* that is fused into every atom of every Stooges album ever cut. The same deranged commitment to expression can be seen in Van Gogh's paintings, Peckinpah's films, Bukowski's poetry: it's the unmistakable Real Deal and it can never, ever be faked. A signal from deep within the collective psyche to which an honest and primal response is required.

In the case of The Stooges this usually involves stomping around the room, kicking over furniture and playing violently exaggerated air guitar solos. And this is exactly how it should be. The music goes straight to the limbic brain and fries the synapses that lay mostly dormant in our domesticated age,

unleashing a surge of adrenalin that reminds you of how good it is to be alive. It also reminds you what rock *should* be and it's in these impoverished days of wet irony and bad repetition that we need The Stooges more than ever.

Popular culture is now a stale turd floating in the toilet bowl of our spent dreams, but the lazy and unimaginative are still picking through it with eager fingers for traces of fibre and nourishment. And now here we are with The Stooges once again providing an easy but meaningless reference for the *NME* goons who want us to fall for their latest haircut band. Eighteen-year-old white boys making a sub-standard racket are championed as the saviours of rock'n'roll by people who wouldn't know the real thing if it ran them over in a Panzer Tank.

Like I said, it *can't* be faked and to assume you can is to make a gross misinterpretation of what's actually going on. The fault line in their supposition starts when you think something as 'basic' as The Stooges sound can easily be replicated. It can't, because it's not just about picking up the instruments, hitting them, strumming them and howling about drugs and dirty girls: it requires a collision of wild possibilities, circumstances and an unruly and feral need that all too rarely occurs. Competence and proficiency in your art cannot be seen as obstacles when the grinding wheels of the universe demand action, and such concerns never got in the way of The Stooges. Their collective abilities redefine the term 'raw talent' and their records illustrate how effective they can be when channelled in the right direction. All that experimentation in basements had given them a sense of confidence and mean disregard for the growing cult of tedium that went on to dominate the stadiums of the world. Their fuel-injected customisation of what acts like The Who and the Stones had turned into stale workmanlike grunts and shuffles was brilliantly simple but far from lacking in smarts.

Where is it written that only Mantovani or snob-endorsed jazz can engage the frontal lobes? The Stooges brought the correct response to their times and have proved their relevance that still resonates today while many of their contemporaries are rightly consigned to the dustbin of history. The images that define that age are not pleasant and joyful: acid casualties slumped in the parks and doorways of

Haight-Ashbury, an increasingly-militarised police force rampaging like SS Werewolves through the streets and college campuses; Vietnamese children running naked down dirt roads burning with hot Yankee napalm; Hell's Angels stomping the hippy dream the death at Altamont; Zodiac's bullet festival and creepy coded taunts; Manson's beach buggy groupies of death and, as a full stop to the decade that saw fatuous fantasies of Camelot turn to shit, Charlie's own Evil Jesus visage, eyes as black as a shadow loaded with a knowledge too terrible for one man to bear. How the fuck could anything other than the raw energy of The Stooges hope to deal with that black carnival?

But, while they are very much of their time, their response was to the dark side of humanity which in the early days of the twenty-first century seems to be in the ascendant once again (as if it ever went away), which makes their music as potent as relevant as ever. The thunderheads of war rumble across the Middle East while a harsh interpretation of Islam is convincing some hotheads to take on the Great Satan in their suicide machines, eclipsing Hollywood's crassest excesses and setting the stage for the last showdown between the two great doctrines of intolerance and inhumanity. The social infrastructures of many developed countries are collapsing and a new mood of ugliness cruises the streets. The poor are scooping sustenance from the gutters, the rich are lost in their own stratosphere and a large percentage of the population are dangerously bored. School kids make death threats to teachers. Children's torsos are found floating in the Thames. Tabloid bullyboys set their pit-bull thugs in against immigrants fleeing war zones and shit-holes worse than the blighted towns the Government 'assigns' them to. Zodiac's protégés aim for a new high-score, white van phantoms cranking up the crime fear paranoia until it's ready to blow. Indians sell their own kidneys for £400 so they don't have to starve just yet. Crackheads beat old women to death for the meagre contents of their purses. Corrupt coppers cover up their own transgressions of power and privilege. A moron is 'elected' as World Sheriff while the Barons in the High Kastle erect Death Kamp malls to distract the masses from moral bankruptcy and destructive greed. An obsequious bed-wetter becomes Prime Minister to a nation in spiritual freefall.

The seas are rising and the mountains are falling. There's a hole in the ozone layer the size of a continent and Nemesis the Death Comet is on its way.

It's too late to party like it's 1999, but we still need some tunes to accompany this shit storm so it's going to have to be The Stooges because I don't think the new Blur album is going to cup our nuts the way we need 'em cupped right now. We need Raw Power, we need No Fun, we need Loose, we need TV Eye because the Fun House is on fire and we are all on the same Death Trip, screeching out of control across the wild highway. The ditch at the side of the road is the locked groove at the end of side two and there is no escape from the fate we have made for ourselves.

The Stooges died for us and we forgot to keep the good faith. They were just like us and we shunned them as degenerate subhuman garbage. They couldn't throw the thieves out of the temple so they burned it down, only to find they'd built a mall on the ashes. They turned piss into whiskey and shit into raw hamburger. They made the deaf hear and the blind truly see for the first time what it takes to rip down the barriers between man and god, between the fan and the performer: nothing less than blood, sweat and, yes, tears.

Did we deserve their sacrifice?
Are we worthy?
Let's pray we never find out.
As you were, I was. As I am, you will be.
Heinrich Himmler

Postscript

AUGUST 2003: Shortly after completion of the above it was announced that Iggy Pop had reconciled his differences with the Asheton Brothers and they were with him in the studio, recording tracks for a new album. Since then the reformed Stooges (with former Minuteman Mike Watt in place of Dave Alexander on bass) have played dates throughout the USA and in Europe, performing songs from the first two albums to an appreciative crowd. We must have faith in The Stooges. They never let us down before.

The Urbane Guerrillas...

THINK ABOUT THIS: What bullets are to war, ideas are to revolution. In the battlefield of insurrection opposing factions compete to control concepts that are the keys to support. And in revolutionary situations they are everywhere. In slogans chanted by street mobs. In agitational rhetoric from would-be leaders. In manifestos and posters, banners, and graffiti sprayed on walls. They are also encrypted into the secret codes of songs... But of course, the late 1960s counter-culture battles are seldom fought near the barricades. They happen in the area of what William Burroughs calls "The Grey Room": The mind, where the propaganda value of ideas is even more important.

And the 'underground' makes it up as it develops. Extemporises it. It is happening for the first time. There have been anarchists and romantic poet revolutionaries, jazz be-boppers and beat generation bohemians, but nothing on this scale. Nothing quite like this — *ever* — before. What comes next? Nuclear Armageddon? World revolution? The dawning of the age of Aquarius? No-one knows. Everything changes. And everything stays the same.

You've thought about that? Right. Now forget it. Some had reservations about Robert Edgar Broughton from the start. To them the British underground — to which his band was '"almost like a news-sheet" — is an odd, idiosyncratic hybrid. An anarchic and irreverent fraternity, looking to America for its models, channelled through hazy dope clouds of ill-disguised and badly misunderstood New Left slogans looted from brief perusals of the *Fontana Modern Masters*. Most of it just so much Idiot Wind, raw material for the great vinyl automuncher of ephemeral mass consumption. America has the Vietnam draft, the anti-segregation struggles, Bob Dylan, Abbie Hoffman, Timothy Leary, The Doors, Jefferson Airplane. England has *It* (*International Times*), The Pink Fairies, *OZ*, LSD, Richard Neville's 'Play-Power'... And The Edgar Broughton Band.

Step one: The ideal prerequisite for an 'underground band' is obscurity, which — largely — the Broughtons achieve. Mick Farren's (social) Deviants are more obscure, and hence — by definition — more valid. Lucifer, with its few dilettante-porn

Edgar Broughton

Voyage around an Underground Band

By Andrew Darlington

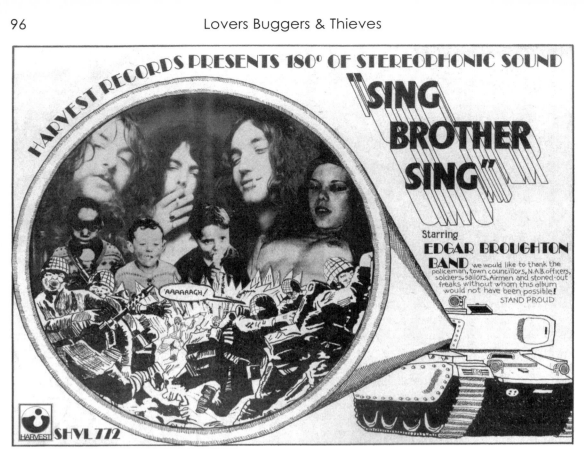

singles obtainable in plain brown wrapper through your mailbox, succeed in remaining obscure to a degree beyond even their own wildest mouth-watering anticipations. But largely, around the turn of the decade — 1960s into 1970s — The Edgar Broughton Band get to become a serviceable street-corner password with which to impress the standard dumb straights.

Of course, all this hard-won oblivion — even when supported by John Peel's *Top Gear* Radio One slot — could so easily have been destroyed by commercial success. But mercifully that never happens. Their first single doesn't catch fire. So their integrity/reputation remains intact. Both sides, It's Evil c/w Death Of An Electric Citizen (Harvest HAR 5001), are later featured on a conveniently historic retrospective *A Bunch Of Forty-Fives* (Harvest HAR 2001), charting the dubious progress of their most visible years. Even if — at the time of its original release — the single, opening with peals of manic laughter, is reviewed as "an unbelievable cacophony

of psychedelic noises, reverberating twangs and berserk vocals" (by *New Musical Express*, who obviously don't get it). But the single does form a useful trailer for their first album, *Wasa Wasa* (Harvest SHVL 757, 1969), an archetypal electric-blues set featuring stand-outs Crying and the "transparently cynical" American Boy Soldier. Love In The Rain uses lascivious Hendrix changes ("Tell your Mother /I'm no fussy lover") "YOU LIKE IT? SO DO I... I'M COMING, I'M COMING, I'M COMING... I'M NEARLY THERE... THAT WAS SO GOOD!!!!" Fading out in lustily post-orgasmic panting. And the heavy guitar figures of Why Can't Somebody Love Me, plus both sides of the single: Of which Electric Citizen had begun as a track spontaneously recorded the year previous in just fifteen minutes at EMI's number two studio. It is clearly a formative album utilising the classic Cream/Hendrix bass-lead-drums power trio line-up, with much of its potential yet to be realised. While the sleeve features the protagonists moodily clustered about a candle. Faces,

suitably solemn, half-eclipsed by its light, emerging from its twilight zone.

At the time Edgar is busily engaged in telling *Zig-Zag* magazine (itself a former fanzine, grown out of the 'counter-culture' community) that "we are the product of the people, a mirror of the people". Prophetically so. For this is the real, and only way, that all that potential will be achieved. They are a working band. Recently down from gentle historic Warwick where they were managed by the Broughton's mother. Beginnings are easy. Encounters that unhinge separate lives into a shared ratio. Two brothers bedazzled by Johnny Kidd And The Pirates on ITV's Saturday evening *Thank Your Lucky Stars*. Watching Hank B. Marvin, the Stones and the two Kink brothers on *Top Of The Pops*. Impressionably idealistic, listening in awe to vinyl editions of Dylan's incendiary political rage. We could do that. We could combine those elements, and change the world with a handful of riffs, and if we score some hippie chick nubiles and some high times along the way, so much the better! From there it's deceptively easy, falling weightless into the heat of a social furnace that will buckle identities and fates into new shapes. Events in pinpricks on the time-map.

But by this time they've been taken up by Blackhill Enterprises, and they're turning up at festivals and benefits playing in the rain off the back of pick-up trucks for free. On stage they are evolving Canned Heat's On The Road riff into Greyday, a song about a businessman who gets killed. But more importantly they've also begun doing Out Demons Out, the chant that will become not only the A-side of their second single (c/w Freedom, Harvest HAR 5015, March 1970) but also the first of their only two bona fide chart records. The band's anthem, and its occasional albatross. Their exhaustive rendition of the repetitive chant incites a frenzy when they do it as part of their set at the high-profile Blind Faith Free Concert at Hyde Park. Whilst the single — which hovers between forty and fifty on the list (aspiring to a high of number thirty-nine on May 2) — had begun life as the Exorcising The Evil Spirits From The Pentagon invocation recorded live-on-the-streets by The Fugs for their *Tenderness Junction* album, something possessed (pun!) Broughton to commit it to wax, replacing the Fugs' documentary authenticity with a heavy

rock backbeat. A dubious trade-off, resulting in a chanta-longa-Broughton incarnation more Dennis-Wheatley-Armies-Of-Hammer-Horror than the Fugs' Norman-Mailer-Armies-Of-The-Night subversive act of insurrectionary street theatre. And, like that never-to-be-repeated epic of Woodstock, the ritual gets spontaneously reborn at a thousand subsequent gigs up and down Europe in all its chanted monotony and subject to the same laws of decreasing returns as said festival.

But pause for a moment here. By nine on the morning of Saturday June 7, 1969 there's an estimated 7,000 psychedelic gypsies here in Hyde Park, clustered in and around a natural amphitheatre called The Cockpit. Many bedraggled freaks have already spent a long and uncomfortable night on this dew-chill grass. Then The Third Ear Band's hypnotic mantra-drone eerily opens up events at around half-past-two. And by now they're talking about something like 150,000-strong of us squatting in the dirt. And the Broughton's, doing a clutch of electronic howl-and-fart numbers, are stalking stage-boards aggressive and lethally raucous. This is a band consisting of Edgar (born October 24, 1947 in Warwick) on vicious mouth-noises and guitar, brother Steve (May 20, 1950) on heavily mortgaged drum kit, and Arthur 'Art' Grant (May 14, 1950) pulsing search-and-destroy bass lines. Edgar is always the visual art-object, his pseudo-romantic bohemian overkill charisma derived somewhere between committed Ian Anderson and media-radical Red Danny Cohn-Bendit. He looks good, down from the Midlands working-class industrially silted wastes (only the A429 separates Warwick from Coventry). A visually right symbol. Aurally, it's not always *quite* so satisfying. But what the hell? Joints are ritually ignited. Street sellers are bartering wonderfully art nouveau copies of printed ephemera, 'UFO' posters, *Frendz*, spirit-duplicated poems. A nude girl idiot-dances to Ritchie Havens. Donovan and Blind Faith (featuring both Stevie Winwood *and* Eric Clapton) follow as the sun filters down through the trees... It's an event. A Renaissance fair. A peak experience.

How to capitalise on that collective buzz? Well, why not subvert the antique hypocrisies of the 1970 General Election by issuing a cut dedicating its "We're all dropping out" raspberry to "All of you in Whitehall"? And the result is an act of Benny Hill

politics. Naughty fun timed to tie in with — and as a comment on — the tired facade of democracy, while also featuring the David Bedford Orchestra and Chorus. Listening to Up Yours (Harvest HAR 5021) now, it seems a vaguely amusing absurdist tribal sing-along — but then, of course, absurdism is a vital part of the Situationist manifesto — and although its "mildly offensive" content gets it banned from the BBC play lists it proves an appetising taster for their second twelve-incher, *Sing Brothers Sing* (SHVL 772) issued in June. On the cover three kids (one black) are framed by a Gothic arch. Inside there are occasionally jazzy rhythms, and The Psychopath, a song about a child molester that features the WEM Hand-Ful for sound distortion and effects. Other cuts include tribal crowd pleaser Momma's Reward (Keep Them Freak's A-Rollin') and Officer Dan; plus Old Gopher, the peaceful Aphrodite and Refugee chanted over a stark percussive backdrop. Press ads for the album read:

> We would like to thank the Policemen, the Councillors, NAB Officers, Soldiers, Sailors, Airmen and Stoned-Out Freaks without whom this album would not have been possible STAND PROUD!

Completing the set is the epic There's No Vibrations, But Wait with its distorted megaphone-voice rap-chanting poem style, complete with bleeped-out obscenity and "negative, negative" repetitions which reduces "the cultured word-wizard" to deliberate nonsense for "as long as the cigarette smoke curls up and not down from the ashtray." We, of course, can all decrypt that code. While there's also The Moth (a three-part dialogue with a moth concerning "Are you a boy or a girl" freak ridicule about what *really* constitutes maturity), Grandma, Is For Butterflies and It's Falling Away...

Turn On, Tune In, Drop Out Boogie

BUT THE BEST is yet to come in the shape of Apache Drop-Out (Harvest 5032), a single from November 1970. In a classic juxtaposition exercise the Broughtons loot Captain Beefheart's *Safe As Milk* album, replicating its Drop-Out Boogie with authentic acid-etched vocals, but substituting the keyboard minuet bits with regurgitated lines from the era-defining Shadows' 1960 instrumental hits. Whether it's Brion Gysin-inspired cut-up collage, or inspired anticipation of the as-yet uninvented mix'n'match hip hop sample culture to come, the fusion — or collision — between the two disparate elements works oddly on vinyl where, on paper, it shouldn't work at all: Swelling into a monumental Jerry Lordan meets Don Van Vliet confrontation crammed into forty five r.p.m. with a hotline, potentially, to both markets, but in actuality to neither.

As it simmers around the chart plimsoll line (reaching a high of number thirty-three on March 27 during an in-and-out four week run) the band are preparing to play eleven German gigs in fourteen apocalyptical December days of riots and headlines. Broughton's crowd-pleasing "free music" notoriety precedes them across Europe, where the dichotomy between such protestations and the gate money demanded by Mama Promotions induces an outrage that the band are made aware of, and on which they capitalise. They declare free gigs, thus earning the animosity of Mama, a two-year ban by German promoters, and the nucleus of a large following across Europe and Scandinavia. Of course, music should be free. As in "free expression". Or Freedom Suite. But that don't necessarily legitimise the Yippies or the White Panther Party storming the perimeter barricades of the Isle Of Wight Festival demanding free access. It doesn't mean that venues don't have to be paid for. Or power bills honoured. But hey, it's a great slogan.

Nevertheless, in the first month of the New Year they add to the momentum by recruiting twenty-four-year-old Warwick guitarist Victor 'Vic' Unitt (July 5, 1946) from The Pretty Things and cut Hotel Room c/w Call Me Liar (Harvest 5040) for June release. Broughton writes Hotel Room about the "injured parties in my bed" in a Hamburg "desolation row" hotel off the Reeperbahn, and it's a strong song, one of their strongest. Strummed guitar, with the smooth girlie voices of The Eruptions dubbed across both sides. Ragged romance. But no intrusive politics. And it makes the German top twenty. As mid summer arrives it seems to be the time the Broughtons might break on through elsewhere. They play a benefit for

Bangladesh (then East Pakistan) in Battersea Park Pavilion with other high profile 'underground' acts including Juicy Lucy and Assegai. Then, in furtherance of their 'peoples band' ideology they go on to do a string of free open-air concerts at seaside venues: Running into trouble at Redcar and Blackpool where local councils forbid same. But they play anyway. July 18, at Redcar, they attempt to play from the back of a truck, but get moved on by police after various hassles. Manager Peter Jenner (credited as co-producer with the Broughtons on *A Bunch Of Forty-Fives*) and a roadie are charged, but later acquitted of "Obstructing Police and a Breach of the Peace". In that same court, the same August — and later in Brighton — the band are prosecuted on obstruction charges, and also have £200 worth of gear, including a Fender and a Burns twelve-string lifted from their van! Property, after all, is theft.

This chaotic tour goes off against a soundtrack of *Edgar Broughton Band* (Harvest SHVL 79, 1971), their most convincing — if occasionally messy — album, enveloped in a meat market sleeve of carcasses hung in neat raw rows. Side one opens with Evening Over The Rooftops, co-written by Unitt and Edgar. The song is accused of vibing Leonard Cohen's bleakness ("The smoke hung over the sky-line/The city fell in silence") while around the symbolist poetics of "The mating of the earth and air" — cryptic with meaning — lurk girlie voices, shivering Palm Court strings and a Salvation Army tambourine. Further along the vinyl

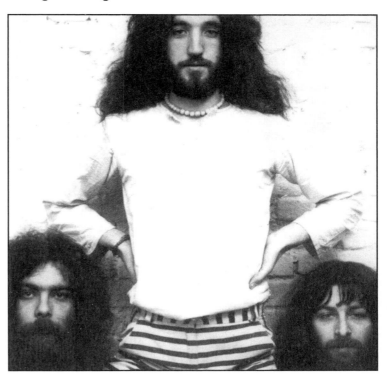

is The Birth, a more orthodox heavy Broughton exercise worded "In the heat shaking her meat/ Pointing her tits up to heaven". Exhibiting more esoteric "back to the farm" sentiments and Johnny Van Derek's appropriately country violin comes Piece Of My Own: "All I want is a piece of my own/A lot of land/And some sticks to build a home". Next track is the novelty strum-along Poppy, a country blues about pollution, with side-swipes at "plastic picnickers" talking about the length of his hair while he's there having deeply meaningful eco-friendly thoughts; although the title could equally be inferred to have an opium connection ("I laid on a poppy/It laid on me"). It is followed by Don't Even Know What Day It Is and House Of Turnabout. Madhatter seemed

like a word game send up, while Getting Hard is painlessly vocalless. After this respite the track bleeds into the impassioned vocal laid across What Is A Woman For?, recalling James Brown's It's A Man's Man's Man's World in an odd way, its long instrumental fade eventually dissolving into Thinking Of You with its pleasant mandolin bits. The album — which allegedly takes a not-inconsiderable (then) £10,000 to record through the months of July 1970 into February 1971 — closes with the violin-ridden Albatross-alike For Doctor Spock Parts One And Two, with the lyrics suitably dumbed down infantile (no pun intended) to "What if all the babies went on strike/For a better life to be born in". There's some nice Hawaiian-style slide guitar on the cut though...

Revolution For The Hell Of It

WHAT BULLETS ARE to war, ideas are to revolution. And in interview the Broughtons' stance and protestations are never less than political. Asked by Pete Frame if working through capitalist giant EMI compromises their ideals, Steve comments: "If we sell as many records as they would like us to, and if we sell as many as *we* want to, eventually we are going to turn people onto burning EMI down." Edgar, in the meantime, is telling *Melody Maker*: "Of course I believe. I've got a social conscience." For this is an underground band. It plays to the underground press. Its audience think of themselves as concerned, as radical. Even Broughtons' company — including eventually the Music Factory in Barnett — is called Weemeenit. When Edgar complains that "The planet's in a bad way, oh yeah/And I'm sitting here counting the days" (Call Me A Liar), his sentiments can be expected to get some kind of sympathetic feedback from their floating turned-on community. Even though his affirmations on behalf of the student shootings at Kent State — "She is my sister/He is my brother" (Freedom) — can so easily be seen as angst-by-proxy.

Sure, as political songs go, they lack the precision and focus of, say, Phil Ochs or even Billy Bragg. But that's hardly the point. Innocence can be a wonderful asset. And their *real* politics are the blurry edged fuzzy logic generational dialectic. Free sex, drugs and rock'n'roll can save the world. Terrorists are romantic idealistic figures, associated with liberation, not atrocity. Do the Broughtons sincerely believe all this? I suspect that — on at least one level, and with some reservations — yes, they do. 'Cos what can a poor boy do, 'cept play for a rock'n'roll band? And on stage Edgar is doing just that, up there playing a Fender Sunburn electric twelve-string, a Gibson Flying Arrow special and a Fender black Stratocaster. Steve does GBH to a Ludwig drum kit. Victor uses a Gibson Les Paul original bass, as does Grant. It's loose, but getting tighter. A working band loud and hairily unsubtle on gigs, but encapsulating that particular brand of inspired spontaneity that can sometimes catch the true essence of rock'n'roll.

Through April of the following year they embark on yet another UK tour to launch the fourth album,

In Side Out (Harvest SHTG 252, 1972). In many ways it contains a more playfully mature approach to lyrics. Although I Got Mad (Soledad) comments with unconvincing rage on the black American prison riots, running "I got mad, really bad/Have you heard about Soledad?/If they take me/I'll take ten for one': A manipulation of media-radical cliché slogans, issues and concepts, built around vintage riffs. "We said 'no more war'/What's there worth fighting for?" In some ways it compares favourably with John Lennon's similarly themed *Sometime In New York City* agit-prop album. The outer sleeve starkly reflecting the monochrome urban working class stance of Home Fit For Heroes, which runs a Dylan harmonica over more local issues: "Up there in the dockyards/They're fighting for their rights". The Broughtons taking on the Lennon Working Class Hero persona. But there's also humour: "You ask me what I'm doing/I'm just picking my nose/My lady's in the kitchen and she ain't wearing no clothes/I'm tired and crazy and I've just come off the road" — the kind of shambling haphazard Diary Of A Rock'n'Roll Band-type thing that Ian Hunter will later write so well. Other tracks include Chilly Morning Mama (an uncomplicated pop song), Totin' This Guitar and Rock'n'Roll (a slow cut, despite its title). It's Not You is eleven-minutes six-seconds long and full of full-on Magic Band dislocated rhythms and Stones raunch ("Jesus please be good to us/Or we'll all be on the news"), and The Rake, which — according to the lyric sheet — is a dirty song riddled with double entendres ("I was looking through her dressing drawers to see what I could find/I found the Ten Commandments stamped on her backside").

"CAN YOU DIG IT/OUT HERE ON A LIMB?" Sure, we can dig it. So dig this: "I love that little hole in the back of her head/I was looking down a needle/A needle full of red". Gone Blue is vaguely menacing, there are sounds of fighting. Don't know what it means, but it sounds nasty. Dreams have a dark side. Inside the gatefold there are atmospheric black-and-white shots of the wind-blown band amid a symmetrical complex of concrete motorway, interposed by effective rural shots. For every country idyll, there's a hard narcotic urban counterpart...

Dream's End/Dream-Sender

KNOWING WHAT we now know, it's strange to evoke other lost possibilities. We obsessively re-examine time into comforting geometries and reassuring clarities until we think we know it. And surely momentum, and the force of that momentum, must have already been at work, defining all the subsequent pathways. But pause on this space of grace. Because back then it still seemed other outcomes were open. And although the revolution hits the dead end of the 1970s in a dark Thatcherite backlash of right-wing violence, its legacy defines us here and now. Gay lib, animal rights, black liberation, feminism, eco-awareness, anti-globalisation protest: They all have their roots in the 'alternative society'. And the Broughtons are defined by their status as a counter-culture band. They can't really be considered any other way. Mick Farren goes on to mainstream music journalism and SF novels. Bopping elf Marc Bolan discovers electricity and becomes a tiny gilt-wrapped teen idol. But the Broughtons never achieve elevation beyond their ragged community. In the years to come 'underground' bands will become more pointedly, more knowingly political: Crass, Poison Girls and Chumbawamba. While for career outrage-ists like Limp Bizkit or Marilyn Manson, the profile gets meticulously rehearsed and premeditated. Into the platinum albums. And the greatest hits DVD compilations.

And, of course, for the likes of the Broughtons, the record companies *really* wanted marketable product all along. Like Family. Or Jethro Tull. And as a concession to such expectations, as the 1970s gets into its stride, they *do* get dutifully more adept at parcelling and selling units of supposed insurrection. But while I guess the Broughtons weren't exactly *averse* to the idea of a hit record, it was hardly their most urgent priority. It is open-ended. No one *really* knows what comes next. It could go this way… Or it could go that way… Nuclear Armageddon? World revolution? The dawning of the age of Aquarius? No one knew for sure. Everything changes. And everything stays the same.

But while we wait, *A Bunch Of Forty-Fives* arrives as a partial "The story so far" re-run of the Broughton's contribution to the German *Masters Of Rock* series: An album that inexplicably omits Apache Drop-Out. By contrast the British version is fleshed out by the 1972 single Gone Blue (HAR 5049), plus its B-sides Mr Crosby and the nice snarly intricate acoustic interplay of Someone ("Someone threw a bomb…"); all nicely repackaged by the Hipgnosis art studio who turn the band's faces green for the cover shot. But beyond the period covered by this retrospective comes the Broughton's final full-length play. The mid 1973 album *Oora* (SHVL 810) which further develops their hallucinogenically humorous angle — with that "long smoke in my hand" and "green lights in your eyes" — set to a slow acoustic knock-knock-knocking on heaven's door and ambient wind "I met her in the garden" sounds. The album's advertising graffiti is also effective, made up of pictures in cartoon-like sequence: A Spitfire, the Palestinian girl guer-

Some other albums:

LIVE HITS HARDER (1979)

AS WAS (Dec 1988, twenty track compilation, EMI Harvest GDP7 909632)

DOCUMENT SERIES PRESENTS: CLASSIC ALBUM AND SINGLES TRACKS 1969–1973 (1992 compilation)

OUT DEMONS OUT: THE BEST OF THE EDGAR BROUGHTON BAND (EMI Harvest 7243-5-31067-2-0, 2001 CD compilation)

rilla Leila Khaled, etc. While the sleeve superimposes the band over a quasi-mystical mandala symbol. But it is album of endings. It will be the last project on which Vic Unitt plays before he splits, contributing nice mouth-harp to Get Out Of Bed. And while it remains probably the band's best-recorded album, it meets standard Broughton sales.

The revolution that had never really happened is over, leaving the band stranded in a time warp of hungover images, legal complications and bad karma. Like a tired *deja vu* flashback of earlier "straight world" complications a last-minute Council veto means that a free gig for the Broughtons — organised by Granada TV in Stoke — has to be hastily transferred to another location. While through October they return to the site of their earlier anarcho-forays in Germany for a fifteen-date tour — their first since the lifting of the two-year ban — during which the group van blows out and has to be abandoned in Frankfurt. Then 1974 sees a Roundhouse concert embellished by their concession to Alice Cooper-style visuals: Stomping on flurries of cellophane butterflies! And this is the act they take with them on their first American tour.

But as they get back a series of management problems conspire to temporarily bring a halt to their recording and performing; and the first, inevitable, Broughton split is announced November 19, 1976. Finis. Yet a long and determined hangover of projects and reformations continue, including their final big-label album *Bandages* (NEMS NEL 6006, 1975), and the intriguing *Parlez Vous English* (1979) with its more complex history. Recording as The Broughtons they temporarily resume in 1979 as a six-piece, the original trio expanded to include Pete Tolson (another one-time Pretty Thing), John Thomas and Richard De Baston. The resulting album achieves its initial release through the Swiss Interhandel indie to coincide with European live dates, although a single from the set, All I Want To Be, contrives a UK release through EMI in a picture sleeve artfully mocking the then-current Sex Pistols product. Who was it who'd originally declared an intention of "burning EMI down" anyway? Later there will be a reversion to trio format for a further single, Ancient Homeland, from Sheet, a songwriter's workshop label. And although the promotional artwork shows them shorn of their extravagant hair in a style

more acceptable to the 1980s, its ironic attack on patriotism indicates that, lyrically, they've lost none of their political bite. An album called *Superchild* arrives in 1982 (there are probably others I've failed to track down, if so, why not let me know?), but by this time the CD reissue program is about to go back to the murky beginnings of it all, and start resurrecting the battered Broughton legacy. Even though, to reviewer Monty Smith of *Q* magazine, "The notion of the Broughtons on CD is kind of cute... Their records were more likely to be played on Dansettes in squats than on stereos in suburbia. If at all." Yet, even into the early nineties, there are tales circulating that Edgar can still be found performing part-time as a component of a late sixties revival show, and on the London pub circuit.

The counter-culture invented itself as it was happening. Extemporised it. Sure, there had been anarchists and romantic poet revolutionaries, jazz be-boppers and beat generation bohemians before it, but nothing on this scale. Nothing quite like this, ever. It was happening for the first time. And, like I said, the British 'underground' — Incredible String Band, Pink Floyd, *Nasty Tales*, Hawkwind, *FRENDZ*, the Deviants and the Broughton Band — might have started out as an often distorted "through the looking glass mirror image" of what they imagined was happening in the San Francisco Haight-Ashbury area, or New York's Greenwich Village, or MC5's Detroit. Yet hippies instantly became global. And it was this skewed misapprehension, this accidental Chinese whispers altering of nuance and emphasis that gives each scene its uniqueness. And now, with hippie head shop ephemera demanding collector's prices — posters, magazines and vinyl albums — those frequent reservations about The Edgar Broughton Band are frequently outweighed by affection, and in retrospect the whole thing even acquires its own internal, if shambling, consistency. One that was seldom apparent at the time. And strangely, I find myself enjoying those urbane guerrilla's albums in retrospect more now than I ever enjoyed their oddly assorted component cuts then.

Out, Demons, Out...

Record stores on the West Coast have been promised Dylan's Isle of Wight performance around mid-January, some unreleased Beatle material shortly thereafter… and that, bootleggers say, is just the beginning. *Rolling Stone, February 7, 1970*

THE REVISED 1978 edition of the book *The Beatles: An Illustrated Record* concludes on a chapter entitled 'Bootlegs'. It's a brief chapter — one whole paragraph in length — in which authors Roy Carr and Tony Tyler state that "the majority of the 200 or more Beatles bootlegs are drawn from live sources. With few exceptions most of these are of low fidelity".

Another book published the same year (*The Complete Bootlegs Checklist & Discography*), pegs the number of clandestine Beatles releases at 176.

It should come as no surprise that the number has increased over the years, given that interest in the world's most popular combo has failed to diminish. What is surprising, however, is the scale of this increase. In 1997 a reliable source listed no less than 1,800 different Beatles bootleg titles on the black market.[1]

But how much hitherto unreleased material can there be from a group who disbanded over thirty years ago? Quite a lot, actually. In their eight years as a creative unit, The Beatles made thirteen long-playing albums and twenty two singles: A body of work of some ten-and-a-half hours duration. However, the actual material the band put to tape that exists in the vault at EMI Records is close on 400 hours.

Even on their earlier sessions, the tape decks were opportunistically kept rolling between the different takes, should anything emerge that could be used on The Beatles' requisite Christmas Fan Club flexi record. Later on, the band's commercial clout was such that they could block-book a studio for months on end, where they not only recorded new material but *created* it, using the tape decks as an audio notebook.

On top of these studio fragments and outtakes are live recordings from around the world. How much of this particular legacy has been committed to tape is anybody's guess, suffice it to say that The Beatles played many hundreds of shows, from their early post-Quarry Men days in 1959 to the end of

Rarer Than Rare

Beatle Bootlegs & Outfakes

By David Kerekes

Top and centre *Get Back To Toronto* and
WBCN Get Back Reference Acetate, two of
the boots to feature radio broadcasts of the
never released *Get Back* album.
Above One entry in the eight CD series, *The
Twickenham Sessions*, excellent quality studio
recordings made on Jan 7–Jan 9, 1969.

their touring years in 1966 (after which The Beatles embarked on their "studio years").

There was a veritable explosion of Beatles bootlegs in the late eighties, when material of an unprecedented high quality became available on the black market. Some credit the period of 1992–1995 as being the heyday of the "modern bootleg era", and claim that by the end of the nineties the well had effectively run dry. However, 1995 happened to be the year in which The Beatles' *Anthology* series was released by Apple, and copyright authorities on both sides of the Atlantic stepped up their interest in under-the-counter activity. Playing it safe, many bootleggers simply took a hiatus. One of the most prestigious bootleg labels, Yellow Dog, was said to be "dead" in an internet article dated June 6, 1996: Only they resurfaced with previously unheard Beatles material all in superb quality (their recent *Day By Day* CD series, drawing from The Beatles' Twickenham sessions, has hit at least thirty volumes, each volume comprising of two CDs).

Conjecture as to how all this material came to be in the hands of bootleggers is rife. From the early seventies through to the eighties, Beatle bootlegs tended to comprise almost exclusively of film soundtracks and scarce, but hitherto available, recordings (such as the Christmas fan club records). With few exceptions, the only true unreleased material came in the form of live recordings,[2] understandable as the bootlegging public had ready access to concerts and material broadcast on TV and radio.

An early example of genuine studio outtake material finding its way onto bootlegs comes with the mix-up that was the aborted *Get Back* album. This ill-fated attempt to get away from the intricate production of their recent recordings and back to their rock'n'roll roots, left The Beatles so disappointed, disillusioned and bored they essentially gave up on the album. It was left to engineer Glyn Johns to try and piece *Get Back* into a commercial product. Suffering lengthy delays, the album was announced and acetates pressed before The Beatles vetoed it altogether.[3]

The *WBCN Get Back Reference Acetate* (released by Yellow Dog in 1993) features the entirety of the *Get Back* album as broadcast by WBCN radio in Boston on September 22, 1969. It comes complete with commentary between tracks from the DJ, who announces early on that he shouldn't really be playing the album at all, that it won't be available until Christmas, and that he may not get the opportunity to play much more if the record company gets wind of it. "In the meantime," he says, "everyone in the world has it."

FM radio broadcasts were the source for a number of *Get Back* bootlegs, the earliest being *Kum Back* (*sans* commentary) released in 1969, followed soon after by *Get Back To Toronto*.

The title of the latter bootleg was a nod to the rumour that *Get Back* — never officially released in any advance form — may have been leaked by a Beatle, notably Lennon whilst in Canada for the Live Peace in Toronto festival. (It was days after his arrival in Canada, on

September 13, 1969, that *Get Back* began to air.) It isn't the first time that Lennon — a collector of Beatle bootlegs — has been attributed with placing unreleased Beatles recordings into the public arena. Hugely disappointed at the fact that his experimental track What's Yer New Mary Jane had been rejected twice as a Beatles release,[4] Lennon supposedly traded a mono mix of the track with a London bootlegger in 1970 (or someone in New York) in exchange for vinyl copies of early Beatles BBC sessions.[5]

Lennon was also the unwitting source for a number of bootlegs that have generally come to be known as the "Auction Tapes". When their touring days ended in 1966 and Alf Bicknell's services were no longer required, as a gift Lennon gave the retiring Beatles chauffeur and bodyguard a collection of five reel-to-reel tapes, which The Beatles had used to record various oddments whilst on the road in 1963/64.[6] The tapes sat forgotten in Bicknell's garage for twenty years before being rediscovered and sold privately in auction in 1989.[7]

Another Beatle with a bootleg connection is Ringo Starr. Several months prior to its release in December 1968, Starr gave his friend Peter Sellers an advance preview of *The Beatles* a.k.a. the "White Album". Containing rough mixes of some of the songs that would feature on the official album, plus some studio banter, "The Peter Sellers Tape" wound up with bootleggers following the actor/comedian's death in 1980.

Although the examples noted above constitute a possible source for a small amount of outtake material, trying to determine where the wealth of material that flooded the market in later years may have originated is a whole different story. It is clear that much of it comes from a source remarkably close to the original master tapes, if not from the master tapes themselves. That these master tapes are locked away in a vault at EMI's Abbey Road studio, the logical explanation would be that an "insider" had to be involved (a sentiment shared by Sir Paul McCartney, who suggested in a 1990 TV interview that engineers or musicians could have procured the tapes).

In the late eighties, author and Beatles expert Mark Lewisohn was given access to The Beatles archives for research on his book *The Complete Beatles*

Recording Sessions. Upon its publication in 1988, the bootleg label The Swingin' Pig rode the wave of publicity created by Lewisohn's book and released *Ultra Rare Trax* volumes I and II, each containing thirty minutes of hitherto unheard Beatles outtakes and alternate takes. Say Jim Berkenstadt and Belmo in their book *Black Market Beatles*:

> The first *Ultra Rare* CDs sent shockwaves throughout the legitimate recording industry. Suddenly there were stereo releases of songs from the first four Beatles albums (which had been released as mono CDs by EMI and Capitol Records). Not only that, but the sound quality was even better than the legitimate compact discs!

No doubt the bootleggers used Lewisohn as a smokescreen, capitalising on the interest that his work and book had created while at the same time attempting to hide their real clandestine sources. Indeed, whenever bootleggers get wind of any activity within the vault at EMI, new illegal releases are sure to follow. Mark Hertsgaard, another journalist with access to the EMI vault, also sparked a flurry of bootleg activity, as did George Martin when he came to remaster The Beatles' catalogue for CD.

Another theory is that "runners" — the people who carry the tapes between the vault and the studios — may have helped to leak material.

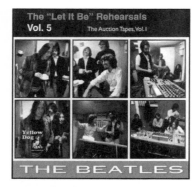

Top More rehearsal material in Yellow Dog's snappy, *The "Let It Be" Rehearsals Vol 5 — The Auction Tapes Vol 1*. Centre Vol 1 of the *Ultra Rare Trax* series — its release sent shockwaves throughout the legitimate recording industry. Above *Abbey Road* — containing material featured in EMI's Abbey Road Experience.

EMI employer Mike Heatley had this to say:

I've had several people say to me, "There must be a leak from Abbey Road because this stuff keeps on appearing." Well, if it was only material from Abbey Road that was appearing, then I would say that's probably right. But recently, a lot of material that was recorded well before Abbey Road has, after many years, started turning up. It's almost as if some collector from way, way back has sat on this stuff for years and then allowed it out. For instance, we've been looking for years for any of the old BBC recordings from 1962, and they were never, ever found. And yet three months ago, while in New York, what do I find? A bootleg.[8]

The idea that someone may have been sitting on this material for years is an interesting one, and appears to ring true for the "Get Back Sessions", as an intensive bootleg bust in January 2003 would seem to testify, netting 500 original Beatles tapes stolen in the seventies.[9]

But it'd be wrong to assume that the source of all illicit recordings is relegated to the distant past, or the notion that all bootleggers are sitting on a treasure chest, biding their time and picking their moment to release their wares. Indeed it didn't take decades for *Sessions* to see the light of day, a Beatles album prepared by EMI in 1984 but subsequently pulled. In time to meet the street date had EMI gone ahead however, bootleggers released a facsimile *Sessions*, sporting a replica of the packaging originally proposed by the studio, right down to the sleeve notes that promised "This is The Beatles album millions of fans have been waiting for…"

Another instance where bootleggers were quick off the mark is the case of The Abbey Road Experience. Whilst it was undergoing renovation in the summer of 1983, EMI decided to open Abbey Road's Studio Two to paying members of the public. Artefacts from The Beatles' recording days were on display, with the undoubted Experience highlight being an "audio visual presentation featuring film clips and promotional videos with previously unreleased recordings." Anticipation was high, as it was to be the first time EMI had officially given fans an opportunity to hear some of what lay unreleased in its vault. Needless to say visitors were not permitted recording equipment and, needless to add, bootlegs appeared soon after which were clearly recorded on smuggled equipment. On top of these ropy recordings however were other bootlegs that contained material of a much higher quality: Recordings that had originated from reels EMI had created whilst preparing the whole Abbey Road Experience.[10]

With regard to the "leaked" material in the above case, researchers associate a young balance engineer at Abbey Road studios by the name of John Barrett. Having been diagnosed ill with cancer in the early eighties, Barrett occupied his mind and time by listening through all available Beatles material and logging it. He did an exemplary job and

was the natural choice when it came to selecting material for the Abbey Road Experience. The taped copies he made for this purpose — much more material than was ever played at the show — remained in his possession up until his death in 1984, after which they were sold privately.

The Barrett tapes are the undoubted source for the higher quality Abbey Road Experience bootlegs, as they are the source for numerous boots that came to light in the late nineties (bringing us full circle: Somebody *has* been sitting on these things for years!).[11]

THE FIRST ROCK BOOTLEG is widely acknowledged to be *Great White Wonder* in 1969, a double album consisting of unreleased material by Bob Dylan. Enormous sales ensured that other illegitimate Dylan albums quickly followed, along with *Live Peace in Toronto*, a live artefact by John Lennon's Plastic Ono Band and supposedly the first non-Dylan boot. Not so well known is the fact that acetate discs of The Beatles were being circulated in Liverpool as early as 1963. The discs featured the — yet unsigned — band performing Richie Barrett's Some Other Guy live at the Cavern Club, as recorded by the Granada film unit for a regional interest television programme.[12]

The road for the clandestine record has since been long and somewhat treacherous. The business of bootleg records is not a scrupulous one, and while there are long-standing companies that make a concerted effort to bring out the best material available, many other companies are fly-by-nights who are intent on nothing more than making a quick buck. Material is constantly being repackaged, with new collections often comprising of tracks that have appeared numerous times before. At least one early bootlegger attributed false song titles to readily available material which had been lifted directly from official albums. In the case of the *Get Back* bootleggers who released material not yet officially issued, working titles or assumed titles would be used. *Renaissance Minstrels* attempted to kid listeners into believing they were privy to some lost Beatles concert, where in actual fact the album comprised of the band's performances on the *Ed Sullivan Show*: Chopped, changed and with more screaming dubbed over the top.

Above The first box in Yellow Dog's three box series, *The Ultimate Collection Vol 1* contains a CD entitled *First Recorded Hour of the Let It Be Sessions*. Below Another deluxe box set, from Vigotone.

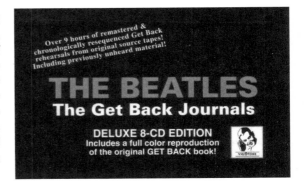

Top *Alone Together*, the 1968 entry in the *Artifacts* CD chronology.

Centre *Sessions* — the EMI album that never was, bootlegged in its entirety, even using the original EMI artwork.

Above *Hollywood Bowl Complete* — better quality than EMI's official *Live at the Hollywood Bowl*.

Right A seven inch single on coloured vinyl, a souvenir record issued for a Boston Beatles convention in 1976.

It is fairly common for bootleg albums to contain misinformation, erroneously accrediting tracks and their sources. Live concerts have often been attributed to the wrong town on the wrong date. Taking this liberty to its extreme, one bootlegging mastermind managed to conjure a completely fictitious location for his concert release, *Live Concert at Whiskey Flat*: In actuality The Beatles at Philadelphia's Convention Hall.

Although underground publications would often keep readers up to speed by reviewing bootleg records, they could also feed the misinformation cycle mill. *Rolling Stone*, for instance, whose role in helping to popularise bootlegs was key, published on September 17, 1970, an article entitled 'The Beatles Album No One Will Ever Hear'. It recounted the tale of master tapes for a fictitious Beatles album being stolen and accidentally erased. Typically, bootleggers would appropriate the title of the non-existent recording — *Hot As Sun* — for their own nefarious ends.

Beatles fans tend to be obsessive about their interest. It is no surprise to find that albums are available which document *The First Recorded Hour of the Let It Be Sessions*, *The Second Recorded Hour of the Let It Be Sessions* and *The Third Recorded Hour of the Let It Be Sessions* (the first hour opens with footsteps and musical equipment being assembled.) The strange thing is, it really is a fascinating world.

In school I knew a boy called Martin who, like me, was a Beatle fan when it was way uncool to be a Beatle fan. His musical tastes suddenly changed to Northern Soul and I asked him why this was. His reply:

"Because I've heard everything there is to hear by The Beatles."

My own interest in the band began to dissipate in the early eighties. By this point I too had heard all there was to *legitimately* hear by The Beatles, but, rather than moving toward Northern Soul, I drifted to Beatle bootlegs. These were still the bad days of vinyl, however, and burned too often I got out.

In 1996 I got back into The Beatles again. My interest was rekindled by the release of Apple's much lauded *Anthology* CDs. Kind of ironic that this official response to the bootleggers, a collection of rare recordings and outtakes, drove me to check out bootlegs once more.[13] What I discovered I simply could not believe: Not only had the wealth of material on the black market increased beyond any rational proportions, but it was of a staggeringly high standard, often presented in glorious packaging with full colour booklets.

Given the amount of literature that exists on Beatles lore, there are still many hazards waiting to snag the unwary traveller, no less one particular dastardly component of bootleg subterfuge: Beatle albums containing tracks that are not actually by The Beatles. This is material about which bootleggers remain deliberately ambiguous, tempting fans with the promise of some long lost musical gem. It could comprise material released by some artist in good faith but appropriated by the bootlegger as being Beatles related, or it may be by artists unknown trying to pass material off as a Beatles outtake.

Equate the concept with the NASA moon landing: We know what it's supposed to be, but is it real or was it faked?

This article concentrates on Beatle material which isn't The Beatles. Not the fake tracks created by people manipulating or remixing existing Beatle material, nor the cash-ins[14] or tracks by soundalike artists who make no pretence at being anything other than musicians who happen to sound a bit like The Beatles.[15] No, these are stand-alone curios, mystery tracks that have long haunted bootleg collectors and which steadfastly refuse to die.

And while you think you may have heard everything there is to hear by The Beatles, you really haven't heard the half of it.

Welcome to the weird and wonderful world of the Beatle "Outfake"...

Ads for boots (from top) appearing in *IT*, Dec 14, 1972–Jan 10, 1973, and the official souvenir programme of a 1981 Beatles convention.

Colliding Circles (1966)
Pink Litmus Paper Shirt (1966)

IN 1971, THE magazine *Disc & Music Echo* ran an article on unreleased Beatles recordings. Amongst the songs it claimed to be languishing in the vaults were the following *Revolver* outtakes: Colliding Circles and Pink Litmus Paper Shirt. Almost thirty years later, the author of the article, Martin Lewis, came clean and confessed that he had struggled to come up with a suitable list of rarities and so simply made up these particular titles in order to pad out the article! (Actually there are other titles Lewis made up for the purpose of what he regards as being an "otherwise scholarly article", but more on those later.)

Needless to say, fans ever since have been on the trail of these elusive tracks, refusing to acknowledge that they don't exist even after being informed of

the scam by Lewis himself, now a Hollywood based humorist and emcee of the annual Beatlefest fan conventions in Los Angeles and New York.

Sometimes in good faith, sometimes not, references to the songs have appeared down the years in books and on bootleg albums. In a section entitled 'Mid 1966 studio out-takes', the book *All Together Now* refers to Pink Litmus Paper Shirt as a song sung by Harrison, while the vocal on Colliding Circles is handled by Lennon. Desperate to come to terms with the mystery, one misconception created in order to compensate for the elusiveness of these two tracks is that they are actually alternate titles for other songs, notably Peace Of Mind (itself an

titles Colliding Circles and Pink Litmus Paper Shirt. Elsewhere, spoof band The Rutles incorporated Lewis' fabricated titles into the lyric of Unfinished Words, a track from their 1996 *Archaeology* album (on which Lewis was executive producer).

Maisy Jones (1965)
Baby Jane (1965)

MAISY JONES and Baby Jane are thought to be unreleased tracks from the 1965 *Rubber Soul* sessions. However, if one traces the origins of this information, it leads back to 1971 and Martin Lewis'

"outfake", see below) and Circles, a genuine unreleased Beatles track dating back to 1968 (but not one sung by Lennon).

Lewis states that Pink Litmus Paper Shirt and Colliding Circles are tellingly absent from the bootlegs that purport to carry them, and is quoted on the internet as saying, "One or two fans even told me they knew of people who had claimed to have heard the rare recordings of songs that I know beyond any doubt don't exist!"[16]

Whatever the contrivance behind them, these songs exist now in multiplicity and legend.

And to add further to the confusion, singer-songwriter R Stevie Moore — an acknowledged Beatles fan — went on to record songs of his own under the

article for the *Disc and Music Echo*.

Lewis acknowledged in 1999 that for his article on unreleased Beatles recordings he fabricated outright four of the song titles. Of these four, we have already discussed Pink Litmus Paper Shirt and Colliding Circles. The other two nonsense titles, claimed Lewis, were Deckchair and Left Is Right (And Right Is Wrong): Both of which are curiously absent from any Beatles reference work[17] and, perhaps more tellingly, have never been name checked on any bootleg.

Not having seen a copy of the original *Disc and Music Echo* article, I suspect that Lewis is guilty of a little extra subterfuge; that he did indeed fabricate four Beatles songs, but Deckchair and Left Is Right

(And Right Is Wrong) were not amongst them and instead these were actually fabricated by Lewis not in 1971 but over two decades later: When Lewis was promoting his own "autobiographical one-man show", which opened in Los Angeles in 1999.

Another two titles that undoubtedly do appear in Lewis' original article are Maisy Jones and Baby Jane. Writing about unreleased Beatles recordings in the July 1982 edition of *Record Collector* magazine, Peter Doggett referred to these particular tracks, stating that they had been

> mentioned in a *Disc and Music Echo* lead story in about 1971 as having turned up on a bootleg single. No such illegal record has been traced and no one has been able to confirm the existence of the tracks. The fact that the article actually described the songs suggests, however, that someone at *Disc* had heard the tape, which was then suppressed.

Later in the article Doggett admits that these and several other untraceable titles may simply "be the figment of someone's overactive imagination".

She Means A Lot (1965)
It's Gonna Be Alright (1965)

TWO MORE TRACKS rumoured to have been recorded during the *Rubber Soul* sessions, but never released. And while She Means A Lot and It's Gonna Be Alright remain highly elusive, unlike Martin Lewis' fabrications above, they have at least been heard in public... Well, once anyway, on Israeli radio.

The story is an interesting one but hinges entirely on an article that appeared in the Winter/Spring 1983 edition of the fanzine, *Beatles Now*. Beyond that nothing else is known about the songs.

Magical Mystery Tour: The Beatles Story was an Israeli radio series that ran every Friday for almost a year on the independent broadcast network. Each episode lasted an hour and, predating Apple's *Anthology* series by almost two decades, featured rarities (such as Lennon giving an impromptu rendition of I Want You together with a folksong in Hebrew to an Israeli newsman during his Amsterdam "Bed-In"

with Yoko) and unreleased material from bootleg sources. The series was the brainchild of one Yoav Kuttner — a DJ, rock specialist for radio and television, and a Beatlefan — who had been working at the station for eight years prior to coming up with *Magical Mystery Tour*. (Prior to this Kuttner had produced shows about record collecting, bootlegs and the "Paul Is Dead" hoax.) Despite having collected material for the series for some years, each episode was invariably rushed together for its weekly deadline, as last minute changes were made and new material incorporated.

Interviewed for *Beatles Now* by Daniel Beller, the thirty-six-year-old Kuttner had this to say about the mystery tracks:

> A very interesting item played on the series was a single that an Israeli Beatlefan picked up in England and was supposed to be an outtake of the *Rubber Soul* session. Hillel Abramov, who supplied most of the rarities played on the series, found this single which has two tracks — She Means A Lot and It's Gonna Be Alright — but bears no label or matrix number, but sounds very much like the Beatles. Since I'm not sure about its sources, I bought the record along and played it but told the story to the listeners as well, because the people who collect records can get conned with fakes and "supposed" rarities, a thing that happens a lot with Beatle bootlegs since no one controls the matter.

And so, for now, that's where the story starts and ends for these two unlikely Beatles obscurities.

Have You Heard The Word? (1967)

MANY BEATLE bootleg albums are comprised of material from a variety of different sources, from no one particular era. Although this practice has diminished somewhat thanks to a greater availability of product and more discriminating fans, it was a fairly regular practice for bootleggers in the days of vinyl to mix-and-match material, i.e. songs from the *Get Back* sessions of 1969 could be indiscriminately sandwiched between live concert

Some of the all-time classic bootleg album covers were drawn by William Stout, amongst them *Tales from The Who* and (above) *Spicy Beatles Songs*. In an interview for *The Comics Journal Special Edition Vol 3* (pub: Fantagraphics Books, 2003), Stout explained how he would deal with the bootleggers: "At 8:00PM on a Friday night I stood at the corner of Franklin and Las Palmas — not the best neighbourhood in the world, but not as dangerous as it is now. This coupe with smoked windows pulled up; the windows rolled down just a crack and some fingers pushed out a sheet of paper. I took the sheet of paper; it said, 'Rolling Stones Winter Tour' followed by a list of songs. A voice inside said, 'Same place. Same time. Two weeks.' Then drove away..."

performances and radio sessions from several years prior. This is the case with *Spicy Beatles Songs* (1973), an eclectic collection that has nevertheless elevated itself from the quagmire of interchangeable bootleg offerings: No small thanks to William Stout, whose sleeve art is a fantastic pastiche of a EC horror comic cover from the fifties.[18] For reasons known only to the artist, the sleeve of *Spicy Beatles Songs* features a half man, half pig creature (in a lab coat), closely reminiscent of Ringo Starr, who waves a hypodermic needle in front of a bound, large breasted female.

"But... Why doctor, why?!" pleads the woman.

"Because you called me a... A pig!" responds Ringo.

"Good Lord! Choke..."

Another facet which has helped sustain *Spicy Beatles Songs* as something of a legendary release is its inclusion of two rare studio cuts, despite the fact that both tracks have since appeared elsewhere in better quality. These are What's The New Mary Jane (credited here as What's Yer New Mary Jane)[19] and Have You Heard The Word? The former is a Lennon-penned number rejected by the rest of the Beatles, while the latter isn't The Beatles at all.

The opening track on *Spicy Beatles Songs*, it isn't difficult to see why Have You Heard The Word? might be misconstrued as a Beatles track. Recorded in 1967, it's a catchy, polished, not unpleasant song imbued with close harmonies and a suitably uplifting "Summer of Love" mentality. Lennon himself supposedly professed a liking for the song, stating in 1974 that "It sounds like us. It's a good imitation." And it was a good enough imitation to cause Yoko Ono to register the song in 1985 for copyright protection.

Initial doubt as to whether it's actually The Beatles however, sits with the title of the track itself: Why would the band — in their most creative period, no less — endeavour to create a song that lyrically drops them back a couple of years to The Word, a track they themselves had recorded for *Rubber Soul* (and whose oft repeated refrain is "Have you heard the word is love?")?

Not long after *Spicy Beatles Songs*, in 1975, the track resurfaced on the eponymous album *Have You Heard The Word*.[20] In its review of the album, *The Complete Bootlegs Checklist and Discography* states that Have You Heard The Word? is from a 1970 rehearsal which included Bee Gees personnel, and credits the song as being "the last Beatles recording". One need only listen to the brooding and generally introspective material the Beatles were recording during their final torturous months as a working unit to appreciate that an effervescent, bubbly song about global love like this one doesn't fit.

In reference to another album on which the track appears, *Their Greatest Unreleased*, Vol XIV of the bootleg bible *Hot Wacks* similarly credits Have You Heard The Word? as being the Beatles *circa* 1970 working with The Bee Gees. (Elsewhere in the same edition, the *Hot Wacks* compilers refute that it's The Beatles at all.)

Why bootleggers should hit on the notion that the song dates from

It's Not Too Bad (PegBoy 1997), in a slipcase and with a twenty eight page booklet, documented the evolution of the complex Strawberry Fields Forever, beginning with Lennon's acoustic demos and featuring many of the studio takes.

1970 rather than the more feasible period of the mid to late sixties, may have something to do with it fitting smugly with another rumour: That Ringo Starr was working with Bee Gee Maurice Gibb in 1970 on an ill-fated electronic album.

But there *is* a Bee Gees connection to the song. Unfortunately it doesn't extend to any Beatles.

In 1967 a duo by the name of Tin Tin[21] were recording an album in London's IBC Studio. Tin Tin comprised of Steve Groves and Steve Kipner, the latter going on to achieve much success as a songwriter, penning hits for the likes of Chicago, Olivia Newton John and Christina Aguilera. Tin Tin's producer was Bee Gee Maurice Gibb, who interrupted the recording session when he arrived at the studio with his wife Lulu, Lulu's brother Billy Laurie, and a bottle of scotch. Falling into a drunken reverie and unable to continue with the business of recording of an album, someone suggested instead that it might be a lark if everyone got around the microphone for an impromptu impersonation of The Beatles. The track was Have You Heard The Word?, which Tin Tin had cut for their album and was nearing completion. Groves, Kipner, Gibb and Laurie proceeded to lay down a live vocal track, without any overdubs. No one ever intended it would ever see the light of day. It was simply done as a joke and forgotten about by the band...

It seems that prior to finding its way onto *Spicy Beatles Songs* in 1973, a deception was underway as early as 1971, when person or persons unknown issued Have You Heard The Word? as a single (on the Beacon label) and credited it to the mysterious, pseudonym-sounding The Fut.[22] Co-writer Steve Kipner claims not to have been aware of its availability, nor that anyone involved in its recording had even *heard* the track, until some twenty-odd years after recording it.

The L S Bumble Bee (1967)

ANOTHER SONG from 1967 attributed to The Beatles by some bootleggers is The LS Bumble Bee. It wound up on self-titled bootleg albums released by CBM and Berkeley in 1975 and 1976, and in more recent years on the *Day Tripping* bootleg.

In actuality a performance by British satirists and comedians Peter Cook and Dudley Moore, The LS Bumble Bee is a topical, humorous take on the then burgeoning acid scene. The story goes that someone heard the record and decided that the agreeable slab of pop psychedelia was actually Lennon: More specifically a Lennon rebuke at the ballyhoo The Beatles had faced over the drug connotations in his *Sgt Pepper* track, Lucy In The Sky With Diamonds.

Some of the bootleg albums to include the outfake, Peace Of Mind: *Documents Vol 3, Doll's House, The Psychedelic Years* and *20 x 4.*

Even when the true artists responsible for the record filtered down to the bootleg buying underground, the Lennon connection resolutely stayed put. If The Beatles weren't actually performing on the record, the story went, then Lennon at least had to have *written* it. Lennon is clearly nowhere to be heard on The L S Bumble Bee, but a listener not familiar with the comedy duo might have misconstrued their dry sense of humour, and in particular Peter Cook's mordant vocal contribution ("Oh, druggy, druggy. Freak out, baby, the bee is coming") as a Lennonism. After all, Lennon made no secret of his fondness for funny voices, as anyone who has listened to live Beatles performances and studio banter will testify.

The simple fact is that if the record is supposed to be Lennon's comment on the Lucy In The Sky With Diamonds debacle, as was claimed, how are we to account for the fact The L S Bumble Bee actually predates the *Sgt Pepper* album — and the release of Lucy In The Sky — by several months?

The LS Bumble Bee received its first public airing in December of 1966 on Peter Cook and Dudley Moore's BBC2 TV show, *Not Only… But Also*. Seeing as it was an episode in which John Lennon had a cameo in one sketch (as a lavatory attendant no less), it seems highly likely that here lies the origin of The Beatles' Bumble Bee myth. Indeed it was later in the same sketch (after Lennon's fifty-one second appearance was over) that Cook joined the Dudley Moore Trio and an orchestra for the song's debut.[23]

Peace of Mind (1967)

RUMOURED TO HAVE been found in a trash bin at Apple (or EMI) in 1970, Peace Of Mind is an almost legendary Beatles outfake. The track first came to light in 1973 on the *Supertracks* album, and has featured elsewhere many times since with bootleggers eager to cash in on yet another supposedly fresh Beatles discovery. The label WRMB were particularly fond of it, including it on no less than three of their releases: *Angel Baby*, *Dr Robert* and *Magical Mystery Tour (Plus Beatles Rarities & True Collector's Items)*.[24]

Though widely acknowledged now as a fake, for many years Peace Of Mind had Beatle fans scratching their heads. Castleman and Podrazik accepted the track as legitimate when they stated in *All Together Now* that, "In spite of the very bad recording available, it still deserves close attention."

Peter Doggett in *Record Collector*[25] wasn't quite so convinced. He wrote in his 1982 article on unreleased material:

> It certainly sounds like the Beatles, although it's hard to imagine that they would have spent much time on such a slight song. There's an acoustic guitar opening, followed by a long succession of lines with harmony vocals — almost every one of which is in a different key to the previous one! Those lyrics that can be made out sound, frankly, awful: "We'll do things never done before, we'll win things never won. And just before it's over, it's really just begun" is a representative sample... There's some backwards guitar sounds to add the proper period flavour.

Erek's Beatles Page on the internet collects together expert conjecture pertaining to Peace Of Mind. Belmo, author of *Not For Sale*, regards it to be either a song lifted from the soundtrack of "a film about witches" (which he is unable to identify) or an outtake by Apple recording artists Trash, who released one single, a cover of the Beatles' Golden Slumbers/Carry That Weight, in October 1969. The name of the band and indeed the B-side of their single — Trash Can — seem rather convenient when one compares them to the rumour about where Peace Of Mind was supposedly discovered... In the trash.

Doug Sulphy, author of *The 910's Guide to the Beatles' Outtakes*, states that

> ... it isn't [the Beatles]. I've been told by someone who was around at the time that they heard the track was originally prepared as a Pink Floyd outfake, but then put it on a Beatles record instead.

Well, it sounds less like Pink Floyd than it does The Beatles. I actually think Peace Of Mind is a passable attempt to imitate post-psychedelic era Fab Four, with its ethereal droning vocal, Dear Prudence style guitar picking and nonsense lyric ("A safety pin returns my smile/I nod a brief hello"). It also has a nice imaginative flourish towards the end and convenient tape distortion helps mask someone's sparse attempt at doing Lennon.

In an article on early vinyl bootlegs, writer John Winn claimed that the track is "merely some stoned bootleggers with a tape recorder and too much time on their hands." Peter Doggett corroborates this theory when he says in his *Record Collector* article that, in spite of the poor quality of the tape, the singers on it appear intoxicated.

Peace Of Mind has generally disappeared from bootlegs of late, but did attempt a recent comeback on the *Day Tripping* album, together with the fresh assertion that it was a George Harrison acetate "with sundry unidentified participants, possibly including Donovan and Mike Love".

This flies in the face of earlier speculation that John supposedly handles the lead vocal, and one can assume it to be misinformation intended to throw fans a new bone and generate fresh interest in the old track. The Beatles did meet and jam with Donovan and Beach Boy Mike Love in Rishikesh, India, during their sabbatical to learn transcendental meditation. However this wasn't until 1968, and actually places Peace Of Mind — should it be legit, which it isn't — in the 'White Album' era more than it does *Magical Mystery Tour*.

To muddy already murky waters, Peace Of Mind is often credited as being an alternate title for Pink Litmus Shirt, the Beatle song title fabricated by Martin Lewis in 1971 (see above). Another alternate title

Anthology Plus was a two CD boot that mimicked the official *Anthology* release and classed itself as 'an authorative addition' to that series. While it did contain much interesting material, it also had the outfakes I Want You (She's So Heavy), a version of the song said to feature McCartney on vocals as opposed to Lennon, and Oh, I Need You. One or the other — or both — these songs also appeared on the albums *Road Runner*, *The Last Year* and *The Abbey Road Companion*.

is The Candle Burns, which is a line lifted from the opening verse.

More recently, Peace Of Mind (along with Colliding Circles, Pink Litmus Paper Shirt and others) has turned up on the album *Apology*. The album has tracks by artists known and unknown using the collective name, The Cheatles. Not to be confused with the tribute band of the same name, The Cheatles was once a website featuring fake Beatles songs collected or created by fans (the powers that be shut it down). According to Rondo Records' online music store [**w**] www.7ater.com/rondo/Apology/apology.htm, *Apology* is an Internet only album, but as of writing it isn't clear how one goes about obtaining it.

I Want You (She's So Heavy) (1969)

LENNON AND McCARTNEY had a tradition of sharing the song writing credit on most everything they did together, even though it was uncommon for them to write anything on a fifty/fifty basis. The rule of thumb is that if Lennon is the featured vocalist he has had the greater input writing the song, and vice versa with McCartney.

By their own admission, the material on their 1968 'White Album' was far from a group effort, but essentially songs performed by Lennon or McCartney backed by the rest of the band.

Therefore, it was nothing short of revelatory to learn that I Want You (She's So Heavy), recorded by the Beatles for their *Abbey Road* album during one of their last sessions together, had found its way onto bootleg with a McCartney vocal. It was after all, to put not too fine a point on it, a Lennon track.

With its pounding drum beat, heavy guitar riff and primordial lyric, I Want You is an obvious precursor to the music on Lennon's first post-Beatles album, *Plastic Ono Band*, and completely removed from the direction on which McCartney was heading with his own solo outing.

The anomalous version of the song was recently featured on *Anthology Plus*, an unofficial two-CD set hot on the heels of EMI's *Anthology* series. Of the recording the liner notes say:

> The Beatles follow the footsteps of Cream as a heavy rock trio while George is absent with this early version of John's I Want You. Funnily enough, it is Paul who sings here, making this the only occasion where he takes the lead vocal on a Beatles original he hasn't written.

Why would McCartney leave it until February 1969 — the month I Want You was recorded — to try his hand at a Lennon cut? And why — given that their relationship was at an all-time low — would Lennon even let him? The answer is rather simple: Although musically the track on *Anthology Plus* is a rather passable note-for-note impersonation of The Beatles, it certainly isn't Paul McCartney on vocals (nor any other Beatle for that matter). The whole thing is a hoax by artists unknown, even down to the surface noise which permeates the track.

Mark Lewisohn in his 1988 book *The Beatles Recording Sessions* says that out of the thirty-five different takes of I Want You recorded by The Beatles at Trident Studios, one was an experimental take sung by McCartney. Updating this information for his *Complete Beatles Chronicle* in 1996, however, Lewisohn omits any reference to the McCartney vocal, suggesting that perhaps Lewisohn too was initially fooled by the mystery bootleg track. Certainly other critics still insist on its authenticity: Belmo in *Not For Sale*, for instance, regards it as the "highlight" of the *Rough Notes* album (on which the track first appeared), adding that repeated listenings have convinced him that it is indeed McCartney on vocal: "Rare!"

Oh, I Need You (1969)

THE AFOREMENTIONED I Want You first came to light on the bootleg *Rough Notes*, released in 1980 by Audifon, where it was credited with having come from a 1968 EMI acetate. The track that followed it on *Rough Notes* was Oh, I Need You. This too was said to be a 1968 acetate, a previously unheard cut by The Beatles with Lennon on vocals.

If I Want You purported to show McCartney "doing Lennon", then it's a rather big leap of faith to expect that Lennon reciprocated with Oh, I Need You, a maudlin, sentimental ballad of a type the bespectacled Beatle most certainly was not fond. Lennon's disdain at having to perform slow songs was made quite evident at the beginning of 1969, during the Get Back sessions, when he contributed a begrudging, half-hearted, cock-up of a performance to the McCartney ballads Let It Be and The Long And Winding Road.

More than that, however, the dirge sounds nothing like The Beatles and the vocalist certainly isn't Lennon. (It may well be the same guy that's doing the McCartney impression on I Want You.)

Always back-to-back, I Want You and Oh, I Need You have appeared on several bootlegs since *Rough Notes*, but tellingly not on any bootleg from the more meticulous and respected labels, such as Yellow Dog or Vigotone.

The compilers of the 1989 boot, *The Complete Recording Sessions* Vol 2, tried to add a little more

colour and depth to the myth when they claimed that Oh, I Need You was "a very melodic love song to Yoko".

A reviewer for the Beatles fanzine *Come Together* (Vol 2, No 8) suggested in 1980 that, while not The Beatles, the song was "a minor hit in America". For whom he doesn't say, though Belmo, in his book *Not For Sale*, suggests The Iveys.

The Long And Winding Road (1968/69)

A SUPPOSED HOME rehearsal tape of this McCartney penned Beatles composition (possibly the worst song in the whole Beatles canon) can be found on the *Hodge-Podge* bootleg. Like I Want You mentioned earlier, the song itself is a Lennon/McCartney composition, but there is much to suspect that none of the Beatles are present on this actual recording at all; that it is merely somebody with a tape recorder atop a piano trying to create new bootleg fodder. The sleeve notes suggest the track might be the earliest known recording of The Long And Winding Road, but then queries the authenticity of the track "since the piano style does not really sound like McCartney's... You be the judge."

Of course, in order to judge anything you would first need to buy the album.

Four Nights In Moscow (1969)

FOUR NIGHTS IN MOSCOW is cited in *All Together Now* as being recorded by The Beatles in their *Abbey Road* era but never officially released. To the knowledge of this author, it has yet to appear anywhere.

The sessions for the *Abbey Road* album were essentially an extension of the sessions for *Let It Be* (or the *Get Back* sessions as the whole thing has come to be known), which ran through the greater part of January 1969. Director Michael Lindsay-Hogg — who had previously worked with The Beatles on promo films for Paperback Writer and Rain, and with The Rolling Stones on their *Rock And Roll Circus* TV special[26] — was assigned the task of making a fly on the wall documentary of the group preparing new songs for an as yet unscheduled live appearance. The cameras and tape decks were left rolling, and as a consequence, the most miserable and frustrating period of The Beatles' entire career was documented for posterity: Hours and hours of lacklustre rehearsals and rambling jams that have since found their way onto bootlegs. Apart from the occasional moment when everything seemed to fall into place (i.e. The Beatles were all playing the same tune), these recordings are a window on a band that at best had little faith in itself anymore. Harrison described the experience as "the low of all-time". Lennon regarded it simply as "Hell".

Of course, much of these recordings don't comprise of any music at

Top The Lost Pepperland Reel and Other Rarities features outtakes, Lennon mellotron experiments and sound effects reels from the *Sgt Pepper* era.
Centre and above Get Back with Let It Be and 11 Other Songs is the unreleased version of the *Let It Be* album along with the rooftop concert. *The Complete Rooftop Concert* offers the same concert along with warm ups and interviews.

all, but bored conversation and heated exchanges. My own suspicion is that the mystery track, Four Nights In Moscow, isn't actually a musical number at all, but derivative of a particularly memorable slice of dialogue, misinterpreted as it made its way down the grapevine from one excitable fan to another.

One of the hotbeds of contention during much of the *Get Back* sessions was the issue of the live concert: Where it should take place and whether it should take place at all. Suggestions for possible locations were thrashed about, mainly between McCartney, Lindsay-Hogg and film producer Denis O'Dell; the other Beatles — Harrison particularly — remained reticent about the whole idea of performing live anywhere.

Refusing to let up, Lindsay-Hogg decided that each Beatle would be allocated a code name for reasons of security should the concert take place overseas. George, he said, would be "France"; Starr would be "Russia", etc.

Lindsay-Hogg: "We've got to get the right audience for Russia."

Lennon: "Oh, Russia! That'd be great!"

Lindsay-Hogg: "No, that's Ringo's code name."

Typical of the fractious nature that dialogue often took on the *Get Back* sessions, this unintentionally amusing exchange has passed into Beatles legend and inspired the title of at least one bootleg album, *Codename Russia*.

Could it be that the roots of this unlikely lost Beatles track has its origins in this conversation, and the general debate over possible live venues (for a concert that ultimately took place on the Apple rooftop)? Following Back In The USSR, the opening track on the 'White Album', would The Beatles really bother with Four Nights In Moscow?

These 1969 sessions are also rumoured to have resulted in a Ringo track entitled I Should Like To Live Up A Tree, but which common sense dictates is actually nothing more than a derivation of the opening line to Ringo's Octopus's Garden (as featured on *Abbey Road*).

Day Tripper Jam (1970)

ACCORDING TO bootleg lore — or rather, several releases of the highly suspect Day Tripper Jam

— at some suitably vague point in 1970, at an indeterminate locale, the paths of John Lennon and Jimi Hendrix crossed.[27] The result: A ropey version of Day Tripper, the riff-driven 1965 Beatles single. This author has a distant memory of picking up Day Tripper Jam as a seven-inch single release (possibly one-sided), credited to The Beatles and Jimi Hendrix. *The Complete Bootlegs Checklist & Discography* credits the jam as "Good Mono", but the quality of the recording I heard was nothing short of diabolical: A murky affair sounding as if it had been recorded onto a cheap personal tape deck from behind several closed doors. For such a historical union this seems an opportunity grossly wasted. Calling the whole thing a "jam" is rather a stretch, too, seeing as the track adhered closely to the original version without any of the blistering guitar pyrotechnics one might expect of a free-wheeling, jamming Hendrix.

Jimi Hendrix was quite fond of Beatles songs, having performed covers of Tomorrow Never Knows and Sgt Pepper's Lonely Hearts Club Band. I rather think that the Day Tripper Jam comes from a session which The Jimi Hendrix Experience recorded for the BBC sometime at the end of the sixties. A cover of Day Tripper — running in at three-minutes twenty-five seconds — can be found on The Jimi Hendrix Experience's *BBC Sessions* album released in 1998. Whether this cut, however, is the same as the one on the bootleg single I heard all those years ago is impossible for me to say (having flogged the thing the moment the needle hit the play out groove).

Lennon doesn't play on the Hendrix BBC sessions, and I would very much doubt he ever played with Hendrix period. But, if you're wanting tenuous connections — and that is often all it takes for the bootlegger — here are three... (i) It might now seem like an apocryphal tale, but Jimi Hendrix got his big American break as an opening act for The Monkees (a band, incidentally, he hated). Although the actual invite came some time after Hendrix's performance at the Monterey Pop Festival, it was in London in 1966 at a dinner party attended by John Lennon, Paul McCartney and Eric Clapton, that Monkee Mike Nesmith first heard the guitar virtuoso. According to Nesmith, Lennon arrived late, enthusing over Hey Joe — the debut single of one Jimi Hendrix — insisting he play it to everyone.

(ii) Some years later, in December of 1968, John Lennon and Yoko Ono made a guest appearance on *The Rolling Stones' Rock And Roll Circus*. Here they performed a live version of The Beatles' track Yer Blues, backed by Keith Richards, Eric Clapton and Mitch Mitchell, drummer for The Jimi Hendrix Experience. (iii) Harrison performed a brief fifteen-second rendition of All Along The Watchtower on January 8, 1969, while The Beatles were rehearsing at Twickenham. Hendrix, of course, had had a hit with his cover of the Dylan track late in 1968.

So endeth the tenuous Beatle/Hendrix connections.

Outfakes that are Genuine Outtakes

GIVEN THE SHEER scale of bootleg material available and the slight information that often accompanies it — if any information at all — there are some instances in which researchers wrongly dismiss genuine Beatles recordings as outfakes. For example, a fairly nondescript track called, simply, 12-Bar Original has been surfacing on bootlegs for some years now. The fact that it's an instrumental seems rather convenient: How much easier it would be to fake The Beatles if no vocals were required! Another thing that works against the track being legit Beatles is the fact that The Beatles weren't great fans of instrumental numbers, having released only one during their entire career[28] (the trippy Flying from *Magical Mystery Tour*).

The liner notes for the 1992 bootleg, *Hodge-Podge*, hardly imbues confidence in the listener when it describes 12-Bar Original thus:

> This odd instrumental circulated among collectors as 12-Bar Original before the actual thing surfaced... We're not sure what, when or even who this is.

A reviewer on Gernhardt's Beatles Pages responds:

> Wait! I know what this is! It's an outfake!

It's easy to see why people would consider 12-Bar Original to be a fake. The rather murky quality of the song on the *Hodge-Podge* album didn't help matters, but then the song itself doesn't seem to fit the time period in which it was apparently recorded. According to Mark Lewisohn's *The Complete Beatles Chronicles*, the Beatles recorded the track in November 1965 for possible inclusion on *Rubber Soul*, an album for which the band were lacking material. However, this rather loose adaptation of Booker T And The MGs' hit record Green Onions[29] (released some three years earlier), hardly seems in keeping with the forward-looking material that would ultimately make up *Rubber Soul*.

Still with Lewisohn, The Beatles recorded two takes of 12-Bar Original. Take one broke down, while the second take was completed without over-dubs and clocked in at an uncharacteristically long six minutes thirty-six seconds.

A truncated and specially remixed version of the second take made it onto The Beatles' official *Anthology 2* compilation in 1996. In spite of it exhibiting certain characteristics of The Beatles' 'sound' (clean guitar; plenty of hi-hat; harmonium in the background), it is only really the count-in by Paul McCartney that suggests the song might be a genuine lost Beatles cut. More concrete proof can be found on the *Soul Sessions* bootleg, which includes not only the complete version of 12-Bar Original take two, but also the fluffed thirty-seconds of take one *and* a rehearsal take! Take one also happens to be preceded by the Abbey Road engineer cueing the tape: A voice familiar to any student of black market recordings.

Another ambiguous instrumental track which has appeared on bootleg is something known as Sessions Jam. Its credibility as a lost Beatles piece lay in the fact that Yellow Dog, a bootleg label of some repute, happened to have released it (on *Get Back and 22 Other Songs*). But when researcher Doug Sulphy said he regarded the track as a fake, common opinion followed suit.

Session Jam supposedly came out of The Beatles' arduous recording sessions in January 1969. An inside source for Yellow Dog would claim that the track was discovered on a reel of tape along with a version of Let It Be. At least one fan, a certain Tom Welch, has flown into the face of adversity and put

A new generation of bootlegs don't bother trying to hide the fact that they contain outfakes — indeed, that's the whole point: *Men & Horses, Hoops & Garters*, for instance, and the series' *Fab Forgeries* and *Oopsology*. *Fab Forgeries* combines alternate takes of existing songs in order to produce fresh mixes. It includes stereo mixes of early material like Love Me Do and Money (That's What I Want) that feature both Ringo and Pete Best's drums (in order that the listener can analyse the two). *Oopsology* is a collection of officially released tracks that have been processed using the Out Of Phase Stereo (OOPS) technique, which effectively isolates the vocal track.

up a credible argument as to why Session Jam could indeed be The Beatles. Welch is convinced that the style of the playing and sound of the instruments fits in with The Beatles of this era, and further observes guitar parts and chord changes that would be used shortly afterwards on McCartney's debut solo album (in the song Maybe I'm Amazed)…

It is time to draw our trek through Beatle outfakes to a close. Having discussed all of the more famous examples,[30] there remains the question of why outfakes should exist in the first place. I don't doubt that some of the people responsible for these recordings are driven by the challenge of trying to emulate The Beatles. While for others, as we have seen in at least one instance above — Have You Heard The Word? — the intent has been nothing more subversive than having a drunken laugh. There was no bigger picture, no consideration by the artists that the track should ever see the light of day.

Then there is the commercial aspect of the outfake. What greater selling point could a bootlegger have than the promise of a newly unearthed recording by the Beatles?

Outfakes are essentially a seventies phenomenon, an era that saw a marked decline in genuine Beatles material, leaving bootleggers to grab at whatever morsel they could. Albums were repackaged, retitled and "recycled almost monthly", according to Jim Berkenstadt and Belmo.[31] It is therefore easy to understand why many bootleg albums of this period were such a mash of material, eclectic compilations of recordings from no one particular era and bearing no common musical thread. Whatever the content, it seemed, the albums would sell anyway.[32] This lack of material is also the reason why some Beatle boots include material by other artists (*Beatles/Stones Live* and *Elvis Vs The Beatles*, for instance). It is also the reason why material that bears only a superficial or tenuous connection to the band often wound up on Beatle bootlegs (because they guest starred with The Beatles in the ill-fated TV production, The Bonzo Dog Band can be heard on *Magical Mystery Tour Plus...*). Sometimes there would be no connection at all.

Nowadays, outfakes rarely come in the guise of hitherto unreleased tracks supposedly rescued from trashcans: One reason being that the market is generally too savvy to believe there can exist any more Fab Four music not already documented. The days of stoned bootleggers singing into a tape recorder are also long gone. In keeping with technological developments, outfakes today are a more subtle affair, in which bootleggers with a mind to deceive will create outfakes from existing Beatle tracks. For instance, *The Alternative Abbey Road* boot contains some dubious mono mixes of tracks from the penultimate Beatles album: Dubious because *Abbey Road* was never mixed into mono. Similarly, tracks from the Ed Sullivan performance that appear on the *Artifacts: Beatlemania* album are lifted from a good source but are fake stereo, created by the bootlegger. Many boots also contain what are purportedly significantly different mixes of Beatle tracks, but in actuality are simply single channel recordings of stereo material. *Finest Collectors* and *Girl Outtakes*, for instance, are two bootleg albums that attempt to pass off one-channel outfakes as rare versions of familiar material.

More creative yet, why not create new rarities by chopping and changing, or binding together *old* rarities? For instance, if you edit out all the dialogue from the 1967 Beatles fan club Christmas single — as bootleggers claim to have done for their *Anthology Plus* album — you are left with several repetitive verses of a frivolous, albeit original, Beatle tune entitled Christmas Time (Is Here Again).

Bootleggers and official sources have been responsible for manipulating existing tracks in this way, in an attempt to create fake rarities or alternate mixes known to have once existed. A "full length version" of You Know My Name (Look Up The Number) cobbled together using the original single B-side and material from *Anthology* can be found

on the *Get Back Second Mix* boot. The bootleggers responsible for the *Off White* album on the other hand, saw fit to add their own sound effects to several of the tracks.

In the realm of official releases, the US edition of *The Beatles Rarities* album released by EMI/Capitol in 1980, includes a cut and paste Penny Lane. Originally released to radio stations in the US and Canada in mono only and with a closing horn solo that was later trimmed for commercial release, the *Beatles Rarities* sleeve states of the track:

Penny Lane has never been released in the US in true stereo (believe it or not). Capitol has taken a stereo version of the song and tagged on the rare final notes which, collectors might argue, actually creates yet another version of this classic tune.

changed. No longer do outfakes hinge upon mimicry or fresh tunes: Now outfakes depend on how adept the bootlegger is at fading one channel of a Beatles track into the other, and tweaking the right knob at the right time. Now they depend on what technology the bootlegger has at his or her disposal.

Which is boring really; a rather lame addition to the outfake canon and to Beatles lore.

However ironic or perverse it may sound, this latest generation of outfake is unlikely to stand the test of time as the likes of Peace Of Mind or Have You Heard The Word have done. Beatle music that isn't The Beatles.

Recently we have seen more bastardisations from official sources in the likes of the remixed *Yellow Submarine* and sundry patchwork tracks on the *Anthology* series.

Gone are the days when you could see a possible outfake coming a mile off, courtesy of an unfamiliar song title and desperate, ambiguous sleeve note ramblings. It might even have taken a couple of concerted listens before you could deduce that, contrary to what it said on the sleeve, the track was not actually The Beatles. But now the rules have

PREVIOUS PAGE

From top *Arrive Without Aging, Code Name Russia* and *Off White.*

THIS PAGE

Apple played around with the mix (and track listing) on the 1999 rerelease of *Yellow Submarine*, and removed bum notes for their 2003 release *Let It Be... Naked*. Included was a second CD featuring snippets of dialogue taken from the January 1969 recording session.

The 1970s Bootleg Scene

A young collector in the south of England and dealers in the north

■ **COLLECTORS**
Roger Sabin, as told to David Kerekes

IT WAS ABOUT BEING A FAN — an absolute fan and wanting just everything by the bands I was interested in. I was a huge Deep Purple freak when I was fourteen or fifteen.

The first way into bootlegs was via fan clubs. I was a member of the Ritchie Blackmore Appreciation Society. Some later fanzines would have reviews of bootlegs in them, and I asked the person who ran one — a zine called *Stargazer* — where I could get boots, but he wouldn't tell me. Eventually I found someone through the zine who was distributing bootleg cassettes, from whom I got a list with cassettes rated from one to five — five being top quality. (The list came with a little cartoon at the top which said 'The Hidden Microphone!', which I kind of liked.)

I was buying cassettes at first, and buying cassettes for my mates. But I wanted vinyl. It was like drugs — I wanted to go to the next step. I then had to hunt down vinyl, which wasn't easy and entailed this ridiculous thing of going into record shops and asking, "Do you do bootlegs?" — the kind of things kids do in pubs, you know, "Can I have half of a beer, please?" [laughs] Of course they look at you askance. But I did eventually find some people on Portobello Road, which in those days was a seedy place. This was around 1977. Back then it was a zoo.

There was one major dealer in vinyl and he used to keep them in crates under the counter — just like the cliché! You had to crouch down and look through his boxes. The records themselves were thick vinyl, as in really chunky, packaged in the classic thick card sleeves with information photocopied onto inserts. They were great things to look at and to have.

At that time I don't remember any bootlegs having picture sleeves at all. I remember them just being like this [holds up a Jimi Hendrix live boot]. You've sometimes got the bootlegger's logo, but not much info at all. This particular album doesn't tell you where it's from — although I later found out it was a Hendrix gig in Copenhagen. Sometimes the bootlegger would disguise the record. This particu-

Black Sabbath

Unorthodox

DEEP PURPLE
on the wings of a russian foxbat

lar one has a label which says it's the Bobby Wells Band. Whether that's an in-joke, whether Hendrix ever played in the Bobby Wells Band, I don't know. But usually the label would be blank.

This dealer wasn't a hippie; he was quite respectable, obviously just an entrepreneur. He used to deal under the West Way on the Portobello Road which, at that time, was divided up with antiques at one end, vegetable stalls at another end, and records and second hand stuff under the big flyover. It was a mixture in those days of hippies — the Hawkwind and Pink Fairies crowd — who used to congregate near the Mounted Grill café; you'd also have punk rockers, Rastas, and a lot of quite scary bikers, who used to go to a pub called the Earl Of Lonsdale. Lemmy used to hang around there. One of the bikers was called 'Speed Machine', and he was the most fearsome individual I'd ever seen in my life.

Anyway, I was picking up Hendrix, Led Zeppelin, Deep Purple stuff, and that's how I started doing my own little business at school. I would ask my school friends what they were interested in and then I'd collect money off them, and include enough money for the train fare up to the Portobello Road. I'd tape all the albums they ordered for myself anyway. These tended to be quite expensive items, around about £10 each.

There were some boots more in demand than

others. Led Zep's *Blueberry Hill* was one that everyone wanted; also Genesis' *As Through the Emerald City*.

Because I was into bootlegs quite heavily, I found the guy who supplied the guys who ran the stalls. He lived in Notting Hill. We went round to his flat to buy up stock. He was a connoisseur and he would have picture sleeves; a Hendrix nut who had lots of amazing psychedelic artwork sleeves. Also cartoon artwork sleeves — they looked like they'd been done by underground comix guys. I think he imported the records from America, and also I think that he was interested in us for reasons other than music! It was all a bit dubious — "Come round to my flat, lads!" We were young fifteen, sixteen-year-olds.

In 1977 the product was mostly American, and you'd get the Allman Brothers and Johnny Winters, artists who weren't even selling legit albums! When punk happened, things moved onto a whole new level. Anything with the Sex Pistols sold like the clappers. The legit labels were very slow to put out a Pistols album, and so you had what was termed "the great Spunk hunt" because there was a bootleg called *Spunk*, demos of tracks that turned up on the *Never Mind the Bollocks* album. We found copies of that down Portobello Road and also Petticoat Lane. These things were around and would sell in big numbers. *Spunk* was repressed a year later as

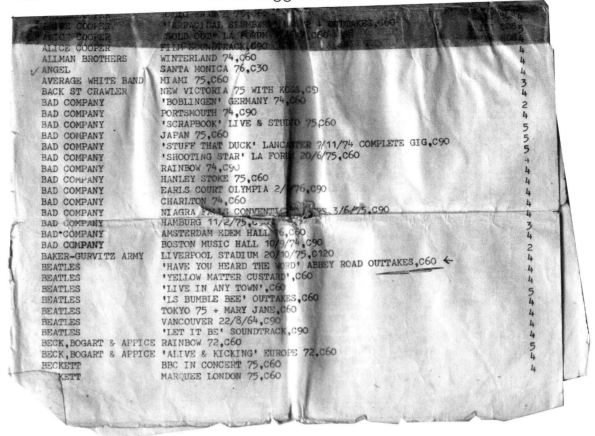

ALICE COOPER	'ARRACIDAL SLUMBER... + OUTTAKES,C60	
ALICE COOPER	'SOLD OUT' LA FORUM ,C60	
ALICE COOPER	FILM SOUNDTRACK,C90	4
ALLMAN BROTHERS	WINTERLAND 74,C60	4
✓ ANGEL	SANTA MONICA 76,C30	4
AVERAGE WHITE BAND	MIAMI 75,C60	3
BACK ST CRAWLER	NEW VICTORIA 75 WITH KOSS,C9	4
BAD COMPANY	'BOBLINGEN' GERMANY 74,C60	2
BAD COMPANY	PORTSMOUTH 74,C90	4
BAD COMPANY	'SCRAPBOOK' LIVE & STUDIO 75,C60	5
BAD COMPANY	JAPAN 75,C60	5
BAD COMPANY	'STUFF THAT DUCK' LANCASTER 7/11/74 COMPLETE GIG,C90	5
BAD COMPANY	'SHOOTING STAR' LA FORUM 20/6/75,C60	4
BAD COMPANY	RAINBOW 74,C90	4
BAD COMPANY	HANLEY STOKE 75,C60	4
BAD COMPANY	EARLS COURT OLYMPIA 2/76,C90	4
BAD COMPANY	CHARLTON 74,C60	4
BAD COMPANY	NIAGRA FALLS CONVENTION ... 3/6/75,C90	4
BAD COMPANY	HAMBURG 11/2/75,C...	3
BAD COMPANY	AMSTERDAM EDEM HALL 76,C60	4
BAD COMPANY	BOSTON MUSIC HALL 10/9/74,C90	2
BAKER-GURVITZ ARMY	LIVERPOOL STADIUM 20/10/75,C120	4
BEATLES	'HAVE YOU HEARD THE WORD' ABBEY ROAD OUTTAKES,C60 ←	4
BEATLES	'YELLOW MATTER CUSTARD',C60	4
BEATLES	'LIVE IN ANY TOWN',C60	4
BEATLES	'LS BUMBLE BEE' OUTTAKES,C60	5
BEATLES	TOKYO 75 + MARY JANE,C60	4
BEATLES	VANCOUVER 22/8/64,C90	4
BEATLES	'LET IT BE' SOUNDTRACK,C90	4
BECK,BOGART & APPICE	RAINBOW 72,C60	5
BECK,BOGART & APPICE	'ALIVE & KICKING' EUROPE 72,C60	4
BECKETT	BBC IN CONCERT 75,C60	4
BECKETT	MARQUEE LONDON 75,C60	

Mail order bootleg list, circa early seventies. The number on the far right denotes sound quality, with (1) being 'Only for avid collectors', (2) 'Listenable', (3) 'Medium Quality, (4) 'Good Quality' and (5) 'Very good quality'.

No Future UK with a bright yellow picture sleeve. That was the big one, the one that kicked it all off. Let me see… then there was *Time's Up* by the Buzzcocks, demos which were later released as a legit album, and *Live at the El Macambo* by Elvis Costello, which came out in about 1978 — another popular one. Then there were a few odd things by the Clash that weren't very good, and a Siouxie and the Banshees boot called *Love in a Void*. These all basically came about because in that short period up until the beginning of 1979, the major labels were so slow to bring records out by the punk groups that this appetite for boots grew.

Sometimes we had a problem and had to take a bootleg back to the dealer.

When you're a kid you think all this kind of malarkey is illegal anyway, and even to be caught in possession of this stuff on the bus would result in the police taking us in. Teenage paranoia. When you got vinyl that was scratched or warped or whatever, it took a bit of courage to take the thing back to the dealer because he's dodgy anyway, and you don't want to get duffed up — which was the parlance of the time. But in reality there was no problem: When I did have to take boots back they were quite happy to swap them.

One of the things that used to happen on the Portobello Road was that artists would bring boots of their own bands and sell them to the dealers. The idea was that they had been ripped off by the labels and so took it into their hands to make some money on the side. Of course, they had access to the means of production as well; they knew people at the pressing rooms

and that sort of thing. There was a good rumour that ——— did it, with regard to a live concert seven-inch single of his band recorded by the BBC, and I actually saw ——— [punk star] selling a stash of his own particular singles.

The boots got released for a variety of reasons other than making money. There was a Deep Purple bootleg album called *On the Wings of a Russian Foxbat* which featured Ritchie Blackmore's replacement, Tommy Bolin, which was motivated by Bolin fans to quash the prevalent attitude that Bolin wasn't as good a guitarist as his predecessor. The official Bolin live album that came out at that time, *Last Concert In Japan* was terrible. Bolin was a heroin addict and had slept on his arm the night before the gig and couldn't play — it does sound fairly terrible. But on the *Foxbat* boot he's fluent and it is a wonderful album.

There was a lot of notoriously bad Iggy Pop boots, because his band could be hit or miss on any given night. But even stuff of really, really poor quality would get pressed onto vinyl.

As a fan, what was interesting about the live boots was that you could hear what was going on between the songs. There's one of the Clash from 1976 where Joe Strummer has a conversation with the audience about what had been on television. He's quite middle class as well, saying "Don't call me a twit" or something ridiculous! Then there was Johnny Rotten who was always fantastic live, really exciting. ("What do you want to hear? Don't say Johnny B.Goode.") On the Black Sabbath boots, Ozzy Osbourne would say to the audience, "Thank you, we love you all!" It was the same on every gig you heard! He used to say, "Are you high?" The audience would scream, "Yeah!" and he'd respond "SO–AM–I!" [laughs] The first time you hear it you think it's really funny, but it's not so funny when you've heard ten bootlegs and he says it on each one.

You realise that with a band like Sabbath it was about showbusinesses; they were doing something completely different to the Sex Pistols, who were reacting to what was going on.

There were a lot of bootlegs from live sources, but some contained outtakes. There was one called, I think, *James Patrick Page*, which contained material that Jimmy Page had done as a sessions musi-

cian. The reason this material came out on a boot was because it had originally been recorded for different labels and was a copyright nightmare to try and bring together. [This has changed with the release of the *Hip Young Guitar Slinger* compilation in 2000, on Sequel Records.] Most of the boots I saw were live gigs. Very occasionally there would be rumours that some boots came from master tapes that had been nicked — there were Who and Beatle boots said to have come from stolen masters, and later in the eighties there was a Prince album.

It was sometimes very difficult to track down specific albums. I only saw the *Foxbat* album once, and Zep's *Blueberry Hill* was very rare. By the time

the punk stuff was coming out there were some common ones, like *Time's Up* and *No Future UK* — they were obviously mass produced so maybe it was a little different to what had gone before. When I first started out you had to pick up what you wanted when you saw it, there and then.

I'd say finally that bootlegs offered an opportunity to hear live bands experimenting; they filled gaps in the history of a group. You could hear the Pistols' doing Small Faces covers and you could hear the Gang of Four doing Velvet Underground covers; the Clash doing Blitzkrieg Bop, and there was even a Smiths boot with them having a crack at Purple Haze. I'm not kidding! Bootlegs allowed us to see another side of the groups. And if you're a real fan,

that's very exciting.

Since the advent of CDs, nobody wants to bother with poor quality recordings. Plus the networking now is so great with the internet that if there is a dud out there you're going to hear about it before parting with your cash. On saying that, the vinyl boots are still aesthetically pleasing — it's so nice to pick up that Hendrix LP and look at the label. The Bobby Wells Band — what's that all about? And it's really heavy vinyl, too. That impresses me.

■ DEALERS
by David Kerekes

THE PRESS REPORTED it as being the "Smashing of the biggest bootleg ring in the UK".[1]

Codenamed Operation Moonbeam, in April 1979 police conducted raids across the UK following an investigation by the British Phonograph Industry (BPI) of several months, seizing an estimated 5,000 bootleg and pirate recordings.[2]

Some 450 of these albums were netted in Manchester shops.

In the days before the www, bootlegs were generally acquired mail order courtesy of lithographed lists, or through the ads in underground newspaper. Occasionally they could be found on the high street in record shops.

Locating bootleg records took a certain guile, perseverance and luck. Rarely did outlets signpost the fact that they had boots for sale, except perhaps in the case of the Manchester based Savoy shops.

Jon Farmer describes Savoy in a forthcoming book (*Iconographers*) as almost single-handedly inventing alternative culture. Through their shops House on the Borderland, Orbis Books and Bookchain they sold pulp literature, import books, magazines, comics, records and later sex material (or "fun packs" as they would call them). This was a volatile combination in the somewhat less than liberal climes of Britain in the seventies and eighties, and consequently the shops became a draw and meeting point for anyone with a leaning towards the counter cultural. "Saturdays was Bedlam," co proprietor David Britton would later state. Many people later to become iconic Mancunians, such as the Buzzcocks, Morrissey, Mark E Smith and

Tony Wilson, passed through their doors. But with speakers planted outside on the pavement (weather permitting) blasting out music, few could pass within a couple of streets of a Savoy shop and not be compelled to investigate.

Clinton Heylin, author of *The Great White Wonders: A History of Rock Bootlegs*, was also a regular visitor to the Savoy shops, crediting their store Orbit Books, off Tib Street, as being the place that fuelled his passion for illicit vinyl.

His first boot purchase as a thirteen year old, Bob Dylan's *Talkin' Bear Mountain Picnic Massacre Blues*, at £2 was cheaper than his most recent legit acquisition, David Bowie's *Aladdin Sane* — which cost £2.19 from Boots the Chemists, as Heylin recalls in his book.

My own experience of the Savoy shops — rather, their shop Bookchain on Peter Street just off Deansgate — was of a place densely packed with books on the ground floor, while downstairs it was equally dense with boxes of comics (predominately b&w ones published by Warren) and a wall of film magazines and more esoteric fayre. I have a vivid memory of one particular Bookchain sojourn and rummaging through boxes as a buddy of mine sat bored on the basement stairs with Jona Lewie's Stop The Cavalry playing on the radio — which would put the time frame at around late 1980/early 1981. I don't recall any bootlegs, or any records at all in the shop, but I wasn't looking for records at the time and the Operation Moonbeam bust would have seen bootlegs removed some months earlier.

(When I did actually embark on bootleg buying my source was the monthly record fair held beneath Piccadilly Plaza in the heart of Manchester.)

The familiar line taken by the press is that bootlegging of live performances or broadcasts costs the British record industry millions each year. Counter to that argument, collectors and dealers will state that no revenue is lost on recordings not owned by the record companies and that it is only hardened fans who will be interested in bootlegs anyway, having already collected the official releases.

Reported as the biggest initiative against UK bootleggers to date, Operation Moonbeam was instigated in April 1979 following a telephone tip off. According to reports a BPI investigator infiltrated the bootlegging organisation posing as a bootleg

manufacturer arranging to press a David Bowie album by the name of *The Wembley Wizard Touches The Dial, Live May 6 Wembley Stadium*. With copies pressed and fed into the distribution network, the album was traced and found on sale at Rough Trade in London and at Bookchain in Manchester, while further investigations led to Newcastle and St Helens.[3]

It was discovered that American bootlegs were being imported into Britain via Holland and distributed to shops and mail order outfits across the country. Manchester was described as being divided into "parishes" (sales areas), each one selling anything between 100 and 2,500 albums a month.

However, investigations against Savoy had started some years before Operation Moonbeam, with solicitors acting on behalf of the BPI having contacted the company back in March 1975 on the matter of boots for sale in their Orbis and Bookchain shops. During the period of August 1974 to October 1975, Savoy was claimed to have purchased in excess of £5,000 worth of bootleg material from their supplier. They were duly fined £700.

It didn't deter Savoy who opened a third shop in Manchester.

Years later, Savoy co proprietor David Britton would admit that "it was the pirate image" that attracted him to bootlegs. "It was the hoisting of the Jolly Roger, of selling forbidden fruit, that really was the fatal attraction. But in the overall picture, they [bootlegs] lost us more money than they made."[4]

Indeed, Operation Moonbeam landed Savoy with a much heavier fine and they only narrowly avoided losing their companies as a result. The case went to the Old Bailey. Included in the list of plaintiffs said to represent all performers and musicians under contract and affected by unlawful sales of their work, were David Bowie, Bob Dylan, and members of the Buzzcocks.

Today all three shops are gone from Manchester. It wasn't the fifty or so police raids over the years that closed them down, emptying the premises of bootlegs and later "fun packs", adult comics, books and just about anything that wasn't locked down. Rather it was the shift in the city's landscape, an insidious redevelopment that has sought to remove the vibrant cultural quagmire of the city, and replace it with a slipstream of branded shop fronts through

SIDE 1
PRETTY VACANT
SEVENTEEN (I'M A LAZY SOD)
SATELLITE
NO FEELINGS
I WANNA BE ME
SUBMISSION
ANARCHY IN THE UK
ANARCHY IN THE UK (DIFFERENT VERSION)

SIDE 2
NO FUN
GOD SAVE THE QUEEN
PROBLEMS
PRETTY VACANT
LIAR
EMI
NEW YORK (LOOKIN' FOR A KISS)

Limited Edition : Promo/DJ cop

which the masses can be herded without incident.

Here David Britton recalls the heyday of the Savoy shops and the business of bootlegs.

"It's all thirty years ago, and the bootlegs were only a sideline, so I can't give you any exact information, but what I can remember is this:

"We had only one supplier, a young long-haired hippy guy, whose name might have been 'Pete' or 'Craig', though I suspect he used a pseudonym even for me. He gave me his personal phone number, which I used to order the titles I needed, in other words, what we'd sold out of. He would call round once a fortnight in a little van with these and the new releases. We'd mostly take an initial half-dozen of everything new, just to see how they went. Sometimes we'd overbuy. I can remember a Free album that stuck with us for months. Obviously, if the new title was one of the top three or four, we'd start off with between twenty five or forty. Bowie, Roxy, Dylan and Zeppelin were the sure sellers. These outstripped everything else five to one. If they'd gone for a full colour cover, like Zeppelin's 'Earl's Court', we'd probably shift 500. Nothing sold in the thousands, but we had very comfortable sales on most of this stuff. Individuals would come to us from all over the North West, word of mouth, you know.

"[These] records were not of my generation, or taste, and I was always pretty ambivalent towards them. But I knew the allure of the pirate flag from

AMERICAN EXPRESS

Import

RECORDS

As well as the shops, Savoy also ran American Express
Import Records, a bootleg mail order outfit, from an address in
Stockport. This is the cover to one of their catalogues.

my own days as a young man scouring the record
shops and second-hand shops in Manchester in the
fifties and sixties looking for Howlin' Wolf or Little
Richard.

"When we arrived in the mornings we'd often
find letters containing money orders or cash just
stuck through the door. People had seen them on
week nights or Sundays when the shop was closed,
and didn't want to miss out. They were very trust-
ing, and we tried not to let them down. Inevitably,
some customers expected a higher quality of sound
than they were getting from certain bootlegs, but
we could always negotiate around this.

"The only time in the thirty years in town I was
ever recognised personally by a complete stranger
was as I was arriving into Victoria Station one night,
joining the queue to get past the ticket inspector

onto my platform. When I got to him he looked at me
and asked me to stand to one side. I thought, 'What
the fuck's this? Is he a policeman in disguise?' After
the crowds had left, and I stood alone, he came up to
me and shook my hand vigorously, and said he just
wanted to thank me personally for the bootlegs he'd
bought twenty years earlier, and how much they had
meant to him. It's one of the strongest memories I
have of my days in the shops in Manchester.

"We sold bootlegs for about eighteen months to
two years (at the same time opening American Ex-
press Bootleg Mail Order from an address in Stock-
port), and as you know we had a couple of busts.

"About ten years later, after we'd finished sell-
ing bootlegs, I was upstairs with Geoff Davis in his
Probe Records shop in Liverpool, and who should
walk in except my old supplier, who not surpris-
ingly was Geoff's supplier too. He'd finished selling
bootlegs by then and he'd gone legit, but we all had
a nice afternoon reminiscing about our days on the
high seas.

"All the Manchester bands and music people
were regular visitors to the shop, the likes of Tony
Wilson and Paul Morley and so on. While reading
a recent copy of *Mojo* on Ian Curtis and Joy Divi-
sion, it dawned on me that not only Steve Morris
hung around my bookshop, but Ian Curtis was a
regular visitor too, who would often buy books,
Burroughs, Ballard and so on. Some years later he
and Morrissey (separately) used call in for their fix
of illicit vinyl, though I've not seen any reference to
this in any history of Manchester. There seems to
be an ignorance of this outlaw culture that existed
in those days.

"The same young people who bought Bowie tend-
ed to buy Roxy. These were the two main influences
on the teenagers of Manchester, before the outbreak
of punk. Dylan, Pink Floyd and such, sold to an older
clientele. The content of the Bowie bootlegs were
to me the most interesting. His bootleg, 'Ziggy's
Last Show', had a great sound — a more driving
intensity than the official release. Another one had
intercuts of Groucho Marx, Marianne Faithful, and
so on. Somebody had taken care to give real value
for money on these. As musical historical documents
they were important releases. In fact, I'm surprised
Bowie never followed Zappa's example and officially
released his own bootlegs."

Disturbo Music

by Rik Rawling

THE WEIRDEST/strangest/oddest/most out of place piece of music I've ever heard? This is a tough one. I look at my rack of CDs and just picking a few at random — *Corpse Love* by Pussy Galore, *1930* by Merzbow, *Jewels Of Thought* by Pharoah Sanders, *Torture Garden* by Naked City, *Superculto* by Sun City Girls — I realise, not for the first time, that I choose to listen to some pretty fucking weird shit. So trying to pick the weirdest, the strangest or the oddest out of that lot is going to be a pretty tall order. So I guess it has to be "out of place" and for that we have to go back, way back into the time when I was still a wide-eyed innocent trembling on the precipice of puberty... To the school disco, Bruntcliffe High School, sometime around 1980-81. I was eleven years old and just discovering the world of music. Punk had been and gone but there were a small cluster of rebels in our town who simply refused to jump on the 'mod' bandwagon and get on down to Madness or The Specials, so we played catch up with dog-eared copies of *Never Mind The Bollocks* or *Machine Gun Etiquette* passed around the schoolyard. We'd heard about some of these other bands like Crass and The Exploited and didn't know what to make of it all but we knew what we liked: The silly fast shit with lots of swearing that made us want to jump around a lot.

In the days before the rise of the superstar DJ the job of playing records to a room full of kids usually fell to the least unfashionable teacher — usually a closet Sky fan and wearer of the beard/jumper/ sandals combo — but at least he didn't smell of gin or mould or look like Davros from *Doctor Who* like the old guard of arse caners. This year he'd got the "house" jumping to the irresistible beat of Green Door by Shakin' Stevens and Cars by Gary Numan. Mock if you will but we all seemed to be having a good time, bouncing around, acting like twats and not caring. We were all about two months

shy of suddenly feeling very self-conscious about everything we did and constantly worrying about "looking cool", and it's like we knew it. So we celebrated the last fleeting moments of our childhoods by dancing happily... Until some twat requested that Death Disco by P.I.L. be played. And when the first bummed-out suicidal note rang out across the assembly room everyone just stopped moving. We were momentarily in a state of shock, frozen to the spot, fresh sweat glistening on our foreheads, shirts untucked, laces undone, and we were all thinking exactly the same thing: What the fuck *is* this shit?

The problem was that the fucking sonic sadist played the record through right to the end, completely oblivious of the effect it had on the kids. Some broke out in tears. Some went off home. And from that moment on the party was ruined. In a weak show of protest some lads chucked sausage rolls and handfuls of jelly at the DJ, but it was too late. The damage had been done. Delicate psyches had been scarred for life, innocence was lost and the world would never be the same again. We really had been to the Death Disco.

I've never heard that record since and wouldn't want to.

Here Come Some Normals

The Beast Inside The Bonzo Dog Band

By Martin Jones

Normals are all about you. They leave signs on the streets that give you clues. They are just people entirely formed by their environment. They are not necessarily middle-aged, middle-classed people. It's the clothes they choose to wear and the way they choose to speak. They imagine they are ordinary, yet they are really dreadful freaks — terrifying. They are people bound by convention, "Normal" is a paradoxical term. *Vivian Stanshall*

IT BEGINS AT THE END, marked by a resigned yell and the ripple of a gong, and then there's no escape from the musical whirlpool: The tribal drums — ripped from the chipboard set of a Hammer Horror flick — begin their bare-chested rumba; the church organ strikes up a two-key mantra, and then the voice walks in, goblet of blood in one hand, skull in the other, intoning in a style somewhere between a Crowleyite worshipper and the narrator of a devilish Simon Raven novel:

Eleven Mustachioed Daughters
Running in a field of fat
The full moon high and the mandrake scream
Please come to our Sabbath

Whist behind it, from far down a closeted stone passageway, a male chorus fills the gaps in such sorcery. The voice continues, soon joined by a rising tide of horns and hysterical female shrieks, before the whole ritual peaks with a deformed lab assistant cry of "WORSHIP FOR SATAN?!"

What spawn of black minds is this? What three-hoofed calf, pulled blinking-onyx-eyes into our world of rationality? From what satanic swamp did such primeval slop bubble forth? The answer is to be found on The Bonzo Dog Band's second album, *The Doughnut In Granny's Greenhouse*: There at the end of side two lies the final song, 11 Mustachioed Daughters. And how do the Bonzos stamp it with their own unique brand of skewered humour? If you listen carefully towards the end, amongst the cacophony of ritual, you will hear a possibly English accent moan, "I don't remember too good but I think John Wayne was in it." Right before the record player needle tips into the run-out abyss...

Welcome to the wonderful and weird world of

The Bonzo Dog Band on the cover of their greatest hits compilation, *Bestiality*.

The Bonzo Dog Band. For a few short years they didn't just go against the grain of popular culture: They built a sandpaper hovercraft and sped off across its plain. In parts absurd, traditional, hilarious and slightly disturbing, over five albums the Bonzos explored worlds not unlike ours, but just, y'know, slightly different. They pulled out the heart of "suburban man" and examined it for signs of life; they revelled in the stupidity of advertising and trends; they took established musical traits and broke their backs, utilising them for their own ends… Oh, did I mention some of their more disturbing songs, as well?

England in the early 1960s was still a land emerging from post-war dullness. The Beatles had not yet returned to home from Hamburg. The teddy boy was the first stage of rebellion for young people, not yet "teenagers". All the things that marked the decade out as a colourful, changing time had not yet occurred. And then in September 1962, a bunch of art school students decided to form The Bonzo Dog Dada Band. Influenced by the satirical songs of The Alberts and the Dada movement that made part of their name (the "Bonzo Dog" being illustrator George Studdy's famous puppy), The Bonzo Dog Dada Band was a group intent on resurrecting the joys of old music hall/novelty seventy-eight RPM records live on stage. Although their outward appearance might have been trad jazz, at any one point there were more than two hands worth of 'musicians' in the band, and their gigs soon became pub cabarets of high invention and joyful chaos. Things started changing when tuba player Vivian Stanshall, a gigantic red haired eccentric, began filling the spot where a vocalist should have been, improvising lyrics and throwing absurdist shapes.

The informal nature of the group was such that many people joined and left without a thought of making a serious effort out of it. By the mid 1960s the Bonzos were a familiar sight on the London pub circuit, and also the working mans clubs of Northeast England. For while the nation's capital was getting ready to wig out, Stanshall and Co. were paying their dues and tightening their act on the harsh and vicious chicken-in-a-basket scene: Travelling back and forth from the north to London in a fart-filled van was the norm. The hell of this seven-nights-a-week existence was later detailed in The Bride Stripped Bare By "Bachelors", on their *Keynsham* album. Numbering nine (or ten, or seven) members at the time, the Bonzos' loud and fast renditions of traditional numbers, coupled with daft props, resolutely

dangerous on-stage explosions and a dress code that made them appear as asylum escapees in zoot suits had them marked as outsiders from the beginning; and in this mess the individuals who would make up the core of the band emerged: Along with Stanshall there was Roger Ruskin Spear (saxophone), Rodney Slater (guitar), 'Legs' Larry Smith (drums) and Neil Innes (piano, guitar and vocals). Spear and Smith could match Stanshall for on-stage provocation: The former with his inventive, mechanical robots; the latter through his oft-realised desire to tap dance instead of play the drums.

By 1966, the group had become The Bonzo Dog Doo Dah Band and released their first single, My Brother Makes The Noises For The Talkies. That and its follow-up, Alley Oop, were more or less straightforward runs through live favourites, business cards from men who were not interested in doing business. It was only through the success of a former Bonzo player that the band decided to change their direction: Cornetist Bob Kerr had left to front a group of session players called The New Vaudeville Band, who went on to have a huge hit with Winchester Cathedral. The collected Bonzos had been asked to make up the Vaudeville's public image but had refused, and the fact that Kerr popped up in their ranks with more than a touch of The Bonzo Dog Dada Band about him induced a severe case of sour grapes. Ignoring the departing comments of the few traditionalists left in the band, the Bonzos took up electric guitars and, with the twin assault of two gifted songwriters, began the first real phase of their history...

Sometimes working together, sometimes alone, Vivian Stanshall and Neil Innes were the Lennon and McCartney of the Bonzos... Or, if not that, they were at least the Burke and Hare. Or the George and Mildred. Innes was maturing as a writer of extremely catchy pop songs, and Stanshall was using the group framework as firewood, before stomping off down a path of his own creation. Free from the labels they had been assigned as a live act, the band could open up new avenues of exploration. On the first track of their debut LP, Gorilla (October 1967), Stanshall molests the trad arrangement Cool Britannia with a sardonic vocal that was to become his trademark: "Cool Britannia/Britannia you are cool/Take a trip!" It's a snide aside at the hip scene

around them, something the Bonzos had never felt part of. Indeed, in a prophetic case of usurping, their flagship song The Intro And The Outro unwittingly took the wind out of The Beatles sails. Possibly written before the release of Sgt Pepper's Lonely Hearts Club Band, its role call of bizarre band members mirrored the album cover line-up of the Fab Four's most famous LP: Although it's hard to imagine artist Peter Blake finding a place for "Adolf Hitler on vibes". The Intro And The Outro also marked the first appearance of a family called the Rawlinsons, but more of them later.

In amongst the cover versions — faithful, destroyed or otherwise — on Gorilla, lay some startlingly witty and dark songs, mapping out the shape of the beast inside the Bonzos, particularly in the form of Stanshall. Look Out, There's A Monster Coming was a plastic movie monster in a Hawaiian skirt, gleefully crushing cardboard cities with a toy guitar in its claws. Over a calypso beat, Stanshall recounts the futile search of the titular terror for a soul mate, who undertakes increasingly desperate methods to find a girl. It's the flipside of Bobby Boris Pickett And The Crypt-kicker's Monster Mash, itself covered on a later Bonzo LP. "I bought a deluxe Merseybeat wig/But it was a size too big," despairs Stanshall, before feeding the chorus through a fuzzy voice-box. This is the beast that doesn't know its own power, the Frankenstein's monster who wants to give you a hug of love, unaware that it'll make your eyeballs pop out. Elsewhere on the LP, it's Stanshall's show. Both Death Cab For Cutie and Big Shot are film noir songs, via a black leather-clad Elvis and Raymond Chandler respectively. With Big Shot, Stanshall takes on his hardboiled narrator role with glee, although, remembering that this is a Bonzo pastiche will help when lines such as "I studied the swell of her enormous boobs!" appear. Before the gleeful disembowelment of The Sound Of Music that closes Gorilla, there is Stanshall's ripsnorting, petulant and utterly superior I'm Bored: A list of subjects that have him yawning like Noel Coward — amongst them "exposé's and LSD" — uttering the lines, "You think that I won't laugh at it/I'm not a weak-willed hypocrite" and finishing with the concrete statement: "I'M/BORED/TODAY!" The listener cowers as Stanshall complains.

If the Bonzos had once been a knockabout hobby,

they were now a fully-fledged rock act with a rising profile. As well as certain members of the band blazing a drunken trail around the drinking dens of Soho (i.e. Legs and Stanshall, more often than not accompanied by The Who's Keith Moon), they made an appearance in The Beatles *Magical Mystery Tour* film, became the house band for the children's TV show *Do Not Adjust Your Set* (which was written by and featured future *Monty Python's Flying Circus* members Terry Gilliam, Eric Idle, Terry Jones and Michael Palin: The meeting of the groups probably playing a significant part in the formation of the future comedy legends) and scored a top ten hit with Neil Innes' charming I'm The Urban Spaceman, produced by a pseudonymous Paul McCartney. The downside of this was that the band had very little time to do anything else. Life in the Bonzos was a continual parade of TV appearances, concerts and recording. Something had to break, and pretty soon. Their second album, *The Doughnut In Granny's Greenhouse*, was released in November 1968, the same month as their big hit single, although it was not included on the record.

Consisting entirely of original songs, *Doughnut* shows flickers of nefarious thought within its grooves. The madness played out by the band in their pre-recording days was unforced, improvised and untainted by outside influence. By the end of 1968, The Bonzo Dog Band (as they were now, finally, called) had received a taste of the music business and didn't like it. Apart from the free drinks. The walls were closing in and, to quote Stanshall in later years, the clocks were baring their teeth. The beginning of the LP is as far removed from the jazz satire of old as you could expect. We Are Normal starts with echo led, backwards voices and a soft heartbeat. Then there's the noise of a busy street: Stanshall — a notorious practical joker — and his cohorts were not averse to picking on members of the public and taping their reactions for their own pleasure. We Are Normal contains the voice of then-bassist Joel Druckman, an American with a fondness for doing moonies and the claim that he once played in Frank Zappa's Mothers Of Invention (Neil Innes later considered that the Bonzos were "the mothers of convention".) For the track, Druckman wandered around Willesden Green — near where they were recording the LP — microphone in hand. Stanshall stood nearby, clad only in dirty underpants and wearing a papier-mâché rabbit head. "Here come

Bonzo album sleeves. *Tadpoles* front and back (main image and top) and a *Gorilla* reissue (above).

some normals," says Druckman. "They look like normal… Hawaiians." These were the "dreadful freaks" Stanshall had always feared: The nine-to-five generation of small talking, petty-minded grey people unable to deal with the abstract chaos of creation that made up his world. Druckman's words are followed by the chatter of disbelieving pedestrians ("He looks like a rabbit! He's got a head on him like a rabbit!") before the song lurches without warning into a spectacular parody of progressive rock. "WE ARE NORMAL AND WE WANT OUR FREEDOM!" they scream, cheekily nicking a line from Love's The Red Telephone. Of course, this being the Bonzos there's a voice in the background that proclaims, "We are normal and we dig Burt Weedon, aha!"

Like that faint voice towards the end of 11 Mustachioed Daughters, the band had a way of slipping in did-I-hear-that-correctly whispers. Halfway through the easygoing Postcard a voice calls out the tennis score "Love fifteen!" only to have a reply to it that sounds like "Love fifteen-year-olds". Surely not? Postcard, and its cousin once-removed, My Pink Half Of the Drainpipe, are Stanshall/Innes collaborations of scathing black comedy, dealing as they do with the "little Englander": The small-minded, xenophobic, seaside-conquering, boring man/woman. Stanshall took all this from experience. He was born in the Essex coastal town of Leigh-on-Sea in 1943 and spent his youth

amongst the decaying seafront funfairs and amusements, experiencing the dual existence of one living in such a place: Plenty to do in the summer, sod all to do in the winter. Postcard is just that, another disinterested scribble on the back of a tacky card faded at the edges by the all-burning sun: "After bingo we went for a swim/Fat sea cows with gorgonzola skin", with the sea cows "writing letters home, 'what a lovely view'". The peak of the song comes with Stanshall crooning the atypical postcard joke, "JUST MARRIED AND IT STICKS OUT FOR A MILE!" and then Innes returns with the "We wish you were here" chorus. Postcard is the Bonzos disembodied and floating high above the seaside, casting a dour eye over the same old proceedings, year-in, year-out. The theme is continued and given a damn good thrashing on the Frenchified My Pink Half Of The Drainpipe, where Stanshall gets to vent full spleen on the "Normals": "You're looking at me across a fence/Of common sense" he sings, before going on to state that "My pink half of the drainpipe/Separates me from the incredibly fascinating story of your life in all its tedious attention to detail…" This is Stanshall the suburban terrorist, the man who would chillingly drag door-to-door salesmen into his home and discuss their wares whilst feeding mice to his collection of snakes (not to mention the piranhas, unseen in their huge, cloudy and precariously perched fish tank), anything to shake them out of inertia, stop them talking about the weather, sport, their new car, decorating, the garden or the annual holiday in bloody Spain. As if to balance such vehemence, Innes ploughs in with his own subtle observations, torn from the body of Postcard: "Have you seen the bullfight poster on me wall/Do you know the happy memories it recalls/Here's a photograph of me and my son Ted/There's me cousin with his hanky on his head!" And finishes with the eternal credo of the lobster-pink Englishman abroad: "We booked into our hotel just after two/And met a family from Bradford that we knew".

The Doughnut In Granny's Greenhouse also provided the listener with their second encounter with the Rawlinson family, who were progressing in their own mad way through the parallel universe of Stanshall's brain. Rhinocratic Oaths was the first of many narrative leaps Stanshall would make throughout the rest of his life, head first into an England that perhaps never existed. Over a trotting Innes accompaniment, Stanshall offers up four anecdotes, including Percy Rawlinson and his Alsatian, a hedge-trimming battle between neighbours (that pink half of the drainpipe again) and "Six foot eight, seventeen stone police sergeant Jeff Bull" undercover at the "Frug-A-Go-Go Beirkeller". But perhaps the one about trombone-playing Betty Pench comes closest to Stanshall's way of thinking: Answering the door not to a "turbaned ruffian" but a young man, she is informed that she's won a competition. Offered a Triumph Spitfire or £3,000, she plumbs for the cash. The man asks her what she'll do with it all. "I think I'll become an alcoholic," Betty replies.

Like so many others, 1969 would prove to be a pivotal and doom

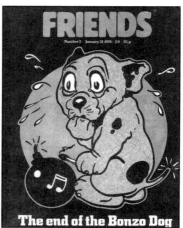

Viv and Neil (top) and the end of
the Bonzos makes the cover of
Friends, No 2 Jan 1970.

laden year for the Bonzos, and Stanshall especially. Although their follow-up to Urban Spaceman didn't do as good in the charts, Mr Apollo was by far the superior song, bringing to the mainstream the vicious streak of humour that had previously laid in wait on the albums. A guitar riff led stomper (the Bonzos were not averse to throwing in the odd big chord here and there), Mr Apollo is a hilarious theft of those "You too can have a body like mine" rip-off adverts found in the back of comics: "I have seen/Mr Apollo/Uproot trees/With his bare hands/I have seen/Mr Apollo's/Body building plan" sings Innes at the start, before Stanshall barges in with "And you can beat up bullies 'til they cry! Oh crikey, let go you rotter! Don't punish me!" For this is indeed his show, his platform to unload some deep set trauma from the id, and get his own back. By the close of Mr Apollo, there's no stopping him, as the Stanshall brain swims off into uncharted waters:

Yes… Just give me ten years of your life, and I'll trade in that puny flab for living *muscles*. Physique *you* deserve. Five years ago I was a four-stone apology. Today I am two separate gorillas. No tiresome exercises. No tricks. No unpleasant bending. Wrestle poodles and win! Play beach-ball! Shave your legs! Look over walls! Tease people! Brush them aside as though they were matchsticks!

Although some restraint must have been enforced by the time the song was recorded, because an earlier draft of the lyrics contained the line: "Kick spastics and laugh!"

Mr Apollo made it onto the third album, *Tadpoles*, released in August 1969: Less a 'proper' LP and more of a compilation. It was made up of songs the Bonzos performed on *Do Not Adjust Your Set*, half covers and half originals, including Stanshall's eyeballs-on-springs take on Monster Mash ("Igor, have you watered the brains today?") and — finally — I'm The Urban Spaceman; plus its B-side, the anatomical love song, Canyons Of Your Mind, which, in its travels through various radio sessions, contained a number of explosive Stanshall belches.

Their next studio LP, *Keynsham*, was not released until November 1969, and it was around then that things began to seriously fall apart. This, after all, was a band that had basically not had a proper break in three years. The cracks started showing with their second tour of the USA within the year. By this point, Stanshall was also unofficially the band's manager; something that piled more pressure on him and thus led to more empty bottles, and more frequent panic attacks. The tour was totally different from their previous jaunt: They arrived to find that nobody knew who they were, no-one could buy their records, and no-one knew where they were playing. Their American record company had done nothing to promote them. To cope with the pressure, Stanshall was prescribed the tranquilliser Valium, a move that left him addicted to the drug for more or less the rest of his life. This, combined with the heavy drinking, was taking its toll. He had also

had a bad LSD trip on the tour, though whether he experimented with it willingly or was spiked it was never known. LSD plus Stanshall's brain equalled... Bad news or a transcendental experience. Whatever the outcome, after the Bonzos returned home early, Stanshall had a serious breakdown and voluntarily booked himself into a private hospital.

Oblivious to all this, *Keynsham* emerged as perhaps the band's best album: fourteen original songs split between Innes and Stanshall. Named after a typically tedious method of winning the "pools" (the old-style lottery), *Keynsham* was a concept album of sorts. The sort you can take or leave. Perhaps it was the increasing divide between Innes and Stanshall's writing styles that makes it such a great record: they only co-wrote two songs and split the rest. Innes' skill as a quality songwriter was now clear, with even his bursts of sentimentality, such as I Want To Be With You and the awesomely depressing voyeuristic fancy of Quiet Talks And Summer Walks made strangely appealing. And on the title track he also turns his hand to prophecy with the electric line, "There are no coincidences/But sometimes the pattern is more obvious."

But whereas Innes was in full control of his talents, Stanshall had wandered off down a precarious wooded path to get a glimpse of the ruined stately home ahead. If Mr Apollo had roused horrible memories in the man, then he dragged them to the surface with Sport (The Odd Boy), a mock Tudor attack on the sadistic practise — still insisted on in schools everywhere — of making children who don't like games *join in*. Usually in atrocious weather conditions.

Sport
Sport
Masculine sport
Equips a young man for society
Yes sport turns out a jolly good sort
It's an odd boy who doesn't like sport

Beautifully turned out and to the point (it begins with the dream introduction of "Let's go back to your childhood, childhood, childhood..."), Stanshall was now in the privileged position to spit venom, in the politest way possible, of course. Equipped with two great gifts — a twisted way with words and a

skewed vision of the British Empire — Stanshall was at the height of his dark powers on *Keynsham*. Even the Eastern-tinged fez instrumental Noises For The Leg begins — perhaps somewhere in the Crimean war with Liston knife in hand — with a curdling howl of "No, no! Please, not the leg!" And then the solemn statement: "I've found the leg, Sir... *By God I wish I hadn't*". But his position as the boozy Baudelaire of a dying decade came with the final track on the album, Busted. Co-written with Innes, it is ostensibly a commentary on the poor downtrodden persecuted student ("I'm so bloody normal/Yet I'm one of nature's freaks") as sung by Innes; but when Stanshall comes in with some lines of his own the viewpoint is skewed like an opium dream:

In the soft grey squeeze as they mind the doors
Like a sacrifice to the Minotaur
All together in the blood-rush hour
Come on fish-face you've got the power!

Four lines that summed up Stanshall's philosophy: The anthropologist in him watched the nine-to-five crowds and shuddered, despairing as to how they could ever go through such routines day-in, day-out. The people bound by convention, "All together in the blood-rush hour" and then holidaying in some Mediterranean sandpit once a year to "get away from it all"... Stanshall successfully navigated around the "soft grey squeeze" and returned with copious field notes to construct perhaps his best lyrics ever.

In early 1970, the Bonzo Dog Band split up due to a number of factors: The "What the fuck are we doing now?" factor brought on after the USA tour, the splintered interests of group members, the fact that the powers-that-be frowned on *The Brain Opera*, their next project-to-be (co-written with flaming loon Arthur Brown) and insisted on more Urban Spaceman-style numbers. Unaware that the split was permanent, Stanshall dived into another big depression and, despite working on a number of solo projects, could not get over the fact that, after eight years, the band was no more.

Well, not quite. After they announced the split, the Bonzos still had a number of gig commitments

to fulfil and a contractual obligation to record one more album in order to ensure their future freedom. Almost two years after their demise, Stanshall, Innes, Legs, Roger Ruskin Spear, regular bassist Denis Cowan and few session chums went back into the studio. The result was *Let's Make Up And Be Friendly*, released in March 1972. By far the band's most 'mature' album (if there is a such a thing) — although having an opening song about constipation might throw some doubt on this — the record was mostly a Stanshall/Innes two-hander, with Spear and Legs throwing in a few wayward pieces. The toilet-challenged The Strain showed Stanshall to be a changed man, his grumbling vocal perhaps the outcome of the personal troubles of recent years. Still erudite, yet somehow darker than the frontman of yore. *Let's Make Up And Be Friendly* is notable for a number of things, the most obvious being a startling quartet of genuine pop songs that pepper the album: Straight From My Heart, Rusty (Champion Thrust), Don't Get Me Wrong and Fresh Wound are instantly catchy and suffer nothing at the hands of the Bonzo sense of humour: The Legs-sung Rusty has him asking, "What's with this *gay front*?" for instance. Elsewhere, Spear's Waiting For The Wardrobe, nominally a 'typical' Bonzo song *a la* Shirt, opens with a hideous musical montage that recalls the beginning of We Are Normal. But this is the Dante's inferno of furniture buying: "Open up the door!" a voice screams from far below, as the electronic noises prowl onwards like a black underground stream. But it's Stanshall's Rawlinson End ("He looked so sinister in that corset") that is the album highlight, an illogical progression of Rhinocratic Oaths. This time he gets nine minutes to spin out a tale or two. Over piano accompaniment it begins, "It is almost three years since Madge and Bobby Rawlinson pulled up roots and were arrested by the Parks Department." And so the scene is set for the insane wordplay that was to take the Rawlinson's onto numerous radio broadcasts, two albums, and a feature film. Stanshall borrowed the "Now read on…" prose of women's magazines (usually the molested kind found in dentists waiting rooms) and bent it to his own, er, end. But, as with most of *Let's Make Up And Be Friendly*, things have turned a shade darker:

Poor Rosemary has her hands full at Rawlinson End trying to bring up Timothy and Leticia, now at that difficult age when they start… Asking questions… And *wanking*.

Then a menacing end of the pier organ drifts in and out of the narrative, a force of its own wrung from Stanshall's childhood. And the story touches the waters of Gothic absurdity — "The stuttering candle traced leering phantoms on the walls" — before pushing the listener nervously into the company of coughing and drunk Sir Henry Rawlinson, last bastion of a bloated island:

Y'see, the natives had it in their *noddles* that if a chap's soul was pure then the snake bite wouldn't harm him. Poor old Hargreaves died almost *immediately*. Horrible agony.

Let's Make Up And Be Friendly ends on a short but sinister note. Slush is two minutes of funeral strings and a continual laugh from Innes, but it's a laugh trying to convince you that *things are going to be alright, really they are…* After the fade-out, the Bonzo Dog Band was no more. In a group of so many individuals, each had their own direction with which to take the band: Stanshall wanted more theatrics, Innes wanted more music… And Legs wanted more sequins. The beast inside was gone, let loose by the departing members, although Vivian Stanshall took him in intermittently for years afterwards. Himself a creature of terrifying brilliance, Stanshall returned to the beast again and again for inspiration, both on and off record.

Disturbo Music

by David Kerekes

PSYCHO KILLER (c/w Prisoner, WEA 1982) by an outfit calling themselves Psycho was a record I bought mail order as a sale item. Buying cheap records by unknown bands was something of a minor pastime for me in my late teens, and sale bins and mail order outlets proved the perfect hunting grounds. Few retailers knew what else to do with the seven-inch singles that had been foisted upon them by enthusiastic sales reps, singles that had failed to come within a mile of the charts or featured bands that had no following outside of their home town. There was a lot of unbearable rubbish out there, but more often than not — defying all probability — I found the majority of purchases to have something of interest about them. Of course it was difficult to feel too burned by a product which had cost next to nothing to buy. But I rather think that whatever had kept these records out of the chart in the first place was the very element that I now found intriguing.

When Andy Partridge of XTC was asked to name his top ten records of all time for a music paper, he declined and offered instead those little nuances that made specific records for him so great. I can't remember any of his list now, except for The Beatles' I Feel Fine and its feedback introduction. Myself, I like The Move's I Can Hear The Grass Grow because of the ridiculously shrill electronic whistle that occurs partway through for no discernible reason. Similarly I am drawn to records with mistakes in them or bad drumming, but I digress.

In my sale bin excavations I picked up an unofficial theme song to *The Evil Dead* in the Tall Boys' Another Half Hour To Sunrise (backed by Island Of Lost Souls). I also found an ode to one of Jack the Ripper's victims in Sleep Softly Mary by synth band Bürlitz ("You're peaceful in your eternal slumber/ You're more/More than just a number to me"). Not forgetting the rocked-up version of the children's TV theme White Horses by Real Macabre, and a ditty entitled Authors 2 by one-man band Vision X, which is essentially Krautrock from Staffordshire.

My favourite seven-inch sale find, however, remains a wonky cover version.

I had still yet to hear the original Talking Heads track when I came across Psycho Killer by Italian duo Psycho. Its sleeve depicts a razor blade, which is either rather subtle or completely tasteless. The record itself starts pleasingly enough with what sounds like a balalaika playing out the familiar Psycho Killer opening refrain. The vocals come in, and while the record does settle eventually into a Euro pop groove, a less likely disco sensation I have yet to hear. So bizarre are the vocals that anyone within ear shot is compelled to sit up and take notice. The lead is sung by a guy with a very basic command of English who sometimes veers into phonetic gobbledegook, clearly having no grasp of the meaning behind what it is he is singing. Phonetic gobbledygook is not uncommon in Euro pop. What is uncommon, however, are the backing vocals which come courtesy of a female companion who taxes her larynx to the limit trying to hit notes that are clearly beyond her. It is quite a shock when she first starts to yodel: the vocal equivalent of The Move's electronic whistle, except that here, in Psycho Killer, the shrill noise keeps on coming back.

It's difficult to keep a straight face when first subjected to Psycho's Psycho Killer. Just exactly how the record slipped through quality control is beyond me. Given their adopted name, I suspect the band was formed for the purpose of a one off experiment in sound, i.e. this record. They've got a major label behind them, so I guess it must involve somebody famous: someone *hugely* famous perhaps with enough clout to swing a release without having to let anyone else hear the thing before hitting the pressing plant.

Or maybe the band are comprised of complete unknowns?

I'm happy to remain ignorant about the rampant oddness that is Psycho and the curious musical plane on which they live.

Psycho *keeller*? Qu'est-ce que c'est?

IN 1964, AUSTRALIA became the latest victim of Beatlemania. Virtually overnight, the rock'n'roll scene changed. Formerly instrumental bands got themselves a singer and began scouring the demo bins for songs that would take them to the top. The most ingenious amongst them discovered that they could write their own songs, with exciting if somewhat wayward results. 'Beat' music was the only sound teenagers wanted to hear, so radio stations eagerly sought bands that might fit the bill, even if they had only just picked up their instruments. Hair was still kept respectably short, and band members were attired in uniform suits, thereby justifying their place as 'entertainers' in Australian showbiz. However, when The Rolling Stones broke into the charts down under, all the rules went out the window. Rhythm and blues, which until then had been played only by 'decadent' jazz bands and the occasional fifties rocker, became the new sound for the rebellious youth of a booming nation. Disgruntled teens unsatisfied with the cute 'mop top' image of bands like The Beatles, started groups forged from the gritty, seedy R&B grind of bands such as The Rolling Stones, The Pretty Things, The Kinks and The Animals. The Stax/Motown soul R&B hitting the charts worldwide at that time also inspired many groups to create their own sound. The initial lack of musical dexterity possessed by many of these bands led to some very basic, stripped to the bone tunes, charging blindly to their finale, the untrained singer yelping sexually frustrated lyrics, drowned out by the pulsing sludge of his accompaniment. The crude record production standards available further enhanced the raw, out of control vitality which is an essential ingredient of the best garage music.

I've chosen to tell the stories of the bands and individuals most thrilling to my ears, basing my opinions on available records, films and contemporary reports. The very nature of the music created by so many of these bands assured them almost instant obscurity. That need no longer be the case. Below are the reasons why…

The Missing Links

■ The Missing Links

By far the wildest and most notorious garage band of the sixties, The Missing Links had two completely different incarnations.

Sydney, 1964. Guitarist Peter Anson met up with mates Dave Boyne (guitar), Ronnie Peel (bass), Bob Brady (Vocals) and drummer Danny Cox and created the first version of The Missing Links, the intention being to raze up an R&B storm like their fave groups, The Rolling Stones and The Pretty Things. They developed a reputation for rowdy behaviour during their shows at such suburban venues as Parramatta Town Hall, which eventually led to their break up after the release of one single We 2 Should Live c/w Untrue: Two grinding numbers with a spit in your eye attitude.

In late 1965, guitarist John Jones, who had joined the band just prior to its dissolution, got together with New Zealand singer Andy James and commenced to recruit a new line-up for The Missing Links. With the entry of Doug Ford (guitar), Ian Thomas (drums), Baden Hutchens (bass) and Ian Gray on keyboards, the new line-up was complete.

Unlike most R&B bands in Australia at the time, The Missing Links played many original compositions. Their first single with the new line-up was the ferocious You're Drivin' Me Insane, with a jagged fuzz guitar cutting through the sinews of a very muscular track, the organ coughing up laughter at its distress. Followed by the lecherous second single, Wild About You, these songs firmly established the band's unique sound, which certainly did not make them popular with the mainstream press, who hailed them as "degenerates".

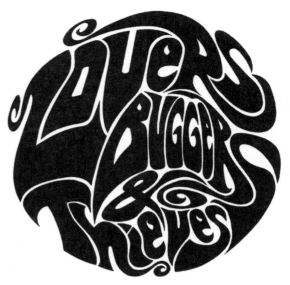

You're Driving Me Insane

Australian Garage Punk Music 1964-67

By Gerard Alexander

Their only album came out in 1966 and it too is crammed with berserk numbers such as a cover of Mama Keep Yor Big Mouth Shut, featuring choking vocals that are terminated by the feedback guitar of Doug Ford. You also get an entirely reversed version of the same song on the album, which they titled H'toum Tuhs and was also released as a single, spread over both sides of the forty-five!

Displeasure at their lack of commercial success soon led to the inevitable split, but not before one last EP, Don't Give Me No Friction, which starts out like a seemingly happy pop tune and descends into a chaotic abyss halfway through. For moments like that, they will always be remembered.

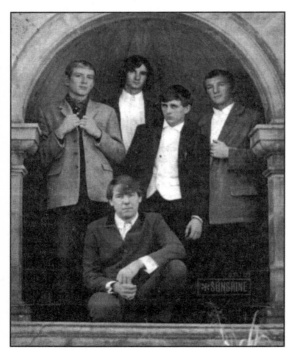

The Purple Hearts

The Purple Hearts

Many expatriate Englishmen made Australia their home in the early 1960s, and a hell of a lot of them seem to have started bands as well. Mick Hadley (vocals) and Bob Dames (bass) were two such Englishmen, and with the assistance of Barry Lyde (guitar, soon to be more well known as Lobby Loyde), Adrian Redmond (drums) and Fred Pickard (guitar) they stopped playing as The Impacts and became The Purple Hearts, named after the amphetamine favoured by many London groups they had known.

A cover of Graham Bond's Long Legged Baby was their first single. Bumping along nicely, it made the charts in their home base of Brisbane. Chasing more gigs the band relocated to the burgeoning nightclub city of Sydney, and released their brooding menace of a single Of Hopes And Dreams And Tombstones which actually touched the national charts.

Once again feeling that the place to be was elsewhere, they moved to Melbourne, and unleashed the marvellously dramatic single Early In The Morning, which was backed by an unusual reworking of the all-time classic Just A Little Bit, ably demonstrating Lobby Loyde's prowess as guitarist extraordinaire.

An EP was released, following which the band announced to the press that they would be breaking up, as they could no longer progress as a simple R&B group. A new sound was about to emerge (see: The Wild Cherries).

■ The Throb

Originally billing themselves as The No Names, The Throb had the distinction of outselling The Rolling Stones' version of Fortune Teller with their own far nastier take on that perennial blues number.

With a line-up comprising of John Bell (vocals/guitar), Peter Figures (drums), Marty Van Wynk (guitar) and Denny Burgess (bass), The Throb became a national sensation, if only for a short while. Playing at venues such as Beatle Village and Suzy Wong's Discotheque in Sydney's sleazy King's Cross, they were exceptionally popular with the girls who adored their long hair, but they soon learnt to stay clear of underground railway stations, where the 'sharpies'(Australia's version of skinheads) would often stage a rumble.

Their second single, Black, which came out in 1966, was their adaptation of an old folk ballad, Black Is The Colour Of My True Love's Hair. Along with a primal intensity not usually associated with pop songs of the time, The Throb ended the track with squealing feedback, which probably contributed to their chart demise. After that, the band fragmented, seeking new directions.

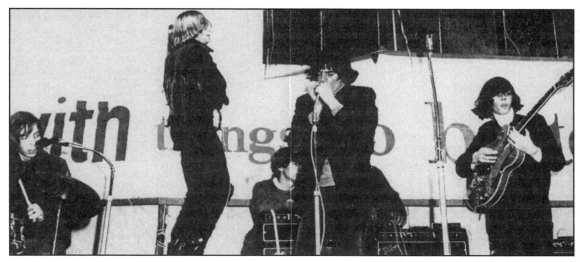

The Throb (above) and The Creatures (below)

■ The Creatures

From the northern Victorian town of Mildura came an instrumental group known as The Beagle Boys. Featuring three Marcic brothers, Eric (guitar), Rudolph (drums) and Herman (bass), along with guitarist Richard White, they were offered a chance to play in Sydney if they could offer something new. To get gigs in the big cities, they recruited Keith Matcham to sing for them, as instrumental groups were on the way out.

The Beagle Boys each dyed their long hair a different colour. Eric dyed his red, Keith chose purple, Richard got a hot pink look, Rudolph's hair became green and Herman got the blue treatment. They renamed themselves The Creatures and cut their first single in 1965, All I Do Is Cry c/w Mona, after helping the construction crew build the recording studio they were to record in. Both songs are laced with an eerie reverb, enhancing the spooky atmosphere generated by the low fidelity glitches. The single helped to get them more gigs, but was not granted airplay.

Next, there was an image change. Keith had his hair dyed black, while everybody else was dyed white. Their second single, Ugly Thing, out in late 1967, was a collision between R&B grunt and flower power dementia. It vanished, naturally, so there was one final stab at success. Now calling themselves The Chocolate, they unleashed a belching version of Eric Burdon's I'm An Animal before finally expiring in 1969/1970. Truly, one of the more colourful groups in Australian musical history.

■ Toni McCann

The sole gutsy female vocalist with R&B tendencies in the 1960s was only a teenager when she released her two frenzied singles.

Residing in Brisbane and backed by The Fabulous Bluejays, Toni McCann was a fifteen-year-old-singer on local TV and recorded her first single, No c/w My Baby in 1965. With a voice comparable to rockabilly queen Wanda Jackson, Toni tears into both tunes

with a frustration only found in teen anxiety. Her next single, Saturday Date c/w If You Don't Come Back also dug deep into the tawdry cellars of juvenile angst for emotional resonance.

Sadly, after those two local hits, Toni was asked to grow up, and she pursued a dull career in the pop/country field, nevermore to bellow with such unashamed abandon.

The Masters Apprentices

■ The Masters Apprentices

Undoubtedly one of Australia best bands ever, The Masters Apprentices had a career that lasted nine years, encompassing every style of music, as appealing to the media as to their adoring fans.

Spawned in the Adelaide, South Australia suburb of Elizabeth, which had been constructed by the Australian Government specifically to house migrants from the United Kingdom, theirs is an exemplary tale. In 1965, Jim Keays (vocals/harmonica) from Scotland joined a group that had been calling themselves The Mustangs, the intention being to play rawer, tougher R&B than had been prevailing in clubs at that time. Guitarists Mick Bower and Rick Morrison, along with Gavin Webb (bass) and Brian Vaughton (drums) had been looking for a singer so that they could stop playing their surf instrumental music and become more contemporary.

Playing at The Beat Basement, they established themselves as *the* band to see when in Adelaide. There had been some record company interest, so they recorded a demo and sent it to Astor, one of the larger labels in Australia at the time. In late 1966 Undecided, a savage punk number, was chosen as

the A-side, with Wars Or Hands Of Time — a freakish anti-war tirade — on the flip. The band didn't know the single had come out until Jim heard it on the radio! Astor had used the demo as the single, allowing its greasy veneer to splash across the national radio waves. It didn't chart well, but it got the Masters much exposure and offers to play in Melbourne, the booming musical Mecca in 1967.

The strain of touring started telling, with Brian then Rick both dropping out of the band. The next single, Buried And Dead c/w She's My Girl, was another garage slugfest, and it made the charts in various cities, giving them more touring options. When Mick Bower wrote Living In A Child's Dream, it finally broke them nationally, in the top ten, and winning the 'Song of the Year' at the Australian Music Awards. Living… is a magical, trippy tune, full of elegiac imagery, and The Masters' first step into Psychedelia.

By this stage, the band had become Beatles-huge, causing riots whenever they appeared in public, their concerts a fainting phantasmagoria. Unfortunately, all was not well with Mick Bowers. He had been experiencing blackouts and odd violent seizures and after he was catatonic during one concert doctors prescribed complete rest for him. The Masters were fortunate, however, in recruiting guitarist Doug Ford, who had blazed his own sonic trails with The Missing Links. He gave them a harder, heavier sound that would eventually propel them into the land of progressive rock and oblivion.

One last single must be mentioned though, before I leave The Masters Apprentices as they slide into the Oz pop phenomenon. The quirky, echo phased Elevator Driver came out in 1968 and also charted in a big way. The Masters were big enough at this stage to have promo film clips shot for every single and Elevator Driver was treated to a gauzy black and white psychodrama.

■ Ray Hoff And The Offbeats

Howler deluxe Ray Hoff first hammered out his rockin' R&B standards in Sydney as early as 1959. Too raw and raunchy for the pop crowd of the time, Ray eventually disbanded the original line-up of The Offbeats after releasing an up-tempo version of

Chuck Berry's Little Queenie as a single in 1964.

Moving to the Western Australian capital Perth, he formed a new version of The Offbeats, comprising a sandblasting brass section. This group recorded a wall rattling self-titled album, one side including live versions of I've Got My Mojo Working, In the Midnight Hour, Mercy, Mercy, Mercy and the ultra soulful Ain't Doin Too Bad; and the other side featuring crazy takes on Sweet Little Rock'n'Roller and the bizarre Uncle Willee.

Touring extensively across Australia, they were one of *the* acts to see live, though never receiving the chart success that they richly deserved.

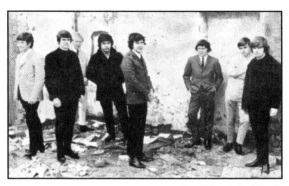

Ray Hoff and the Offbeats

■ The Black Diamonds

Just the other side of the Blue Mountains lies the tough mining town of Lithgow, the birthplace of The Black Diamonds.

Allan 'Olly' Oloman (guitar), Glenn Bland (vocals/blues harp), Alan Keogh (bass), Col McAuley (drums) and Felix Wilkinson (keyboards) came up with an uncompromising brand of R&B that made them as many friends as enemies in the small rural town. In 1967 they cut their most blistering single in the pairing of See The Way c/w I Want, Need, Love You, both original songs.

Knowing that Sydney was where they could play more regularly and to bigger audiences, they developed their set to cover all sorts of material. As a result, they were offered a deal to record The Lion Sleeps Tonight, which they released under the name The Love Machine, and it was a big hit. Having to play more music in that style to please their audiences, The Black Diamonds went for a name change upon their permanent move to Sydney. They became Tymepiece. In 1968 they swung towards country rock, along with countless other local bands. But in 1972, Tymepiece unleashed their only album, *Sweet Release*, which features the devastating grunge guitar of Olly Oloman on Shake Off, an eight-minute epic of uncontrolled emotion.

Then they more or less broke up, and the town of Lithgow was safe again.

LB&T How much interest in The Black Diamonds was there from the media?

ALAN 'OLLY' OLOMAN There was a bit actually. Our local paper in Lithgow were interested, because we were the first rock and roll band west of Sydney around about 1966 or so. Clelia Calvo, of Orange, became president of our fan club, and later became one of the editors of *Go-Set* magazine. Because of her write-ups, we were doing a bit of TV and stuff, even before we started playing in Sydney.

LB&T At what point did you consider the band was doing something artistic?

ALAN 'OLLY' OLOMAN I kinda realized at an early stage that I wanted to make music my life, but at that age you don't have too many aspirations because everything looks so difficult. Especially for us, living in the bush, we thought, "We'll have a go," but I don't think we ever consciously thought, "This is going to be important down the track." I was never very happy with any of the recordings we did, with one or two exceptions. So I never expected any kudos in the future for that work. It's been quite a surprise.

LB&T Was there much of a sense of camaraderie between bands?

ALAN 'OLLY' OLOMAN It depends. We started playing in Lithgow, around 1959, just jamming around, doing stage work until about 1961. There was a fair bit of jealousy in the town itself because a lot of little bands were springing up. I know we inspired a few of them as we'd been inspired by the fellows playing jazz before us. So there wasn't a great deal of mate-

Sweet Release, Tympiece

rived, and Neil said, "Bugger it, I'm not scared," and he picked up his amp and walked out to the car. These guys are following us calling out, "You fucking pricks," and my brother casually opened the boot of his car and pulled out a .303 rifle. He cocked it and swung it around in their general direction and they took off like rabbits. The gun wasn't loaded of course. My brother was always very careful with his guns (laughs). The police finally arrived and escorted us out of town, having heard that there was guy outside the pub with a gun! (Laughs). I always thought that the greatest danger came from driving long distances at night, risking falling asleep at the wheel. It's interesting to note the difference in drug habits at the time. When I was about seventeen or so, a top night for us was a hot milkshake after the gig. Later on that became a rum and coke, which someone would sneak in backstage at a dance.

LB&T What about the use of amphetamines at that time?

ALAN 'OLLY' OLOMAN It was a different ball game to us, coming from Lithgow and moving into Sydney in 1968. We changed the name of the band to Tymepiece and our manager put us straight into the 'jive joints', the 'rest and recreation' places where American soldiers came for a good time. Places like Hawaiian Eye, Caesar's Place and Electric Circus were all American-style joints, where we would play from eight-fifteen p.m. to two-thirty a.m., six nights a week. That was like "baptism by fire" to us coz we were used to working like two nights a week. It was wild and crazy but it tightened the band up. Sailors would come in with bags of grass and there was lots of speed floating around and LSD. We tried all that stuff and luckily all of us, bar one, came through without having any after effects, except for the odd cold shiver (laughs). One time, I remember we were playing the Marion Shops, in Adelaide, and three of us decided to drop acid before the gig. This was at a car park and I recall not being able to remember the arrangements of any of the songs as I hallucinated. Worst of all, the zipper to my trousers had broken and I was trying to pull it up with my back to the audience. We ended up playing one song that lasted twenty-five minutes and the newspapers gave us a great review the next day, calling the fact that

ship in those days. We've since become good friends, as you do when you get a bit older. I never felt that way about them, but they seemed to be jealous of our success, I think. Though when we moved to Sydney things were a bit different. I'm not knocking Lithgow because I love the place but that's just the way things were then. In a big city like Sydney, there was no animosity because there was so many more spots to play. You didn't run into the same band every week as you might've in Lithgow.

LB&T Were there any dangerous situations at a gig?

ALAN 'OLLY' OLOMAN Working out west in the country towns we frequently had to be escorted out of town by the local coppers because the rednecks always threatened to lynch us. They probably saw us as these blokes that came all the way to their town to steal their girlfriends. Not that we were, but it looked that way to them (laughs). One time, my brother Neil, who was then our rhythm guitarist, was working at the Australian Defence Industry factory at Lithgow. He was a gun designer there. So anyway one evening we were working at Springwood, and the rednecks had been heckling us all night, which made us a bit scared to go outside. Someone had called the police, but they hadn't ar-

I was not facing the crowd, "great showmanship" (laughs).

LB&T How hard was it getting the right sound on stage in those days?

ALAN 'OLLY' OLOMAN They didn't make decent PA systems in those days. In Lithgow we had these skinny boxes with four eights in them and a fifty watt amp. The vocals always sounded dreadful. You couldn't buy left-handed bass guitars so our bass player had to make one. I made an electric twelve-string guitar out of an old Jason by adding extra machine heads. The Maton Firebird guitars that my brother and I played were like playing a barbed wire fence! My dad was a welder working in the power station and he saved up enough money to buy us two Fender Bandmaster amplifiers. We were very much working class, but he saw the potential in Neil and I. Both my parents were musical people, dad played violin and mum an old pedal organ. Those amps put us a bit ahead of some people in Lithgow I think. I bought for myself an Echolet tape effect pedal. What was unusual about this analogue echo device was that you could get unevenly spaced echoes, like you'd hear on Hank Marvin tracks. The Echolet opened up a whole new world. I completely overloaded the input so that it was red-lining, creating a primitive distortion effect.

LB&T With Tymepiece were you developing a lot more original material?

ALAN 'OLLY' OLOMAN That's certainly true. We did quite a few instrumental originals as The Black Diamonds, when that was very much in vogue. With Tymepiece about half the set was made up of pop songs that we liked to change completely. So that we'd heavy them up if they were light or lighten them up if they were heavy (laughs). We always stuck to the original arrangements with Beatles songs because people didn't like to hear them changed. The other half of our set was made up of our own songs, which was really difficult at first. Coming up with your own structures and arrangements took some doing but it was very enjoyable.

LB&T Was the song writing carried out by all members of the band or an individual?

ALAN 'OLLY' OLOMAN A bit of both actually. The Tymepiece album, *Sweet Release* was mostly written by me because the other guys were a little spaced out and they didn't have much time for collaborating, which we had done a lot earlier.

LB&T How important was the visual aspect of performance in those days?

ALAN 'OLLY' OLOMAN Going back to The Black Diamonds, we used to have a good tailor, and we dressed in very flash looking black suits. We were always into presenting well, though I was glad when we got to the stage where we didn't have to wear uniforms anymore (laughs). Later with Tymepiece we got right into stage make-up, probably inspired by our long trips to Coffs Harbour, where they had many magic mushrooms growing in the paddocks there. We used to have them on toast by the side of the road for breakfast. So all this affected our stage make-up. One bloke got right into the American Indian style of face painting, another got into the Bikie look but I always thought that in my previous life I had been a soldier in the Confederate army, so I took to wearing a Confederate army uniform (laughs). The two guys we had doing our light and sound were more spaced out than we were. One time in Lismore, we had a great act with a mattress behind the amplifier. During the final cacophony, which had us playing completely out of time, but in pitch, Richard Dawson had all this smoke pumping around the room. He'd set up his lighting desk right near all the power switches of the room. I was supposed to fling my brand new Strat in the air and at the point at which it hit the mattress, Richard was supposed to turn all the lights off in the room and leave the place in total darkness. This particular night however, my Strat missed the mattress and hit the floor, splitting in half. We still had this feeling of satisfaction at the end of the show though (laughs). Where the guitar came from was a story in itself. We had been doing a residency at the Electric Circus, an old theatre up at King's Cross, and I was on the lookout for new instruments. I was playing a Fender Jag at the time which was okay for jazz but not a very good rock and roll guitar. All these venues we played were filled with gangsters and prostitutes, who are great people by the way. I'd

trust them before I'd trust the coppers. Mind you some of my best friends are coppers... Anyway, we had heard that the owner of Les Girls had acquired a shipment of musical instruments and we were invited up to this flat to check them out. I saw this Sunburst Stratocaster there which I really wanted. The guys that were there at this room didn't have any idea what the instruments were worth. I offered them thirty-nine dollars, as I had only forty dollars on me and wanted to keep some change to avoid being picked up for vagrancy (laughs). The guitar was worth about $600 at the time, but the guy said, "Yeah, that'll do, you'll be right." So I walked out of the place expecting to get shot any second. Nothing was ever said by the gangsters about the deal, but that was the very guitar which I broke not a month later in Lismore.

■ The Loved Ones

Starting out in the early 1960s, The Red Onions Jazz Band, comprising singer Gerry Humphreys, pianist Ian Clyne and bassist Kim Lynch played trad-jazz to devotees in Melbourne's busy café scene. Noting the resurgence of blues groups resulting from a tour by The Rolling Stones, The Red Onions picked up drummer Terry Knott and guitarist Rob Lovett and added them to the stew, hoping something savoury would arise.

The Loved One c/w This Is Love was the result,

an off kilter handclap infested paean to romance, incorporating the rich, vibrant tones of Gerry Humphreys to forever inculcate itself in a listener's mind. The tempo changes and widely dynamic range would come henceforth to be associated with the newly christened The Loved Ones. The follow up single, Everlovin' Man c/w More Than Love, also distinguished itself with dextrous playing combined with effortlessly smooth vocals. The Loved Ones were enjoying wild chart success as well, but by 1967 the single Sad Dark Eyes marked a change in direction towards a more pop sensibility.

With Ian Clyne dropping out due to "artistic differences", the band soon folded. A compilation album, *Magic Box* came out and has been in print ever since, available to those who want to hear unique sounds.

■ The Four Strangers/The Sunsets

The Four Strangers were initially Alex 'Zac' Zytnik (guitar), Eric Connell (bass), Dannie Davidson (drums) and Gary Johns (guitar). They played surf instrumentals in Newcastle, a steel city in New South Wales, and released one single, The Rip c/w Pearl Diver before Lindsay Bjerre replaced the departing Johns and added vocals to the line-up. Lindsay also changed the musical direction by steering them towards the R&B sounds he craved to hear. They recorded the mystical blues numbers, Sad And Lonely c/w You'll Be Mine and then changed their name to The Sunsets.

Whilst playing R&B in the clubs, they also recorded the soundtrack to two surfing movies called *A Life In The Sun* and *Hot Generation*. Both scores were composed by Lindsay and featured all instrumental numbers. The next single however, was the brusque I Want Love, a return to their gritty blues feel. At this stage, about 1967, the band relocated to Sydney and became involved in the acid scene. Peter Barron came in as new bass player when Eric found the freak-outs too much.

Then The Sunsets realised they didn't feel like playing R&B anymore. They had to change... (See Tamam Shud in the chapter 'Fanciful Flights Of Mind'.)

LB&T What type of set were you doing with The Strangers and then The Sunsets?

ALEX 'ZAC' ZYTNIK When The Beatles hit we got into that. Before that we were doing The Shadows and other instrumentals. We weren't big on the vocals at first, but then Lindsay Bjerre started singing. We got Gary Johns to be our lead singer, sorta like Cliff Richard And The Shadows type of thing. At the Palais Ballroom in Newcastle, there'd be a fourteen-piece band on one stage and in-between their brackets, the rock'n'roll band would play on the other stage.

LB&T At what point did you start to regard music as more than just a pastime?

ALEX 'ZAC' ZYTNIK I had a career as a boilermaker myself, doing an apprenticeship for three years, but the minute it finished I went to work full-time with the band. The band lasted for a while but then I had to go back to make a living and I ended up making surfboards part-time. I had a lot of money compared to others cause I was working in a trade and playing in a band. The minute you tried to just live off the music though you'd just barely survive. We went to Surfers' Paradise and we played six nights a week there for about twelve to eighteen months and I think that's when we got good. We got to know each other as musicians and you get to just know when someone is going to do a drum solo or finish their bit. Towards the end of that stint, we didn't even rehearse. We'd learn a new song backstage and then just go out and do it. You'd say, "I've written a new number," and yell the chords out and off we'd go.

LB&T What kind of set up did you use when playing live?

ALEX 'ZAC' ZYTNIK I had a Fender Twin Reverb with four ten-inch speakers with a set of controls on either side. You could have two guitars playing through it quite nicely. At the Surfers' Paradise club, we ended up plugging the PA system through my amp. This little box that sat on the floor went into four microphones and into my amp, through which I was also playing my lead guitar!

LB&T Was the long hair a problem when playing the circuit?

ALEX 'ZAC' ZYTNIK Not really, because we did it after The Beatles and the Stones had already been into that. We would get write-ups with things like, "The Beatles know we've got Newcastle's own Strangers," and we would wear the uniform suits and the pointy toe shoes.

LB&T Whose decision was it to start writing your own material?

ALEX 'ZAC' ZYTNIK That slowly evolved. We had an instrumental called The Rip which I wrote, which was released as single in 1964. When we moved from Newcastle to Sydney we lived around Manly (a northern beach suburb). We had been known as The Strangers but we had to change our name to The Four Strangers because of the Melbourne pop band The Strangers, who were on TV a lot. I wanted the band's name to be Deep Purple (laughs) but the other guys didn't go for that. So we released a few singles as The Sunsets. When we became Tamam Shud, I wasn't really happy with it, because it wasn't very commercial. That's the way Lindsay was going at the time, making it hard for us. I was hoping to get closer to the top but Lindsay was getting very underground.

LB&T How much was the music being created affected by the introduction of LSD?

ALEX 'ZAC' ZYTNIK When we went to Surfers' Paradise we were introduced to acid and that changed the way we thought. Lindsay came back wearing John Lennon glasses and fur coats and things like that. I thought if we had a number one record we can make more money and then we can afford to experiment but Lindsay wanted to change everything first.

LB&T Did you have any dangerous encounters at a gig?

ALEX 'ZAC' ZYTNIK We were playing at a university once and this mob of people came in who were not from that university and a brawl erupted, but I don't think it had anything to do with the music

we were playing. We ended up getting a following there and most of the time people would just sit down and watch us play, with the bubbles and light show behind us. That's why we were not a three-minute song pop band. One of our numbers could go for ten or fifteen minutes with a drum solo here and there and people enjoyed that. It taught me how to improvise, how to extend and try out new things on my guitar. I wouldn't swap those musically innovative years for anything.

■ The In-Sect

This group, which had been playing in Adelaide since 1961 as Dave Thunder And The Macmen, became known as The In-Sect after The Beatles hit town. Their first single came out in 1966. Let This Be A Lesson is a pounding, chainsaw fuzz powered admonition to all girls who don't "love truly" to beware the consequences. Which are not named. The follow-up single was the tougher I Can See My Love. Both made the top ten of the Adelaide charts and boosted their teenage fan base.

The In-Sect led a somewhat schizoid existence as they also enjoyed playing the cabaret/easy listening circuits, where they would sway to the hits of Dean Martin and Frank Sinatra. Adding DJ John Vincent as featured vocalist, they released Madge's Charity Badges, a novelty tune about a brutal seller of charity pins. This too was a top ten hit and encouraged them to turn out more novelty songs until Frank Sebastyan set up The Entertainment Revue, which toured all the cabaret venues well into the seventies.

Disturbo Music
by Phil Tonge

THE BANANAMEN: Fake sixties garage punk hoax exposed. Finally.

In the latter part of 1983, a notably nondescript year in history, the minor label Big Beat a.k.a. Ace Records released a three-track single by a band called The Bananamen (cat.No.NS88). Much interest was shown by the record buying public as the single claimed to be a reissue of a long forgotten 1965 recording from a long forgotten garage punk band from the US.

On the rear sleeve, which was headlined, "Bananamen play songs made popular by the Cramps," the story of the recording was relayed. According to this story, The Bananamen were a short-lived band who released one record on the Hava Banana label in Minneapolis in 1965. A press release (reproduced alongside the notes) unearthed in a junk shop in the same town had been discovered in 1982, and this had sparked off the hunt for the recording. The scrappy looking press release was on the letterheaded stationary of one RS Promotions Inc. and gave a hand-written address at 5157 Flynn Parkway, Minneapolis. It contained a brief line-up of the band and one sentence plugging the record. The track listing for the forty-five was The Crusher (by The Novas), Surfin' Bird (by The Trashmen, who like the Novas, were from the Minneapolis area) and Love Me by The Phantom. The sleeve also came with the following apology/disclaimer: "We regret any surface noise you may experience whilst listening to this disc. This is due to the fact that it has been mastered from a single as we could not unearth the master tapes."

It didn't take long for record collectors, music journalists and rock music fans to smell a corpulent rodent corpse. Certain give-aways could be found on the sleeve notes that this was a wind up, such as the Hava Banana label name and

Sleeve for the mysterious Banana
Men's one and only single, The Crusher
c/w Love Me, Surfin' Bird (left) and cryptic,
badly reproduced sleeve notes (below).

the credited producer being a certain Major Wang
Taylor (retired) or the fact that "Flynn Parkway"
is an anagram of "Lynk Wray Pfan". Or is that a
bit too Alan Turing?

Certain people pointed to the line in the notes
that gave a big hint, namely "they bear a remarkable
resemblance to the sounds of… (the) Cramps". This,
and the fact that Big Beat were releasing records by
The Cramps at the time, led most people to believe
that the record was a collection of very early Cramps
demos and/or out-takes. This is still taken as fact by
certain text books (e.g. *Indie Hits 1980-1989*, Cherry
Red Books 1997, compiled by Barry Lazell. Page
sixteen if you're interested). But not me.

For one, the singer ("Exterior" Dec) sounded
nothing like Lux Interior. Secondly, while listen-
ing to a tape I'd made of a *Punk'n'Disorderly*
show (a programme on Bristol based Radio West
that lasted from 1982-3, hosted by Lynne Mullen
— newsreader — and Simon Edwards, the owner
of Riot City records. Famed for not being able to
cue a record to save their lives), our chummy hosts
played a track by then-current psychobilly band
The Stingrays.

Suddenly the cover was blown: The sound was
identical to The Bananamen, especially the vocals,
right down to the yelps, howls and gurgles. They
were also signed to Big Beat and if final proof were
needed, looking back at The Bananamen sleeve

```
      T H E  B A N A N A M E N  A R E  H E R E  !
PEEL ONE ! Guitarist "Poison" Pick, 21, one hell of a psychotic
teen in his dyed orange hair and mini-skirt !
PEEL TWO ! "Kongo" Keith, 22, the spooky slapper of the bass
fiddle with the blonde streak !
PEEL THREE ! Al Knocks, 20, who learnt to play drums in the
haunted swamps and marshes of f.l.a. !
PEEL FOUR ! And last but by no means least singer "Exterior  Dec,
21, a regular living voodoo doll in jolly English "topper" and
leather pants !

SO, GET HIP TO THE BANANAMEN AND THEIR NOW SOUND - IT'S WHAT'S
HAPPENING, IT'S WHERE IT'S AT - CHECK OUT THEIR NEW WAXING "THE
CRUSHER" ⇒ THE DEBUT NAVA BANANA LABEL - YEAH !
```

notes you could see that the "shadowy" RS Promo-
tions' director was one Ray Stinger.

The next piece of info came from walking encyclo-
paedia of obscure rock facts, Pete Kitts, of "mature"
punk band Pointy Boss, who has it that to get the
surface noise on the EP, the record producers took
the acetate and gave it a careful wipe with a Brillo
pad. Nice. Just for the record (pun intended) the
actual single is surprisingly good. Its version of The
Crusher is the best and most bestial I've heard, while
the cover of Surfin' Bird is the most demented. Well
done.

El disco es cultura

A Mexican Musical Overdose

By Joe Scott Wilson

I HAD AN UNCLE who used to collect Italian forty-fives, imported into Bedford in lorries carrying grapes with which the Italian community there would make wine. I have a clear childhood recollection of standing by his extremely huge gramophone player (so big he stored fruit in it), and watching him listening to these curious platters. His favourites didn't actually contain music as such, just dialogue, mainly in which men and women argued, pretending to be irate motorists caught in a traffic jam or some such. There was no singing on these records, just these comedic Italian monologues (though my uncle was the only one ever laughing, as best a man on sixty Capstan Full Strength a day could). My uncle would encourage me to dance to the argumentative banter, and would call contemporary 'sounds' (i.e. any records he didn't own) "rubbish". On the flip side of some of these records could be found the occasional accordion solo, or more comedy.

Mexican music reminds me of that.

On the trail of extremely cheap records over the years, I have accumulated something of a minor collection of albums featuring bands from South of the Border. The thing that first attracted me to these 'gems' (other than the price) were their sleeves... Rather, the sleeve of one album in particular: Yoyito Cabrera's *La Carne Lo Mato*. A man seated in a meat locker has a vacant expression on his face and a slab of meat in his hand (!), he's flanked by two young women who bend over for no reason other than to flash their knickers to the camera. I simply had to know what kind of sounds might be contained beneath such a well-turned-out sleeve. Indeed, I wasn't disappointed. I found Yoyito Cabrera alluring enough to send me on a Mexican music trip, and I returned to the cheap record store to pick up whatever Mex platters they had remaining.

I listened to my modest collection, back to back, one after another, in no particular order...

■ Los Cuatitos Cantu

[*Los Cuatitos Cantu* Falcon Records, 1979] The more astute record collector, upon setting eyes on the sleeve of this particular disc, might notice that two of the band members are dwarves. They're the singers. The opening track, Me Gustas Mucho

[translation: "I Am Fat"?], kicks in with a syncopated drumbeat and an accordionist who plays like a man possessed. For the casual record buyer who might not have noticed the midget Cantu brothers in their show-time suits, once the vocals start it will be patently obvious that the sound is being produced by people who are 'vertically challenged'. There's that *tininess* about it. But it is on the track Eleazar Del Fierro that the boys really come into their warbling own, furnishing each line of each verse with soft focus quackery. It has a cocktail lounge ambience, but then, what clubs would Los Cuatitos Cantu play, I wonder? Is there a place for this stuff in Texas? (Where the House Of Falcon recording studios are situated.) Or might there have been in 1979? (When the recording was made.) The music is pretty much by the book: Not novelty or comedy, as one might expect given the circumstances. No-one really puts their musical neck out, except perhaps the drummer, who provides a fill on Amor Derecho that is shockingly uncharacteristic given the easy-going nature of the album. He's really had enough by the time Sentimiento De Color, the last track of the album, rolls around. Here the boys get to croon in a drunken, forlorn kind of way, and the pigskin punctuation goes completely ballistic.

■ Mike Rentería: Con Los Cupidos Negros

[*Mike Rentería* Eclipse, 197?] Truly horrible easy listening. Look at the sleeve and Los Cupidos Negros — the 'Black Lovers', Henry Silva lookalikes — and think *un*easy listening. A keyboard swamps the mix, pumping out chord changes over which the other instruments play. Band leader Mike Rentería knows nothing of the economy of sound; there is no texture in any of his tracks; no shades of grey, just one instrument atop another, and all atop the droning keyboard. Occasional instrumental breaks are provided by a musical device that sounds unlike any other on Earth, and is totally out of step with the rest of the Mike Rentería experience. The sheer arrogance of this strange musical instrument can perhaps be likened to the experimental tweakings of Brian Eno in Roxy Music: So let's call this instrument the Eno Organ for the sake of argument. The Eno Organ makes a distortion sound between verses, basically. Strange too is the drumming, which consists almost entirely of sixteenths all the way through the album, and is so unnecessarily fast and twee that the listener supposes it must be a drum machine, which of course probably wasn't invented back then. No Me Niegues Tus Besos, the opening track on side two, utilises a guitar with an effect on it, but apart from that, no production at

Will the real Mike Rentería please step forward?

all seems to have gone into this album. The instruments — with noted exception — all produce a flat and colourless sound over the unbroken keyboard drone. In fact, all ten tracks appear to be takes on the same song. (Los Cuatitos Cantu — the dwarves from above — come over as Page and Plant next to this.) Turning to the reverse of the sleeve for a moment, look at the guy at the back of the group line-up, relegated a few steps behind everyone else: Boy, does he look pissed off! (Presumably he operates the Eno Organ, which must be pretty taxing.) The guy one step in front of him looks like he's just flipped Santo out of the ring. This isn't a musical group, it's the evolution of man on a record sleeve.

Mike Rentería is credited as being the composer of some great love songs... So, where are they?

■ Los Hnos. Barron

[*Conjunto Sabor* Joey Records, 1979] As with the above albums, the sleeve notes to *Conjuto Sabor* would indicate that Los Hnos. Barron are an established act with some success behind them. However, unlike Los Cuatitos Cantu and Mike Rentería, this has a more 'rural' quality to it, lacking the 'showbiz' feel of the former. It's full of El Mariachi guitar with working man vocals and a trumpet. The lyrics are less ballroom, too, with songs about police, prison and piss-ups. Should there be any doubt that these boys are *of* the people *for* the people, take a look at them being rounded-up and arrested on the front and back covers. That's right, *arrested!* Each of the four photos features the band and guns, like they're about to re-enact an episode of *Bonanza*. (Is this the boys at their day job?) Two of the outstanding tracks on an album that is consistently entertaining are A Las Tres De La Mañana and El Negrito Del Batey, both perfectly capturing the essence of outlaw, the stench of overripe bartenders and too much tequila. Maracaibo kicks off with a cheap plinking piano, intercepted by vocals in best free-rolling Hispanic

tradition. (Very small children love this sound; they dance and turn the volume up. I take satisfaction in hiding my two-year-old nephew's Early Learning Nursery Rhymes cassette and playing for him instead Los Hnos. Barron.) The accordionist demonstrates some fancy licks on side two's Los Tres Campesinos, through which also runs a peculiar discordant guitar riff. Funnily enough, this second side of the album is without the cheap piano which permeates every track of side one. Perhaps the pianist had a mishap in the photo shoot and is no longer with us?

■ Yoyito Cabrera

[*La Carne Lo Mato* West Side Records, 19??] If ever Joe Scott Wilson was stranded on a desert island this is the record he would hope to have with him (or failing that, its sleeve). Yoyito Cabrera — presumably that's him in the meat locker — is to music what Alejandro Jodorowsky is to film. The opening track, Lo Matto La Carne, gets the album off to a blistering start, *erupting* from the speakers and setting the tone for what is to follow (more of the same, basically). It's a cacophony all right, but an engagingly inventive one, in that, defying the laws of gravity, it somehow hangs together. If each instrument was to be isolated (guitar, tom toms, piano, trumpets), I'm

certain their musical paths would be diametrically opposed. But Yoyito and his babbling vocal style — driving, dynamic and audacious — somehow keeps them all in check, and saves the whole thing from crashing down to Earth. Part way through the opening track, Yoyito suddenly starts to laugh and scream. No matter how many times I listen to Lo Matto La Carne I can't figure if this is a predetermined aspect of the composition or merely a rash decision on Yoyito's part. It's brilliant, whichever. On Yaya Con Dios, Yoyito sings as though he's forgotten to put his teeth in. His voice is gruff and wise in liquor. (I don't expect any of these Mex artists had the opportunity to go for a second take or bother with overdubs: Life was simply too cheap.) Yoyito cackles again on this track. He is without question a spokesperson for an intoxicated generation. The song Son Guanajo is some reflection on politics and poverty: It's also the last track on side one and in the play-out groove, leaking through, can be heard the faint but incontestable sound of some other track by some other artist. It's the sound you might expect to hear after re-recording on a cheap cassette. Or, the sound which results when magnetic tapes are stored in close proximity for a lengthy duration. But the album doesn't let up: It's fast and contains no sentimental filler, just abbreviated psychosis. There is a funny moment on the play-out of Que No Me Toquen Mi Violin, the last track, in which

do take it upon themselves to play over and above elementary *chords*. Alas, that said, three tracks into the album and we hit ballad territory (Todo Pasara). On the sleeve, Los Bárbaros look as though they have just commandeered a bridge for drug money. I thought they might have been a surf/garage unknown, being nerdy-looking in a garage kind of way whilst wearing sunglasses. But the nearest Los Bárbaros get to rockin' out is a guitar solo on La Culebra. There are also several cover versions too many: Hoy Tan Bonita is a familiar Perry Como-type of standard whose original title escapes me; Cuando Llegue A Phoenix is By The Time I Get To Phoenix by way of Bert Weedon. For all of that, however, the band breezily adopt the stereotype image of Mexican music and produce a colourful, lively, samba-like racket with no black notes.

IT IS INTERESTING that all of the above albums have ten tracks, no more, no less. Was this a contractual obligation imposed on Mexican artists, I wonder, or the maximum number of recordings they could hope to achieve before the studio rates slipped into the second half hour?

Well, my uncle from Bedford has been dead for some years. I remember his house and I remember the cramped room in which he would sit, smoking Capstan Full Strength, listening to his traditional Italian music. But moreover I remember his comedy records. These were records imbued with a quality and a tradition that I did not understand at the time: They were for my Italian uncle the key to a distant time zone. In the days before satellite TV and the global village, these funny little monologues on vinyl were the best sense of place that money could buy.

I don't know what became of my uncle's Italian forty-fives, but I would hope it was a better fate than his big old gramophone player, which was relegated to the city dump. It hadn't worked for years and the Italian record collection was out of favour next to the novelty of audio cassettes and a portable cassette player.

But listening to the Mexican records above, that's my key to a time zone that traverses geographical borders, taking me back to a smoke filled room in which my uncle's wheezing laugh can barely be heard over scratched records of people arguing.

the electric guitar (the only instance of electricity on the whole album) overstays its welcome and the trumpets simply overpower it, playing even louder, in order to bring the song to a close. On the reverse of the album sleeve can be found other artists and discs in the West Side Records canon. Amongst them is another Yoyito Cabrera platter, *Tomo Pegapalo*, which features on its cover a man in a dapper suit on a sidewalk, with a bevy of buxom Mexican bikini-clad beauties around him, full of figure and big of thigh. The woman at the guy's feet isn't smiling. All the other West Side albums look to be of the easy listening variety, with 'respectable' covers. (I wonder what Yomo Toro, another member of the West Side Records canon, sounds like?) Incidentally, *La Carne Lo Mato* translates as "Breakfast with Meat": Now *that's* an album title!

■ Los Bárbaros

[*Los Bárbaros* Raff, 1973] The opening number on this sounds like it's about to swing into comedy, what with its rinky-dink electric piano. Indeed, the track in question, El Hombre Aparecido, is almost eighty percent keyboard solo. But it's difficult not to be carried along on the enthusiasm of the whole thing: And there is a qualifying difference between this and, say, Mike Rentería in that the musicians

Disturbo Music

by Gerard Alexander

SOMETIME IN THE MID EIGHTIES, a good friend of mine handed me a tape which he thought I'd like, as he knew I was into industrial groups such as Throbbing Gristle and Coil. All he told me was that it had been recorded by a Sydney band called Fetus Productions but that it wasn't connected with any of Jim Thirwell's projects such as Scraping Foetus Off The Wheel or Wiseblood.

The first track was a bleak little gothic song called Halocast, which did nothing for me, but the next track, Annoying, was different. As violins screech and undulate, a voice slides in and out yelling the word "annoying". A piano pounds in the background, getting louder and fighting for dominance of the tune. The following track, Caution, is carried along by delayed footfalls as an electrofizzing sprays all over a calm bass line. The rest of side one is made up of quieter, more relaxing pieces, but I was unsettled.

Side two begins with a zippy goth guitar track which I found very disappointing. Then Marvellous started…

A cacophony of growling, coughing and screaming buried by the scraping of torture instruments. Not one to play loudly in your home unit if you want to continue living there. Human Weakness is filled with moaning, idiotic gibbering and odd whistling which somehow fits the occasion. A drum-heavy song follows, sounding as if it's from some other album. Then comes the most disturbo track of all, I Call Plastic Surgery Patients. As a machine pulse throbs, a woman wails, a baby babbles and a descending bass hums menacingly. Not recommended for playing just before bedtime.

My other disturbo musical experience occurred as I was having lunch! I often went to the park for a little sunshine at lunchtime but this day in 1988 I found doom!

I could hear what sounded like the buzzing of several jet engines as I approached a bearded, painted guy sitting in the lotus position. His name was India Bharti. He was strumming a device of his own invention, the Bhartiphone. It had a long, stringed neck, like a guitar's, and it was connected to a keyboard and several effect pedals. Though plugged into a small forty-watt amplifier, the vast sounds issuing from the Bhartiphone easily disturbed shoppers within a 500 metre radius.

I don't know how many copies of his tape India sold that day, but I didn't exactly have to wait in line to buy mine. Songs like Money, about all the evils of its possession, backed with a distorted whining guitar drone, and Names Of Shiva with lyrics like "Shiva danced in Hiroshima" can't have appealed to the curious masses of suburban Parramatta. Dominant Paradigm, with its flanged madness, reveals the origin of India Bharti: How he went from Sydney to Calcutta and found his guru there.

I never saw India Bharti again, but I believe he is residing in the commune wastes of Northern New South Wales, preaching to the perverted. At least I got his autograph.

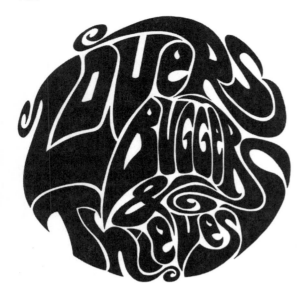

All Black And Hairy

Screaming Lord Sutch and The Savages

By David Kerekes

A NUMBER OF YEARS ago the opportunity to interview Screaming Lord Sutch came my way and I let it pass. I forget the exact year, but the place was a Manchester hotel where a fantasy film festival was being held. Sutch was guest of honour. Despite his early career in the kitschy realm of Monster Rock — a contemporary term suited to Sutch's penchant for theatrics and songs about vampires and other creatures — Sutch's fame in more recent memory was due not to rock'n'roll at all, but rather as figurehead for the Monster Raving Loony political party. Lord Sutch in outlandish dress, adding much colour to the proceedings but winning few votes, was a familiar sight on many a televised election night.

When I saw him in Manchester he was dressed in his customary top hat, brandishing oversized badges and rosettes, but appeared not at all boisterous and if anything a little bit shy. He was handing out 'Bank Of Loonyland' facsimile £1 notes, a promotional gimmick that featured Margaret Thatcher as the Queen on one side and Sutch as Prime Minister on the other.

It was only several years after his death that I came to realise how I had missed a fantastic opportunity to speak with one of Britain's neglected musical legends.

David 'Screaming Lord' Sutch committed suicide and was found hanged at his London home on June 16, 1999, aged fifty-nine. I got to hear his music for the first time shortly after that date, courtesy of *That Driving Beat*, an album I had found in a sale bin. A collection of rare early British freakbeat recordings by various artists, the album included a version of Johnny Burnette's The Train Kept A-Rollin' as performed by Screaming Lord Sutch And The Savages. The thing that made me sit up and take notice was the fact that I didn't think the vocals were quite right. Sutch sounded wrong somehow, his voice a slow snarl, threatening to upturn the musical accompaniment if it so much as threw him a backward glance. Wrong, but perfectly suited. The other thing that got me was the guitar break on the record, a blistering fretboard squeal quite unlike anything else on the compilation or indeed anything else that was happening in 1965. (I later found that the perpetrator was none other than Ritchie Blackmore, said to have been discovered by Sutch, and later to become axe hero with Deep Purple.)

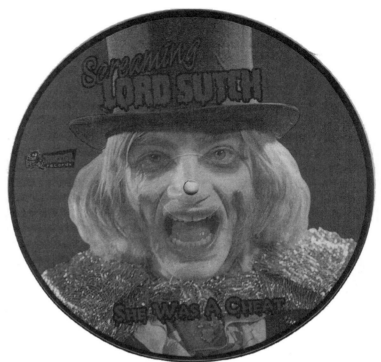

THIS PAGE

Compilation albums featuring Screaming Lord Sutch, including *Screaming Lord Sutch & The Savages*, *Rock & Horror* and — on the Munster label from Spain — *Munster Rock* and the picture disc single *She Was A Cheat*.

NEXT PAGE

The one pound note promotional gimmick that Sutch was handing out in a Manchester hotel.

Impressed with his treatment of Train Kept A-Rollin', I endeavoured to search out more music by Screaming Lord Sutch. This was not such an easy task, as Sutch's albums seemed to have all been deleted. Over a period of some months I did find *Rock And Horror*, a Sutch compilation on Ace Records dating back to 1991. And, shortly after that, *Munster Rock*, a compilation from the Spanish label Munster released in 2000.

Between the two came a limited seven-inch picture disc single, which featured on the one side Screamin' Jay Hawkins (the US Monster Rocker on whom Sutch had modelled himself) performing Potluck, and on the other side Sutch performing Lee Hazlewood's She Was A Cheat. Of the latter, the sleeve blurb asks the listener if they can "guess who's playing here?"

Well, the guitar work sounds pretty fresh and dynamic, so I assumed a young Jimmy Page, but there weren't many people Page *didn't* play with as a jobbing session man in the early sixties. And besides, I think I read something about a Page and Sutch connection in Pete Frame's *Rock Family Trees*.

Sutch's first single was Til The Following Night in 1961, which was originally titled My Big Black Coffin but was later changed after the record company fretted over what the BBC might think. The legendary Joe Meek was the producer on this and several other singles for Sutch And The Savages. Meek's landlady, Mrs Violet Shenton, took exception to Sutch arriving at the house in a hearse. Such is the stuff

Screaming Lord Sutch - Prime Minister (Designate)

of legend.

While I found none of the material on the two albums I picked up to quite match the dementia of The Train Kept A-Rollin', I did like the fact that Sutch growled, screamed and gurgled with an unbridled, heartfelt conviction (in a manner that only someone with no formal vocal training could). I also found an idiosyncrasy that I liked in one particular track that appears on both albums.

Hailed as "nauseating trash" by the *Melody Maker*, the song in question, Jack The Ripper, became something of a trademark for Sutch, and he performed many of his shows in the guise of the titular Victorian murderer. It opens with the sound of a woman running, followed by her screams. Interspersed with a backing that bellows the refrain, "The Ripper/

Jack the Ripper", Sutch relates the tale of "A man that walks the streets at night/With a little black bag that's o-so tight". The chorus divulges how Jack is hunting down Mary Kelly, the victim who — as historical records show — was despatched with particular ferocity:

Well, he walks down the street
Every girl he meets
He says, "Is your name Mary Kelly?"

Or rather, that's the chorus of the version on *Rock And Horror*. The version on *Munster Rock*, produced some years earlier (in 1963) by Meek, omits the victim's name in the last line and replaces it instead with a bit of gobbledegook:

He says, "Is your name *May-blowauch*?"

Could this be another last minute change imposed for the sake of airplay? Well if it was, it didn't work and the BBC banned Jack The Ripper outright. (Any allusion to taste and decency goes out the window for the later *Rock And Horror* cut, recorded in 1981, the coda of which has Sutch himself becoming the Ripper and chasing Mary Kelly with his "knife so sharp", ready to cut her up.)

Lord Sutch — not really a lord but a plumber's mate from Harrow — is now mostly remembered for his political non-career, which he entered back in 1963, representing the National Teenage Party with the slogan "Vote for the ghoul; he's no fool." And while his records never fared particularly well in the charts (Jack The Ripper was his biggest hit and that was banned), ever the showman, his live appearances rarely failed to draw the crowds.

Sutch was a publicity hound and the newspapers loved him. His long hair was enough in itself to grab attention in the early sixties, but he thought nothing of running down crowded streets half naked, dressed as the Wild Man of Borneo or as a Viking, brandishing an axe. For amusement, he would drive around in his hearse, waving to passers-by.

He would invariably start his gigs by leaping from a coffin, wielding skulls or sometimes bloody organs which he had acquired from a butcher shop.

Sutch gave The Sex Pistols their first break, allowing them

to play support on one of his tours (before kicking them off after five dates for smashing his PA). In 1970 he released an album called *Lord Sutch And Heavy Friends*, which featured Sutch backed by Jimmy Page, Jeff Beck, Noel Redding, Nicky Hopkins and John Bonham. Hell's teeth, with a line-up like that, you'd expect *Heavy Friends* to crush your turntable! Some critics called it the worst rock album ever made. I've yet to *see* the album let alone hear it, but I don't believe it can be anything short of sensational.

As noted earlier, there's nothing I've heard of Sutch's music that quite matches the intensity of The Train Kept A-Rollin'. Some of it is audacious and some of it makes me laugh, but a lot of it is twee and silly, not a quality in music that stands up particularly well to the cynical rigours of time.

There's a book on Screaming Lord Sutch waiting to be written, but here endeth my belated tip of the hat and acknowledgement of an interview that never was.

Talking of audacious, what about this verse from the Sutch A-side, Dracula's Daughter, dating back to 1964?

We find a tree and I said can we
Please pardon my intrusion?
Well, you gave me a grin and said
 "My, you're thin,
You could do with a blood transfusion"

Disturbo Music

by Johnny Strike

AFTER LOW: This unique reworking and deconstruction of David Bowie's *Low* is a weird and successful release. A loose collective of San Francisco underground and avant-garde recording artists, record store employees, Bowie fanatics,

electronic engineers and visual/video artists — even a guy from something called the Free Music Society — altogether recorded a low-fi, spooky, sometimes messy, yet seamless rendition that leaves other Bowie tributes in the dust. That is if we can even classify this as a tribute since in a way it even surpasses the original. I remember liking *Low* when it came out, but I got bored with it: a bit too perfect. In a way, *After Low* is the real *Low*…

The players' roster reads like a list of pop groups from *A Clockwork Orange*: Elephone, Foibles, Whoa Nellies, The Sadnesses, Love Among Puppets, Troll, The Gentle Leader. The uncanny effect is a subtle connectedness and the feeling that the same ensemble, with changes here and there, is doing it all. I understand the project was done very quickly, and this too I think adds to the appeal. This is not rock'n'roll *per se*. If you want to be rocked over, under, sideways, down, pick up The Hotwires or Rocket From The Crypt's *Live From Camp X-Ray*. Speaking of rays, the artist Rex Ray was the organizer of the Bowie exhibit titled *Fascination* at a Mission District art gallery, which even included the presentation of a one act play of the same name. The characters were Angie, Hermione, Marc Bolan, Valerie Solanis and Lindsay Kemp. The *After Low* CD is contained in a booklet that catalogues the show's work and various writings, held together by a huge rubber band.

Does this fit fairly under the title 'Strange Music'? Well, yes, in my opinion it does. What it is is spaced out, experimental, industrial and ambient rock in the best sense of those tired terms. Perhaps 'An incidental soundtrack for a quiet mind warp' would be a better way of putting it. The outstanding bonus track is Let's Dance which is sung/spoken in German, and the band sounds like some zapped-out lounge group entertaining tourists on a trip to Mars.

THERE WERE 1,000 copies of *After Low* pressed but there may be snafus regarding a more general release due to legal complications over the song rights. But copies with the smart, arty booklet are available from: Gallery 16, 1616 16th Street, San Francisco, California, 94103, USA.

Lawrence of Euphoria

The Itinerant Life & Music of Alexander Spence

By Martin Jones

> Where was the statement of the Haight/Ashbury *ever*, I mean the real statement? And the only one I ever saw was throwing flowers at each other and "Let's do something tomorrow." What happened to tomorrow?
> *San Francisco promoter Bill Graham, on the 1960s Haight-Ashbury music scene*[1]

LISTEN MY FRIENDS, THIS IS A STORY. A story of rock music, drugs and madness. And, like any other tale involving those three essential alchemical components, it is everything you've heard before and nothing you've heard before. This is a story of underused talent, record company hype, insanity, black acid, dark magic and, obviously, death. This is the story of Alexander Spence: Singer, songwriter, guitarist, drummer, *savant* musician, and unpredictable, unprecedented centre of energy. From his beginnings in the pioneering San Francisco folk/rock amalgamation Jefferson Airplane, to incomprehensible fame with hype-buried golden boys Moby Grape, to a tarnished diamond of a solo album at the end of the 1960s, Alexander Spence (or 'Skip', or 'Skippy' as he was always known to his friends) stood far, far away from the bands he slipped in and out of; far away from the other music he went along with. A figure in a colourful crowd, Skip Spence travelled through some pretty interesting times, but he didn't always stay on the beat. Often, it was the unplanned events of his life that had the most impact, times when Skip would weave off on trips with no map to help…

Fasten Your Seatbelts 1946–66

> San Francisco in the middle sixties was a very special time and place to be a part of. Maybe it *meant something*. Maybe not, in the long run… But no explanation, no mix of words or music or memories can touch that sense of knowing that you were there and alive in that corner of time and the world. Whatever it meant…
> *Hunter S. Thompson,*
> *Fear And Loathing In Las Vegas*[2]

SKIP'S STORY TRAILS out to a tangled, mysterious and derelict mess, ending with years in the American West Coast wilderness: a life stained by schizophrenia, alcoholism and other debilitating illnesses. But it began on April 18, 1946, in Canada, where Alexander Lee Spence junior was born in Windsor, Ontario, the only son (although he also had a younger sister, Sherry) of Gwenneth and Alexander Spence. Alexander senior was a Canadian Air Force pilot and decorated World War Two hero; he was also a jazz pianist (and sometimes travelling salesman) whose post-war career took the Spence family through several places in several years, such as Cincinnati, New York and Arizona. Skip's father had recorded with his own band and as part of Nat King Cole's backing group. Although in his childhood baseball-loving Alexander displayed no musical interests, at the age of ten he was given a guitar as a present, a concession to the new force of rock 'n' roll that was constructing the embryonic teenager, Frankenstein-style, through records, radio and concerts. Skip must have been caught up in the storm, for within the year, he found Little Richard's LA phone number and rang the piano-basher to complain about his desertion from music to take up religion. "He'd told me he'd seen the light," Skip later said. "I told him I didn't want him to be a minister."[3]

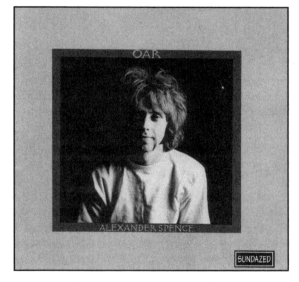

In the spring of 1965, The Honeybucket, a jazz club situated on Filmore Street in the Bay area of San Francisco was taken over by Marty Balin, a twenty-three-year-old silk-screen artist and aspiring singer. Balin wanted an area where artists of any kind could hang out. He built a stage at the furthest end and decorated the walls with his own artwork. Balin already had some musical weight behind him: He'd released two solo singles in 1962 and had played with The Town Criers, an LA folk band. But it was seeing The Beatles on *The Ed Sullivan Show* in 1964 that finally made him decide to form a full-on rock group, something that could fit in with the slowly changing Bay scene. The folk roots of the area were mutating with the help of electric guitars: Inspired by The Beatles, brought into realisation by Los Angeles' The Byrds, who played San Francisco over three weeks in early 1965 and were a sensation. Along with bands, promoters were emerging, organising 'dances': Hippie trio The Family Dog

were the instigators, wanting to make SF the new Liverpool. By the time the summer of 1965 had rolled round, Balin had recruited another vocalist, Washington DC émigré Signe Toly Anderson, two guitarist friends, Jorma Kaukonen and Paul Kanter (Kaukonen had previously jammed with Janis Joplin), and bassist Bob Harvey. The weak link was their drummer, Jerry Peloquin, who was really only with the band so they could crash at his Haight-Ashbury apartment. A Berkeley scenester called Steve Talbot came up with the band name, and passed it on to Kaukonen.

Around the same time, nineteen-year-old Skip Spence — no longer Alexander — was a singer/guitarist for hire on the Sausalito coffee house/folk circuit. His family had finally settled in the Bay area in 1959. By 1965, Skip had been discharged from the obligatory stint in the US Navy, and was now a joint smoking, long haired busker, married to a girl called Patricia and with a son, Aaron. One morning that summer he was sitting in The Matrix (Marty Balin's new name for The Honeybucket), drinking at the bar, waiting for a band audition that was taking place there that day. Balin spotted him and straight away knew he had found his replacement drummer. Balin had a thing about people looking *right*:

Skip had never played drums in his life. But I saw him sitting in a club one day and I was looking for a drummer and I saw Skip Spence. I'm very struck by images of people. And I saw him and I said, "That's my drummer." And I went up to him and I said, "What are you doing?" He was auditioning for The Quicksilver at the time. And he said, "I play guitar and I sing." I said, "Do you play drums?" And he said, "No." I said, "Why don't you get some sticks and work with them, you know? You'd be a great drummer, I can tell." He said, "I don't play drums." And I said, "Play for a week and see what happens. If you can play in a week, you can play in our group." So I called him a week later and I said, "Do you think you could do it?" And he said, "I'll try it." So I said, "Come on down tonight, we have a job."[4]

The only other time Skip had drummed was

with the school band back in Canada, but, showing a portent for later work, he instinctively picked up the basics and was soon on board Jefferson Airplane, now ready to debut as one of the first of the new wave of San Francisco rock groups. Ironically, the guitar audition Skip had been waiting for at The Matrix was for the nascent Quicksilver Messenger Service, who might have been able to make better use of his talents and aspirations at that time. Skip had jammed with them on a few occasions, but they took on Greg Elmore instead. Balin, however, knew he had the right man, lauding him in a contemporary interview:

He was a rhythm guitar player. I don't know how he changed over, doing these different things. He's not a technically really daring drummer but he's creative. Like he doesn't always stay on the beat. Sometimes the bass'll stay on the beat and he'll take off on little things. Create. And he's exciting to watch.[5]

Thanks to Balin's scene connections and the band's manager Matthew Katz, Jefferson Airplane played continually after their first gig in August, along with other emerging local groups such as The Charlatans, The Great Society and The Marbles. Bob Harvey, whose style had previously been bluegrass, was replaced a few months in by Jack Casady. The high profile paid off in the winter, when the Airplane was the first San Francisco band to win a recording contract. RCA advanced them $20,000 to produce a debut album, and their first single, It's No Secret c/w Runnin' Round This World was released in March 1966. The A-side was an unobtrusive mid-beat number made noticeable by Signe Toly Anderson's deep lead vocals, some decent poppy guitar and the obligatory tambourine. The eleven track *Jefferson Airplane Takes Off* was released in April and caused a swarm of A&R narks to fall on the golden city in search of, as ever, the next big thing… Or the next big thing after the one they had missed.

Beyond the postage stamp pastiche album cover, with the band posing by an airplane propeller, naturally (and Skip staying background right), *Jefferson Airplane Takes Off* was as good a beginning as any. Skip and Balin co-wrote the opening track, Blues From An Airplane, a short,

bass-heavy brooder with the opening lines, "Do you know/How sad it is to be a man alone." Skip's cymbal-led drumming on this song, and throughout the LP, was impressively sharp, proving that he was no impostor behind the kit (Jack Casady: "Skip was effervescent as a drummer... You'd look back and see him shaking his hair like Ringo, really kicking the band in."[6]) He and Balin also wrote Don't Slip Away, which, with its title and lines like "Almost been a year since we've been together/Seems so long ago since you drifted away" put the flag out on Skip's intrusive melancholy streak. Other songs of note on the LP were Let's Get Together — which later became a hippie anthem when covered by The Youngbloods — and the curious Come Up The Years, a seemingly innocent love song that is in fact a full-blown case of the Lolitas:

> I ought to get going
> I shouldn't stay here and love you more than I do
> Because you're so much younger than I am
> Come up the years come up the years
> And love me, love me, love me...

Shortly after the album's release, Anderson left to bring up a child, away from the instability of the music scene. Two further singles were released — Come Up The Years had Blues From An Airplane on the B-side — but Marty Balin was already looking towards a replacement. Grace Slick and her then-husband Jerry had been compelled to start a band after watching one of the Airplane's early gigs. As the unsigned, unrecorded Great Society, they had often hung out at the headliner's rehearsals. Slick brought some new toys to the Airplane line-up: Beauty, presence, attitude, a killer voice and a couple of songs to counterbalance the majority written by Balin. In The Great Society, her brother-in-law Darby had written an upfront rocker entitled Somebody To Love; Slick herself had crossed formative LSD trips with Lewis Carroll and emerged with the prowling, provocative White Rabbit. Both would take Jefferson Airplane into a whole different league, but Skip refused the ride. He had become increasingly fed up with what was to him a step away from his original intention. Drumming, even drumming in a popular band, was just a job to him,

and he turned up to fewer and fewer rehearsals. A year after Balin had met him, he was fired. The reason was to become typical of Skip's impulsive behaviour: He'd jumped ship on a gig, preferring to hit the road to Mexico with a girl and a bagful of acid. However, magnanimous to the last (Skip: "I came back from this trip and found the music all weird... I couldn't figure out what Jorma and Paul were doing."[7]), when Skip returned to the news of his sacking, he offered to stay on with the Airplane until Balin had found a replacement: Spencer Dryden came up from LA, unaware of who the band were, or where they were going.

Skip was not the only one to leave. Manager Matthew Katz had also been ousted — by big shot local promoter Bill Graham — and was looking to start another band, preferably one based around Skip's singer/guitarist wishes. Now broke after blowing his last $500 in Mexico, Skip set about doing things his way: Drumming behind rock stars was not the road forward. Thanks to Grace Slick's songs, and a big, popular second album (*Surrealistic Pillow*, released early in 1967), Jefferson Airplane were ascending at a fast rate. Skip waved them off and left some luggage on board in the form of the self-penned, nursery-like My Best Friend (the A-side of the new improved Airplane's forth single), with its map-of-a-future-plan chorus, "Follow your dream/Do you know what I mean?"

The Right Wail 1966–68

There is, for instance, the case of Moby Grape, an American group, approximately avant garde, who were given a 200,000-dollar build-up by their record company, Columbia. This involved the standard stunts, posters and badges and brochures, blanket advertising in *Cashbox* and *Billboard*, plus no less than six singles issued simultaneously. And what happened? Exactly nothing: the progressive pop audience was far too hip to get bought by such crude ballyhoo and they rejected the whole package.
Nick Cohn, writing on manufactured bands in Awopbopaloobop Alopbamboom[8]

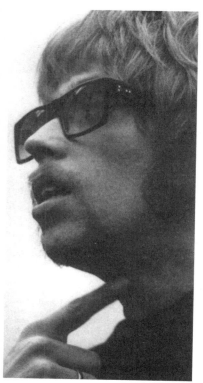

Skip Spence in an image from
Sundazed's reissue of *Oar*.

FROM ONE ANGLE, Moby Grape *was* as manufactured as any one-hit pop combo in the history of music. They were like a credible version of The Monkees: Whereas that group had been stuck together by producers auditioning actors, Moby Grape consisted of musicians thrown into a rehearsal room and told to hit the big time, fast. Unbeknown to all concerned, the Grape was a lumbering disaster at sea: Inevitable, but fun to watch. In the wake of Jefferson Airplane's success, groups began forming all over California — and San Francisco in particular — usually at the behest of a shrewd manager. The whiff of units shifted reached the noses of record company moneymen like barbequed meat. West Coast meat. The musicians in Moby Grape were perhaps more talented than most, but in the end that only meant there was more to lose.

Matthew Katz drafted in four others around the band-less Skip, and Moby Grape was born in Marin County in August 1966 (the name came from a drippy sixties joke told by the bass player: What's purple and floats at the bottom of the sea?) Peter Lewis, Jerry Miller, Don Stevenson and Bob Mosley had arrived from various points of California, and their musical histories were suitably intertwined. Lewis and Mosley had been playing in Los Angeles band Peter And The Wolves (Lewis, son of film star Loretta Young, had also ridden in surf combo The Cornells) when Katz invited them up to meet Skip. Miller and Stevenson were from Marin County's Marsh Gas, and had once been in Seattle band The Frantics with Mosley. It soon became apparent to all four that the man Katz wanted them to join up with was a buzzing amp of energy, even in such electric times. Skip, it seemed, was a wild, impulsive, eccentric and frightening man for someone just twenty years of age; a musician with the uncanny knack for picking up instruments and getting what he wanted out of them, a course of action unfamiliar to the near-session styles of the others, all raised on Louie, Louie done chicken-in-the-basket style. But these five relative strangers managed to merge seamlessly: Each was also a songwriter (Jerry Miller and Don Stevenson being the only writing team), Skip and Lewis played rhythm guitar, Miller handled lead, with Mosley on bass and Stevenson on drums; and everyone sang. As Moby Grape, they looked a bit more worn-in than your average band, certainly not of the same clean-cut type as The Monkees and others: Skip may have been the wild card but Mosley looked like a stocky blonde brawler, Lewis was the raven haired heartthrob waiting to happen; Miller and Stevenson the quiet musos in the background. Katz set them to work straight away. An intense set of eight-hour-day rehearsals in a Sausalito club called The Ark during September and October sharpened the individual ideas into a tight unit. The Ark was a converted paddleboat, a 'space' that people drifted in and out of, and the jams and workouts by Moby Grape soon attracted the usual crowds of musicians and musical detritus, there to hang out during songs and party after. One such group was Buffalo Springfield, who, for the few weeks they were in town, played alternate sets with the Grape. Springfield was a LA band, caught up in the whole 'real' and

'fake' battle of the two cities. They had come to San Francisco broke and tense — their first LP still not yet released — but had seen similarities between the massed guitars and vocal set-ups of the two groups. Stephen Stills hung out with Bob Mosley and Neil Young with Peter Lewis, the latter pair — seemingly at a distance from their respective band mates — even contemplated swapping roles. When Buffalo Springfield returned to LA in November, the town was being turned upside down by the Sunset Strip riots. Stills wrote a song about it, playing with a tune he'd pinched from two Grape songs performed at the Ark. For What It's Worth became Buffalo Springfield's biggest hit. When later asked what effect Moby Grape had on Buffalo Springfield, Neil Young replied cryptically, "The same effect Buffalo Springfield had on Moby Grape."[9] From SF to LA, the word was getting around about the Grape. It seemed that they were destined for great things, and Skip was now doing exactly what he wanted: Playing guitar, as well as fathering a second son, Adam.

If there's a certain chemistry involved in the make up of a band, something that can bring them riches on and off stage, then that good magic can soon turn bad: Ready to conjure up doom. In retrospect, Moby Grape's first three years of erratic success and spectacular failure could be traced back to their debut concert on November 4, 1966, at San Francisco's California Hall. Thanks to woeful under-promotion on the part of Katz, the band played their (headlining) first public set to a handful of people and hundreds of empty chairs. But they still played, and the month did get better, giving the Grape the chance to gig with the likes of new friends Buffalo Springfield, catching record company interest along the way. David Rubinson, a young in-house producer for Columbia who divided his job between hip young things and MOR stalwarts, caught them at a weekend bash at the Fillmore Auditorium. Rubinson was also Columbia's left-field talent magnet, signing the likes of Taj Mahal, Tim Rose and The United States Of America. He fought through the coming months with a handful of other record companies to sign up Moby Grape, most notably against Paul Rothchild, from folk haven Elektra Records. Rothchild got so far as to record a demo acetate with the band in January 1967, but Rubinson triumphed by appealing to

the band's baser instincts: He put their hotel and restaurant bills on his own expenses, and even paid for Skip to get his teeth fixed (a mere $1,500). Moby Grape signed to Columbia in February 1967.

The new deal put increasing strain on the band's relationship with their manager, which was already coming to an antagonistic end. But now there was no time to think about what Katz might do next, as David Rubinson was eager to get the Grape started on album rehearsals right away. He may have had different ideas if he knew that at some point during their first six months together, all five members had signed an agreement with Katz giving him full legal rights to the name "Moby Grape" (Katz had threatened to stop paying Skip and Bob's rent if they didn't), a seemingly insignificant act done in minutes that would haunt them in later years.

At a CBS radio facility in Hollywood, the Grape knuckled down to three weeks of pre-production rehearsals. The goal was to cut the length of their live set, tightening up the magical guitar and vocal interplay to create radio-friendly rock songs. The jams and more out-there stuff, such as Skip's wonderfully titled Dark Magic ("An extended raga-esque beauty" according to one set of sleeve notes[10]), were dropped from the list at the insistence of Rubinson, who was trying to bring out the musicians' potential to record company guidelines. It worked, as what was Moby Grape if not a set of strangers with their own scattershot ideas? This was not a die-hard gang that had grown up together. More upbeat, shorter numbers such as Miller and Stevenson's Hey Grandma and Changes became the yardstick. Rubinson later admitted that steering the band in this direction so fast may have been a mistake:

> I was exercising an excessive amount of discipline to what might have been a freer situation. I was trying to crystallize what they had… The group dynamic was very weird. These guys never had the time to get to know each other. They didn't live on a commune or go on a bus, doing one-nighters and changing tires in a rainstorm. That separateness worked musically. But they were never all-for-one, one-for-all.[11]

Moby Grape's eponymous first album was recorded live (with only some vocals being re-recorded) in three weeks during March and April 1967, at a cost of $11,000. Of the thirteen tracks, Skip wrote two: Omaha and Indifference, with a third, Rounder — a sprightly instrumental — being left off (although it was used, with lyrics, for opening gigs). Between the album's completion and its launch, Moby Grape played only one major show, a May two-nighter — the 'Rock Revolution' — supporting iconoclastic nutcases Love and PJ Proby. It was business as usual, with no signs of the horrors to come.

Moby Grape was released on June 6, 1967, two days after The Beatles' *Sgt Pepper's Lonely Hearts Club Band*. The campaign behind it was perhaps the biggest case of over-promotion of that or any other decade. David Rubinson had returned to Columbia drunk on enthusiasm and totally convinced of the album's potential to give birth to several hit singles. Perhaps in a flurry of misunderstanding, the company took Rubinson's words too literally and released five singles off *Moby Grape* on the same day as its release: Fall On You, Sitting By The Window, 8:05, Omaha and Hey Grandma. Each came in a picture sleeve identical to the album cover with only the titles differentiating which single it was, and each B-side was *another* LP track (Skip's aptly-titled Indifference was on the flip of Sitting By The Window). To add insult to this already extravagant promotion (such as a purple-painted elephant walking down Sunset Boulevard!), the album launch party at the Avalon Ballroom on the same night turned out to be a cross between Bacchanalian excess and slapstick vaudeville. Each party guest received a purple velvet press kit, containing the five singles and photos of each band member. Seven hundred bottles of wine with specially made 'Moby Grape' labels had been laid on, but someone had neglected to include even a single corkscrew. To provide the finishing touch to these errors, ten thousand purple orchids were later released from the ceiling: When they hit the ground and were trampled underfoot, the venue floor became a slippery, ankle-breaking, flower-scented ice-rink…

Despite these rather embarrassing record company tactics, Moby Grape played a well received set, but the next morning the after show partying was stopped when Marin County Police caught Skip, Jerry Miller and Peter Lewis with three high school girls. The fact that Skip's belt was unbuckled spoke volumes and they were arrested for "contributing to the delinquency of minors". Miller was also booked with possession of marijuana, but all the charges were later dropped. The album launch must have seemed to some the worst kind of sign, the slush of orchids like entrails to be studied, leading to a dark, oblivious future. The arrests overshadowed the gig and made more column inches in the daily newspapers than the release of *Moby Grape*. Any credibility the Grape might have had in San Francisco suddenly went out the window. It also didn't help that they had been brought into the scene by the much-hated Katz. These incidents distracted attention from the most important thing about the band: Their songs. The album was a good debut — despite the insane overexposure which resulted in it reaching only number twenty-four in the Billboard charts (Omaha was the one single to chart, reaching number eighty-eight) — playing perfectly to the time and place it was recorded in. The vocals and instruments tuned in together to mix energetic rockers with more introspective numbers, all wrapped in studio-perfect harmonies and overlaid guitars, showing a little country influence here, a little psych there. Hey Grandma, the album's opener, was about the Haight-Ashbury babes who wore junkshop granny dresses and still manage to look good: "Hey grandma you're so fine/Your old man is just a boy"; whilst Bob Mosley's Come In The Morning hit the smiley zeitgeist with its spoken intro: "C'mon people we're gonna tell you about good things and make you happy." Songs like Changes and Fall On You highlighted the exposed guitar sound that had so impressed Buffalo Springfield. Skip's blues stomper Indifference closed the album, all catch-me-if-you-can vocals ("What a difference a day has made"), high-speed chord changes and a cheery unwillingness to end. But it is Omaha that is *Moby Grape*'s centrepiece, and possibly the greatest song the band ever recorded. With hindsight, Columbia were probably kicking themselves that they didn't trash the flowers, picture sleeves and wine and concentrate all available energy on making Omaha the only single from the album, and a sure-fire hit. It was a permanent marking in

the ground of Skip's instinctual talents; even the title — it had been known to the band as Listen My Friends — came from nowhere: When pushed for one by a phone call from Columbia (nervy with the album pressing looming), Skip replied off the top of his head, "Omaha". A wall of reversed guitars and drums leap from speaker to speaker, before the song gallops off on a deceptively light riff and the massed vocals, although pitch perfect, manage to make only "Listen my friends/Won't leave you ever" clear to the listener. *Rolling Stone*'s David Fricke has described the song as "The Beatles on speed, at once demonic, ravishing and irresistible."[12] But really Omaha is one of the most euphoric, upbeat songs ever recorded, guitars and voices stumbling over themselves with glee, ready and willing to bring a smile to the most cynical of faces.

Its presence was definitely needed in the coming months for the band, when they set off on a countrywide tour to promote the album. The Grape made an impact both on and off the stage, determined to cast off the shadow of their costly inception; determined to prove that they were just as credible as Jefferson Airplane or The Grateful Dead. Such were the antics that Columbia president Clive Davis was prompted to send a telegram to the band reprimanding their behaviour. In a 1994 interview, Rubinson recalled:

> Columbia was a really conservative company back then... Skip would *ponce* into Davis' office, and prop his feet up on Clive's desk. The band would go out on the road and wreak hotels like the Who. We'd fight like crazy to get them on AM radio, and they'd act like lunatics in these towns and get booted off of airwaves.[13]

Skip was the beaming centre of the tornado on tour (Rubinson: "Skip was always in motion, you couldn't keep your eyes off him. He was the Brian Jones of the Moby Grape."[14]), a weirdly attractive magnet for female fans off stage, a self-conscious blending of Pete Townsend and Jimi Hendrix on; although his admiration for such guitar heroes failed to register the fact that they used common-or-garden Stratocasters to pile-drive into the boards: Skip smashing up a polished, maple-necked '67

Sunburst every night was having a noticeable effect on the Grape's limited finances.

A few weeks after *Moby Grape*'s release, the band was lined up to play a three-day festival being staged at the Monterey Fairgrounds, south of San Francisco. The event had been born when Sunset Strip rich kid Alan Pariser and booking agent Benny Shapiro went into partnership and had the idea of approaching The Mamas And The Papas to headline a rock festival. Before they knew it, Mamas front man John Phillips, with the help Paul Simon and Mamas producer Lou Adler, had taken control of the idea by twisting it into a charity fundraising event. The Mamas were rock royalty in LA: Big cars, mansions and swimming pools. Phillips was married to co-singer Michelle Phillips, herself the elfin blonde epitome of the times. He called upon his famous friends to help organise the event, but had less success when visiting San Francisco, being treated with suspicion, as most flash LA musicians were. Organisation was tight right up until the opening day, but on the weekend of June 16, 17 and 18, a sackful of diverse, talented acts — including Jimi Hendrix, The Who and Ravi Shanker — gathered together. Moby Grape was booked to play Saturday night, right under Otis Redding. It could have been the highest profile gig of their career so far, sweeping away any credibility doubts of the hipsters. But Katz approached Lou Adler with wild demands for huge sums of money and the headlining slot. As a result of the confrontation, Adler stuck the Grape on in the afternoon: After Canned Heat, Janis Joplin and Electric Flag, but before The Byrds, Laura Nyro and Jefferson Airplane. They all had their forty-five minutes in the sun. The band fired Katz the next day. It was no doubt due to Katz's bullishness that the Grape never made it onto DA Pennebaker's groundbreaking documentary *Monterey Pop*, released in 1968. Another chance had passed them by.

The experience at Monterey didn't deter the Grape: They supported The Mamas And The Papas a few times, and also appeared second billed at Santa Monica's Civic Auditorium at the end of July as part of a dream line-up that included The Yardbirds, Captain Beefheart And His Magic Band, Iron Butterfly and The West Coast Pop Art Experimental Band. But back in California, David Rubinson had

to deal with a few more nails in the hidden coffin. After *Moby Grape* had been released, he discovered purely by accident that when its stereo mix was played back in mono, the broader vocal harmonies (on Omaha, for instance) had disappeared. Given that more and more people were listening to FM stereo underground rock stations like Frisco's KMPX (the mainstream chart shows being on AM) on mono radios, this meant that the true sound of the band was cut off to its largest potential audience. Also after the release, a Columbia employee noticed that the album cover photo showed Don Stevenson — seated with a washboard in front of him — giving the finger, a gesture made by the drummer after a long, tedious day of set-ups and shoots around San Francisco (and one that could have been made by any of the morose-looking band). All subsequent copies came with the offending digit airbrushed, and just as an added inexplicable panic measure the record company had the American flag behind Skip erased, as well. It was a far cry from the music within.

Suitably chastised and mock-neutered by Columbia, in August 1967 Moby Grape retreated to Hollywood with Rubinson to record new material. But living in a Malibu beach house and partying with other bands did little for the creative process. The continually fraught Buffalo Springfield had moved in next door, their presence instigating many jams, including an acid-soaked session with Jimi Hendrix. As a result, a mere four songs were recorded, with only one being a band effort: Sweet Ride (a.k.a. Never Again), a barefaced appropriation of Hendrix's Foxy Lady that would turn up on the soundtrack of teen surf movie *The Sweet Ride*, released the same year. Columbia, understandably, were still concerned about getting another record out of the band. How could they work on their home turf, with so many disruptive, enticing influences? As a preventative measure, they insisted that Moby Grape's second album be recorded in New York. Nothing could have prepared them, or the band, for the events that would soon take place. Leaving Patricia and his two sons behind in San Jose, Skip took off with the rest of the band, unaware of the abyss he was about to topple into.

In three long, long months between November 6, 1967 and January 31, 1968, the Grape recorded their next album, to be entitled *Wow*. The remaining three songs from the Hollywood holiday were brought along: Bitter Wind, The Place And The Time and He (the only track they didn't bother to re-record). All showed a slow maturity in the group dynamic, which in post-*Sgt Pepper* days meant incorporating orchestral arrangements. But off-tape things were breaking down, fast. Relationships between band members — who had by now had more than enough time to run the entire gauntlet of comradeship/trust/dislike — were markedly different from the rush of those early, colourful days at The Ark. Abandoning his own contributions, Peter Lewis quit the band at one point to try and patch up his failing marriage. Elsewhere, the mischievous Grape boys were thrown out of hotels all over Manhattan: The harsh urban landscape was slowly tearing them apart. They still managed to pull together to play live during the recording time — in NYC, Philadelphia, Detroit and a Christmas break back in California (at the Whiskey-A-Go Go) — but it was Skip who was taking the full brunt of those darkening times. In the first days of the sessions he recorded two demos for *Wow* that were never used: Skip's Song and You Can Do Anything. The former was perhaps his second-best composition after Omaha, a plaintive slow burner that lashes out into a near screaming plea of guitars and Skip's grizzled angel vocals, shouting "Save me! Save me!" like he *knows* he's slipping away. The latter acted as a clue to Skip's post-Grape work, at odds with the usual layered tracks elsewhere: All quiet bass and guitar, his voice filling spaces between the music (and when there was no actual singing, improvised harmonies), and a dirty sense of humour probably revealing a little too much about his personal life: "Well me and your old lady were drinking cider/You came home and I was inside her…"

After those demos never saw the light of day, the other members of the band found their very own evil Yoko Ono in the form of a woman named Joanna Wells, who Skip had got it together with during one of the Grape's New York shows. Wells was a practising witch, and encouraged Skip to consume acid at an alarming rate, far greater than whatever he had done back in carefree San Francisco. Whilst the others recorded things piece-meal, one or two musicians at a time, Skip came under the sway of his NYC sorceress. She turned him onto the occult and

made him believe that he was the true leader of the band. It was at her suggestion that Skip proposed to the others to change their name to The Cows: A new name for new music. Black magic had made a revival in the 1960s, another avenue for the young and free to explore, but Joanna Wells' trip was different altogether. "This woman was showing Skippy that everything was a battle between good and evil," Peter Lewis said. "It was that point in the sixties when we turned the corner from love and peace to people like her — and bad trips like Altamont. This girl acted as a fulcrum for Skippy's change from Mr. Love into Mr. Hate."[15]

Skip had fallen into a newborn, grim alternative reality beyond the sunshine of Haight-Ashbury. He transformed from the colourful, well-groomed San Francisco peacock into a bearded, shambling man in a stinking black leather jacket. He wore inverted crosses round his neck and carved devil horns into his Strat Cutaways. At one point during his dalliance with Wells, they picked up a street bum and made him their guru, calling him "Father", and treating his every word as the oracle. Skip singing "Save me!" the previous November was like a cry to his future, now just beginning. David Rubinson witnessed the change:

He became very irrational and very destructive, and was very upset with the members of the band, with the engineer — he really just got completely beside himself. We had to have him physically removed from the studio area. He was threatening people, and he was very self-destructive, he could have really hurt some people in the group and himself... He just wasn't himself. He was a very mercurial person, but not a nasty or angry person.[16]

In reality, Skip was over-sensitive to the insanities that the world of rock music threw at a band: He'd had less experience than the others of such a vagabond lifestyle, where everything you considered as 'normal' was left far behind. He was also doing more speed and acid to boost flagging confidence in his own musical abilities. Despite his instinctual talents, Skip considered himself inferior to the other guitarists: "When I was onstage, I didn't know what I was doing... I was stricken with stage fright."[17]

Moby Grape was now fragmented as a whole, so it's surprising that a decent follow-up to their debut was ever completed, although Skip's final compositions for the album do tend to stick out like a sore-but-appealing thumb. *Wow* was released in April 1968 as a double album package: The second disk, *Grape Jam*, being a collection of blues workouts that the band had churned out during breaks in recording (a dubious trend made popular by Love's interminable Revelation, which filled a whole side of their 1967 *Da Capo* LP), with guest spots from keyboard player Al Kooper and Paul Butterfield Blues Band guitarist Mike Bloomfield. Both had played on Dylan's 1965 LP *Highway 61 Revisted* (Kooper had created the distinctive Hammond riff for Like A Rolling Stone), and Al Kooper's band, Blood, Sweat And Tears had made their live debut with the Grape at NYC's Café Au Go-Go the previous year. Unfortunately for Skip, Columbia and his band mates had vetoed his idea to put out an album of rock 'n' roll classics done Grape-style. The industry and the public were wary after the five single stunt pulled with their first record, but *Wow* still managed the slightly higher placing of number twenty in the Billboard chart. Considering the bright variety of their debut, Skip's contributions to *Wow* were very much the stand out tracks. Recorded towards the end of the album sessions, they showed Skip's mind to be wandering, looking elsewhere. Which, considering the shadowy circumstances of his life, was not unsurprising. Motorcycle Irene, a jaunty tale of a real life biker acquaintance, was probably the most 'regular' song amongst them. Funky-Tunk was a speeded up country workout with cartoon chipmunk vocals, a bit of an anomaly before Bob Mosley's downbeat Rose Coloured Eyes. But not as much as Just Like Gene Autry; A Foxtrot, an on-the-nail 1930's ballroom-style number (complete with orchestra) with Skip slurring/crooning his vocals accordingly. Just for added authenticity he roped in an unsuspecting veteran CBS radio announcer, Arthur Godfrey, to do the introduction (and got him to add banjo and ukulele parts). Godfrey thought it was the kind of music the Grape played all the time. Mischievously, to polish the track off it could only be played at seventy-eight r.p.m. on the record deck...

And mischief off record was boiling over. Joanna Wells' hold over Skip now seemed to be total. Whatever nefarious results she was after seemed to have materialised. He had transformed in the eyes of the band and those who loved him. Don Stevenson recalled a strange occurrence between two Grape roadies: "One of them was building a box, and the other one asked him what he was doing. 'I'm building your coffin, man,' the guy answers. 'Skippy told me to.'"[18] At the end of May 1968, Marty Balin encountered the transformed Skip in NYC: "I remember walking up the stage steps of the Filmore East… And passing this guy coming down. 'Well, don't say hello,' the guy says to me. And I go, 'Skippy?' But all the aura of light was gone. He didn't look anything like the guy I loved."[19]

It was after their second night at the Filmore East, on June 1, that Skip went off with Wells to drop some acid. Hearsay suggests she misled him and fed him some 'blue cheer', a particularly potent strain of LSD. Whatever the truth, the next day Skip was spotted wandering around the Albert Hotel clad only in his pyjamas, a fire axe in one hand. He was acting on instructions from Wells, and was looking for Jerry Miller and Don Stevenson, whom she had said were a "snake" and "evil" respectively. Skip hacked through the door to their room in order to "save" Stevenson, only to find it empty. Then he flagged down a taxi and, axe in hand, headed over to the studio to complete his mission (strangely, Skip and Stevenson actually passed each other going opposite directions). When the police arrived they refused to endanger themselves disarming him, so it was up to Rubinson to get the axe off Skip. The rest of the band would have left it at that, but Skip was arrested for attempted assault and taken away to the notorious Tombs cells.

Diagnosed as paranoid schizophrenic, Skip was committed to Manhattan's Bellevue Hospital for six months. Moby Grape carried on as a four piece, recording the third LP over November, sessions finally finished from their beginnings in May. Bellevue was perhaps the best and worst thing that could have happened to Skip. He was isolated from the band (they felt that Rubinson had been too hasty in getting him arrested) and, in turn, his family back West. All of a sudden he was pulled off of the insane ride that he had been part of for three years, suddenly told he was ill, and prodded into an alien environment. On the other hand, apart from all the treatment he received, Skip continued to act as he had done on the 'outside': He gave possessions away and only kept hold of writing pads, which over the months were gradually filled with lyrics.

In December 1968, Skip was discharged. He left Bellevue in his pyjamas. David Rubinson had persuaded Columbia to shell out on a hotel room at the Regency, and was there to check him in. Skip had plans. He wanted to buy a motorbike and cruise down to Nashville, to lay down the lyrics he had written. To Rubinson, that seemed like a good option: The remaining members of Moby Grape were having their own problems, yet again. Matthew Katz was filing a million-dollar lawsuit against the band, claiming ownership of the name, and wanting sole use of it. He'd already got a 'fake', session musician Moby Grape on the road, an expensive way to make his point. Rubinson managed to wrangle a $1,000 recording advance out of Columbia. Skip bought a chopper with part of it and, pre-*Easy Rider*, headed down to the Columbia Recording Studios in Nashville.

In six days between December 3 and 12, with the help of one staff engineer, Mike Figlio, Skip recorded and produced twenty-eight musical pieces (roughly: A few may have been segments of songs yet to be welded together, or mere instrumental tracks), singing and playing guitar, bass and drums on three-track tape. By December 6, Skip had recorded seven new songs with intriguing titles slightly removed from the Moby Grape canon: Diana, War In Peace, Little Hands, Cripple Creek, Weighted Down (The Prison Song), Books Of Moses and Lawrence Of Euphoria. He sent these back up to Rubinson in New York, who then managed to secure his errant charge another day of recording time. Skip made full use of it, at one point recording fifteen tracks in one day.

Then after December 13 passed, he got onto his Harley and rode back west to San Jose, the place of family and friends, and now a third son, Omar, born that year.

Dark Magic 1968–78

They say that all artists start out as dandies and become innocent. This love thing and then they get so hurt that they turn toward Satan… Macabre things. That's very sad. I feel outraged… I don't know. The groovy thing, I guess, is just to keep that positive thing happening.

Marty Balin, interviewed in 1968 [20]

It was left to Rubinson and engineer Don Meehan to mix the Nashville sessions into a releasable record. Skip seemed to have washed his hands of music for the time being. Moby Grape's third LP, *Moby Grape '69*, was released in January 1969, and was conspicuous by Skip's absence. By now the band had left the horrors of New York far behind and returned to California, only to find that they were out of step in a scene already falling apart. Former interested parties like Elektra were now signing up head-on, street-bruised musical collisions such as the MC5 and The Stooges, both of whom were not exactly groomed for mainstream success like the Grape. The dark days of that New Year — Altamont, the Manson 'family' — would find many gentle people of San Francisco naked and alone. Black-hearted, black-minded, black-clad bands such as NYC's Velvet Underground were now playing venues like The Matrix (ironically, VU's Sterling Morrison would later tell David Fricke that the only SF bands he had any time for were Quicksilver Messenger Service and Moby Grape), shattering the divide between East and West. Every shadowy little detail was added to the wake-up call, the admission that the Monterey dream had not worked. The Grape had lost the introspection and daring of their music in the shape of Skip. The dark magic had gone elsewhere, then dissipated. The *Wow* session recording, Skip's Song, made it onto *Moby Grape'69*, overdubbed with a touch of polish and new non-Skip vocals. Re-titled Seeing, its power was only slightly diminished, its place as the final album track belittling the ten songs that had gone before. All of them — barring Lewis's rueful I Am Not Willing — were simply well crafted blips in the groove. The LP was put out when the band were on their first and only European tour. Back home in February, Bob Mosley quit the band and went off to join the most unlikely of groups for a West Coast musician: The US Marines. Mosley wanted some sense of order back in his life, if only for a short time. Now reduced to three, Moby Grape finally ground to a halt with a follow-up, *Truly Fine Citizen*. Like Skip's LP, it was recorded in Nashville in a few days, but here the results showed: This was the full stop on a contractual obligation, Miller and Stevenson having to convince Lewis to make the record, with session players filling in the gaps. Rubinson was absent from the producer's chair this time (Dylan producer Bob Johnson took up the job, and no shit from the band, hence the short recording time), and the ongoing lawsuit with Katz meant that all songs were absurdly credited to Grape road manager Tim Dell'Ara. Skip's only tenuous presence on this sinking ship was a co-writing credit with Miller on Tongue Tied. By the time the LP was released in August 1969, Moby Grape was no more.

Columbia released twelve of Skip's solo recordings as per his instructions on May 19, 1969. Skip had titled it *Oar*, and requested that the artist name on the cover be "Alexander Spence". These instructions were the only things the record company adhered to. There was no promotion to accompany it. There was *nothing* to accompany it, only Skip staring out, wistful and honest, from the plain cover. This was about as simple as it got, and in a decade rapidly fading but carrying along with its musicians' grandiose plans — unwittingly unleashed by The Beatles (who, after all, had the money to perfect every sound in the studio) — *Oar* was about as out of time as a record could be. West Coast music was either getting rock heavy or unearthing country influences, and, although Skip's record could have been pushed begrudgingly towards the latter, Columbia remained bemused. They quietly pressed the album, then left it alone. Legend now goes that it sold just 700 copies: No one knew what to do with it. After all, this wasn't Dylan or The Byrds sliding down South to record *Nashville Skyline* or *Sweetheart Of The Rodeo*, this was the guitarist of an over-hyped San Francisco band whose day came and went quickly. Skip had long-disappeared from the minds of the music press and record buying public (journalists knew only that he had become "ill"). Few anticipated his first solo recordings.

Peter Lewis accompanied Skip to a record store when *Oar* was released, buying it and Neil Young's eponymous debut, released at the beginning of the year. After he'd listened to both of them (records made by two friends of his), he judged Skip's to be the better purchase. The man he knew the longest had gone through the songs, right out to the other side. "They were songs written in a predicament, in prison," said Lewis. "He was driven crazy. What he's saying on that album, in those songs, is coming from a place where he is really out of his mind — where he's more like a medium."[21]

"This album reminds me of one of those old scratchy 78's by Pinetop Smith." So wrote David Rubinson on *Oar*'s liner notes, conjuring up an image of an acid-scarred musician sitting under the rust-red metal shadow of the Golden Gate Bridge, gently pushing out songs by a dying fire. Skip had a lot to say about 1968, and utilised all musical strands he could turn his hand to with just those three instruments. He'd already been removed from the West Coast equation by those black nights in NYC, the witchcraft of Joanna Wells and the bleached corridors of Belleview. *Oar* was the postcard home...

"Little hands clapping/Children are laughing/ Little hands clapping/All over the world", so begins the spooky psychedelia of Little Hands: A melodic, catchy clap-along song with a slow chopping riff that offers *Oar* as the soundtrack to an acid comedown. There is a hiss behind the music, an edge. Skip's weathered voice, high or low, does nothing to help decipher his lyrics. The filler harmonies utilised in Moby Grape now took on a life of their own. Does he really sing, "How many friends do you call your own"? *Oar* is a place of depressed angels, where the creative spirits of Dylan and Johnny Cash meet and don't get on. For every downbeat song, there is one below it, looking up; darker or, as is the case with the hammer-knocking Biblical rainstorm of Books Of Moses, weirder. But the album is also a haven for Omaha-like positivity, filled with humour in the strangest places. Dixie Peach Promenade (Yin For Yang), for instance, was thought for many years to be a spiritual plea, until Skip later revealed in an interview that it was a reference to the hair product Dixie Peach pomade, "I used to jack off with it as a kid. My parents were never around, and you

know how it is."[22] Likewise, playful tracks such as Lawrence Of Euphoria and Margaret — Tiger Rug show Skip's humour to be cryptic and private. The dum-dum bass and drums of Margaret displays his train of thought going off on a journey, as he sings of the tiger in the zoo: "If he could be free he wouldn't have stripes on him like jail/Dinner comes in twice a day and feeds him a hunk of meat/That is just the same as you get out upon the street". And these are just some of they lyrics that can be made out. But sometimes the music takes centre stage and the listener finds it hard to remember that it's just one man pouring his heart out. The comparable All Come To Meet Her and War In Peace ("What a funny combination") are as close to rocking as *Oar* gets, with the latter making a spastic steal from Cream's Sunshine Of Your Love towards its end. Elsewhere, it's plain where Skip's thoughts were whilst in Belleview. The straight country of Broken Heart contains the line, "A severed eye would gratify/My soul I must confess", and Weighted Down (The Prison Song) is perhaps *Oar*'s black hole of a centre: A six-and-a-half minute jail song that might be about missing his family, or might be about suspicions of infidelity by his wife: "But whose socks were you darning, darlin'/While I been gone so long?" A resignation to a separation or just the paranoid scribblings of a man alone? Skip's in no doubt as to what went on: "If you can't find your woman/Don't take another's wife".

Oar ends with almost ten minutes of Grey/ Afro, an improvised mantra of bass, drums and whispered vocals. It is a gradually quickening trip down an unlit tunnel, with Skip being shot out the other side, just before the LP literally fades into obscurity. But more than the music was fading: The bright Haight-Ashbury days were also on the way out. The final year of the decade would bring on malevolent changes: The end of The Beatles, the end of Hollywood, the end of the Monterey dream. The world's greatest band splintered through non-communication, drugs and pushy girlfriends; Beverley Hills received a slap round the face from a stranger in their midst: Charles Manson and his hippie cronies crawling through the summer... And Saturday December 9, 1969 drew the huge black cape over it all. At a speedway north of San Francisco, The Rolling Stones — just over the ghost of Brian

Jones — staged a free concert. Sonny Barger's Hell's Angels played security guards. Trouble kicked off during Jefferson Airplane's support slot (Marty Balin was knocked unconscious) and brewed up horribly during the Stones' Sympathy for the Devil: Audience member Meredith Hunter was stabbed to death by Angel Alan Passaro. An unwitting occult ritual — strangely, Katz's fake Grape were also on the bill — it brought about the end easily enough.

Not that Skip was a figure in that scene anymore. He had already gone, back to his home in San Jose's Campbell district, unprepared to face a future scarred beyond redemption. There were some flame keepers for *Oar*, however. Greil Marcus gave it an exemplary review in the September 20, 1969 issue of *Rolling Stone*, but even he admitted that "this unique LP is bound to be forgotten."[23] Perhaps the highest — and most obscured — praise given to it came a few years later, in the June 1971 issue of *Creem*. In 'Psychotic Reactions And Carburetor Dung: A Tale Of These Times', journalist Lester Bangs fabricated a five album history for one LP/one hit wonders The Count Five, famous for their nihilistic garage classic Psychotic Reaction. The story veers off into tangents occupied by the gas of Captain Beefheart and Frank Zappa, but when Bangs gets onto the lack of promotion around The Count Five's 'second' LP, *Carburetor Dung*, he notes mournfully: "I think it just quietly faded away, like Alexander Spence's *Oar* and so many other notable albums."[24] Praise of the highest order, to be compared to a record that never even existed.

After the final map markings of *Oar*, Skip became harder to pin down. Despite fathering a daughter, Heather, in 1970, he grew distanced from his family, eventually losing contact with them within a few years and finally ending up on the street. His increasing use of drugs was matched by heavy drinking. The paranoid schizophrenia his band mates thought a misdiagnosis at Bellevue had become a self-fulfilling prophecy. The heavy acid of NYC and the hospital incarceration had spat Skip into the 1970s, unprepared. He undertook sporadic acts of mayhem and was locked up intermittently in psychiatric hospitals. Although he continued to play with bands, he never made a full return to recorded music. His manic shape flitted through the subsequent decades, leaving a few clues here and there…

In 1970, drummer John Hartman travelled from West Virginia to San Jose with the intention of joining a Moby Grape reunion. That never happened, but he did become friendly with Skip, who introduced him to singer/guitarist Tom Johnson. The pair decided to form a band, calling themselves Pud. Skip came up with a better name: The Doobie Brothers. They signed to Warners, and Skip got a credit on their eponymous debut LP, released in 1971. In the same year, Moby Grape was long forgotten, despite having released their last LP only a year-and-a-half previous. Columbia had washed their hands of the band, but David Rubinson managed somehow to gather all five original members back together, including Skip and Bob Mosley (who was also undergoing psychological problems of his own). He put them up in a house in Scotts Valley and set them to polishing up new songs. The resulting album, *20 Granite Creek* (the address of the house) was issued by Reprise in February 1971: It failed to even get near the Billboard top 100, and — after a few East/West Coast gigs without Skip — the Grape split up again shortly after its release. Their subsequent reunions would become irregular and touched by the shadow of Katz's actions: In 1973 he won the long running lawsuit, and kept the copyright to the band's name. That, and any royalties, trickled through their fingers like Pacific sand. Skip disappeared quicker than the others, and *20 Granite Creek* was symbolic of this: For all intents and purposes, he might just as well have not turned up for the recording sessions. He didn't contribute vocals and his guitar was lost amongst the others. His only songwriting credit was Chinese Song, a sprawling six-minute long instrumental experiment that found Skip playing the Japanese koto. As usual, it was totally at odds with the rest of the band.

At the time, Skip was living in his mother's apartment and still playing gigs in the area. He was the house musician at the Chateau Liberte restaurant in the Santa Cruz mountains, a place frequented by likes of The Doobie Brothers and Hot Tuna. He also did a few engagements with bluesman/needle-user Dr John, and had put together a group called The Yankees. In 1972 they went into the Pacific Studios, San Mateo and recorded two songs, All My Life (I Love You) and The Space Song. The

latter was an instrumental inspired by the 1960's TV series *Star Trek*, the former a Beatles homage of hard rocking simplicity, with its title called out repeatedly over a backing akin to the upbeat vibe of Omaha. Both songs were never released in their time. Although it's doubtful that Skip ever gave up playing guitar and composing songs, after the non-appearance of The Yankees he retreated back to the drugs (now using heroin as well), booze and madness, aged twenty-six. 1972 was the last mark on the post of this wayward pioneer, but, like all trails of madness, stories appeared, apocryphal or maybe not: There were a lot of lost years ahead of Skip. One time in Santa Cruz, a coroner declared him dead of a drugs overdose, then straight after he got up and asked for a glass of water; another time, at a monastery in Big Sur, Peter Lewis found himself terrified whilst driving down a mountain, because Skip had his hands around his throat and was intent on strangling his former band mate...

Shadows of possible stories. There was one actual escapade in the late 1970's, though, again with Moby Grape. Lewis and Jerry Miller were back together again (Don Stevenson was AWOL and Bob Mosley was in The Ducks, a ramshackle Santa Cruz mob thrown together by Neil Young) doing a few gigs here and there with a new rhythm section. Two gigs in early 1978 were recorded and a selection put together for *Live Grape* (same year) and released on independent label Escape Custom Record Productions: No band pictures, no mention of "Moby Grape". Katz still held his grip tight in that department. Skip turned up on the record, albeit for only one song, thus reuniting the Grape guitarists for the first time in ten years. Part sound check, part actual gig, *Live Grape* only really takes off when Skip arrives, powers up, and crashes into his own composition, Must Be Goin' Now Dear, stealing the lead back from Lewis and Miller, reminding them why the band was nothing without him. Manic, infectious energy for a few minutes, and then Skip left the record, left the band, left for good. It was his last appearance on vinyl before his death some twenty years later.

What Happened To Tomorrow? 1978–99

Kids today don't even do acid anymore — how can they make good rock and roll?
Skip Spence, interviewed in 1994 [25]

AFTER THE LAST known sighting of Skip within the vinyl grooves of *Live Grape*, he vanished from sight. There was a 1979 stint at Santa Cruz's Harbor Hill care centre, and many stays at Santa Clara and Napa Valley state hospitals throughout the 1970s and 1980s. There was no single lost weekend for Skip, but a whole lost decade: The 1980s. The post-*Oar* figure had finally gone, living a life of vagrancy, alcoholism and long periods of hospitalisation. There was no music, no jams, no get together with the musicians who had shaped the San Francisco scene. Skip was to all intents and purposes a dead man, an unknown guitarist destined for a one paragraph obituary in the local newspaper. There was no money from Moby Grape records, although the other remaining members still took it upon themselves to record material. In 1983 they released the thirteen track *Moby Grape* LP (a.k.a. *Moby Grape — Silver Wheels*) on the San Francisco Sound label. Ironically, it was produced by Matthew Katz. Skip was nowhere to be seen; but one song, the bland Better Day, co-credited him as songwriter with Bob Mosley, although authenticity is dubious. On a brighter note, the Edsel label reissued *Oar* in 1988, after many years of non-availability. It would be the first small step in the musical resuscitation of Skip Spence.

After the aberration of the 1983 LP, the Grape still had battles with Katz. Although they would periodically reform for gigs in California throughout the 1980s and 1990s, their last recorded document was a ten-track cassette only release entitled *Legendary Grape* (also known as *The Melvilles*), issued in 1990. It was punningly released on Herman Records. Somewhere in it, the remaining four members hit a spirited rendition of Skip's All My Life (I Love You), then as-yet-unreleased. More encouragingly, Sony Records offered a second reissue of *Oar*, but this time with five extra tracks taken from the Nashville sessions, all of them small but important sketches filling out the album's history.

Bereft of some of the psychedelic surroundings of the original album tracks, they are even more lyrically obscure, although This Time He Has Come solved the Grey/Afro fade-out question, being essentially a continuation of that final track. And It's the Best Thing for You has Skip laughing at the end, "There we go, oops! Hot chords, hot chords!"

In the early 1990s Skip was reunited with his four children, whom he had been out of touch with for nearly twenty years. He also discovered he had a half-brother — Richard Young — born in 1956. By that time he had been named a ward of Santa Cruz county and was living in a residential care home in downtown San Jose. His rent was paid by the Social Security. In March 1994, local journalist Johnny Angel visited Skip at the home for *Metro*, a San Jose free paper. The man he found was a good deal different from the many photos of Moby Grape days: Stick thin and dressed in nondescript clothes (which led Skip to joke that he looked like Lee Harvey Oswald), his substance-ravaged face was hidden beneath long hair and a thick grey beard covered his bad teeth. The *Metro* cover photo shows him holding a cigarette in one hand and a beer bottle in the other, but his eyes still give out light: That mischievous spirit of decades past trapped within them. Angel discovered that Skip was plagued by good and bad days, the bad days being when he conversed with the voices inside his head. Still diagnosed as paranoid schizophrenic, Skip was on a grab bag of anti-psychotic drugs, and combined with alcohol and coffee, they took him further away from the real world, into a life free of material gain and stripped down to its basics. "Scoring psychedelics is no longer a priority for Spence, whose daily routine revolves around more pedestrian highs," wrote Angel:

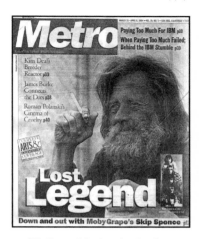

Skip Spence interviewed and on the cover of *Metro*, Santa Clara Valley's weekly newspaper, March–April 1994.

> It begins with breakfast and usually continues with a trip to the county welfare office to secure $1 of so-called "Personal Needs Money." Then, Spence generally panhandles until he can afford a cup of 7-Eleven coffee and a few 40-ounce bottles of King Cobra Malt Liquor, which he'll consume while chain smoking cigarettes.[26]

Two of Skip's sons, Adam and Omar, knew that he owned half the publishing rights to *Oar*, and set about putting together a project asking other artists to cover its songs, in order to raise enough money for them to buy their father a proper home. Angel's visit concluded with Skip jamming in Epicentre, a community band project. Angel joined him for an enthusiastic run-through of Omaha — the first time he'd played it in ten years — then Skip cadged some change out of him and disappeared off to buy beer.

One person who read the *Metro* article was Brian Vaughan, a thirty-seven-year-old San Jose musician and psychedelia fan. A mutual friend introduced him to Skip in May 1994. The pair got on well and did a few jams together, which Skip enjoyed so much that he began talking about starting a band with Vaughan; but then a spate of relocations meant

they lost contact in the summer, and Vaughan did not get back in touch with Skip until 1995, when he had moved out of the sheltered accommodation and was living in a trailer in Santa Cruz with his girlfriend, Terry Lewis. By November 1995, Skip and Vaughan were recording rhythm/lead guitar tracks — initially stuff Skip had written throughout the 1970s and 1980s — on a four-track in the living room at Skip's home. It was obvious to the younger musician that when Skip picked up an instrument he really sparkled:

> The amount of things Skip knew was amazing. He learned a lot of other people's songs that he liked. We sometimes had fun playing his versions of songs by Hendrix, the Rolling Stones, old blues tunes, old spiritual songs (Amazing Grace was one), the list goes on. Lots of times he would play the cover songs by himself… A lot of Skip's technique, particularly on acoustic guitar, had a lot of classical elements in it. He was better known for folk and rock, but he could do much more. When he played a cover, you could tell what song it was: But Skip could make it sound like he wrote it himself, the way Hendrix did with Dylan's All Along the Watchtower.[27]

One of the songs Skip and Vaughan laid down in December was Land Of The Sun, a track Skip would occasionally play with Epicentre. The pair recorded three different versions of it, with Skip improvising a vocal. Around the same time, producer John Chellew was in contact with Skip and Terry Lewis, trying to get him involved in the Warner Brothers soundtrack CD for the forthcoming *The X-Files: The Movie*. Vaughan saw it as a chance to get Skip back on record again. He put together a five-minute edit of Land Of The Sun and played it down the phone to Chellew, who was so impressed he asked for a tape he could present to Warner Brothers executives. The response was positive. On Christmas Day 1995, Skip recorded a proper vocal for the song at his home. The same day, Vaughan found out from Chellew that he had neglected to inform Warner Brothers of his involvement in the project, despite Vaughan listing credits on the initial tape he had sent. Undeterred, Vaughan went along

with Chellew's plans. Earlier in the month he had met Jack Casady at a Jefferson Starship reunion gig, and learned that Chellew had contacted Skip's old band mate with a view to playing on Land Of The Sun. Vaughan thought he might be able to steer the project away from the direction Chellew was taking. He also recruited Peter Lewis, and on December 29, 1995, the four of them went to the Mobius studio in San Francisco. From the moment they entered, it must have been clear that Chellew was intent on doing things his own way: A tabla player was practising along to a tape of Land Of The Sun. Nobody had been told about this. Undeterred, Skip laid down some drums, Lewis contributed some vocals, and Casady provided bass. It was the first time in over twenty-five years that Skip had seen Casady, and they got along fine, even talking about recording together again in the future. Chellew used the next two days to mix the results, and early in 1996 he went round to Skip's house with a copy of the final track. Skip, Terry and Vaughan were not pleased with what they heard: Skip's drums had disappeared; Peter Lewis had disappeared. The guitar tracks had been cut into simple, repetitive loops. The tabla and Casady's bass were prominent in the foreground of the song. By the time *The X-Files* soundtrack was released in spring 1996, Vaughan was unsurprised to find that Land Of The Sun was not amongst the tracks listed, citing the fact that Chellew had erased all trace of what Warner Brothers had originally heard, and liked. In a 1999 interview he mentioned that "Terry heard an unconfirmed rumour earlier this year that someone said Land of the Sun was 'too spooky', so that's why it was dropped. Even after all we've been through, I think of this as a back-handed compliment. 'Too spooky' for *The X-Files* — now that's scary!"[28]

Despite this bad experience, Skip and Vaughan continued to jam and record together. On September 9, 1996 Skip played what was to be his last gig with Moby Grape, an hour long set at the Palookaville club in Santa Cruz. Vaughan witnessed a revitalised artist:

> Skip never lost his magic. When you saw him on stage it was obvious he belonged there. He did everything from playing guitar to singing, working the crowd and greeting his band

mates with hugs — raising their spirits as well... When everything was over & we were sitting in the van chilling for a bit before going home, Skip said "Man, that was fun! We're going to have to do this again before long".[29]

Although there was little activity from the duo in 1997, by 1998 Skip was writing new material, practising regularly and performing acts of musical spontaneity that were commonplace in his Grape days. According to Vaughan, they recorded approximately three fifty-minute CDs worth of material together, most of it, like *Oar*, done in one take, with other instruments overdubbed later. The scale of the sessions went from psychedelic and hard rock to blues, folk, country, jazz and progressive/experimental. Vaughan tried unsuccessfully to release some tracks in 1997, and also a CD in 2000. It still remains in his hands, but he is resolutely sure of Skip's legacy:

Skip embraced new ideas in his work. His interest extended out to electronic music and experimental forms as well. His style could expand into any range or form — but he was never lost, his signature was still there, whatever new form it was written in. He would never stagnate or remain static. He even played his old songs in different ways at different times. Most of his time spent on music was used to create his own tunes... Playing tunes with him was fun and very interesting. There was definitely magic there. There still is.[30]

But in tandem with this creativity was the fact that Skip continued to battle with his mental/physical health problems. Although he had given up drink in recent years his liver was packing up, and the decades of substance abuse were finally catching right up with him, as were the after effects of medical problems such as pneumonia and congestive heart failure. On Monday April 5, 1999 Skip was admitted to the Dominican Hospital in Santa Cruz and placed on a ventilator. On Friday April 16, 1999, he died of advanced lung cancer. He was fifty-two: Another two days and he would have reached his fifty-third birthday. Before he died, Skip was given a copy of *More Oar*, the tribute project his sons had put together, and it was playing during his final hours. Contributors included long-time admirer Robert Plant (who had been a Moby Grape fan since his Led Zeppelin days) and individualistic singers such as Tom Waits (appropriately abducting Books Of Moses) and Beck. Later in the year, Sundazed Records released the definitive *Oar* CD in 1999, complete with five more unearthed tracks to complement the ones included on the Sony reissue: If I'm Good, You Know, Doodle, Fountain and I Think You And I. If anything, these fragments reveal more about Skip's time in Belleview: They are simple songs that could be conceived through a hum and a writing pad. Then in 2000 Sundazed issued the stomping All My Life (I Love You) as a seven-inch single, twenty-eight years after it was recorded. On the B-side was Land Of The Sun, the version that Warner Brothers rejected. It's not quite the aberration that Vaughan described it as. True, the tabla and bass are most prominent, but the wailing guitar loops in the background certainly mark it out as "too spooky", as do Skip's spoken vocals, mud thick words filtered through twenty-five years of bad living and bad teeth. As a snapshot of his later work, it's a fitting end to an itinerant musical career, a ghostly psychedelic squeal that leaves the listener hungry for more tunes from the private vaults. The gaps between these too-few recordings could make you forget about Skip's importance in music, something Peter Lewis recognised:

To overlook him in the great scheme of rock history would be a mistake; he was a visionary. Skip Spence was a genius, a powerful metaphysical force. He's advanced to a place past materialism where so many of us are hung up now. I'd say he's the holiest man I ever met.[31]

A short life and even shorter presence on record makes the last words on the Sundazed reissue of *Oar* even more poignant: At the close of I Think You And I Skip asks, "We out of tape? That just run out?" In the Nashville studio on that day of December 12, 1968, everything did run out, and Alexander 'Skip' Spence spent the remaining thirty years of his life dealing with the empty space left behind.

Notes & Sources

THE SONICS

1 There appears to be some confusion over the spelling of Mr Roslie's name. This confusion seems to have started with the release of Big Beat's *Psycho-Sonic* compilation CD (1993 Cat. No.CDWIKD 115) whose sleeve notes refer to him as "Jerry". Since then "Jerry Gerald Gerry Roasalie Roslie Rosaley" has more spellings than Shakespeare does. The spelling at the start of this article appears to be the genuine article.

2 Quoted on the sleeve notes of *Psycho-Sonic*.

3 From an interview with Andy Parypa conducted June 28, 1987. Unknown source.

4 ibid.

5 Interview with Larry Parypa in *Here 'Tis* magazine January 17, 1987.

6 Although fucking around with amps was nothing new by 1964. "I was blowing out amps in '57" — Dick Dale quoted in *Cult Rockers* (Wayne Jancik and Tad Lathrop, Fireside/Simon and Schuster, 1995, p.81). On that subject, Stagediving was not invented by US punks in the late seventies. It was invented by slightly mental

"Crying" Tommy Brown in 1955 (approx). Tommy would, in the middle of a very sad song (I think it was Baby, Please Don't Leave or something like that) take a step back, launch himself off the stage and then land ON HIS FACE onto what was usually a concrete floor. Then after rolling around a bit and sobbing into his mike, he'd get back up there and do it again. Then he'd run crying into the audience and fling his arms around some (by now terrified) fifties teenager whilst singing "I promise I'll never do you wrong no more". That's what I call punk.

7 Not to be confused with The Witch by odd mid seventies German folk-rockers The Rattles.

8 Interview with the *Seattle Times*, 1985.

9 A situation familiar to anyone who remembers the British chart debacle over God Save The Queen.

10 Interview with Larry Parypa in *Here 'Tis* magazine January 17, 1987.

11 In what could be an apocryphal story, The Shangri-Las used to relax on the road by buying up white mice from pet shops, fashioning parachutes out

of hankies and then catapulting them out of the windows of their moving tour bus. Cute.

12 Excellent Herman's Hermits story: On their first tour of the States, lead singer Peter Noone is in the hotel bar schmoozing with the press when the reception's Tannoy barks into life, "Paging Mister No One... Would Mr No One come to reception please."

13 Interview with Larry Parypa in *Here 'Tis* magazine January 17, 1987.

14 Interview with Andy Parypa conducted June 28, 1987. Unknown source.

15 ibid.

16 A rather eccentric nightclub that looked like someone's living room had been converted into an after-hours nip-house. Has now moved to larger premises down the road that look like a proper club but it still plays the same wacky blend of music and still refuses to join the ranks of snobby, dance-fixated bongo-barns.

DISTURBO MUSIC: ARCESIA

■ Many thanks to both Irwin Chusid and Paul Major for their assistance with the writing of this chapter.

AUSTRALIAN PSYCHEDELIA

■ Thanks to all the artists who gave so freely of their time, as well as Glen A. Baker, who made so much of it possible, and Tom Pitsis for the Allen Connection.

THE MONKS

1 *Kink: An Autobiography*, Dave Davies, Boxtree, 1996, p.88.
2 *Five Upstart Americans*, Omplatten, 1999. Sleeve-notes by Eddie Shaw.
3 ibid.
4 ibid. Sleevenotes by Gary Burger.
5 'Music in Black & White: The Year of the Monks', Will Bedard [**w**]www.the-monks.com

■ Much important information for this chapter was found on the excellent official Monks website [**w**] www.the-monks.com — *everything* you need to know or purchase about the band can be found here. Especial thanks go to Will Bedard and Will Shade for their online articles on the history and records of the band respectively. For the Monks interview, a special thanks to Josh and Babs, organisers of the Wild Weekend, and of course the band who were courteous and made time for the interview in spite of things running way behind schedule. A full review of the gig and event can be found in *Headpress 26* [**w**] www.headpress.com

CHARLES MANSON

1 Manson, interviewed in the documentary film *Charles Manson, Superstar* (see 'Further Information' section, p.60).
2 Alvin Karpis, quoted in *The Family* by Ed Sanders (Nemesis Books, 1993, p. 22).
3 Phil Kaufman, quoted in Channel 4 TV documentary *Charles Manson: The Man Who Killed The Sixties*, broadcast 10.8.94.
4 Dennis Wilson talking to *Rave* magazine, quoted in *Headpress 21*, p.36.
5 Neil Young, quoted in *The Shadow Over Santa Susana* by Adam Gorightly (iUniverse.com, 2001, p. 229).
6 Manson, from BBC Radio One documentary *Cease To Exist*.
7 Steve Despar, from *Cease To Exist*.
8 By an interesting coincidence, on the very same day as the Beach Boys' Bluebirds Over the Mountain c/w Never learn Not To Love single release.
9 Vincent Bugliosi, from *Cease To Exist*.
10 Gregg Jakobson, quoted in *The Garbage People* by John Gilmore and Ron Kenner (Amok Books, 1995, p. 79).
11 There is some disagreement about the release date of the *LIE* album. Adam Gorightly says it came out in 1971, but Ed Sanders (in *The Family*) says it was 1970. I find

Sanders' account more plausible.
12 Again, accounts differ as to how many copies of the original edition were pressed. Sanders says 2,000, Gorightly says 3,000. Take your pick. What does seem certain is that relatively few of these records were sold, with many copies disappearing into the sticky fingers of Family members.
13 Phil Kaufman, *Road Mangler Deluxe* (White-Boucke, 1993).
14 Gorightly, op. cit., p. 374-377.
15 Gorightly, op.cit., p. 145.
16 Bravin, op. cit., p. 88.
17 Sanders, op.cit., p. 374.
18 Phil Kaufman, quoted in *Squeaky: The Life and Times of Lynette Alice Fromme* by Jess Bravin (Buzz Books, 1997, p. 110).
19 Sandra Good, from *Cease To Exist*.
20 This sorry tale is most exhaustively recounted in the widely acclaimed *Lords of Chaos* by Michael Moynihan and Didrik Søderlind (Feral House, 1998).
21 Phil Kaufman, quoted in *Death Trip* by Johnny Satan (Death Valley Books, 1994, p.103).

■ With thanks to John Harrison, Jack Sargeant and Jan Bruun for help in sourcing illustrations.

THE STOOGES

- SOURCES
 I Need More by Iggy Pop; *Please Kill Me* by Legs McNeil and Gillian Mc-Cain; Ron Asheton interview by Jason Gross for *Perfect Sound Forever*; *Ron Asheton: Calling From The Funhouse* by Ken Shimamoto; *Raw Power* sleevenotes (Interview with Iggy Pop by Arthur Levy), and various anonymous sources on the web.

THE BEATLES

1 It can be found in the book, *Not For Sale: The Beatles Musical Legacy As Archived On Unauthorized Recordings*.

2 Many critics and fans have stated that The Beatles were not a particularly good live act. The band's touring years (1963–66) constitute repetitive and largely unimaginative sets of approximately thirty minutes duration. Despite this era being the primary source for Beatle bootlegs back in the late seventies/ early eighties, Castleman and Podrazik hit the nail on the head when they wrote (in *All Together Now*): "How many versions of Long Tall Sally do you really want to hear?" There was no such thing as mixing desk feeds, and so the sound fidelity at concerts was invariably poor, on top of which was the incessant screaming. True, The Beatles were starting to record material that was difficult to pull off live, but then their sets still comprised standards which they had been performing for the past several years. As the most popular and influential group in the history of the world it is hard to comprehend that as live performers The Beatles should be so staid. Recordings of many later shows reveal how very bored The Beatles were with the whole live experience. One 1966 performance in Tokyo, captured for posterity on the *Five Nights in a Judo Arena* bootleg, is a shining example: Full of bum notes, out of tune instruments, flat harmonies, faulty equipment and a general malice toward the fans themselves (courtesy of Lennon mocking the Japanese language, which is met with even greater fervour by the audience).

It is staggering to learn that The Beatles never sound checked before a performance, nor did they even rehearse before embarking on their later tours.

When they were on form however, there is no doubting that The Beatles could rock. A good example are The Beatles' Hollywood Bowl, Los Angeles, performances, which were recorded for the specific purpose of a live concert release. A compilation of the best numbers from the August 23, 1964, and August 30, 1965, sets were released by EMI in 1977 — over a decade after the performances themselves — as *The Beatles Live at the Hollywood Bowl*. Twenty years after this, the entire, unedited three nights became available (in excellent stereo) as a bootleg box set from Midnight Beat: *Complete Hollywood Bowl Concerts*. Listening to cuts on EMI's official Hollywood Bowl release, one is particularly knocked out by the way in which McCartney's bass simply *erupts* from the speakers, pounding away with demented, unwavering ease. In fact everything *pounds*.

3 It came out eventually as *Let It Be*, The Beatles' swan song. The ultimate irony of course was that far from the warts and all, raw rock'n'roll record The Beatles had intended, *Let It Be* was cleaned up and swamped with strings by producer by Phil Spector.

4 Reportedly dropped from the 'White Album' in favour of Revolution No 9 and later replaced by You Know My Name (Look Up The Number) as the B-side of the Let It Be single.

5 What's Yer New Mary Jane is essentially gobbledygook with a basic structure and lots of random sounds. The version on the *Spicy Beatles Songs* boot

is said to differ in that the mix is cleaner and more imaginative than other releases of the song, factors which have helped sustain the rumour that not only was Lennon himself the source for the bootleg but that he was also personally involved in mixing it.

6 Such as Lennon making a demo of If I Fell and Harrison composing his first song Don't Bother Me. Considerably less interesting were the humorous nursery rhymes, hymns and Bible recitals.

7 Auction houses have been the source for some illicit Beatle material over the years, although this option seems very much closed now that the likes of EMI are in the bidding (after all, what bootlegger could afford the £70,000 which official sources paid for a 1957 recording of the pre-Beatles Quarry Men?) As in the case of Bicknell's "Auction Tapes", these recordings may not necessarily contain much of interest and can often be of poor quality. Not that these are facts which deter the bootlegger.

8 Mike Heatley in a November 1988 interview with ICE The Monthly CD Newsletter, reproduced in Black Market Beatles.

9 Following a year-long investigation by the music industry and police, the "priceless" tapes — missing for thirty years — were traced to Holland. Raids in both London and the Netherlands resulted in the arrest of several individuals. Speculation on the internet as to whether the seizure would bring Yellow Dog's Day By Day series to a premature end was mixed.

10 The author was in attendance at one of the Abbey Road events (but did not have with him any recording equipment he hastens to add!) His overriding memory was the emotional charge in that room during the film show, and the strange sensation of displacement upon hearing slightly different takes of otherwise overly familiar songs. When the film finished there was not a sound; you could literally hear a pin drop. Nobody spoke, nobody applauded, nobody moved.

11 Indeed, the bootleg label Strawberry caused quite a stir when they issued three box sets (eleven CDs in total) of these John Barrett tapes in 1999, even reproducing Barrett's hand written notes in their entirety! Record Collector (No 250) suggests that another source for bootlegs cultivated from the whole Abbey Road affair may have been Roger Scott, a DJ and collector of rock memorabilia chosen to narrate the Abbey Road film. Scott had access to a different lot of tapes to that of John Barrett, which Scott sold sometime prior to his death in 1989.

12 Anywhere between two and 400 copies of the two-sided acetate are thought to have been pressed, and made available through the record store owned by Beatles manager Brian Epstein. The disc incidentally contained a version of Some Other Guy different to the one aired by Granada TV. (This version was later sold at Sotheby's in 1982 and found its way onto Yellow Dog's boot box set, The Ultimate Collection Vol 1.)

13 Even more ironic is the fact that some of the material on Anthology had been pilfered from the bootlegs themselves. More than one source claimed the bootlegs to be better!

14 Such as the Ram You Hard single by one John Lennon And The Bleechers, Spike Milligen's spoof of Yellow Submarine entitled Purple Aeroplane, and John, You Went Too Far This Time by Rainbo: Supposedly a reference to Lennon's comment on The Beatles being bigger than Jesus Christ. There are literally hundreds more.

15 The Knickerbockers are a good example of a soundalike, their outstanding 1966 hit Lies being perfectly suited to the term "Beatlesque". It could be argued that the mysterious outfit Klaatu also fit loosely

into this category. Though not exactly a soundalike band, rumours in 1976–77 that Klaatu might be Beatles-in-disguise were so great the band issued a statement to the contrary (see *Beatles Book & Record Collector*, January 1980). An article by Steve Smith in the *Providence Journal* suggested some 150 clues pointing to a Klaatu-Beatles connection, no less that a University of Miami voice print test proved that the Klaatu vocalist and Paul McCartney were one and the same, and that playing the Klaatu track Sub Rosa Subway backwards, using filters and a low speed frequency oscillator, revealed the hidden message "It's us, it's the Beeeeetles!"…

16 Beatles fans are regarded as a generally serious lot. What a Shame, Mary Jane Had A Pain At The Party, a twelve-inch bootleg single, featured on its cover a doctored image of The Beatles with cropped hair, surrounded by images of naked women wearing monster masks. "That's when I found out that Beatles fans, as a whole, don't have much of a sense of humour," noted the *What a Shame* bootlegger in Clinton Heylin's *The Great White Wonders*. "There was all kinds of flak about the cover. People wouldn't buy it or they'd buy it and go 'Euhhhh!" The anonymous bootlegger went on to release *The Beatles Vs The Third Reich*, a complete live set recorded in 1962 at the Star Club, Hamburg, and *Elvis Presley's Greatest Shit*, the first bootleg of The King following his death.

18 They aren't even mentioned in Philip Cowan's book *Behind the Beatles Songs*, which manages to list just about every other fictitious Beatles recording.

19 If proof be needed that Stout's artwork is key to the longevity of *Spicy Beatles Songs*, it should be noted that the same album had been released a couple of years earlier — *sans* Stout's artwork — under the now largely forgotten title of *Maryjane*. Stout, an underground artist who also enjoyed success in mainstream publications such as *Playboy*, *Oui* and the 'Tarzan' comic strip, would turn again to EC for inspiration on The Who's live bootleg *Tales From the Who*.

20 The track would also later turn up under another, slightly different title What's The News Maryjane?

21 Suitably mixed'n'matched, *Have You Heard The Word* also contains material pilfered from the 1970 *Let It Be* movie soundtrack, together with studio outtakes and live recordings dating back to 1962.

22 Not to be confused with Tin Tin And The Marbles, another group of the day signed to RSO!

23 The B-side was an instrumental called Futting, seemingly by a different band altogether.

24 Many years later, Peter Cook would host a music show entitled *Revolver*.

25 As is often the case with dubious Beatles material, Peace Of Mind is tellingly absent from bootlegs by the more respected labels.

26 'The Beatles' Unreleased Recordings', *Record Collector*, July 1982.

27 Amongst the other artists featured on the show were Jethro Tull, Marianne Faithfull and The Who. At the behest of The Rolling Stones, who financed the show but whose performance was decidedly lacklustre, *Rock And Roll Circus* was shelved, as was the intended soundtrack album. Twenty-odd years would pass before *The Rolling Stones' Rock And Roll Circus* found an official release. Needless to say, *unofficial* releases have been knocking about for quite some time.

28 Hendrix died in September 1970.

29 Instrumental numbers were very much a part of The Beatles' live repertoire prior to their explosion onto the international scene, however. It isn't likely that much of this material exists in any recorded form, although Catswalk — one

instrumental composition that was a staple of live performances from 1958 (when the band was known as The Quarry Men) through to 1962 — was given by The Beatles to The Chris Barber Band, who released it in 1967 under the title of Catcall. A recording of the track as performed by The Beatles (at a Cavern Club rehearsal in March 1962) turned up for the first time in 1994 on *The Ultimate Collection Volume 1*.

There is a suggestion that some crudely recorded, early Beatles material — including hitherto unreleased instrumental tracks — were featured on demo tapes that manager Brian Epstein touted around to record companies back in the early to mid sixties. Why Epstein should bother with rough demos when at this stage he had at his disposal polished recordings of the band from their unsuccessful (instrumental-free) audition for Decca is not clear.

30 It's funny, in that this article is about bootlegs: Booker T had a 1965 single called Boot-Leg.

31 There are a number of other songs associated with The Beatles that have yet to turn up in any form. These include You'll Know What To Do and Always And Only, tracks supposedly rejected from the 1964 *Beatles for Sale*

album. Other unlikely, rumoured-to-exist tracks, collated by one "Dinsdale P" in an article on the internet include: I'm Sorry, Bad Penny Blues, Echoes Of The Mersey, Home, Just Dancing Around, Moonglow, My Kind Of Girl, Portrait Of My Love, Proud As You Are, Rubber Soul (said to be an outtake from guess where?), Swinging Days, Zero Is Just Another Even Number, Keep Your Hands Off My Baby and Tell Me If You Can. All remain, for the time being, speculative titles of songs The Beatles probably never recorded. Not quite so elusive, but suspect nonetheless, are the following tracks: What I'd Say (a Ray Charles song that The Beatles performed live in the sixties before they made the big time, although a recording on *Artifacts II: Youngblood* of The Beatles playing it at the Cavern club in 1962 is suspect); My Girl Is Red Hot ("the only twelve seconds known to exist" have featured on at least four boots); I'm In Love (a composition which The Beatles gave to The Fourmost can be found as a supposed Lennon demo/outtake on *Artifacts: The Early Years* and *Arrive Without Aging*); and Let's Twist Again (an unlikely demo that appears on *Classified Documents Vol 2*).

32 *Black Market Beatles*, p.36.

33 "The odd thing is, it doesn't seem to matter. They all sell. I've sold hundreds of everything I can get," a spokesperson for one pressing plant producing bootlegs was quoted as saying in the February 7, 1970, edition of *Rolling Stone*.

■ With thanks to Nick and Guiseppe.

BIBLIOGRAPHY
Anon, *The Complete Bootlegs Checklist & Discography*. Manchester: Babylon Books, 1978
Belmo, *Not For Sale: The Beatles Musical Legacy As Archived On Unauthorized Recordings*. KY: Collector's Guide Publishing, 1997
Berkenstadt, Jim & Belmo, *Black Market Beatles: The Story Behind the Lost Recordings*. Ontario: Collector's Guide Publishing, 1995
Carr, Roy & Tyler, Tony, *The Beatles: An Illustrated Record*. London: New English Library, 1978
Castleman, Harry & Podrazik, Walter J., *All Together Now: The First Beatles Discography 1961–1975*. NY: Ballantine Books, 1975
Cowan, Philip, *Behind the Beatles Songs*. London: Polytantric Press (year unknown)
Fong-Torres, Ben (ed), *The Rolling Stone Rock'n'Roll Reader*. NY: Bantam, 1974
Heylin, Clinton, *The Great*

White Wonders: A History of Rock Bootlegs. London: Viking, 1994

Lewisohn, Mark, *The Complete Beatles Recording Sessions*. London: Chancellor Press, 1996

Sulpy, Doug, *The 910's Guide to the Beatles' Outtakes*. 910 Press, 1996

Walker, Bob, *Hot Wacks Vol XIV*. Ontario: Hot Wacks Press, 1990

MAGAZINES

Beatles Monthly Book, The Beatles Now
Beatles Unlimited
Come Together
Record Collector

WEBSITES

There are many Beatle and bootleg web sites out there, but the following were particularly useful in writing this article (and also provided some good links):

Bootleg Zone [**w**] www.bootlegzone.com (extensive list of Beatles bootlegs, artwork and track listings); *Erek's Beatles Pages* (appears to be down as of writing); *Harald Gernhardt's Beatles Pages* [**w**] www.gernhardt.com/beatles; *Martin Lewis* [**w**] www.martinlewis.com

THE 1970s BOOTLEGGING SCENE

1 *Melody Maker*, Sept 1, 1979.
2 A bootleg differs from a pirate in that a boot-

leg contains unreleased product whereas a pirate is a facsimile of an existing product made without the copyright owners consent.

3 In suitably evocative language, reporting the bust the press referred to 'a syndicate', the use of long range cameras during the five month investigation and Mafia style threats against the BPI.

4 *A Serious Life*, DM Mitchell, Savoy Books 2004. p.205

■ Thanks to Roger Sabin, Dave Britton and Mike Butterworth

BONZO DOG BAND

■ The backbone of this chapter was kept stiff with the help of the following items: *Cornology* (EMI, 1992), a three-CD box set comprising of the five studio LPs, plus the early singles, a few rarities and post-Bonzo tracks. Each CD contains excellent sleevenotes by Brian Hogg. *Urban Spacemen and Wayfaring Strangers* by Richie Unterberger (Backbeat UK, 2000) contains the madmen (and women) that didn't make his previous book, *Unknown Legends of Rock'n'Roll*, and has a chapter on the history of the Bonzos, complete with a Neil Innes interview. *Ginger Geezer: The Life of Vivian Stanshall* by Lucian Randall and Chris Welch (Forth Estate, 2002) is a highly entertain-

ing and comprehensive biography of Stanshall's ultimately tragic life. It contains plenty of inspiring and frankly mental anecdotes.

AUSTRALIAN GARAGE PUNK

■ Thanks to all the artists who gave so freely of their time, as well as Glen A. Baker, who made so much of it possible, and Tom Pitsis for the Allen Connection.

SKIP SPENCE

1 *The Jefferson Airplane And The San Francisco Sound*, Ralph J. Gleason, Paladin, 1969, p.299.
2 *Fear And Loathing In Las Vegas*, Paladin, 19??, pp. 66-7.
3 'Sour Grape', Johnny Angel, *Metro*, March 31-April 6, 1994.
4 *The Jefferson Airplane And The San Francisco Sound*, p.91.
5 ibid.
6 'Sour Grape'.
7 ibid.
8 *Awopbopaloobop Alopbamboo: Pop From The Beginning*, Nik Cohn, Paladin, 1972, p.216.
9 *Shakey: Neil Young's Biography*, Jimmy McDonough, Jonathan Cape, 2002.
10 *Vintage: The Very Best Of Moby Grape*, sleeve notes by David Fricke.
11 ibid.
12 ibid.
13 'Sour Grape'.
14 ibid.
15 'Through A Glass Darkly',

Jud Cost, *Oar* sleeve notes.

16 *Unknown Legends Of Rock 'n' Roll: Psychedelic Unknowns, Mad Geniuses, Punk Pioneers, Lo-Fi Mavericks And More*, Richie Unterberger, Miller Freeman Books, 1998, p.151.

17 'Sour Grape'.

18 'Through A Glass Darkly'.

19 ibid.

20 *The Jefferson Airplane And The San Francisco Sound*, p.265.

21 'The Man Who Loved Too Much', David Fricke, *Oar* sleeve notes.

22 'Sour Grape'.

23 Review reprinted in *Oar* sleeve notes.

24 *Psychotic Reactions And Carburetor Dung*, Lester Bangs (edited by Greil Marcus), Serpent's Tail, 1996, p.19.

25 'Sour Grape'.

26 ibid.

27 'Seeing Skip Spence: The Brian Vaughan Interview', Paul Gouldhawke, *Picnic: The Online Interview Mag.*

28 ibid.

29 ibid.

30 ibid.

31 'Sour Grape.'

■ Thanks to Johnny Angel, Andy Darlington, Tim Livingstone, Lynn Quinlan, Rik Rawling and Brian Vaughan.

BIBLIOGRAPHY
Awopbopaloobop Alopbamboo: Pop From The Beginning, Nik Cohn, Paladin, 1972

Backstage Passes And Backstabbing Bastards: Memoirs Of A Rock'n'Roll Survivior, Al Kooper, Billboard Books, 1998

Fear And Loathing In Las Vegas, Hunter S. Thompson, Paladin, 19??

High Art: A History Of The Psychedelic Poster, Ted Owen & Denise Dickson, Sanctuary Publishing Limited, 1999

The Jefferson Airplane And The San Francisco Sound, Ralph J. Gleason, Paladin, 1969

Oar, sleeve-notes: 'The Man Who Loved Too Much' by David Fricke; *Rolling Stone* review by Greil Marcus; 'Through A Glass Darkly' by Jud Cost, Sundazed CD, 1999.

Psychotic Reactions And Carburetor Dung, Lester Bangs (edited by Greil Marcus), Serpent's Tail, 1996.

'Seeing Skip Spence: The Brian Vaughan Interview', Paul Gouldhawke, *Picnic: The Online Interview Mag.*

Shakey: Neil Young's Biography, Jimmy McDonough, Jonathan Cape, 2002.

'Skip Spence' (obituary), Mike Oldfield, *The Guardian*, 20th April 1999.

'Skip Spence' (obituary), Pierre Perrone. *The Independent*, 20th April 1999.

Somebody To Love: A Rock And Roll Memoir, Grace Slick with Andrea Cagan, Virgin, 199?

Songs In The Key of Z: The Curious Universe Of Outsider Music, Irwin Chusid, Cherry Red Books, 2000

'Sour Grape', Johnny Angel, *Metro*, March 31-April 6, 1994.

Unknown Legends Of Rock'n'Roll: Psychedelic Unknowns, Mad Geniuses, PunkPioneers,Lo-FiMavericks AndMore,RichieUnterberger, Miller Freeman Books, 1998

Vintage: The Very Best Of Moby Grape, sleeve-notes by David Fricke, Legacy CD, 1993.

Waiting for the Sun: The Story Of The Los Angeles Music Scene, Barney Hoskyns, Penguin Books, 1996.

WEBSITES
The Ark [w]
www.mobygrape.net/ The offical Moby Grape site.
Borderline Books [w]

The Contributors

GERARD ALEXANDER writes for *Shock Cinema*, *Asian Cult Cinema* and other journals of a filmic taint. Singer of The Elders, El Exotico and The Trillion Dollar Band. New material out soon on his Spanish label. Scripted *Paradisiac*, *Unnatural Progression* and other sordid films. Also has four children's books looking for a publisher. For all inquiries [**e**] elcondedelanoche@hotmail.com

SIMON COLLINS has been contributing to *Headpress* magazine off and on since 1993, though his writing on music has mostly appeared in *Judas Kiss*. He was exposed at a tender age to the sounds of Lou Reed, Iggy Pop and Throbbing Gristle by the scary dad of his friend who lived down the road, and he has been interested in bizarre and extreme music ever since. These days, depending on his mood, you might find him listening to French loungecore, Ukrainian black metal, Slovenian industrial, Japanese noise, Finnish folk or Mongolian throat-singing. Or Fleetwood Mac...

ANDREW DARLINGTON's book *I Was Elvis Presley's Bastard Love-Child* (Headpress/Critical Vision) is a revised collection of eighteen interviews selected from the best of twenty-odd years of music journalism for the likes of *IT*, *Zig Zag*, *Hot Press* and many others. He is also the author of a poetry collection, *Euroshima Mon Amour*, and likes the Greek islands, The Electric Prunes, *Bladerunner*, Daffy Duck, vegetarian pasta with chilli sauce, The Ramones, *2000AD* comic, Budweiser, second-hand bookshops, Soft-Mints and 'Jet-Ace Logan'. [**w**] www14.brinkster.com/andydarlington

MARTIN JONES is the author of the Headpress/Critical Vision book *Psychedelic Decadence*, and has written many things for many publications. His one half-arsed concession to rock'n'roll comes through having a tattoo of the former Cramps bass player Candy Del Mar on his right arm. With the artist Oliver Tomlinson he runs Omnium Gatherum Press, publishers of *Careful*, a comic so sinister one would normally shun it: [**w**] www.omniumgatherumpress.com

DAVID KEREKES is the editor/publisher of *Headpress* journal and co-author of the books *Killing For Culture* and *See No Evil*. He remembers vividly the first albums he ever bought: *Let It Be* by the Beatles and *Monster Mash* by Bobby (Boris) Pickett and the Crypt-Kickers. Too young to fully appreciate one; too grown up to like much of the other. An early *Pebbles* compilation opened his ears to the crushing notion that plenty of great music had already come and gone and that he, and the rest of the world, had missed it.

MICHAEL LUCAS has spent thirty years in a variety of stupid bands, including the barely noted Junior Executives and the slightly noted Phantom Surfers, and he still doesn't know any better. His nonfiction has appeared in such periodicals as *Ugly Things*, *Kicks*, *Scram*, *MaximumRocknRoll*, the *Manchester Guardian* and *Spectator*, while his fiction has been widely regarded as depraved and misanthropic.

RIK RAWLING's rock'n'roll art has graced the covers of more books, magazines, CDs and t-shirts than he cares to recollect. His mind was first blown from exposure to Meatloaf's *Bat Out Of Hell* LP cover at an early age and since then he hasn't looked back. Nowadays, he mostly concentrates on visionary paintings, soundtracked by the likes of Godspeed You Black Emperor!, Miles Davis and, of course, The Stooges. [**w**] www.rikrawling.com

EDDIE SHAW continues to play bass with the legendary Monks. Along with his wife Anita Klemke he is author of the book *Black Monk Time* (Carson Street Publishing, 1994).

SLEAZEGRINDER is the king daddy Cadillac Superboss of the Super Rock Revolution. He is the edi-

tor of *Gigs From Hell* (Headpress/Critical Vision 2003), the book that proves, once and for all, that rock'n'roll is not a musical genre, it's a mental illness. He's also the head honcho of the cleverly named Sleazegrinder records, which appears to have something to with cock rock and porn stars. When not concocting disastrous schemes, he enjoys driving erratically, chain smoking, and showing The Man that he really means business. [**w**] www.sleazegrinder.com

JOHNNY STRIKE has been published in a number of journals including *Headpress* and *Ambit*. His first novel, *Ports of Hell* was published by Diagonal (an imprint of Headpress) in 2004. He is a founding member of the influential US Punk band Crime who have recently reformed.

PHIL TONGE's art, cartoons and writing have appeared in over forty publications since the early 1980s, although if you buy him enough beer he'll admit that his finest moment so far has been appearing on Crass's *Bullshit Detector Three* LP. His regular *Headpress* column, Cak-Watch, deals out justice to all manner of crap TV, film and video. Visit Phil's website to read more about his quest to install The Very Things into the rock'n'roll Hall of Fame. [**w**] www.geocities.com/hedgehog662003/index. html

JOE SCOTT WILSON was born in the north of England and is lame. His passion for life is equalled only by his love for great music. He shuns publicity and doesn't care much for modern things (except computers and the television). He is a contributor to *Headpress*.

GOOD MUSIC	ROCK 'N ROLL
Variety of pitches	Constant repetition of pitches
Melodies	Almost no melody (only oft-repeated fragments)
Accurate pitches	Slightly under true pitch (as in "blues")
Uses many chords (harmonies)	Repetition of same chords (usually I, IV, V)
Modulations (changing keys, or tonal levels)	Almost never modulates (stays in same key)
Uses very high pitches for contrast and climax points	Overuse of high pitches to give wild, screaming sounds (instruments can be made to scream)
Well-organized pitch patterns	"Wild sound" (often incoherent)
Much contrast between loud and soft	As loud as possible, as long as possible
Constant change in dynamic level	Use of powerful hi-fi equipment for greatest possible intensity to "completely captivate the listener"
Sound level always controlled, even in more exciting pieces	Sound level often reaches uncontrolled wild stage (measured at 95 decibels which equals riveting— riveters wear ear plugs)
Wide variation in use of "force intensity" (this is qualitative, not quantitative, and can be as strong in soft music as in loud)	Always full of strong "force intensity" (with record playing, turn the volume all the way down and listen)
Well-ordered system	Chaos
Lifting-up quality	Degrading quality
Strengthens moral and spiritual principles	Tears away moral principles, is anti-spiritual and anti-God in many instances
Clean words, with good purposes	Sensual, dirty, sadistic, neurotic, and even blasphemous words

If you would like to contribute to a future volume of *Lovers Buggers & Thieves* (and agree with the chart above) please send a proposal to: Headpress/Critical Vision, PO Box 26, Manchester, M26 1PQ, UK

More Music & Pop Culture Titles from Headpress

I WAS ELVIS PRESLEY'S BASTARD LOVE-CHILD & other stories of rock'n'roll excess

by Andrew Darlington

Andrew Darlington has been interviewing Rock's luminaries and legends for several decades. *I Was Elvis Presley's Bastard Love-Child* collects together his timeless and engaging conversations with a diverse selection of artists and band members, amongst them: Peter Green (Fleetwood Mac), Country Joe McDonald, Grace Slick (Jefferson Airplane), Kraftwerk, Cabaret Voltaire, Gene Clark (The Byrds), Robert Plant (Led Zeppelin), Holger Czukay (Can), Dave Davies (The Kinks), Mark E Smith (The Fall), The Stone Roses

Pages 224 ISBN 1 900486 17 2
UK£13.99 US$19.95 AUS $39.95

RED LIGHT ZONES The World's Most Unsavoury Nightspots

David Kerekes, Editor

A collection of (Beat) writings from around the world, focusing on the Red Light Zones found in all major cities. Amongst the eye-opening and fascinating travels down unmapped streets (some of which may be just around the corner from you!), this book presents a lengthy report from Wild Weekend V in Benidorm, Spain. Playing live at this annual festival were The Monks, The (Amazing) Staggers, The Black Diamonds, The Embrooks, and plenty more garage legends and unknowns. Lots of reviews!

Pages 160 ISBN 1-900486-44X
UK £12.99 US $16.95 AUS$39.95

BAD MAGS The strangest, sleaziest and most unusual periodicals ever published!

by Tom Brinkmann

The strangest periodicals ever to hit the newsstands, *Bad Mags* illuminates the darker recesses of "pop lit" — focusing upon magazines and tabloids published up until the 1980s.

Bad Mags gives full contents listings, background information, publisher details on each title it covers, along with anecdotal information.

Includes everything from relatively familiar true crime magazines through to incredibly obscure, brutal and tasteless one-shots and short-run titles. Plus a large section devoted to the punk phenomenon — its changing face and fashion.

Pages 254 ISBN 1-900486-423
UK £14.99 US$19.95 AUS $39.95

Info & secure online ordering: www.headpress.com

An SAE/2 x IRC gets a catalog: Headpress/Critical Vision, PO Box 26, Manchester, M26 1PQ, UK